THE FIVE C'S OF
CINEMATOGRAPHY

THE FIVE C'S OF
CINEMATOGRAPHY

MOTION PICTURE FILMING TECHNIQUES

JOSEPH V. MASCELLI

SILMAN-JAMES PRESS LOS ANGELES

TO MARION

First Silman-James Press Edition

18 19 20

Library of Congress Cataloging-in-Publication Data

Mascelli, Joseph V.
The five C's of cinematography / Joseph V. Mascelli.
p. cm.
Includes index.
1. Cinematography—Handbooks, manuals, Etc. I. Title.
TR850.M33 1998 778.5'3—dc21 98-12705

ISBN: 1-879505-41-X

Cover design by Wade Lageose, Art Hotel

Cover photograph courtesy of Panavision

Printed and bound in the United States of America

SILMAN-JAMES PRESS
silmanjamespress.com

CONTENTS

INTRODUCTION

BY

ARTHUR C. MILLER, A.S.C

While production of motion pictures has changed considerably since I photographed *The Perils of Pauline* in 1914, some aspects — particularly those involving story telling — are still the same as they were half a century ago.

Motion pictures are faster paced for today's more sophisticated audiences. Television dramas now introduce the characters, set the scene and establish story line in a few minutes. To accomplish this, early films took a reel or more. Today's uses of the moving camera — especially helicopter shots — and wide-screen formats permit more continuous filming with fewer editorial cuts. Modern filming trends are moving away from theatrical effects, and toward more natural lighting and camera treatment, involving the audience more deeply with the screen story. That is good!

Motion picture production was vastly different in 1908, when it was my good fortune as a boy of 14 to become assistant — or "camera boy" as he was then called — to Fred J. Balshofer, a pioneer motion picture producer, director and cameraman. Mr. Balshofer initiated many filming techniques — such as strict adherence to *directional continuity* — which have become accepted production standards. The following year I went to work for Edwin S. Porter — who in 1903 had produced what is now considered the first story film — *The Great Train Robbery*. Early audiences recognized these *story* pictures as resembling stage plays — because of their *continuity*, which was a great advance over the animated movie snapshots presented until then.

This year marks the golden anniversary of the release of *The Birth of a Nation*, produced and directed by D. W. Griffith, the acknowledged originator of screen syntax — as we now know it.

Yet, despite the influence on cinematographers everywhere exerted by these outstanding pioneers — and by many competent cinematographers and directors of today and yesterday — not one of these masters of our

Mr. Miller is a three-time Academy Award winner for Cinematography. He is a past President of the American Society of Cinematographers, and its present Treasurer and Museum Curator; Associate Editor of the American Cinematographer Manual and Chairman of the A.S.C. Publications Committee. Mr. Miller is an honorary member of Delta Kappa Alpha cinema fraternity, and active in many technical and cultural areas of the motion picture industry.

craft has ever written in clear words just *how* the camera can be used to greater advantage in recording screen stories. The only way to learn to shoot better pictures was to serve an apprenticeship under a competent teacher — or to study films and try to figure out how they were made.

To my knowledge this is the first book that has attempted to translate the many intangibles of film making into definitive explanations. In my opinion, no one is more qualified to write this book than Joe Mascelli. Mascelli is a rarity. He combines the wide experience of a working cameraman — who films both theatrical and non-theatrical pictures — with a vast knowledge of all phases of motion picture production, along with the desire to instruct and inspire. He is an astute student of motion picture history — particularly cinematography — and has researched, studied and analyzed the work of motion picture photographers, from Billy Bitzer to Leon Shamroy. He has the unique ability to clarify shooting techniques for those who find the complexities of motion picture production mystifying.

I believe that this book will be truly valuable to cinematographers of limited experience, and particularly to students studying motion picture production. By understanding and applying the principles presented in this book, the reader will be able to *visualize* a story in motion picture terms. For, above all, it is the power of visualization that makes the successful cinematographer.

Reading the script of THE FIVE C's was for me both interesting and thought provoking. I hope you find this book as stimulating and informative as I have.

Arthur C. Miller

PROLOGUE

In 1928, when Eastman Kodak introduced 16mm Kodacolor — a well-known physicist remarked: "It's impossible — *but not quite!*"

On many occasions during the years devoted to preparation and writing of this book, I have felt that defining, explaining, clarifying and graphically illustrating motion picture filming techniques in an easy-to-understand way — *is* impossible — *but not quite.*

Most professionals instinctively know the right way to film the subject — but seem unable to explain just how they do it. They have learned what *not* to do, either from past experience or by serving as apprentices under capable technicians. However — although they are employing the rules constantly! — few can explain the rules by which motion pictures are filmed.

Many cameramen — particularly those shooting non-theatrical pictures —become so involved in the technical aspects of movie making that they tend to forget that the primary purpose of a motion picture is to tell an *interesting story*! There is much more to shooting motion pictures than threading a roll of film in a camera, and exposing the picture correctly.

The aims of this book are to make the reader aware of the many factors involved in telling a story with film, and to show how theatrical filming techniques can be successfully applied to non-theatrical pictures. There is no need for tremendous budgets to shoot a motion picture properly! The same professional rules may be successfully applied to a documentary film report.

The definitions, rules and recommendations in this book are not meant to be absolute. Most of these precepts have gradually developed through the years, and have become routine procedures. In a few cases, I have had to discover the hidden rule by which certain types of filming is accomplished. I have also had to invent names — such as *Action Axis* and *Triple-Take Technique* — for definition and explanation of shooting methods.

The production of a motion picture, particularly a non-theatrical film, can be a highly personal undertaking. It is up to the individual to accept, change or twist the rule to fit his particular purpose. Filming methods are continuously changing. The so-called "new wave" has shattered many established techniques — with some success. The coming generations of film makers may find some of today's standard filming methods stifling, and even obsolete. Film production can use changes — but they should be changes for the better. Changes that involve the audience more deeply in the screen story are constructive and always welcome.

It is important, however, that ambitious movie makers *first learn the rules* before breaking them. Learn the right way to film, learn the acceptable methods, learn how audiences become involved in the screen story — and what viewers have been conditioned to accept through years of movie going. Experiment; be bold; shoot in an unorthodox fashion! But, first *learn* the correct way, don't simply do it a "new" way — which, very likely, was new thirty years ago! — because of a lack of knowledge of proper filming techniques.

Learn to know your audience. Place yourself in the viewer's position.

Be truly objective in judging a new method or idea. Try it. If it plays — if it is acceptable — and the audience comprehends and enjoys it — *use it*. If it simply confuses, teases or even distracts the audience from the narrative — *discard it*!

Experiences in both theatrical and non-theatrical film making has led me to the conclusion that the documentary — in-plant, military, industrial and educational — cameraman working with a small crew, often on remote locations, without a detailed script or other benefits of a studio production department, must have knowledge and experience reaching far beyond that of a technical nature. He must often act as a cameraman/director and later edit his own film. His work may cover everything from conceiving and producing the picture — to putting it on the screen!

This book will, I sincerely hope, provide such individuals with greater insight into the many ways in which a movie narrative may be filmed — with the assurance that the picture can be edited into an interesting, coherent, smooth-flowing screen story.

The serious student should also consider a sixth "C" — *Cheating* — which can *not* be learned from this or any other book! Cheating is the art of rearranging people, objects or actions, during filming or editing, so that the screen effect is enhanced. Only experience will teach the cameraman and film editor *when* and *how* to cheat. The secret of effective cheating is in knowing how to make changes without the audience being aware of the cheat. The only crime in cheating is in getting caught! A player's height may be cheated higher in a two-shot; or the corner of a lamp may be cheated out of a close-up; or portions of the event may be cheated out of the final edited picture — for a better screen result. The beginner may be either afraid to cheat, or he may cheat too much. The experienced technician knows exactly how far cheating can be carried before the viewer is aware of a change.

This volume is not intended to be a means to an end — but a beginning! My purpose is to make you *aware* of the many facets of movie making. With that attitude you may analyze any filming situation, and decide on the best procedures for the shooting job at hand. What I hope to do is help you *think* about motion picture production professionally!

Joseph V. Mascelli

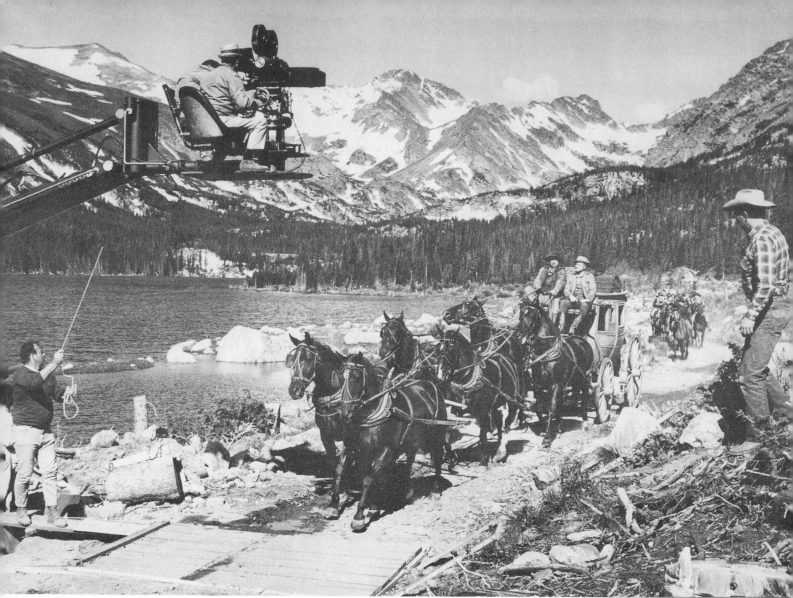

STAGECOACH

CAMERA ANGLES

INTRODUCTION

A motion picture is made up of many shots. Each shot requires placing the camera in the best position for viewing players, setting and action at that *particular moment* in the narrative. Positioning the camera — the *camera angle* — is influenced by several factors. Solutions to many problems involving choice of camera angles may be reached by thoughtful analysis of story requirements. With experience, decisions can be made almost intuitively. The camera angle determines both audience *viewpoint* and *area* covered in the shot. Each time the camera is moved to a new set-up, two questions must be answered: What is the *best viewpoint* for filming this portion of the event? *How much area* should be included in this shot?

A carefully-chosen camera angle can heighten *dramatic visualization* of the story. A carelessly-picked camera angle may distract or confuse the audience by depicting the scene so that its meaning is difficult to comprehend. Therefore, selection of camera angles is a most important factor in constructing a picture of continued interest.

In most instances, theatrical film scripts designate the type of shot required for each scene in a sequence. Some studios prefer "master scene" scripts in which all action and dialogue in an entire sequence is presented — but camera angles are not indicated. In either case, the director has the prerogative of choosing his own angles in accordance with his interpretation of the script. Since the cameraman positions the camera, it is he who usually makes final decision on viewpoint and area, based on the director's wishes. Directors vary in their approach to the camera angle question: many will leave the final decision up to the cameraman once their request is made. Others may be more camera-oriented and work more closely with the cameraman in arriving at the precise camera placement for each shot.

When shooting from script, the non-theatrical cameraman and director may work in the same manner. If working alone, however, the cameraman must call his own shots. When shooting documentary films off-the-cuff, he has the further responsibility of breaking down the event into individual shots, and deciding the type of shot required for each portion of the action. In either case, the experience of the cameraman, his knowledge of the problems and his visual imagination, will strongly influence the choice of camera angle.

Both theatrical and non-theatrical film makers often employ a "Production Designer" to prepare a "story board" — a series of sketches of key incidents which suggest camera angle, camera and player movement, and compositional treatment. These sketches may be very simple — the merest outlines; or very elaborate — in the case of high

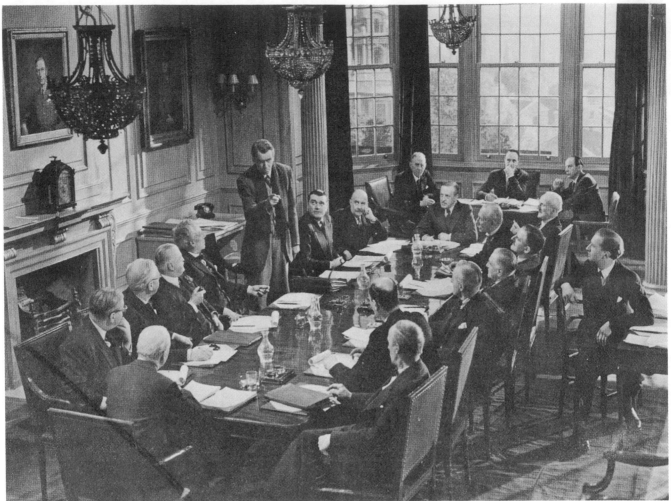

20th Century-Fox Film Corp.

Theatrical film scripts designate type of shot required for each scene in sequence. Production designer may supply sketches that suggest how camera will be placed and moved. Director of photography is responsible for precise placement of camera.

budget theatrical films — in which detailed color renderings of the scenes are closely followed by director and cameraman in setting up the shot.

A screen story is a *series of continuously changing images* which portray events from a *variety of viewpoints.* Choice of camera angle can position the audience *closer* to the action to view a significant portion in a large close-up; *farther away* to appreciate the magnificent grandeur of a vast landscape; *higher* to look down upon a vast construction project; *lower* to look up at the face of a judge. Camera angle can *shift* viewpoint from one player to another, as dramatic emphasis changes during a scene; *travel* alongside a galloping horseman as he escapes pursuers; *move into a* dramatic scene, as story interest heightens; *move away* from gruesome setting depicting death and destruction; *see* otherwise unseen microscopic world; *observe* the earth from a satellite in orbit.

The audience may be positioned *anywhere* — *instantly* to view *anything* from *any angle* — at the discretion of the cameraman and film editor. Such is the power of the motion picture! Such is the importance of choosing the right camera angle!

North American Aviation

The documentary cameraman shooting off-the-cuff has further responsibility of breaking event into individual shots, and deciding type of shot for each portion of action. Knowledge of editorial requirements is valuable when filming without a script.

SCENE, SHOT & SEQUENCE

The terms *scene*, *shot* and *sequence* are sometimes misunderstood.

Scene defines the *place or setting* where the action is laid. This expression is borrowed from stage productions, where an act may be divided into several scenes, each of which is set in a different locale. A scene may consist of one shot or series of shots depicting a continuous event.

Shot defines a continuous view filmed by one camera without interruption. Each shot is a *take*. When additional shots of the same action are filmed from the same set-up — because of technical or dramatic mistakes — the subsequent shots are called *re-takes*. If the set-up is changed in any way — camera moved, lens changed, or different action filmed — it is a new shot, *not* a re-take.

A *sequence* is a *series of scenes, or shots*, complete in itself. A sequence may occur in a single setting, or in several settings. Action should match in a sequence whenever it continues across several consecutive shots with straight cuts — so that it depicts the event in a continuous manner, as in real life. A sequence may begin as an exterior scene, and continue inside a building, as the players enter and settle down to talk or perform. A

sequence may begin or end with a fade or dissolve; or it may be straight-cut with bracketing sequences.

Confusion arises when the terms *scene* and *shot* are used interchangeably. Individual shots in a script are referred to as scenes. But, a master scene script would require a number of shots to film the entire event. In such cases, a single scene number may be used and the shots designated by letters *a*, *b*, *c*, etc. While production personnel may consider a single take as a shot, they refer to the shot by scene number. For practical purposes, therefore, *scene* and *shot* are generally interchangeable.

A shot — or a portion of a shot — is also referred to as a *cut*. This term is derived from a portion of a shot which is *cut out* and used separately — such as a cut of a player's silent reaction removed from a dialogue sequence.

TYPES OF CAMERA ANGLES
 OBJECTIVE
 SUBJECTIVE
 POINT-OF-VIEW

OBJECTIVE CAMERA ANGLES

The *objective* camera films from a *sideline* viewpoint. The audience views the event through

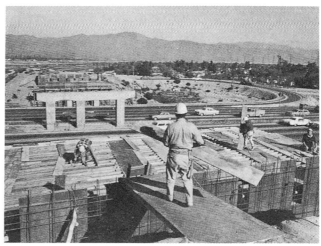

Calif. Div. of Highways

This documentary shot — depicting construction of a freeway — is filmed from objective camera angle, sometimes referred to as "audience point of view."

the eyes of an unseen observer, as if eavesdropping. Cameramen and directors sometimes refer to this candid camera treatment as the *audience* point of view. Since they do not present the event from the viewpoint of anyone *within* the scene, objective camera angles are impersonal. People photographed appear unaware of the camera and *never* look directly into the lens. Should a player look inadvertently into the lens, even with a sideways glance, the scene must be retaken — if objective angle is maintained. Most motion picture scenes are filmed from *objective* camera angles.

SUBJECTIVE CAMERA ANGLES

The *subjective* camera films from a *personal* viewpoint. The audience participates in the screen action as a personal experience. The viewer is placed *in the picture*, either on his own as an active participant, or by trading places with a person in the picture and seeing the event through his eyes. The viewer is also involved in the picture when anyone in the scene looks directly into the camera lens — thus establishing a performer-viewer *eye-to-eye* relationship.

The subjective camera may film the event in the following ways:

The camera acts as the eyes of the audience to place the viewer in the scene. The audience may

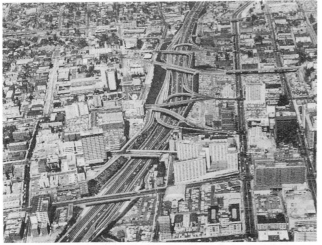

Calif. Div. of Highways

Camera may act as eye of audience to place viewer aboard airplane. If shot is preceded by close-up of person looking out window — viewer will comprehend that he is seeing what screen player sees.

be taken on a camera tour of an art museum and shown the paintings. Or, the camera may dolly slowly along an automobile assembly line, giving the viewer a close look at the process. Involvement is greatest when the viewer is startled or shocked. A classic subjective camera example is the roller coaster ride in Cinerama. Personal reaction results not only from wide-screen treatment and stereophonic sound; but especially because the viewer *experiences* the event as if it were actually happening to him. A like effect is achieved when the camera films subjectively from a speeding bobsled, an airplane, an aerial tramway, a funicular railroad, or similar vehicle; particularly if the view shown is precarious, such as a twisting mountain road!

A camera may be dropped from a height — on a shock cord — to simulate what a falling person sees. A camera may be encased in a football and spiraled through the air to the receiver.

The camera may fly in the pilot's seat of a giant airliner as it makes a landing. It may ride the rapids on the prow of a boat; roar down a ski jump; leap over a fence during a steeplechase; dive under water; jockey for position in a horse race; fall down a mountain — or go for a quiet stroll in the park.

In all these instances the camera acts as the viewer's *eyes*. Each member of the audience receives the impression that he is *in* the scene — not merely viewing events as an unseen observer. The camera places him in the midst of the setting, as if *he* were riding the bobsled, flying the airplane or jumping the hurdles. Subjective shots, such as these, add dramatic impact to the story-telling.

Abruptly inserted in an otherwise objectively filmed picture, subjective shots increase audience involvement and interest.

The camera changes places with a person in the picture. The viewer may see the event through the eyes of a particular person with whom he identifies. When subjective shots previously described are *preceded* by a close-up of a person looking off-screen, the viewer will comprehend that he is seeing what the screen player sees. The shot itself may be filmed in precisely the same manner, but the viewer is no longer on his own — he has

traded positions with the on-screen player to view the event as he sees it.

If an airplane pilot, jockey or mountain climber is established in the scene, the following subjective shot is what *that person sees*. The spectator may experience the same sensations, because he is seeing the scene through screen player's eyes.

In the following examples, the subjective shots will be the same — providing the viewer is looking at inanimate objects, empty settings, or events in which people in the picture do *not* relate directly with the camera. A clock on the wall, an unoccupied room, an action ride, or people in the park — will all appear the same, regardless of whether the viewer sees the scene directly, or through the eyes of a person in the picture. The thrilling moving camera ride is *always* subjective, but static shots may be objective *or* subjective, according to the way they are edited. The clock, the room, or the park scene may be interpreted as objective, unless a close-up of a player is shown looking off-screen. The audience will then understand that what they see is what *player* sees in the scene.

The scene following that of an individual looking off-screen will be interpreted by audience as what that person sees. The man above is looking up — at a building filmed from his point-of-view. Upward or downward points of view of a player may be simulated by similar camera angling.

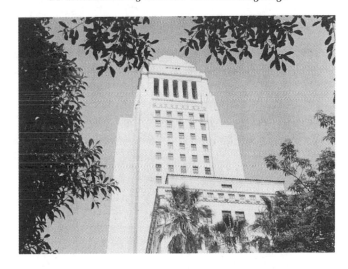

Lockheed-California Co.

Viewer may trade places with person in picture if shot above is followed by point-of-view shot of operation. P.o.v. shots are best for training films because they place viewers in workers' positions.

Few shooting or editing problems are encountered when a subjective shot is inserted in an objective sequence; whether or not a person, with whom the audience can identify, is shown.

Difficulties do arise, however, when the camera replaces a player who must *relate with other players* in the scene. Whenever other players in the scene look into the eyes of the subjective player they must *look directly into the lens*.

The unexpected appearance of a player looking directly into the lens startles the audience, because they suddenly become aware of the camera. It is as if the people being filmed detected the eavesdropping camera. Such treatment can prove very distracting, and may disrupt the story-telling.

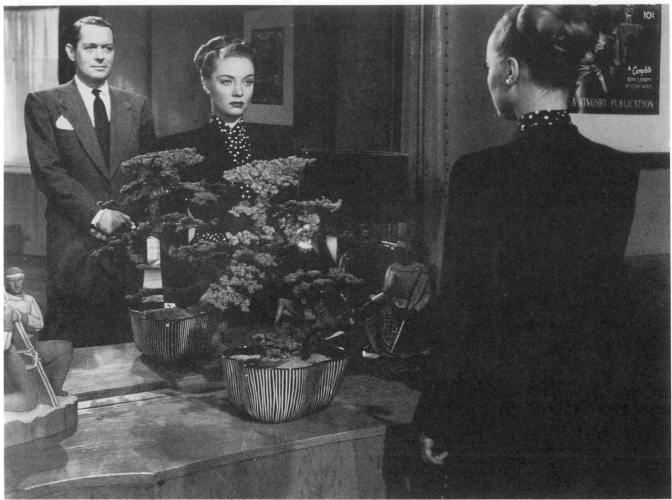

Metro-Goldwyn-Mayer

"Lady In The Lake" used subjective camera, which traded places with detective-hero. He was seen by audience only when introduced, and when reflected in mirrors.

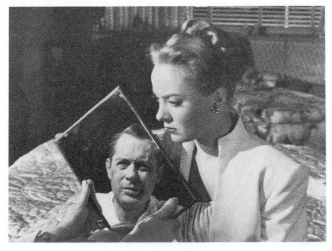

The audience is shocked when it is abruptly switched from an unseen observer *outside* the picture (looking at players who are seemingly unaware of the camera's presence), to a participant in the picture (directly relating with the players). The viewer may want to become *emotionally involved* in the story, but he may be uncomfortably surprised when required to become *actively involved* with the players!

A sudden *switch* from an objective to a subjective look-into-the-lens shot is startling in a dramatic film because the audience is unprepared for such treatment. Viewers cannot immediately adjust to active participation in the event. When the camera returns to objective filming, the audience will again have to re-orient itself. The subjective treatment is rarely successful when the audience is asked abruptly to trade places with a

Metro-Goldwyn-Mayer

player, with all the other performers in the scene looking directly at him.

If an entire sequence, or a complete picture, is filmed subjectively, other difficulties arise. Since the camera replaces the player, it must *behave* like the player, and see what he sees through his eyes *at all times*. This necessitates *continuous* filming with a *mobile* camera, which looks about as the player moves, sits, stands or looks at another player. Normal editing techniques may *not* be used, because filming cannot be interrupted.

The subjective player may be introduced in an objective shot; but when the camera replaces him, the audience must view *everything* subjectively, as *he* sees it. While the person of the subjective player is no longer seen, his reflection may be visible in a mirror, a window or a pool of water. The camera must move to simulate the player's move-

Entire cast had to look directly into lens whenever relating with hero. The audience did not see hero's reactions. Only his voice was heard.

ments as he walks around. The player (camera) may enter a room, look about, sit down, converse with another player, look at his own hand lighting a cigarette, look down at an ash tray, turn his head to look at a ringing telephone, get up and walk out. The player, or players, in the scene must look directly *into the lens* when looking into the subjective player's eyes during dialogue exchanges, or otherwise relating with him.

Metro-Goldwyn-Mayer

When heroine made love to hero — she had to perform with the camera lens!

The result of this continuous filming treatment is a great deal of useless footage *between* significant actions — which often cannot be edited out because continuity would be disrupted. Subjective player technique used in an entire theatrical picture, usually results in a dull effect, because it eliminates the player's face and does not show *his reactions* to other player's dialogue or actions. The audience is teased because they actually see only *half* of the normal interchange between players. While subjective treatment may be interesting in the beginning, it becomes boring, if extended.

There are a few exceptions to the no-editing rule. These permit orthodox editing of a subjective sequence whenever the subjective player *recalls* an event in a flashback. Subjective flashbacks may be presented in *fragmented* fashion, because a person telling a story need relate only *significant* highlights, not every single move or action. A subjective sequence may also be edited whenever a

Kramer Co.-Columbia Pictures Corp.

Subjective camera is employed on rare occasions in dramatic theatrical feature films. In "Ship of Fools" narrator-player (at right above) relates with a fellow player; and directly with the audience, below, to comment on story.

Kramer Co.-Columbia Pictures Corp.

player is *mentally* or otherwise *unbalanced* because of drinks, drugs or illness. The audience will understand, in such cases, that the player receives *impressions,* rather than a continuous clear picture, of what is happening. The subjective player may, therefore, *see* events through his *mind's eye* as a series of individual images, instead of a continuous happening.

Normal editing may be employed in these instances, rather than continuous camera filming otherwise required. A direct cut may be made to a

ringing telephone, rather than a pan to simulate a head turning. A series of related or unrelated images, sharp or distorted, may be shown as *individual* subjective shots, rather than as a continuous unbroken scene.

Subjective sequences, which may be edited, can be successfully inserted in objectively-filmed pictures if they are properly introduced, so that the audience comprehends what is going on. Such scenes will work better with inanimate objects, empty settings or other scenes not involving live players. A story told in flashback may show an old house, a climb up a staircase, entry into a room and the discovery of a body. This would be excellent if treated subjectively, because it does not show other players who would have to look into the lens to relate with the subjective player. Into-the-lens subjective filming should be reserved for mentally-unbalanced sequences to involve the viewer more closely with the subjective player's condition. These will be more effective if distorted, blurred, or shaken. A fight sequence could be very effective because the audience would — in a sense — receive blows, and fall down and look up into the lights, etc.

The camera acts as the eye of the unseen audience. A person on-screen looks into the lens to set up a performer-viewer eye-to-eye relationship. A typical example is the television newscaster who speaks directly into the lens. Eye contact creates a personal relationship between performer and viewer, because each is looking directly at the other. This treatment evolved from radio broadcasting, in which the announcer speaks directly to the listener.

A personal relationship may be set up in a dramatic film by having the narrator, or a performer, step forward, look directly into the lens and introduce the event, the players or the setting; or to explain or interpret what is happening. This generally works best at beginning and end of a picture. Or, the story may be interrupted at intervals to sum up what has transpired, or to introduce a new story element.

The man or woman promoting the sponsor's product in a television commercial speaks directly into the lens for greater attention, and to attract

the viewer personally. The narrator in a television or documentary film may step into the foreground, while the event transpires behind him, to explain what is happening. He may interview people involved, or simply step out of the picture and let the event proceed. The players in this case perform as if the narrator were not present — unless they are called for an interview. A further refinement of this technique presents the performers "frozen" in their positions — perhaps in silhouette — when the scene opens. They hold their attitudes while the narrator introduces the story. When he walks off, they come to life. They may freeze again at the end, if an epilogue is presented. A variation may be used in which one of the players comes forward to introduce the story. He may also step forward at intervals to recap what is happening; and then rejoin his fellow players and continue with the performance.

CBS

Camera may act as eye of unseen audience. Newscaster looks directly into lens to set up performer-viewer eye-to-eye relationship. Each viewer feels that person on motion picture or television screen is speaking directly to him. This subjective treatment is ideal for documentary films whenever a personal relationship between viewer and person on screen is desirable.

Such subjective treatment lends itself equally well to mysteries, historical documentaries, modern news stories, industrial or military subjects. The weird happenings in an ancient castle may be described by the old caretaker, who then exits

the scene as the players enact the drama. Generals in battle may be interviewed in a *you-are-there* treatment. Current events may present eye witnesses, who tell their stories directly to the television audience. An automotive engineer may relate his experience in developing a new car. An astronaut may look directly into the lens, and describe his feelings while orbiting the earth in a space capsule.

An off-screen narrator taking the audience for a typical tour of a factory may logically stop a worker on an assembly line, and question him in

behalf of the audience. A company president, a space scientist, a test pilot, may all be interviewed during their work, and speak directly to the audience.

When filming news interviews, care should be taken to prevent the *double-look*, in which the person being questioned *shifts* his look back and

Look into lens may be better handled if reporter and person being interviewed are filmed over-the-shoulder. After introduction, camera may cut — or zoom in — to close-up of individual looking into lens as he is questioned by off-screen reporter. Opening remarks of reporter — when both are looking at each other — may be filmed later in a point-of-view close-up without need for interviewee. This is a time-saver when filming very important persons.

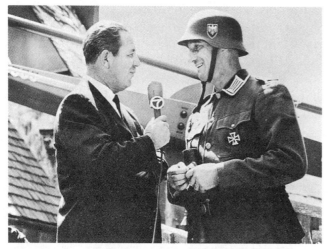

Television interviews should avoid the "double-look" — at both interviewer and camera lens. Person being interviewed should look either at reporter, or directly into lens as soon as introduced. Back-and-forth looks are very distracting.

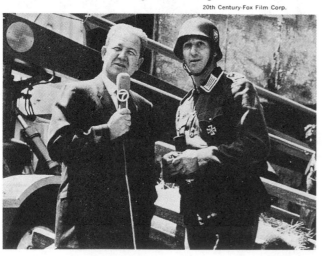

forth from interviewer to camera lens. The subjective effect is weakened when audience attention is divided. The viewer is distracted whenever the interviewee looks back and forth. The person should be instructed *before* the scene is filmed to speak directly into the lens at *all* times. A performer in a dramatic or documentary film will, of course, be properly rehearsed. The look-into-the-lens may be better handled if reporter-interviewee are positioned for an over-the-shoulder shot. The camera may employ a zoom lens, which may close-in on the interviewee as soon as he is introduced and begins to talk. Or, the reporter may remain off-screen at the side of the camera, and direct his questions so that the person answering may speak more easily into the lens. Two-shots, in which reporter-interviewee face each other in profile and sneak glances at the lens now and then, should always be avoided!

To sum up the subjective camera:

Its employment from a particular player's viewpoint, in which the viewer is asked to trade places with the screen performer, and relate with other players, is questionable. An occasional shot of this type inserted in an otherwise objectively filmed picture is startling, because the players in the picture are suddenly looking at the lens. A sequence, or an entire picture, filmed in this manner can be very annoying to audience. Its successful use in a dramatic motion picture should be limited to flashbacks or special effects. The subjective camera is most effective whenever orthodox editing, rather than continuous filming, can be employed.

Subjective shots from the audience viewpoint, in which the camera acts as the collective eye of the audience, can be successfully used in both theatrical and non-theatrical films in a variety of ways. The subjective treatment is excellent whenever the camera performs as a participant in an event to place the viewer in-the-picture. Such shots may be inserted into objectively-filmed sequences, because the viewer trades places with the performer momentarily, or employs the camera lens as his own personal eye — and the people in the picture do *not* look into the lens. This is the important difference that makes the audience viewpoint shot *acceptable;* and the *particular player viewpoint*, in which the other players look at the lens, *unacceptable.*

While subjective shots in which the camera takes the place of an unseen audience have limited use in theatrical films, they offer opportunities for experimenting in non-theatrical and television films. Use of subjective shots for news events and documentaries is successful because it brings the key persons into direct relationship with the viewer, on a person-to-person basis.

The subjective camera must be employed with discretion, or it may shock or intrude on the audience in a way that will destroy their emotional attraction to the subject. Properly employed, however, this technique may result in greater audience involvement because of added personal relationship it sets up. A great deal of careful thought should be given switches from objective to subjective filming, particularly if the camera replaces a player in the picture. No difficulty will be encountered with subjective shots where the relationship is between a newscaster, an interviewee or a performer and viewer; or where the camera acts as the collective eye of the audience.

Santa Fe Railway

Scenic shot may be objective or subjective — according to way sequence is edited. If presented alone, scene will be seen subjectively by viewer through camera lens acting as his eyes. If scene is preceded by a close-up of player looking off-screen, viewer will accept it as point-of-view shot—and see scene objectively from player's viewpoint.

POINT-OF-VIEW CAMERA ANGLES

Point-of-view, or simply p.o.v., camera angles record the scene from a *particular player's viewpoint*. The point-of-view is an objective angle, but since it falls between the objective and subjective angle, it should be placed in a separate category and given special consideration.

A point-of-view shot is as close as an objective shot can approach a subjective shot — and still remain objective. The camera is positioned at the *side* of a subjective player — whose viewpoint is being depicted — so that the audience is given the impression they are standing cheek-to-cheek with

An over-the-shoulder close-up prepares audience for point-of-view close-up. Audience sees each player from opposing player's point of view.

the off-screen player. The viewer does *not* see the event through the player's eyes, as in a subjective shot in which the camera trades places with the screen player. He sees the event from the player's *viewpoint*, as if standing alongside him. Thus, the camera angle remains objective, since it is an unseen observer not involved in the action. An on-screen player looking at the player whose viewpoint is depicted, looks slightly to the side of the camera — *not* into the lens.

Point-of-view shots may be used whenever it is desirable to involve the viewer more closely with the event. The audience steps into the picture, so to speak, and sees the players and the setting from the viewpoint of a particular player — by standing beside him. This creates a stronger identity with the screen player in the action, and provides the viewer with a more intimate glimpse of the event.

Point-of-view shots often follow over-the-shoulder shots, when a pair of players face each other and exchange dialogue. The over-the-shoulder shot sets up the relationship between the two players, and the p.o.v. shot moves the audience into the player's position. Each player may be seen from the opposing player's point-of-view.

Any shot may become a point-of-view shot if it is preceded with a shot of a player looking off-screen. The audience will accept the following shot as being from the player's viewpoint. The player may look at: another player, a group of players, an object, a distant scene, a vehicle, etc. Thus, an objective shot, which is — in essence — the audience's own point of view, may become the point of view of a particular player by inserting a close-up of the player looking off-screen. Anyone in the scene who looks *at* the player must look slightly to one side of the camera (which side is dependent upon the action axis drawn from the off-screen player to the on-screen performer).

It is easier for the audience to identify with the hero in a dramatic picture, or the reporter/narrator in a documentary film, if viewers see people and objects as the screen player sees them, rather than as a bystander on the sidelines. Objective camera treatment is maintained in point-of-view shots, so that the audience is never startled — as in subjective shots, where the other players look

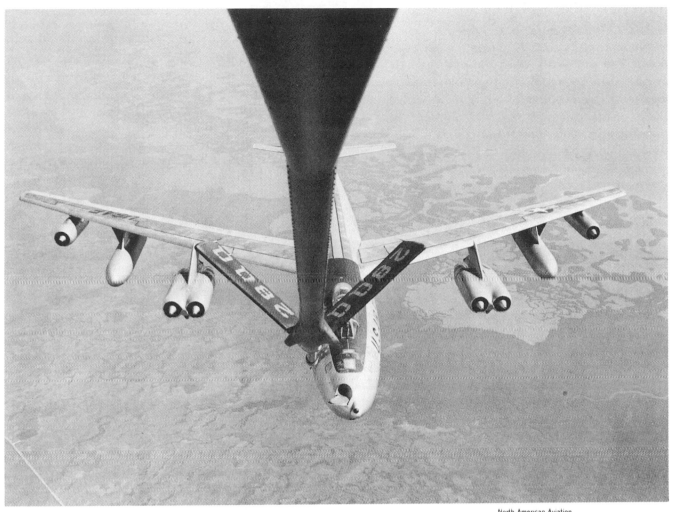

North American Aviation

Viewer may interpret above scene — of aerial tanker boom making connection for mid-air refueling — as either subjective or point-of-view shot. This shot is subjective, because viewer is made to feel that he is in boom operator's vicarious position, performing the task. It would be a p.o.v. shot if preceded by a close-up of the operator looking off-screen. Subjective and point-of-view shots involve audience more intimately with event than do objective scenes.

directly into the lens. Yet, the event is presented in an intimate manner, because it is seen from a particular player's viewpoint. Switching back and forth from objective to point-of-view camera angles is not jarring because both angles are actually objective.

There are two important *don'ts* to be observed when filming point-of-view shots:

Don't show a player looking off-screen, then cut to what he sees — and pan the camera around and end up on the player. This will jar the audience,

because a person *cannot see himself as he looks about!* What starts off as a point-of-view shot becomes a straight objective shot, as soon as the player is included.

Don't have a player point off-screen, to a wall clock for instance, and then walk out in the same direction. Always walk a player off-screen in a direction different than to which pointed, unless a direct relationship exists between player's movement and the object.

SUBJECT SIZE, SUBJECT ANGLE & CAMERA HEIGHT

A *camera angle* is defined as the *area* and *viewpoint* recorded by the lens. Placement of the camera decides how much area* will be included, and viewpoint from which the *audience* will observe the event. It is important to remember the relationship between camera angle and audience. Every time the camera is shifted, the audience is repositioned, and observes the event from a fresh viewpoint. Three factors determine the camera angle:

SUBJECT SIZE

SUBJECT ANGLE

CAMERA HEIGHT

SUBJECT SIZE

The *image size*, the size of the subject in relation to the over-all frame, determines the *type* of shot photographed. The size of the image on the film is determined by the distance of the camera from the subject, and the focal length of lens used to make the shot. The closer the camera; the larger the image. The longer the lens; the larger the image. The converse is also true: the further away the camera; the shorter the lens, the smaller the image.

Image size may vary *during* the shot by moving the camera, moving players, or employing a zoom lens. The camera may pan or dolly so that the subject is brought closer to or further away from the lens. The players may move toward or away from the camera. The zoom lens may be varied in focal length as the scene progresses. Thus, a long shot may graduate into a close-up; a close-up become a long shot, in a single shot.

Many cameramen and directors think only in terms of long shot, medium shot and close-up in a by-the-numbers progression. Such elementary thinking falls far short of the many types of shots that may be filmed. Relative terms have different meanings to different people. What one cameraman would consider a medium shot, may be a medium close-up to another. Distance of the camera from the subject, or lens focal length, do *not* determine the type of shot filmed. The camera distance, and the area photographed, would vary greatly in filming a close-up of a baby human and a baby elephant! The shot should be defined with regard to the *subject matter*, and *its image size* in *relation to the over-all picture area*. A *head close-up* would, therefore, depict a *head* — whether of baby human or of baby elephant — full-screen.

The shot definitions which follow should not be considered in absolute terms. They should be used to describe requirements in general terms.

ABC-TV

Image size may vary during a shot. These players may walk toward camera as scene progresses. Or, camera may move closer to them—or they may be filmed with a zoom lens. A long shot may thus graduate into a close-up in a single take.

ABC-TV

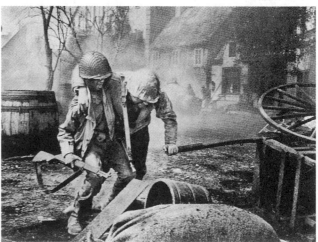

* The area covered is also dependent upon lens focal length.

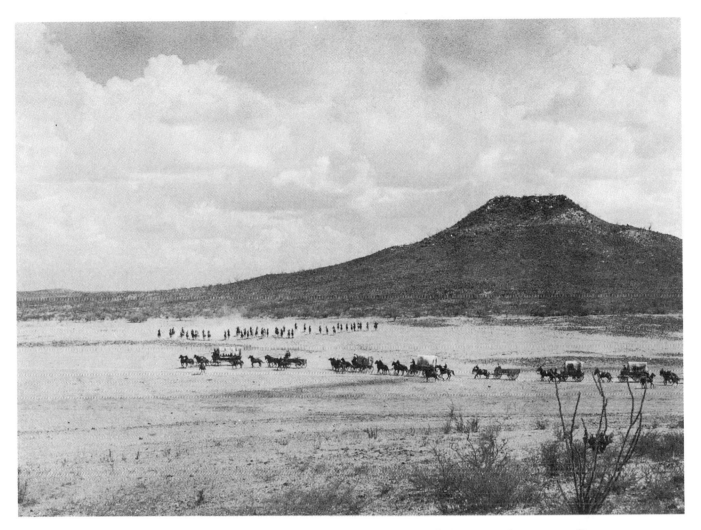

Extreme long shots may depict vast area from great distance, to impress audience with grandeur or scope of undertaking. Such shots establish geography of setting. A wide-angle static shot is best, but a pan shot may be employed if it increases in interest as pan progresses.

EXTREME LONG SHOT (ELS)

An extreme long shot depicts a vast area from a great distance. It may be used whenever the audience should be impressed with the huge scope of the setting or event. An extremely wide angle static shot is usually more adaptable for extreme long shots than is a panning camera movement. The pan should be employed only when it increase in interest, or reveals more of the setting or action, as it progresses. The static shot should be used whenever a map type shot, which establishes the geography of the locale, is desirable. Extreme long shots are best filmed from a high vantage point, such as a high camera platform, the top of a building, a hilltop or a mountain peak; or from an airplane or helicopter. A large ranch, a farm, a city skyline, an industrial complex, an oil field, a mountain range, a military base; or a mass movement such as a cattle drive, a ship convoy or a moving army, may be very impressive as opening shots to introduce a sequence or to begin a picture. Such massive shots set the scene for what follows by putting the audience in the proper mood, and providing them with the over-all picture before introducing characters and establishing story line. Whenever possible,

Lockheed-California Co.

An extreme long shot of test base under construction may serve to introduce sequence or begin picture. Such scenes establish setting and open picture on grand scale.

extreme long shots should be filmed to open up the picture on a grand scale, and capture audience interest from the start.

LONG SHOT (LS)

A long shot takes in the entire area of action. The place, the people, and the objects in the scene are shown in a long shot to acquaint the audience with their over-all appearance. A long shot may include a street, a house, or a room, or any setting where the event takes place. The long shot should be employed to establish all elements in the scene, so that viewers will know who is involved, where they are located as they move

about, and when seen in closer shots as the sequence progresses. Players' entrances, exits and movements should be shown in long shot whenever their location in the setting is narratively significant. Following the players around in close shots may confuse the audience as to their whereabouts in relation to the setting and the other players. It is therefore wise to re-establish the scene in a long shot whenever considerable player movement is involved.

Long shots are generally loosely composed, so that players are given sufficient room to move about, and the setting may be shown to advantage in its entirety. While this may seem to dwarf the

Long shots establish area of action and players' positions. Players' entrances, exits and movements should be covered in long shot whenever their location in setting is narratively significant.

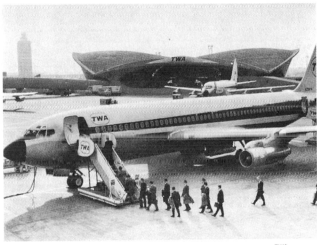

TWA

Long shots depict size of objects — such as this jet airliner — and dwarf players, who will be seen to advantage in later medium shots and close-ups.

players, the long shot is on the screen for a very short time and players can be seen to individual advantage in subsequent shots. Long shots lend scope to a picture, because they play up the size of the setting. Even a sequence taking place *within* a house should open with an exterior long shot to establish the location. This is particularly important when an entire film takes place in-

doors, in a series of rooms. Such a picture will appear closed in and lacking in spaciousness. Exterior long shots will open up the picture at intervals and furnish "air" for a breather.

Long shots are kept to a bare minimum in television films because of limited size of picture tubes, and inability to resolve a great deal of detail. In this case *medium long shots,* which cover the players full length but do not depict the setting in its entirety, may be substituted. Such scenes are sometimes referred to as *full* shots.

MEDIUM SHOT (MS or MED)

A medium shot may be better defined as an *intermediate* shot because it falls between a long shot and a close-up. Players are filmed from above the knees, or from just below the waist. While several players may be grouped in a medium shot, the camera will be close enough to record with clarity their gestures, facial expressions and movements. Medium shots are excellent for television filming, because they present all action within a restricted area in large size figures. Medium shots generally comprise the bulk of theatrical films, because they place the audience at a middle distance, excellent for presenting events after the long shot has established the scene. Because it has many narrative uses, a great deal may

20th Century-Fox Film Corp.

Medium shots comprise bulk of theatrical and television films, because they position audience at middle distance. This is excellent for presenting events after long shot has established scene.

27

Harann Prod.

The author confers with Producer-Director Irvin Berwick on a two-shot for "Street Is My Beat."

be depicted in a medium shot. One or more players may be followed about, with a pan or dolly movement, so that enough of the setting is shown to keep viewers constantly oriented. The story may move into medium shots after the long shot. It may return to a medium shot after close-ups, to re-establish the players.

The most dramatically interesting medium shot is the *two-shot*, in which two players confront each other and exchange dialogue. The two-shot originated in Hollywood, and is known in France, Italy and Spain as the "American-shot." A famous director has stated: "Regardless of the size of the picture, whether it boasts a cast of thousands or a modest number, the action always winds up in a two-shot featuring boy and girl, hero and villain, or hero and his buddy."

There are numerous variations of the two-shot. The most widely used, but not always the most pictorially interesting, is that in which both players sit or stand facing each other with their profiles to the lens. Young people with clean-cut profiles and good necklines will generally photograph well. Older persons with jowls, puffy faces or double chins should seldom be filmed in profile. The main problem with the profile two-shot is that neither player can dominate the composition if each is equally well lighted. Dominance is achieved through dialogue, action or favorable lighting, which captures audience attention at the expense of the less favored player. The players

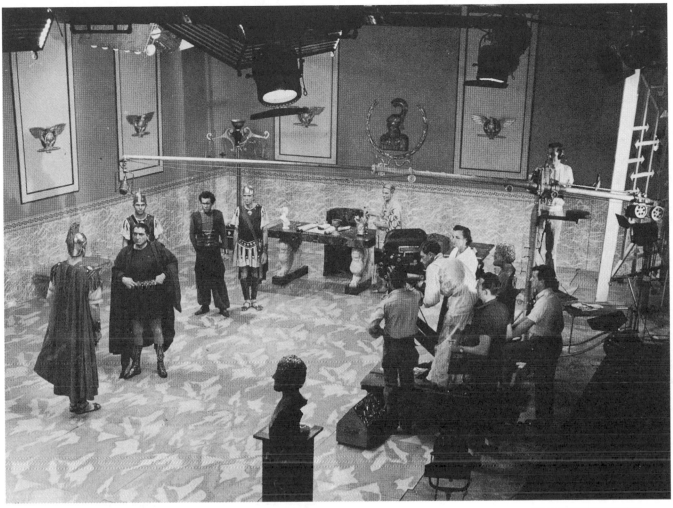

Bob Jones University Unusual Films student camera crew line up two-shot for "Wine Of The Morning."

may move about, or even change positions as the scene progresses; and dramatic interest may switch from one to the other, if required.

Two-shots may be angled and played in depth, so that nearest player is turned slightly away from the camera and the farther player positioned so that he is filmed in a three-quarter angle. Or, one player may appear in profile and the other in a three-quarter angle or facing the camera. Television employs an unusual variation of the two-shot in which *both* players face the camera: the nearer player looks off screen while the farther player looks at the nearer player's back. This allows both players to be filmed facing the camera, in a single shot. Although it saves additional camera set-up, it is dramatically inadequate because the players do not truly relate with each other. One is dreamily looking away, while the other seems to be trying to get his attention.

Two-shots may grow or progress out of medium or long shots. A player may break from a group, and join another player; or two players may pull out and move into a two-shot. Player and/or camera movement should be employed whenever possible to bring players together in a two-shot in a *casual* way. Two-shots should not be filmed with both players standing flat-footed toe-to-toe, unless the script requires such treatment. This may occur in a dramatic confrontation between hero and villain, in which neither will back away.

TYPICAL
TWO-SHOTS

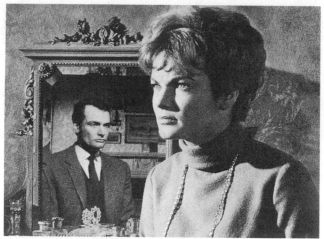

Universal City Studios

Unique staging of two-shot by use of mirror. Player on right dominates scene because of larger image size, better position, three-quarter angling and lighting. Player in mirror captures audience interest because of reverse image, odd positioning and rear look toward foreground player.

Universal City Studios

Typical profile boy-girl seated two-shots. Neither player dominates the scene from composition or lighting standpoint. Each player dominates in turn, as he or she speaks or performs an action that captures audience attention. Eye appeal is lessened in a profile shot.

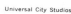

Universal City Studios

Although players' heights and positioning vary in this shot, they are compositionally balanced. Profiled player on left is higher and well modeled with light. Player on right makes up for his lowered position by being angled toward camera, so that both eyes and front and side of his face are seen.

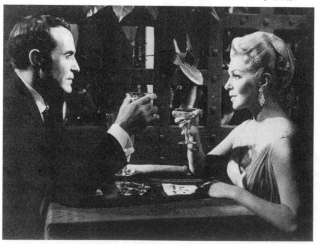

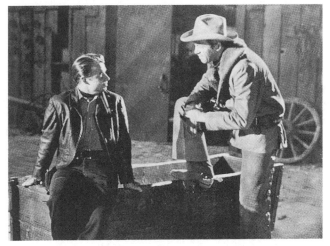

Universal City Studios

Profile two-shot with one player seated and the other standing. The standing player dominates the scene because he is compositionally stronger — on the right side and higher in the frame.

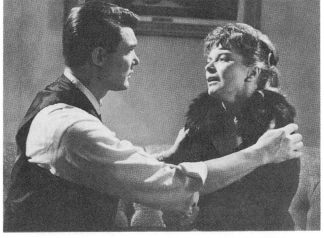

Harann Prod.

Player on right dominates scene because of more favorable positioning and lighting.

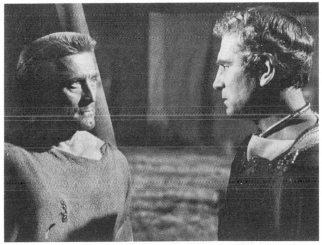

Universal City Studios

Although positioned lower in frame, player on left dominates this two-shot because he is more favorably angled to lens, and his features are sharply chiseled with light and shadow. A face angled three-quarters to lens diplays front and side, both eyes; and finer modeling than one filmed in profile.

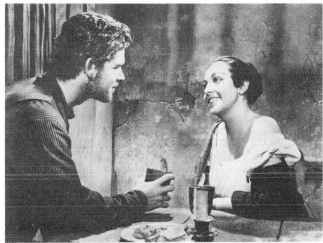

20th Century-Fox Film Corp.

Player on right is favored in this two-shot because of better position and lighting.

Player on left dominates scene because he is slightly angled toward camera, and given more dramatic lighting. Player on right is turned away from camera and is, therefore, compositionally less interesting.

20th Century-Fox Film Corp.

31

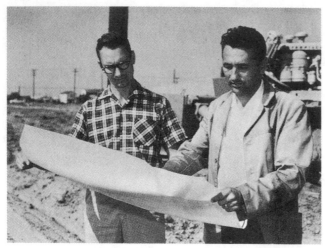

Two-shots may be employed in documentary films — such as this shot of engineers studying plans for construction project.

Calif. Div. of Highways

CLOSE-UP (CU)

A close-up of a person is generally designated in the script according to image size. A *medium close-up* films a player from approximately midway between waist and shoulders to above the head; a *head and shoulder close-up*, from just below the shoulders to above the head; a *head close-up* includes the head only; a *choker close-up* includes a facial area from just below the lips to just above the eyes. Many cameramen and directors have their own ideas of what area should be filmed for a close-up. However, when a particular close-up is not specified, it is generally safe to film a head and shoulder close-up. (NOTE: The *CLOSE-UP* is so significant that it is covered in detail in a separate chapter.)

INSERTS

Full-screen close-ups of letters, telegrams, photographs, newspapers, signs, posters or other written or printed matter, are called *inserts*. For reasons of economy, inserts are usually filmed after principal production shooting is completed. When a vertical subject does not fill the horizontal frame, so that portions of background or setting may be seen, it may be best to film the insert during regular production. Generally, inserts are filmed so that they overlap the frame slightly,

thus eliminating the background. Positions of hands, or fingers, which may appear in the insert, should match positions in the preceding shot. Theatrical wide-screen projection may cut off important portions of the insert, or make them otherwise illegible. It is important to bear this in mind whenever filming a 35mm picture in wide-screen ratio. The insert, in such instances, should be photographed loosely, so that nothing of importance is near top, bottom or side of the frame.*

DESCRIPTIVE SHOTS

Professional production personnel employ many descriptive terms in script writing and during filming to identify further the type and/or content of a shot. A moving shot may be designated as a *pan shot*, if the camera revolves upon its vertical axis to follow the action; or as a *dolly, crane* or *boom shot*, whenever the camera is mounted on any one of these camera platforms to film the event. A moving shot may be further

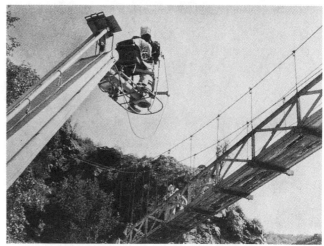

Warner Bros.

Camera is mounted on crane to follow players across bridge. Dolly or crane mounted camera may also be varied in height; or moved toward or away from subject as scene progresses.

*Many theatre screens cut off the sides of "squeezed" 'scope-type films; and may cut the top or bottom, or both, of "non-squeezed" flat films shot in various aspect ratios.

defined by the type of shot at the beginning and end of the move: such as dolly, from a medium shot to a close-up. A shot in which the camera tracks along to film moving players is called a *follow shot or a tracking shot*. A *low-shot* is one in which the camera is angled upward at the subject, while a *high shot* is just the opposite, with the camera looking down. A *reverse shot* is a scene made from the reverse direction of a previous shot.

A *cut-in shot* is one that cuts directly into a portion of the previous scene, generally a cut-in close-up of a person or object. A *cut-away shot* is a secondary event occurring elsewhere — a few feet away, such as in the case of a cut-away close-up of someone just off camera; or miles away, if the story is switched to another locale. A *reaction shot* is a silent shot, ordinarily a close-up, of a player reacting to what another player is saying or doing. Reaction shots are filmed as separate scenes if observation only is involved. They are

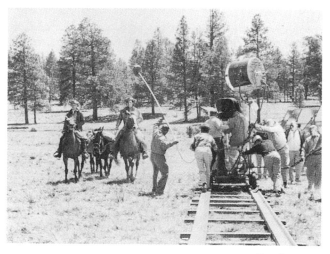

Warner Bros.

Camera films follow shot or tracking shot whenever it moves to follow action of traveling players.

Universal City Studios

Number of players photographed — such as this three-shot — also defines type of scene.

U.S. Air Force

A pan shot (short for panoram) is employed when camera revolves upon its vertical axis to follow action in horizontal plane, such as airplane landing.

cut from portions of a dialogue sequence when two or more players speak and listen alternately.

The lens used for a particular type of shot may be mentioned, such as a *wide-angle, telephoto* or *zoom shot*. The number of players in a scene may also define the shot, such as a *two-shot* or a

three-shot, or sometimes a *group-shot* when all players are included in a single shot.

Such descriptive terms are usually employed in combination with the type of shot being filmed, so that they aid in further identifying what is required. A tracking shot of several players may be described as a wide-angle, low-angle dolly shot. Definitions vary throughout the industry. Most important is that their meaning is the same within the group producing the film, so that everyone understands requirements thoroughly.

CAMERA ANGLES

SUBJECT ANGLE

All subject matter has three dimensions. Even flat objects, such as paper, have thickness. People, furniture, rooms, buildings, streets, all have height, width and depth. All are solid, whether they have rounded or flat surfaces, or combinations of both. Their solidity is most pronounced when viewed so that two or more surfaces are seen. Whenever an object presents only a *single surface* to the eye or the camera it is said to be *flat* — because its depth is not apparent. A building viewed straight on shows only its height and width, not its depth. It has the appearance of a false front, or a cardboard cut-out. The same building viewed from an angle, so that a side is seen, appears three-dimensional. A person viewed in profile lacks *roundness*. The modeling of a face and a body is best judged from an angle which presents *both* the front and side.

Facial modeling is best when subject is turned forty five degrees — so-called three-quarter angling — to the camera. Front and side of face, if properly lighted, will appear round, and eyes are displayed fully.

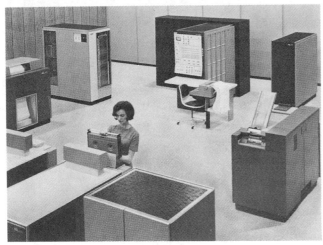

IBM

Three-dimensional solidity is most pronounced when two or more surfaces are photographed. Angling the camera in relation to the subject so that two sides and top — or bottom — are viewed, results in most effective rendition.

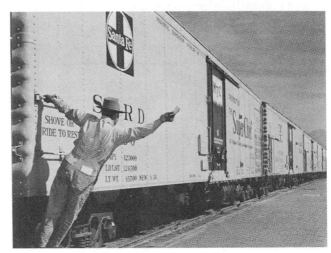

Santa Fe Railway

Angle camera so that parallel lines diminish and converge — preferably toward the right — so that viewers' eyes are carried into distance. Shooting these box cars square-on would result in flat cut-out appearance, lacking in solidity and depth.

The cameraman must record a three-dimensional world on a two-dimensional film surface. The solution generally lies in angling the camera in relation to the subject, so that a depth *effect* is recorded. There are many ways to achieve depth in filming: with lighting, camera and player movement; overlapping subject matter; linear and aerial perspective; use of short focal length lenses, etc. The most effective method to record depth, however, is by choosing the proper camera angle. Angles are the most important factor in producing illusion of scenic depth.

Unless flatness is required for narrative reasons, the cameraman should always strive to position the camera at an angle, preferably a forty-five degree, or so-called three-quarter angle, to the subject. Such angling will record people with roundness, and solid objects with two or more surfaces, and converging lines which produce perspective — suggesting three dimensions. Shooting square-on, so that *only* the front *or* side

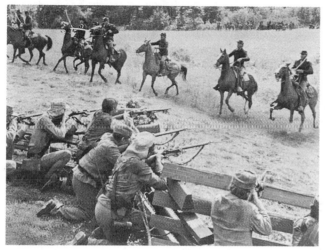

Universal City Studios

Angling camera in relation to subject presents this war scene with greater conflict, because of diagonal pattern of horsemen, soldiers in foreground, guns and swords. Position of camera in relation to subjects and setting greatly influences composition of scene.

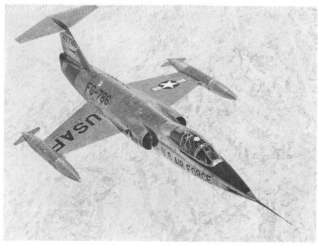

Lockheed-California Co.

Dynamic angling of this jet fighter produces more dramatic effect than would have resulted from level angle shot.

of people or objects are filmed, should be avoided.

Move the camera to one side; move furniture, vehicles and props; so that they are seen with as many surfaces as possible. Angle the camera so that it looks down a street that converges into the distance. Shoot a room or setting, so that two or more walls are seen. There are a few exceptions to this rule, where a flat front treatment of the subject may be preferred, such as a public building, a stage, a courtroom or a church interior. Most often, it is wise to angle the camera in relation to the subject for a well-rounded three-dimensional effect.

CAMERA HEIGHT

While camera *height* is as important as camera distance and subject angle, it is often disregarded. Theatrical cameramen are very careful about lens height in *relation* to subject matter. Many non-theatrical cameramen merely adjust the tripod so that the camera is at convenient height for looking through the finder. They completely overlook the subject's special requirements!

Artistic, dramatic and psychological overtones may be contributed to the story-telling by adjusting the height of the camera to the subject. Audience involvement and reaction to the event depicted may be influenced by whether the scene is viewed from eye-level, or above or below subject.

LEVEL ANGLE

A *level* camera films from the *eye-level* of an *observer of average height*, or from the *subject's eye-level*. A level camera views a setting or an object so that vertical lines do *not* converge.

Shots filmed with a level camera are generally less interesting than those filmed from an upward or downward angle. A level camera is required, however, whenever eye-level views are filmed, or vertical lines must remain vertical and parallel to each other. A level camera does not distort verticals, so walls and sides of buildings, or objects, will remain true.

Objective shots, which present the view as seen by an observer, should be filmed from the *eye-level of an average person* — about five and one-half feet high. It is important, however, that *close-ups*

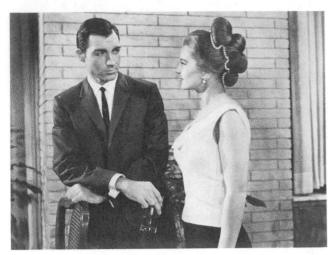

Harann Prod.

Objective shots — which present setting and players as seen by a sidelines observer — should be filmed from eye-level of average person, about five and one-half feet high.

of a person be filmed from the *subject's* eye-level, whether standing or sitting, so that the audience sees the person on an eye-to-eye basis. It is necessary, therefore, when moving in from a long or medium shot to a close-up, to adjust the camera height to the particular subject being filmed.

Many non-theatrical cameramen ignore the seated person's lowered height, and continue to shoot close-ups from a standing eye-level. A paradox about camera height is that inexperienced cameramen tend to film from *their own* eye-levels rather than from subject's eye-level! This works well for shots of standing people, but results in *downward* angling on seated persons. A subject's eyes, plus the intimate relationship desired between viewer and screen player, are completely lost from a high downward angle which records top of head, half-closed eyelids and a distorted view of the player. Just as an individual may be judged by "how he looks you in the eye," much of the appeal of a player in a dramatic film, or a person in a documentary film, is expressed through the eyes. It is imperative that cameramen understand this significance, and strive to position the lens at the *subject's eye-level* when filming objective close-ups.

Point-of-view close-ups are filmed from the subject's eye-level when the players who are relating with each other are approximately the same height. They are filmed from the opposing player's height when a difference in height exists, or when one player is seated and the other standing, or when an adult relates with a child. The camera must be angled upward and downward on a pair of back-and-forth p.o.v. close-ups, in these instances. Such angling need not be precisely from the opposing person's head position. The angle

University of So. Calif. Cinema Dept.

A seated person filmed from cameraman's standing eye-level results in high downward angle shot of top of head, half-closed eyelids and distorted view of subject. A much better shot results when filmed from subject's eye-level.

University of So. Calif. Cinema Dept

may be cheated to prevent distortion, but it should *simulate* the up-or-down look that occurs under these conditions.

Subjective close-ups, in which the subject looks directly into the lens, are always filmed from the eye-level of the person photographed. A higher or lower camera will cause the person to look up or down in order to look into the lens — and thus create an awkward relationship with the viewer. The person presented subjectively should always be seen on a level eye-to-eye basis, as if the viewer were sitting or standing on the same eye-level.

The importance of shooting close-ups at the subject's eye-level cannot be over-emphasized, because so many non-theatrical cameramen fail to *lower* the camera, particularly when a person is seated. Students may note how carefully close-ups in theatrical feature pictures are positioned. Slight variations from subject's eye-level are made only when necessary to correct facial faults; such as a turned-up nose, which may look better from a slightly higher angle; or a weak chin, which may be improved by a slightly lower angle. Men may appear more virile when filmed from slightly lower angles, with the camera looking up. Flabby jowls or wide nostrils may be visually corrected by a slightly higher angle, so that the camera looks

Charles O. Probst

Level camera and simplest photographic treatment are required for shooting technical films — such as this Electron Density Profile Probe, which will be launched into space for study of ionosphere.

down. All these up-and-down angles are very slight, however, and usually may go unnoticed.

While level angles are not as pictorially interesting or dramatic as higher or lower angles, they are best for close-ups of people and for shooting general scenes which should be presented from normal eye-level. Eye-level shots provide frames of reference. They present an easily identifiable viewpoint, because the audience sees the event as if on the scene.

There are instances when level camera shots are more dramatic than angle shots. Shots of a car, train, or other vehicle rushing head-on toward the camera give the viewer a subjective impression similar to a player looking into the lens. The speed, increase in image size and subjective treatment can be highly dramatic.

It may be necessary or preferable in technical films to present a flat, level, undistorted view of a tool, machine or instrument panel.

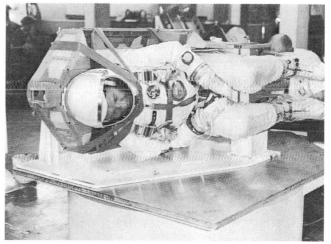

Weber Aircraft

A technical shot — such as this scene of an astronaut being tested in Gemini ejection seat on inertia table — requires level camera filming set-up square-on for engineering study.

HIGH ANGLE

A *high angle* shot is any shot in which the camera is tilted *downward* to view the subject. High angle does not necessarily infer that the camera be placed at a great height. Actually, the

camera may be placed *below* the cameraman's eye-level, to look down at a small object. Yet, it is filming from a high angle!

All angles are relative and should be considered in relation to the height of the *subject* being filmed. The camera may be positioned to shoot a normal eye-level scene of a person looking out of a window of a tall building. Any downward angling of the camera should be considered a high angle shot, regardless of whether the camera is angled slightly to photograph the top of a package, or almost vertically downward to depict a mountain climber's point of view!

A high angle shot may be chosen for esthetic, technical or psychological reasons. Placing the camera higher than the subject and looking down may result in a more artistic picture; make it easier to keep action occurring in depth in sharp focus; or influence audience reaction.

Subject matter laid out in a pattern upon the ground may look better from a high angle. Included are: a vast garden with patterned flower beds, winding paths and sculptured hedges; a walled enclosure; a race track; an airport; a military base; an industrial complex; a terraced courtyard; a golf course; a construction site. High angle shots help acquaint the audience with the geography of the setting. Looking down provides a map-like layout, allowing viewer to orient himself.

Action occurring in depth, such as a football game, a military formation, a production line or an animal migration, may be viewed in its entirety from a high angle. A level or low angle shot will only record foreground action. The camera may shoot across the entire area of the action, from front to back, only from a high angle. Raising the camera and shooting downward is also useful whenever reducing the lens depth of field aids in keeping sharp focus across the entire picture area. A level shot may require filming near and far objects over a greater area than it is possible to carry sharp focus. A high angle may cover

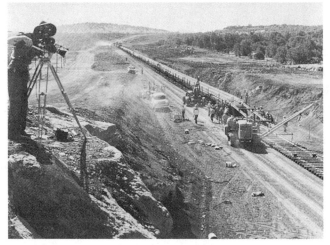

Santa Fe Railway

Laying railroad rail bed is best viewed from above. High side three-quarter angles —which causes construction area to diminish into the far distance — results in composition with greatest depth effect.

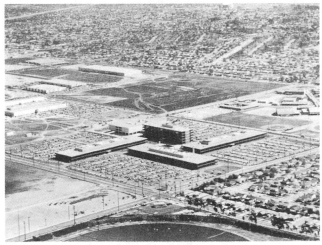

TRW Systems

A film on industrial complex may open with high angle extreme long shot to establish story.

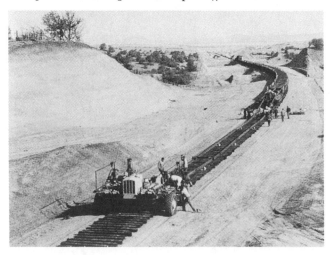

the same front-to-back area with less difference between near-and-far focus.

High angle shots reduce the height of a player or object. A tall player would look down at a shorter person or a child in a point-of-view shot. The subjective camera may also place the audience higher, so that it may look down on a player to feel superior to him; and to achieve a certain heavenly transcendence over both the player *and*

his situation. Such high-angling is excellent whenever a player should be belittled, either by his surroundings or by his actions. An important player who loses prestige or honor may thus be depicted as beaten down by circumstances, or natural elements, or terrain, simply by positioning the camera high, employing a wide-angle lens to look down upon him, and reducing his image to lowly insignificance in relation to the setting.

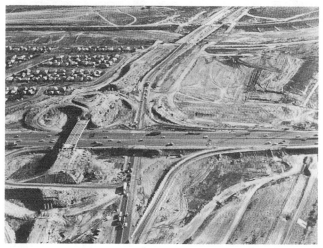

Calif. Div. of Highways

Subject matter which forms a ground pattern — such as this freeway under construction — may be viewed with map-like detail from high angle.

Harann Prod.

Low camera angle should be used when presenting symbol of law or authority. Such scenes are best filmed by positioning opposing player in lowly position.

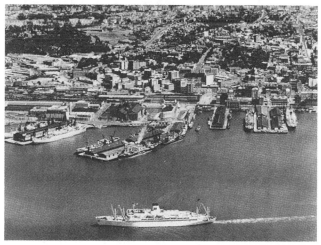

Matson Lines

Ship entering harbor — filmed from high angle — may introduce travel film. Such extreme long shots acquaint viewer with geography of area.

Harann Prod.

Suspect's beaten appearance is intensified by high-angle treatment. High and low camera angles are most useful for presenting players as dominating or degraded.

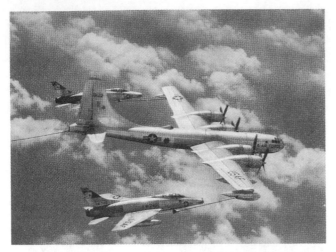

North American Aviation

Above scene of aerial tanker refueling jet fighters in flight is filmed from objective — side lines — viewpoint. This shot may be compared with scene on page 23 depicting tanker boom from operator's viewpoint. Subjective or p.o.v. shot involves audience more intimately in the screen event than would objective shot filmed from impersonal viewpoint. Documentary cameramen should employ subjective camera angles, rather than stand-offish, objective camera angles, whenever possible.

North American Aviation

High angle shot of electronic microscope would be poor choice for opening scene of picture, because it is not immediately identifiable. It may be used later, when viewer is more familiar with instrument. Weirdly-angled shots in technical films may bewilder or confuse viewer.

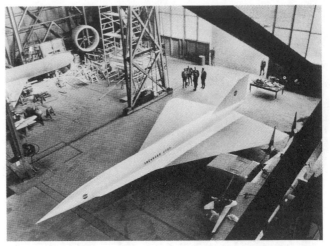

Lockheed-California Co.

Aircraft configuration is best depicted from high angle.

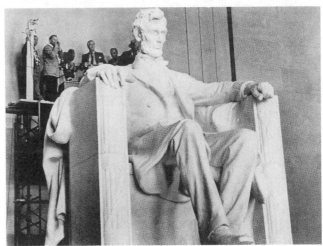

Warner Bros.

A high angle shot may be filmed to take advantage of particular framing — such as this over-the-shoulder shot of statue of President Lincoln.

The subjective camera, acting as the collective eye of the audience, may look down from an airplane in flight, a tall building, a bridge or a mountain peak to view the terrain below, city traffic, the top deck of an ocean liner, or a vast crevasse.

A high, downward angle should be used with discretion on fast-moving action, such as a horse or auto race or chase, because movement will be slowed down. The slow effect is greatest toward or away from the camera and less apparent cross-

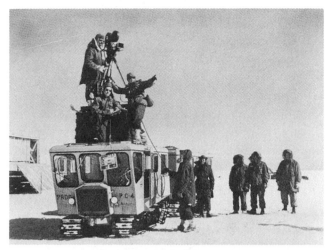

U. S. Army camera crew — filming in Greenland — makes use of unique snow tractor camera car for high angle shooting.

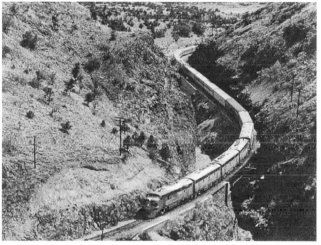

High downward camera angles slow down subject movement. Slow effect is greatest toward or away from camera; less apparent cross-screen.

screen. Such scenes may not match similar shots filmed at eye-level unless under-cranked.*

High angle shots are a welcome departure from eye-level shots and provide contrast, variety and dramatic impact even to commonplace scenes. High angles should be considered to establish the story, supply pictorial beauty, or influence audience reaction to the screen players.

*Filmed at less than 24 f.p.s., so that they will appear faster when projected.

LOW ANGLE

A *low-angle* shot is any shot in which the camera is tilted *upward* to view the subject. A low angle does not necessarily mean a "worm's-eye" view of the setting or action. Neither does it imply that the camera be positioned *below* the cameraman's eye-level. A low angle shot may be made of a bug, a building or a baby. In some instances it may be necessary to place a player or object on a pedestal, in order to enable subject to appear higher in relation to the camera. Or, the camera may be placed in a hole, or below a false floor, to achieve the required lens height in relation to the subject. Low angles should be used when desirable to inspire awe, or excitement; increase subject height or speed; separate players or objects; eliminate unwanted foreground; drop the horizon and eliminate the background; distort compositional lines and create a more forceful perspective; position players or objects against the sky; and intensify dramatic impact.

Low angle shots of religious objects or architecture, such as a crucifix or church interior, may inspire awe in the audience, because the viewer is placed in a lowly position from which he must look *up* to the symbol of the Almighty. The same effect is useful in filming important personages, such as a President, judge or company executive.

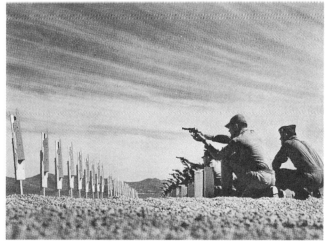

Low angle shot of soldiers on firing range produces diminishing perspective, converging lines and dropped horizon — all of which contribute toward unusual shot.

41

Low camera angles are also useful when one player should look up to another player who dominates the story at that point. This works particularly well with point-of-view shots, because the audience will identify with the lowly player and become emotionally involved with his plight. A player who is knocked down in a fight, must stand beneath a judge for sentencing. If degraded in some manner — he would look up at his opponent, or symbol of authority.

The star, or dominant character in a scene, may stand out from a group if he is positioned slightly forward of the others and filmed from a low angle. This will cause him to tower over the players behind him. This simple trick will give a player prominence, and allow him to dominate the event. Sometimes the effect is more dramatic if the player steps forward *during* the scene to coincide with an increase in dramatic action, or significant dialogue.

A low angle is excellent for cheating a cut-away reaction close-up against the sky, or other nondescript background. Dropping the horizon out of the frame removes all background identity and permits filming such close-ups almost anywhere at any time. Jump-cuts or other editing problems discovered when the film is later assembled, may be easily solved by insertion of low-angle reaction

close-ups without requiring matching a studio set, or returning to a particular outdoor location site.

Low angles cause people, objects and structures to *loom* up in the picture because they are recorded with a broad base and a diminishing perspective. Employment of wide-angle lenses further emphasize the optical effect. When filming players, however, from a low angle with a wide-angle lens, care must be taken — or a caricature may result.

ABC-TV

Low angle shot of advancing soldier increases his size, and causes him to rise higher in frame as he approaches camera. Wide-angle lens will increase this effect.

QM Prod.— 20th-Fox—ABC-TV

Low-angle shot of this wounded airman allows camera to look up into his face, and also provides added stature by causing figures to loom upward in the frame.

Warner Bros.

Three-quarter low angle shot of Marine formation provides distinct separation between rows of men — with front row appearing higher than rear row.

20th Century Fox Film Corp.

Low angle shot of location interior allows filming unique ceiling. Note how priestly official in left foreground is positioned much higher than centered player – and how rear player provides subtle accent to complete triangular composition.

Both natural and man-made structures may be given increased height and dominance by shooting up at them. Skyscrapers, church steeples, mountains, may all benefit from such treatment. The distortion inherent in such filming is acceptable, because viewers have been conditioned to seeing tilted photographic perspectives, and realize that the converging lines are parallel. In reality, a person looking up from close to the base of a tall structure gets an impression similar to that produced by the camera.

Low-angle studio interiors are rarely filmed for theatrical pictures, because sets are generally con-

structed minus ceilings, to allow overhead lighting. However, location interiors of actual buildings may utilize ceilings if they provide additional dramatic effect to setting or story. Low-angle shots of players against a sculptured church ceiling, a wooden-beamed colonial inn ceiling, or a glass-domed library ceiling, would present them against unusually picturesque backgrounds, tying them in with the setting.

A low-angle static shot of an advancing group of players may provide a dramatic introduction, if they enter from the *bottom* of the frame as they approach the camera. An advancing army may

43

thus appear to rise up against a clouded sky as they press forward, and grow in stature and numbers as they file past. An individual player may be treated in this manner either as an introduction, or during a sequence when he must approach another player in a dominating manner. Autos, trucks and other vehicles may be similarly handled. Such low-angle treatment is most effective if filmed as described in the next paragraph.

Low angle positions subject against sky and produces tilting verticals. Combined with train movement, this adds hazard to shot.

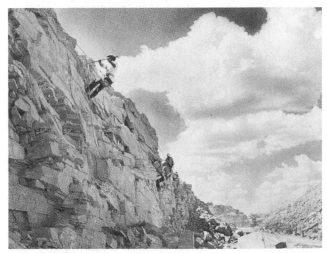

Santa Fe Railway

Shooting upward from a low angle at these men quarrying rock, positions workers against sky with greater separation than if filmed with level camera against cliff background.

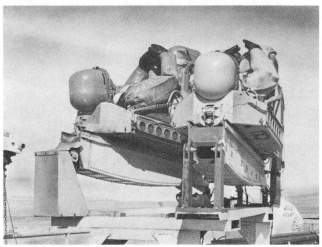

Weber Aircraft

Engineering progress report employs low angle shot of dummy crew prepared for test launching of experimental spacecraft ejection seat — to depict clearly construction and positioning of components.

International Harvester Co.

Low angle shot of farm tractor at work causes it to loom làrger and higher in the frame as it advances toward camera.

ANGLE-PLUS-ANGLE

An *angle-plus-angle shot* is filmed with a camera *angled in relation to the subject*, and *tilted* either *upward* or *downward*. Such *double angling* will record the greatest number of subject facets; result in the finest modeling; deliver the most forceful linear perspective; and produce a third

dimensional effect. Angle-plus-angle shooting eliminates the two-dimensional flatness of straight-on angling, and the dullness of filming with a level camera. Not only are the front and side of the subject depicted, but the camera also looks *up* or *down* to record the *underside* or *top* of the subject. The resulting three-dimensional modeling and diminishing compositional lines present the subject — whether person, building, or machine — in a realistically solid manner.

The camera angling need not be very high or very low, or from a full three-quarter angle. The

Front view of building is flat, because it records only height and width.

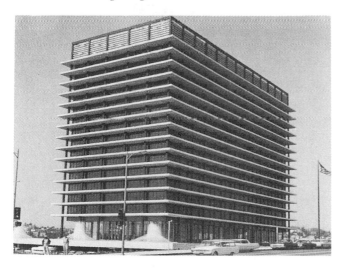

By presenting front and side of building, three-quarter angle records height, width — and depth.

trick is to prevent flatness at all costs, by angling even slightly to introduce diagonals in lines of setting and background, and plastic modeling in players. Players and objects will stand out more prominently in the setting, and the separation between players and background will be greater if the camera records the scene at an angle depicting both front and side, and a tilt that reveals the top or bottom of objects.

Very high and very low angles will present the most drastic effects, and should be utilized only when highly dramatic results are required. More subtle angling should be employed as a matter of course on every possible type of shot. Wide-angle lenses will increase the angular effect by recording a more forceful perspective. Players should be positioned so that they present a three-quarter view to the camera, and travel in diagonal lines, whenever feasible. Furniture and other props should be cheated, if necessary, so that they are turned at an angle to the lens. The background should be filmed at an angle, rather than flat-on, to produce diminishing compositional lines.

Linear perspective is greatest, and presents the most interesting series of converging lines when the camera is placed very high, and shoots downward on streets, roads, industrial complexes, preferably with a wide angle lens. A three-quarter low

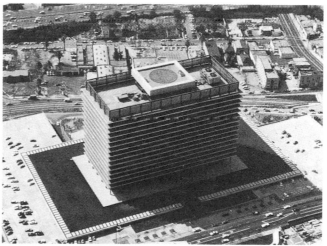

Calif. Div. of Highways

Aerial view of building also records top. Three-dimensional effect is greatest when camera is angled so that front, side and top — or bottom — of subject are seen.

angle shot is excellent for filming a moving column of soldiers, a long line of vehicles or a train. Such movement should approach the camera, so that it becomes larger as it advances. Side three-quarter angling, plus the low viewpoint will produce converging lines, which are made more interesting by player or vehicle movement.

A three-quarter low angle, employing a wide-angle lens, adds illusion of tremendous speed and power to moving vehicles. Starting from a mere speck in the distance, an automobile develops long sleek lines as it rapidly approaches, and becomes larger and higher in the frame. Such angling requires careful placement, so that most of the horizon is close to the bottom frame line and forms a solid base for the movement. This treatment may

ABC-TV

Background should be angled to produce diminishing compositional lines. Players should travel in diagonal line, not straight across screen. Flat-on angles, presenting subject travel and background square to lens, should be avoided.

ABC-TV

Angle-plus-angle camera set-up with low three-quarter angle. Infantryman looms up in frame and background falls away with greater separation.

Camera #1 records background with gradually diminishing lines; and running player with gradually increasing image. Camera #2 records flat square-on background and player with same size image.

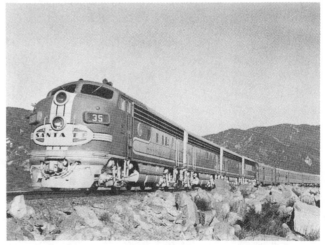

Santa Fe Railway

Low three-quarter angle on fast-moving subject adds to illusion of speed and power. Train image becomes larger and higher in frame as it approaches camera.

Lockheed-California Co.

Angle-plus-angle shooting presents interesting compositional lines. Downward angling on this magnetic tape set-up records equipment at side and rear of room; and console deck as well.

also be applied to a long line of moving vehicles. Those in the foreground will fill the frame from top to bottom, while the remainder will gradually diminish and converge in the distance.

Rooms with ornate ceilings, or patterned floors, may be filmed with a slightly lower or higher camera; that requires tilting upward or downward — in addition to three-quarter angling, which records two walls. Double-angling in this manner will present the greatest number of facets to the camera, and the greatest convergence of lines — particularly if a wide-angle lens is employed.

Trucking shots, filmed with a camera tilted slightly upward, will cause the background to slop away from the players. This is excellent for frenzied chase scenes where players are presented in turmoil. Buildings or trees will not simply slide past the players — as in a level shot — but fall away backward.

Angle-plus-angle shooting should be considered whenever the greatest three-dimensional effect and greatest convergence of lines are desired.

TILT "DUTCH" ANGLES

In Hollywood studio parlance a "Dutch" angle is a crazily-tilted camera angle, in which the vertical axis of the camera is at an angle to the vertical axis of the subject. This results in tilting of the screen image, so that it slopes diagonally, off-balance. Such slanted images must be used with discretion, or they may detract from the story-telling. They should be reserved for sequences when weird, violent, unstable, impressionistic or other novel effects are required. A player who has lost his equilibrium, or is drunk or delirious, or in a high emotional state, may be shown to advantage in a tilted shot, or a series of tilted shots, perhaps in pairs of opposing tilts, so

Harann Prod.

Dutch tilt angle may be employed to shoot scene of distraught player in highly emotional state. Series of such scenes may utilize opposing tilts for greater effect.

that the audience realizes he is behaving irrationally. These shots may be combined with subjective point-of-view shots, in which the upset player sees other players or events in a tilted off-balance series of shots.

A man-made or natural catastrophe, such as an accident, fire, riot, fight, shipwreck or earthquake may employ tilted camera angles for conveying violence, or topsy-turvy, out-of-this-world effects to the audience. If preceded by calm, static, peaceful shots that lull the audience into believing everything is all right, such scenes will be much more effective. A quiet, statically-filmed, slowly-paced sequence in an art museum, for instance, could suddenly be thrown into uncontrolled pandemonium by sudden insertion of a tilt shot of a

man racing through a doorway and crying: "Fire!" The remainder of the sequence could employ a series of tilted shots, to portray the panic of the trapped museum visitors. Editorial effects may be enhanced by using opposing left and right tilts, in pairs, and player movement in opposite directions.

Dutch angle shots may also be employed in montage sequences, for creating an over-all impression of passage of time or space. Short shots of clocks, calendars, feet walking, wheels turning, ship's whistle blowing steam, etc., may be angled in a tilting manner. A series of tilted angle shots may be used in research, industrial, advertising,

Cameras should *never* be tilted just a *little off level*, so that the slightly slanted image seems accidental. A tilt should be deliberate, with a definite slant of sufficient angle to throw the image off balance, but not so steep as to appear on its side. The actual angle will vary with subject matter and action. The camera need not be tilted throughout the shot. It may start level, and then abruptly tilt to depict a weird change in events, or introduce sudden unbalance in player involved. Or, a tilted shot may return to level when events return to normal. The camera may, on rare occasions, rock back and forth during the shot, tilting from one side to the other.

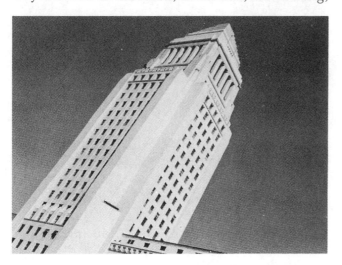

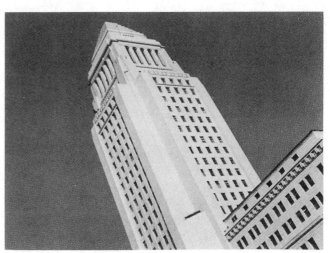

Dutch tilt angle of building produces impressionistic view; unusual treatment suitable for montage sequence. Scene should be filmed with opposing tilts, for editor's choice. This is important when series of tilt shots oppose one another.

engineering and similar documentary films that require dynamic depiction of a great deal of action in small snatches, which show mere glimpses of the events. Thus, the assembly of an automobile, the manufacturing and packaging of a new product, or the numerous experiments involved in developing a synthetic yarn, may be shown with unusual treatment. Several, or all, of these shots at tilt angle, will forcefully portray the situation. Pairs of opposing tilt shots should employ the same degree of tilt in opposite pattern.

The angle of tilt is most important. An image that slants to the right is active, forceful, while one that slants to the left is weak, static. A slanted horizon, running from lower left to upper right, suggests ascent; while one that slants from upper left to lower right suggests descent. The angle of the horizon is important in shots of traveling players, moving objects, or vehicles; especially if they advance from a distant point toward the camera, or retreat from the lens to the distance. They should climb *up coming toward the lens*, and climb *down going away*.

Dutch angles are most effective if filmed from a low camera set-up, which throws the images backwards in a crazy slant. A wide-angle lens, low-angle tilt, combined with a three-quarter camera angle is strongest, because such angle-plus-angle shooting with a short focal-length lens

records the most violent angling, the greatest separation of subject and background, and the most forceful perspective. The effect is further increased on moving action, because the wide-angle lens enlarges or diminishes the moving player, object or vehicle as it moves toward or away from the camera.

EMPLOYING CAMERA ANGLES

The *area* photographed, or type of shot, and the *viewpoint*, or angle of the camera in relation to the subject, may be employed in various combinations to produce a motion picture story with visual variety, dramatic interest, cinematic continuity.

Universal City Studios

Contrasting shots utilize pairs of different size images in opposition; such as long shot and cut-away close-up.

20th Century-Fox Film Corp.

Progressive series of images may depict full shot of group; medium shot of two players, and close-up of dominant player.

AREA

The area photographed determines the subject's *image size* on the film. The camera may film long shots, with tiny images; or close-ups, with large images. Image sizes may be employed in a series of shots to present the event in a *progressive* (or regressive), *contrasting* or *repetitious* manner.

Progressive (or regressive) shots utilize a *series of images increasing* (or decreasing) *in size*. Sequences may proceed from long shot to medium shot to close-up; or procedure may be reversed. The sequence may begin and end with any type of shot. Most important is the progressive change in image size, from shot to shot.

Repetitious shots employ same size images, such as these close-ups. Long shots — or any size image — may be used provided they are similar in size.

Contrasting shots utilize *pairs of different size images in opposition*. A long shot may be contrasted with a close-up, or the other way around. Each pair of shots should have sufficient difference in image size to provide suitable contrast. For greater over-all effect, series of contrasting pairs may be used.

Repetitious shots utilize a *series of same size images*. A series of close-ups may depict reactions of a crowd to a speaker. A series of long shots may show several industrial sites. Any series of similarly-sized narratively-connected images may be used.

Similar series or pairs of shots need not be used throughout a sequence. A sequence may begin progressively, so that it moves in from establishing long shot to close-up. Then, it may move into a repetitious series of close-ups — such as individual reaction shots; and climax with a series of back-and-forth contrasting shots. Movie makers lacking imagination sometimes resort to a monotonous pattern of progressive long shots, medium shots, close-ups. A more vigorous representation will result by integrating progressive, contrasting and repetitious series of shots within sequences, throughout a picture.

VIEWPOINT

The viewpoint determines the subject's image angle, or the camera angle from which the audience views the subject matter. The viewpoint may be *progressive* (or regressive), *contrasting*, or *repetitious*.

In a *progressive* (or regressive) series, *each angle* is either *greater* (or smaller) than the preceding angle. Angles may also progress in height, going from low to eye-level to high angle (or may regress in opposite manner). Or they may progress in relation to the subject, such as going from front to side to rear angle. Any series of angles progressing (or regressing) in orderly fashion — in or out, up or down, or around, the subject — is governed by this principle.

Contrasting angles are *pairs of shots* employing camera angles in direct *opposition to each other*. A high angle may be followed by a low angle; a low angle by a high angle; a front angle by a

reverse angle; a reverse by a front angle. To be most effective, angles selected should be dramatically opposing in viewpoint.

Repetitious angles are *series of similar angles* applied to the same or different subject matter. A series of shots may be filmed from the same angle at intervals, to show various stages of manufacturing process. Or, similar angles may be employed to film different people, objects or actions. The viewpoint remains the same, the subject matter changes, as events progress; or different subjects are depicted from similar angles.

Harann Prod.

Back-and-forth series of shots should employ opposing angles. Camera distance and camera angles should be similar, in order to produce uniform appearance.

Harann Prod.

It is not necessary to employ similar series of angles throught a sequence. Angles may be varied in the same manner as sizes of images. Treatment of angles and images should be integrated, and used in combinations to provide visual variety: so that the audience is brought in closer and closer, in diminishing angles; is moved back and forth to view contrasting images; stays the same distance from various people — or moves up and down, round and about, in a series of camera moves which place the audience in the best position for viewing the action occurring at *that* moment in the narrative. Recording the required series of images from the proper camera angles cannot be successfully accomplished in a haphazard manner. Thoughtful planning, with definite editorial patterns in mind, is required.

HOW TO SELECT AREA AND VIEWPOINT

It is often difficult to draw the line where a certain type of shot ends and another begins. However, it is necessary that a *definite* change in *both* image size and camera angle take place whenever they are employed progressively or regressively. A slight angle change with the same image size will look like the figures shifted abruptly. A slight image change from the same angle will appear as a sudden expansion or contraction of the image.

The same procedure applies to contrasting images and camera angles. Contrasts from one extreme to the other should be marked. Half-way changes in image size, in between camera angles, present only slight changes; not a radical contrast to each other.

A series of repetitious images or camera angles means exactly that. *Don't* vary the images. Keep them approximately the same size. *Don't* shift the camera angle slightly, so that it views each subject from a different angle. Keep the camera the *same distance* from each subject. Shoot each subject from the same angle. Use similar camera angles, or opposing matched angles, such as in a series of repetitious back-and-forth over-the-shoulder shots, or a series of objective or point-of-view close-ups.

Image size and camera angle should be integrated so that they match. Progression in image

Same camera angle with slight change in image size — such as between close-up above and below — will appear as slight expansion of image, rather than definite image change.

This close-up depicts a definite change in image size from first close-up.

be depicted at that *particular moment* in the narrative. Simple progression from long shot to close-up may not always provide the most suitable type of sequence. For instance, subject matter or dramatic content of the story may require that the camera first record a close-up, in order to isolate, emphasize, or introduce a small object. An extreme long shot may be required to portray scope, grandeur, complexity; so that the audience fully appreciates the vastness, beauty, or conflict involved in the story. The over-all action of each sequence should be broken down before shooting, and the type of shot required for each portion of the action determined in advance.

Establish the setting with a long shot, or an extreme long shot — if vast in nature. Move into a medium shot to introduce the players as a group, and use close-ups for individual screen filling shots of each. Employ long shots to show the players in relation to the background, and to allow them space to move from one place to another, as the action progresses. Use medium shots, particularly two-shots, to show important inter-action between players. Utilize close-ups to emphasize a particular action, or to isolate a player or action by removing all else from view. Use extreme close-ups for full-screen shots of very small objects or actions. Progress inward as the action develops. Move back to re-establish the over-all scene, to depict new developments, to introduce a

size should also employ camera angles that move around and shoot the subject from a side angle as it moves closer. Contrasting pairs of shots may utilize contrast in *both* image size and camera angle to be more effective. Series of repetitious shots should repeat *both* similarly-sized images and similarly-angled camera set-ups, or repeat similarly-sized images with opposing matched camera angles.

DEPICTING THE ACTION

The camera angle chosen for each shot is determined by how the players and the action should

On occasion it may be more dramatically effective to open sequence with a close-up — and then pull back to reveal content of over-all scene.

QM Prod.—ABC-TV

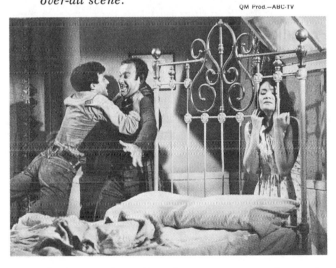

new player or allow the players to move about. As example, contrast an extreme long shot of a missile launching with an extreme close-up of the firing button! Think in terms of dramatic impact on audience as well as visual variety. Employ a repetitious series of reaction close-ups of various persons to the launching; or a repetitious series of medium shots of personnel at tracking stations.

Don't attempt to tell the entire story in a single shot! Remember that a sequence is a *series* of shots, and each shot should depict its particular portion of the story in the best possible way. Think *first* of the area required for the particular shot, and *then* of the best viewpoint.

The cameraman should ask himself: "How *much* should be included in this shot? *Where* should the camera be positioned to view this particular part of the action?"

The area and viewpoint should be considered from both esthetic and dramatic requirements. Difficulties encountered by pioneers in crossing a trackless wasteland may be most expressively conveyed to the audience by an extreme long shot, which dwarfs the people against the rugged terrain. On the other hand, technical problems involved in soldering may best be shown by moving in close and filling the screen with a single drop of solder!

Claude Michael, Inc.

A single drop of solder being applied to an electronic circuit may be as dramatic as long shot of group of pioneers crossing rugged terrain.

20th Century-Fox Film Corp.

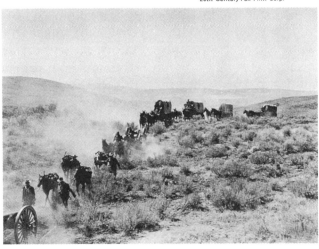

Think, first of the *impression* the shot should make upon the audience. Should the screen event influence their emotions, or should they be detached from the proceedings so that they may evaluate events without prejudice? A comparison of prototype aircraft may be best presented objectively without trying to make up the viewers' minds. Events must be individually evaluated, and filmed accordingly.

Inclusion or removal of people, objects or actions should be justified by whether or not they are essential to the story-telling. Only significant portions of setting, performers and events should be depicted in each shot. It should be remembered, however, that on occasions a blank frame is significant! What is depicted at any moment should contribute to the over-all story-telling.

While the point in the action where a shot should be terminated, and another type shot begun, is usually an editorial decision; it must be made by the cameraman or director, if not indicated in the script — or if filming is off-the-cuff. A shot should be held no longer than required to make its point. When setting and players are established and camera is moved in, the bulk of the sequence should be continued in a variety of medium, medium close and close shots. The over-all scene should be re-established, however, whenever a wider expanse is required to move players about, introduce a new player or allow the players to exit.

Emphasize and isolate significant players, actions or dialogue with close-ups. Shift the camera on movement that may be overlapped from shot to shot. Move the players out of and into shots. Shoot cut-in and cut-away close-ups wherever possible. If in doubt about unusual camera angles, pan or dolly shots, or any shots that may cause editorial problems, shoot protection shots for additional coverage. Don't be hide-bound by a by-the-numbers 1-2-3 shooting pattern. Approach each sequence with a fresh attitude; and strive to treat the action in an individual manner. Employ progression as a standard operating technique, but always look out for dramatic contrast or unusual oppositional treatment which can lift the sequence out of the run-of-the-mill cinematic rut.

Many cameramen fall into this rut because of habit, or lack of imagination, or laziness. Employ repetitious treatment whenever a matching pair or series of similar shots — such as a series of close-ups — must present the same size image from similar or opposing viewpoints.

CHANGE CAMERA ANGLE, LENS, OR BOTH

Change the camera angle, the lens, or preferably *both* every time the camera stops shooting during a series of continuous shots. Adapt this technique as a standard operating procedure whenever filming continuous action that must be presented without a break, without cutting to something else, or without opticals. Using the *same camera angle* and *same lens* on consecutive shots will result in a jarring *jump-cut,* due to changes in players' positions. This is tantamount to stopping the camera in the *middle* of a shot, since nothing photographic is changed; but player movement which occurred during the shut-off interval is missing. There should be a definite *change* in *image size* and *viewing angle* from *shot to shot.* This may be accomplished if camera is moved, if lens is changed, or if camera and lens are both changed to meet requirements of the new set-up. Moving the camera with the same lens is better than changing lenses from the same camera position. Most rewarding results will be obtained when the camera is repositioned for the

Santa Fe Railway

Camera may move straight-in to shoot a close-up of individual in crowd.

best possible angle for each shot; and a focal length lens that meets the technical and dramatic aspects of the scene is chosen.

Some inexperienced, unimaginative, or lazy cameramen change the lens, and continue filming from the same position. This requires only revolving the lens turret, so that a different focal length lens is shifted into shooting position. If a longer lens is brought into play, the screen effect is that of an *optical pop-in*, because a portion of the previous shot is suddenly *magnified* to fill the screen.

There are instances when *pop-in* treatment — either switching to a longer focal length lens or moving the camera straight in, preferably the latter — should be employed. It may be used when filming a single person in a long shot, such as a master of ceremonies on stage. A long shot from the back of the theater may be followed by a close-up which moves straight into the subject. A subject seen from a distance, such as a person in a crowd, may be followed by a closer shot from a similar viewpoint. A person centered in a group

QM Prod.—20th-Fox—ABC-TV

QM Prod.—20th-Fox—ABC-TV

A magnified or pop-in effect is similar to intermittent zoom — minus actual zooming — because camera is moved straight in for closer shots. This treatment may be used when a player is centered, and relates with other players on each side. Camera #1 films long shot, #2 medium shot and #3 close-up.

so that he must relate with others on either side, may be filmed in a closer shot with a straight-in camera move.

The point-of-view close-up which follows an over-the-shoulder shot, is another instance where the camera is moved straight in. The reason for filming over-the-shoulder of a foreground player is to prepare the audience for the close-up that follows — as seen from that player's viewpoint.

A director of photography on a theatrical feature picture would rarely shoot a close-up with a telephoto lens from the long shot camera position. The camera would be moved in closer, an intermediate focal length lens employed, and a camera

angle and lens height chosen that would best portray the player. The camera is moved *in, around to the side,* and *raised* or *lowered* for closer shots. This results in decided changes in image size, camera angle and lens height. Although there are a few exceptions to this rule, it should be applied whenever filming conditions permit.

The zoom lens does not lend itself to this type of treatment. Unless the camera is positioned on a dolly boom arm, it cannot be lowered as the lens is zoomed into a close-up. The zoom would only be useful whenever the camera would be moved straight in for a subsequent close-up — when an actor is centered and relates with others on each side of him. It will not provide the best close-up when the camera should be moved around to the side — whenever players relate across the screen.

Universal City Studios

Camera should move in and around to the side whenever two or more people relate with others across screen.

Universal City Studios

Camera #1 films long shot. Camera #2 is moved in and to the side to film close-up of lead player. Camera #3 films opposing player from opposite angle. This treatment is recommended whenever players relate across screen.

The camera is generally higher for long shots than it is for close-ups — so it is usually necessary to lower the camera when it is moved in. There are instances, however, when the camera is positioned at eye-level for the long or medium shot. so that it only requires being moved in and around, or straight in — in certain cases, to film close-ups. Or, the lens focal length need not be changed, the move *in* is sufficient to alter the image size. There are also occasions during filming of documentary or newsreel films when the camera must shoot from a fixed platform, or other static position, so

Universal City Studios

Moving camera in and around to side angle for closer shot will help cover inadvertent minor mis-matches in players' positions. A major mis-match, as shown here, would require insertion of cut-away shot of another individual in the scene.

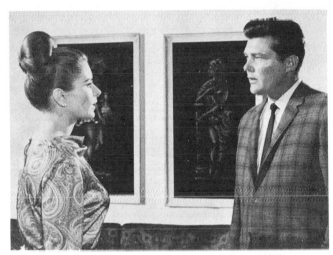

Universal City Studios

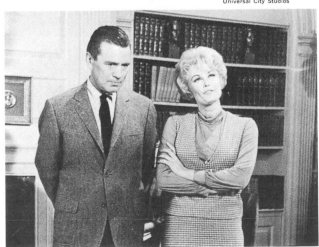

Retaining same image size in consecutive shots with slight change in camera angle results in jump-cut, because players will appear to jerk or shift across splice.

that switching lenses from the same camera set-up is the only way to record different size images. The most impressive screen effects, however, occur when the *camera is moved* to a fresh viewpoint, the *camera height is adjusted* to suit the subject, and the *lens focal length is chosen* to fit the individual shot.

While is it not absolutely necessary to change the lens for each shot, it is wise to switch to a lens focal length best suited for the particular scene being filmed. Generally, this necessitates a change, since a wide-angle lens may be required for a distant shot, a normal lens for a medium shot and a semi-telephoto or telephoto for a close-up or extreme close-up. A normal focal length lens may be used to film an entire picture, if the camera has sufficient room to be moved about for every type of shot. Such situations are unlikely in professional production filming, where a variety of different focal length lenses are available to record the area and perspective required.

Moving the camera *in and around* to a new angle helps cover inadvertent mis-matches in players' positions. A mis-match is much more noticeable if the camera moves straight in, since the only change is that of magnification. Thus, a slightly different head position or changes in hand or arm movement may be apparent to even the casual viewer. Moving in and around, however, permit considerable cheating, because the audience views the players from a completely new angle. All effort should be made to match player positions, but small discrepancies due to slight mis-matching between shots will be less apparent with a change to a new viewpoint, than with a straight-in move.

The camera angle should *not* be shifted *slightly* in consecutive shots of the same subject filmed with the same image size. A two-shot of players facing each other will appear as a jump-cut if filmed from a matched pair of camera set-ups, which are varied *slightly* to favor each player in turn. Since the pair of images are the same size, and the angle is only slightly changed, the players — rather than the camera angle — will appear to shift. A *definite* change in camera angle will assure a smoother flow of images.

SCENE REQUIREMENTS

Each scene should be considered as part of a sequence, or series of shots; but must be given individual attention based on story requirements. In addition to esthetic, technical and psychological factors that determine camera angles, there are dramatic, editorial, natural and physical phases to be considered. These factors need not be individually considered for each shot or sequence. Many are handled intuitively by experienced movie makers. But all these elements should be included in over-all planning of a sequence, so that each series of shots will depict its portion in the best possible cinematic manner.

ESTHETIC FACTORS

Many esthetic factors should be considered in selecting the right camera angle. All compositional elements: players, props, furniture, setting, background, vehicles, etc., should be studied with player movements and general action of the scene in mind. Objects should be arranged to facilitate suitable staging and pleasing photography. To achieve the desired effect, some items may have to be added or eliminated. Filming fictional features present few esthetic problems, because sets are designed and built around the scene's requirements. Documentary films, shot on actual locations, often require much improvising to stage the

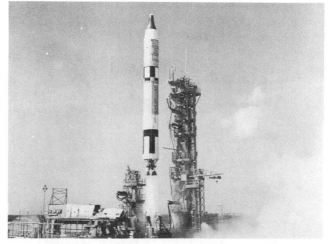

NASA

Some documentary films require compromising camera angles because of uncontrollable factors.

action, particularly in interiors of real structures. Compromises in choosing camera angles may have to be made.

When filming exteriors, advantages of foreground frames, such as tree branches and arches, should be considered. Whenever possible, angle-plus-angle viewpoints should be chosen to record the best modeling, greatest number of planes, and solid three-dimensional effects. Compositional forms should suit subject matter and aid in creating proper atmosphere and mood.

Relationship between players and background also warrants forethought. If the background is important to the story — such as an oil field, an assembly line, a waterfront — players should be so positioned that the background is tied-in with foreground action. Compositional lines, forms and movements should all be exploited to facilitate the story-telling. (*See:* COMPOSITION)

TECHNICAL FACTORS

Few technical restrictions are imposed on theatrical cinematographers, either in the studio or on location. On the other hand, because of budget, personnel, transportation and other limitations; most documentary cameramen have less camera,

Lockheed-California Co.

Many technical restrictions are placed on documentary camera crews shooting on location. Camera angles and staging may have to be compromised to meet limitations set by lighting facilities and equipment availability.

lighting and accessory equipment. Need for portability, lack of trained personnel, inadequate electrical power, insufficient time, cost and difficulties of transporting heavy studio equipment — particularly by air — all contribute to the technical problems encountered by non-theatrical cameramen filming on actual locations. Lack of camera dollies restricts filming to fixed tripods. The area that can be adequately illuminated is determined by electrical power and lighting facilities available. The amount of equipment that may be carried to location generally precludes many camera and lighting accessories, ordinarily available in studios. All these technical factors combine to restrict the cameraman in his handling of the subject matter. So, camera and player movement, camera placement, area to be filmed, and over-all camera treatment must be compromised to make-do with available equipment and conditions.

PSYCHOLOGICAL FACTORS

As explained in the discussion of camera height, the audience may be emotionally affected by the camera viewpoint. Up, down, Dutch tilt, and subjective angling of the camera may place the viewer in other than normal eye-level objective viewing position, and strongly influence his emotional reaction to events depicted on the screen. Such abnormal viewpoints may bring the viewer closer to identification with the picture and the screen players. If disinterest is the effect desired, or the scene is too violent to view close-up, long and medium shots will position the audience at a distance from the event. Closer shots actually help to involve the viewer in the action. Subjective angles tend to depict the scene as the screen player sees it, and bring the viewer even more intimately into the story.

Through distorted subjective camera treatment, the viewer may actually experience the intoxicated, frenzied or insane attitude of the player through whose eyes he is looking. Thus, psychological reaction of viewer is based, to a great extent, on camera angles and editorial treatment. The principal psychological purpose of a motion picture is to sway the audience to react in a desired mood. Whether a picture's purpose is to sell,

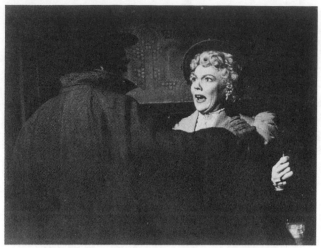

Columbia Pictures Corp.

Murderer in mystery picture may startle audience by suddenly revealing himself.

educate or entertain, its success depends on how thoroughly it interests the viewer in the picture's story or message.

Choice of camera angle may be decided by analyzing the *purpose* of the shot, and the *effect* wanted on the viewer. Should the audience be *shocked* at slum conditions depicted . . . *sold* on a new product . . . *angered* by a corrupt political situation . . . *awed* by a display of atomic weapons . . . *look with disdain* upon a despicable character . . . be *inspired* by a religious message . . . be *shown* the world as seen by a mental patient? All these suggest specific camera placements, and photographic techniques designed to make the viewers *care* about the subject matter. The audience is not only impressed by what *appears on the screen*, but by players, objects or actions *partially or completely hidden, revealed in a sudden or startling manner*, or not *shown at all!*

The camera need not do all the work! The viewer should be urged to use his own imagination in understanding what is happening. The camera may create suspense by angling downward on the murderer, showing a knife in his hand — but his identity is not revealed. A reverse angle may show the backs of villains as they conspire. The camera may pan, tilt, zoom or move to reveal suddenly a player, object or action. Because it is a direct link to the viewer's emotions, psycholog-

ical camera angling is one of the most powerful story-telling weapons available to the cameraman.

DRAMATIC FACTORS

If the story requires an exciting treatment of the action, dramatic factors should be analyzed. Ordinarily, the camera should not intrude on the story-telling. Since it is able to interest the viewer by content alone, inherently dramatic subject matter requires little or no special camera treatment. For instance, a dramatic speech should not be filmed with complicated lighting, tricky angles or distracting background action, if full audience attention belongs to the speaker.

Static, prosaic or commonplace subjects may be enlivened, however, by imaginative camera handling. When the cameraman is faced with dull material, the audience should be aroused. On other occasions, dramatic material may be further enhanced by inspired camera treatment. Would an extreme long shot impress the audience with the majestic grandeur of the setting? Would extreme close-ups of key players, objects or actions bring greater audience attention? Would low-angle filming increase tension, distort compositional lines or exaggerate action? Would high-angle filming add significance to players, setting or action? Would subjective camera angles aid audience identity with lead player?

Should the cameraman employ Dutch tilt angles? Dolly shots? Dramatic lighting? Extreme

Bob Jones University-Unusual Films

Straightforward camera treatment is generally best for highly dramatic scenes.

wide-angle lenses? Agitated movement? Or, should the story be told in a straightforward documentary style, devoid of camera tricks and lighting effects; or fancy camera angling which may detract from the narrative? Unorthodox camera treatment should *not* be employed when it may distract the audience from the picture to awareness of camera. On the other hand, audience emotion may be raised to a high pitch by presenting subject matter in a distinctive, dramatic manner. The cameraman should study the event to be filmed, along with the script; and decide whether forceful camera *participation* would be an asset to the story-telling; or whether the camera should function merely as a *detached* observer.

EDITORIAL FACTORS

Editorial requirements often dictate the preferred camera angles for a series of shots. Detailed shooting scripts usually specify type of shot or camera treatment. Many scripts, however, are written in master scenes, in which the filming treatment is left to the director and cameraman. A cameraman filming a documentary off-the-cuff should shoot according to editorial requirements. While a few key scenes in a picture may be treated individually, all scenes must be considered in relation to other scenes in the sequence.

<div align="right">North American Aviation</div>

Documentary subjects filmed off-the-cuff must be photographed with definite editorial pattern in mind. Over-all event must be broken down into types of shots required for each portion of action.

The cameraman must plan the event as a whole, and decide on its breakdown into individual shots. He must decide how much setting should be included in the establishing long shot; what portions of the action require medium shots; and where the emphasis should be placed with close-ups.

Normal progressions from long shot to close-ups are generally safe, but not always the best technique. If the sequence develops into a series of back-and-forth close-ups of various players, progressive camera angles should switch to repetitious camera angles. If a great deal of player movement is involved, or new elements are introduced, it may be necessary to return to the long shot to re-orient the audience. The cameraman should continually try to analyze the event through viewers' eyes. The audience should be shown the player, object or action which they are most interested in seeing at that point. This becomes of vital importance when narrative interest is divided. The camera must concentrate on the more interesting of the two story elements. The film editor should be supplied with every possible type of shot consistent with time and budget limitations imposed on the production.

NATURAL FACTORS

Sun position, weather, terrain, influence choice of camera angles on exterior filming. Outdoor filming — particularly in color — depends upon the sun angle. Except for special effects, such as backlighted scenes; the sun angle is best when the scene is side or three-quarter front lighted. Even with careful planning to take full advantage of the sun at various times of the day or season, this restricts choice of camera angles. Fronts of structures facing north, for instance are rarely directly illuminated by sun in the northern hemisphere.

Weather can be a factor, although overcast light permits filming with equal ease from almost any angle. It may be necessary to shoot in a direction that avoids bald skies. Terrain, particularly backgrounds, may force the cameraman to choose camera angles that either include or eliminate trees, roads, mountains, or other natural elements. Allowances for sun angles, weather and topography are made in construction of outdoor

sets; but uncontrollable elements in natural settings often handicap the cameraman, so that he must compromise camera angles to fit prevailing conditions. Weather maps in corresponding seasons of past years should be studied, if extensive outdoor production filming must be accomplished in unfamiliar locations.

PHYSICAL FACTORS

Physical factors seldom interfere with the studio cinematographer's choice of camera angles. The documentary cameraman, to the contrary, has to work within physical limitations necessitated by size and shape of rooms; fixed dimensions of settings (without aid of "wild walls" which may be moved at will); ceilinged rooms (particularly low ceilings); practical props, machines, structures and objects that do not "break-away" for filming, poorly painted walls (especially light-tinted walls in color filming); and many other physical factors beyond his control. A very small room, for instance, may be difficult to light and impossible to shoot without an extremely wide-angle lens which distorts the players. Actual interiors of airplane cockpits, automobiles, control rooms, engineering instrumentation trailers, blockhouses, and similar "live" sets may provide little space for camera and light placement. The choice of camera angle in many documentary interiors depends

more often on *where* the camera and lights can be squeezed into position, rather than the best angle for telling the story.

CAMERA ANGLES ON SIGNS & PRINTED MATTER

Signs, plaques, labels and similar identifications should be filmed either straight-on — in the manner of titles — or given a three-quarter angle, so that the lettering diminishes in size as it recedes from left to right. This is particularly important if the sign is of considerable length, such as lettering covering the front of a wide building. It is of less importance if it occupies little area — such as a sign on a door — and may be read at a glance. The name on the front of a courthouse, post office, school or other structure is more quickly legible if angled in this left-to-right diminishing manner.

A lengthy sign, filmed with a panning or dollying camera movement, must necessarily be filmed so that lettering enters from screen right and slides across the picture from *right to left*. Care must be taken to angle the camera in the manner described above for static shots. Square-on camera angles may cause a skipping effect — in which the letters break as they chatter across the screen.

A sign, poster, newspaper headline, label or any piece of printed matter, such as a letter or report,

Universal City Studios

On occasion, major studio theatrical cinematographers have to shoot in crowded quarters — such as this "submarine" set.

Lengthy signs on buildings are best filmed so that lettering diminishes in size as it recedes from left to right.

should be given an upbeat effect by positioning it in the frame so that it slopes up-hill — that is, from *lower left* to *upper right*. This treatment is essential when two or more lines must be read, because the eye has a tendency to *drop down* to read the next line. If the printed material is sloped downward (from upper left to lower right) the eye is forced to *move up* to read the next line. Such unnatural eye movement will distress the viewer. Applications of these reading angles may seem like splitting hairs, but they are based on established reading habits. It is unwise to cause the viewer to strain or react unpleasantly in order to read poorly angled material. (*See: COMPOSITION, Eye Scan*)

PROBLEM CAMERA ANGLES

Angling the camera for a particular effect may introduce unforeseen photographic problems which may require compromising the set-up. For example, an establishing long shot filmed with a wide-angle lens, may include the desired width, but record too much foreground. Lowering the camera will eliminate some of the foreground, without disturbing the basic composition. Raising the camera, so that the setting is viewed from a high angle, should also be considered as a solution.

If a wide-angle lens must be employed to film a tight area, the camera should *not* be drastically angled so that perspective distortion is increased. The wider the lens angle, the greater the linear convergence. In this case, the camera angle should be as square-on as possible to prevent weird foreshortening. Persons in the scene should not reach toward the camera to pick up objects — such as a mechanic reaching for a tool in the foreground — or a hand may appear like a ham! Try to keep the players equi-distant from the camera under such conditions, or the closest player may appear unduly large in comparison with a player standing a short distance away.

Extreme wide-angle lenses record the area from front to back of the setting so that it appears lengthier than in reality. Player or vehicle movement toward or away from the camera will cause the subject to grow progressively larger or regressively smaller at an accelerated rate — resulting in the subject appearing to cover a greater distance than exists. Such movement should be avoided, unless desired for a special effect.

Problems often arise in positioning the camera because of physical limitations. Small, low rooms, confined areas — such as the interior of a space capsule — may prevent the camera from being

North American Aviation

Camera should not be drastically angled on tight interiors, filmed with wide-angle lens. Distortion and linear convergence may be held to minimum with slight angling or shooting square-on.

North American Aviation

Tight interior shots — such as this scene in missile capsule — provide little room for camera and light placement. Choice of camera angle on many documentary scenes is often severely limited.

positioned as far back as desired. Rather than use of an extreme wide-angle lens — which generally seems to afford the simplest solution — the sequence may be broken into additional shots, so that several normal angle shots are filmed, rather than a single wide-angle shot. Or, it may be best to pan the camera with a normal lens to cover the area, rather than record the entire width in a single static shot with an extreme wide-angle lens. This is particularly important in industrial, scientific and research films — where distortion of tools and equipment cannot be tolerated.

Camera angles are related to subject angles. A tilted object — filmed with an equally-tilted camera may be filmed to appear level on the screen.

Tilted verticals can often be straightened, or vertical lines may be tilted as desired, by angling the camera. For example, a three-quarter low angle shot of a columned courthouse may look better if shot with a slightly off-level camera so that the side of the building nearest the camera is squared off to appear approximately parallel with the side of the screen. This may look better than having both sides of the building converge skyward. The important point is not how the camera should be angled — it is the screen appearance of the subject. Studying the image in the viewfinder with various tilts will aid in deciding the best solution.

There are no pat solutions to every camera angle problem. If the subject should appear as in

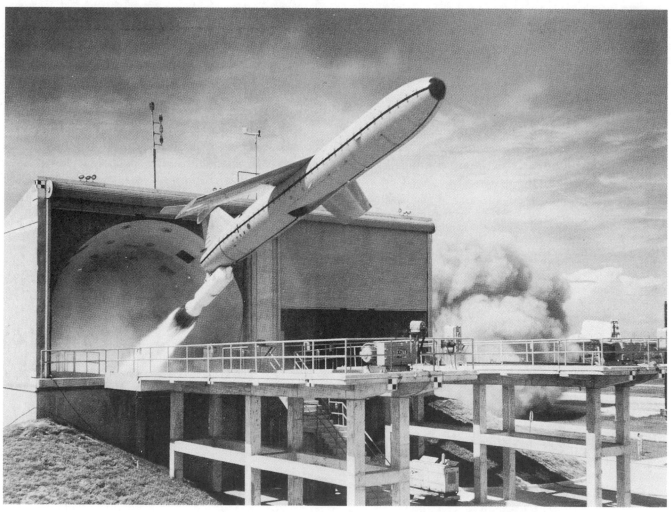

U.S. Air Force

Low three-quarter angle shot presents U. S. Air Force MACE — surface-to-air missile — with lower-left to upper-right ascending flight line.

real life, it must be presented in a manner that is acceptable to the viewer. If a special effect is desired — anything goes! Distorted, violent, trick, gimmicky effects are easily achieved because it is easier to break the rules than to film the subject in a natural way! The most natural results are achieved when the subject is filmed in an undistorted manner with normal perspective effects. This requires avoidance of extreme wide angle lenses, weird camera angles and abnormal movement of players or vehicles. This does not imply that everything should be filmed from eye level with a normal focal length lens! Visual variety — not weird variety — will keep the viewer interested in the narrative.

CONCLUSION

Proper camera angles can make the difference between audience appreciation and indifference. Image size and image angle determine how much of the subject matter the viewer will see, and from what viewpoint. Each time the camera is moved, the audience is transported to a new viewpoint. Since the audience should never be moved about needlessly, every change in camera angle should count.

Whether working with a shooting script or off-the-cuff, the cameraman should film the event with definite editing pattern in mind. The series of shots comprising a sequence should be recorded with progressive, regressive, repetitious or contrasting treatment — singularly or in combination —not with an oddly assorted hodge-podge of shots.

To be truly successful, a motion picture should visually surprise the audience by presenting fresh viewpoints, different types of shots, varied image sizes, in an unpredictable pattern. A series of close-ups may be followed by an extreme long shot: or a sequence may open with a close-up instead of a long shot. The camera should view events now from this angle, now from that. Images should be scaled up in one shot, down in the next. Players and/or camera movements should be changed, switched, reversed: not simply repeated in a similar pattern. Settings should

be viewed from the side or even the top, not always from the front. Visual variety should be the keynote, so that the audience is kept interested in what is happening and what will happen *next*. If films are composed and filmed in a long shot, medium shot, close-up, 1-2-3 manner, the audience will subconsciously expect a certain type of shot, a certain angle, a certain scene length. As a result, viewing the film becomes tedious. Viewers should be shown something new or different at every opportunity.

Non-theatrical cameramen should consider filming more over-the-shoulder and point-of-view camera angles, in order to involve the audience in the subject. The story should not be filmed with a stand-offish objective camera. The viewer should be brought *into* the picture intermittently and stand alongside the players and view the other players, the setting and the action from an *inside* angle. The viewer may thus more readily identify with the people in the picture and become more engrossed with the message.

The documentary cameraman has the advantage over the theatrical fiction feature director of photography, in that he can employ the subjective camera now and then, and allow the subject to look directly into the lens. The engineer, salesman or company executive may be presented with a performer-viewer eye-to-eye relationship to relay the picture's message more forcefully.

The most difficult camera angle — and one worthy of experimentation — is the subjective treatment in which the camera replaces a player who must relate with the other players in the picture — in the manner of *Lady In The Lake*. This technique should be considered whenever an unusual subject may be treated in a novel manner that requires shocking or startling the viewer. Or, whenever the mental condition of the player, or an event told in flashback, would be enhanced with a little different treatment.

Thoughtful use of camera angles can add variety and impact to story-telling. Camera angles designed to capture, sustain and point the way to continued audience interest, should be selected.

Lockheed-California Co.

CONTINUITY

INTRODUCTION

A professional sound motion picture should present a *continuous*, smooth, logical flow of visual images, supplemented by sound, depicting the filmed event in a coherent manner. It is the *continuous* aspect of a motion picture; it is *Continuity* that decides success or failure of the production.

A picture with perfect continuity is preferred because it depicts events realistically. A picture with faulty continuity is unacceptable, because it *distracts* rather than *attracts*. This does not imply that action should flow smoothly across every cut in a motion picture. There are times when an impression or a disturbed mental condition must be so portrayed; so that the audience can be emotionally aroused by incoherent images. These are exceptions.

A motion picture is a record of an event, in fact, fiction or fantasy. The images should reproduce real life, or a make-believe world. Sound may be dialogue and/or narration, accompanied by appropriate music and sound effects. Visual and audio elements of a motion picture should be integrated, so that they complement each other in affecting the audience.

Every motion picture should be based on a shooting plan. The plan may be a few mental notes, scribbled suggestions, an outline, a story board, or a detailed shooting script. The better the plan — or *continuity* — the stronger the chances of success. A *continuity*, or shooting script, is a preliminary motion picture on paper — a *continuous plan* for photographing and editing the production. Other than a simple news shot, a motion picture cannot depict an event in a single scene. A series of scenes — a sequence — are required to portray any action properly. A sequence without a time lapse should present the event in a continuous, realistic fashion.

Motion picture sequences may be compared to chapters in a book. A director, working from a detailed script, is forced to think of the picture as a series of *shots* comprising each sequence; and a series of *sequences* making up the complete picture. A cameraman shooting off-the-cuff must also think in sequences, and *not* in individual shots. Action will flow smoothly from shot to shot only when the over-all action of the entire sequence is broken down into particular actions required in each shot. Without good continuity, a motion picture would be a jumble of unrelated animated snapshots. While these pictures may have movement in each individual shot, they are not a series of fluid, flowing, merging images. Because of its jerky, jarring, mis-matched images, poor continuity distracts audience attention from the subject matter. Good continuity encourages the viewer to become absorbed in the story-telling, without bothersome distractions. The prime purpose of a motion picture, whether theatrical fiction feature

or documentary fact film, is to capture and hold audience attention — from opening shot to final fade-out. To accomplish this, the film must be presented in visual images, inviting viewers to become involved in the screen story. If viewers have to figure out where the camera has suddenly shifted, or why an unexplained change has occurred in players' action, the spell is broken.

Motion pictures create and sustain illusions. The illusion is shattered whenever viewers' attention or interest is distracted. *Smooth, fluid, realistic continuity can contribute more to a motion picture's success than any other cinematic device.*

CINEMATIC TIME & SPACE
TIME & SPACE CONTINUITY

A motion picture can create its own time and space, to fit any particular story-telling situation. Time may be compressed or expanded; speeded or slowed; remain in the present or go forward or backward; or it may even be held constant for as long as desired. Space may be shortened or stretched; moved nearer or farther; presented in true or false perspective; or be completely remade into a setting that may exist only on film. Both — or either — time and space may be eliminated, recreated and presented in any manner that will help the audience comprehend.

A motion picture can go *anywhere* in time and space at *any* moment. Thus, a story may suddenly go back into history, or shift across the world; or a scene may be speeded up; or a setting made to appear fore-shortened. Time and space may be real or imagined, enlarged or reduced, torn apart or tied together. An event may be presented in its entirety as it actually happened; or fragmented into bits in which only highlights or impressions are actually shown. Several locations separated in space may be presented singly, or combined on film to appear as a single setting. Proper handling of both time and space will enhance the visual and audio values of the motion picture story. Abusing time and space requirements may shatter the audience's receptiveness to the screen happenings.

TIME CONTINUITY

Actual time moves forward only, chronologically. Motion picture chronology, however, may present the story in *reel* — rather than real — time. Motion picture time may be divided into four categories: present, past, future, and conditional. A motion picture story may employ one or more of these time elements, singly or in any combination. The film may depict events as happening in the present, and then switch backward or forward; or it may compress, expand or freeze time in any

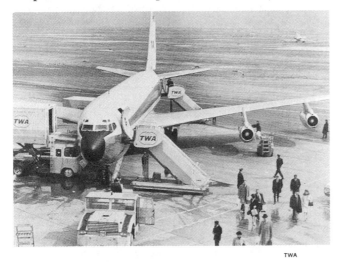

TWA

A motion picture may go anywhere — by showing actual travel — or editorially, by cutting from one locale to another.

Santa Fe Railway

An event — such as this Indian making a sand painting — may be presented in entirety, or by showing only highlights.

68

manner. However time is portrayed, its handling must be easily comprehended by the audience.

Uses of real time, and employment of dream time, are limited only by the imagination and technical abilities of those producing the film. However the time factor is employed, the film story based on time continuity is told with the passage of either *actual* or *fanciful* time.

Present-time continuity depicts the action as if occurring *now*. This is the most popular and least confusing method of presenting the material. Events transpire in a logical, straightforward *see-it-now* way; so that, regardless of story developments, transitions, continuity lapses, the audience is always watching the event in the present. The viewer observing events this way has a stronger feeling of participation in the screen happenings. Neither he nor the screen characters know what will come next. This keeps the viewer *interested* in following the screen story to its conclusion.

While most modern theatrical features employ present-time continuity, use is also made of other time and transitional techniques, as required. By presenting the facts in a *see-it-now* manner, most documentaries could benefit from present-time continuity, which would enliven the material and give it greater dramatic impact and audience participation. Rather than depict a laboratory experiment as a past event; a research project or construction of a missile base as a historical document; it may be more dramatically shown as

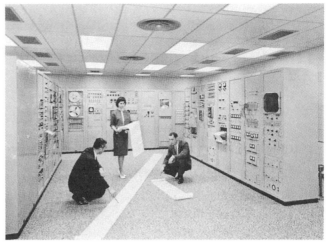

Documentary films benefit from presentation in a see-it-now manner.

occurring *now*, before spectators' eyes. Thus, the event is re-lived as if happening in the present, rather than in the past.

An event progressing in one locale: such as a construction project, an athletic contest, a scientific demonstration — any happening *without* moving from place to place — may be filmed with present-time continuity.

Past-time continuity may be divided into two types: occurring in the past; a flashback, from present to past.

Stories based on present-time continuity depict events as if occurring now.

Construction project may be filmed with time continuity, because events are depicted progressing in a single locale.

Historical stories may be presented as past happenings, or as flashback.

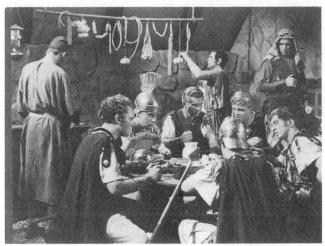

Past events should be filmed alive on the screen, as if happening now.

Events occurring in the past — presented in their entirety or as prologue to a story transpiring in the present — are depicted in a manner similar to present-time continuity; except that the audience should be made aware of the time element involved. Historical stories have past-time continuity; but other than the fact that the audience is aware that these events have already happened, there is little change in presentation. The viewer must be made to feel, however, that "this is what happened *as* it happened" rather than "this is what *is* happening." The picture story will be most successful when the audience is transported back into the time period with a *you-were-there* technique.

One problem in presenting past events is that the audience may be either aware of the outcome — if the story is historical — or feels that the event is over and decided. This would not be the case if the story is begun in the past — in order to bring the audience up-to-date on developments — and then brought into present tense. While once-upon-a-time treatment may be excellent for fairy tales, such fantasies make the audience work harder to become involved in the screened event; and become identified with the players. For this reason, historical screen subjects often fail to gain favorable response. Stories of past events succeed only when players, story and setting "come alive" on the screen in a way designed to capture both in-

terest and full acceptance of the audience. The events should be depicted as if happening *now*!

A *flashback* may portray an event that occurred *before* the present story began. Or, it may retrogress in time to depict a *portion* of the story not previously shown. Or, it may repeat an earlier event. Thus, a character may tell a story that happened years ago or explain an incident in the present story; not shown to the audience. Several characters may each tell his or her version of what happened.

Flashbacks are often employed to clear up a plot point, by showing what actually happened in a mystery story; or development of a mechanical process. Or, flashbacks may provide background material by showing what took place years before to bring about the present situation. Often, a story is told entirely in flashbacks; or may even go so far as to employ a flashback *within* a flashback, in which a character tells about another charcter, who — in turn also relates an incident!

There is no limit to the ways flashbacks may be used in a dramatic film — providing the story always returns to the present, and the editorial pattern is carefully worked out so that the audience is not confused. This is particularly important if several characters each tells his or her portion of the story out of chronological sequence. Flashbacks may be effectively employed in industrial films, when comparing the old with the new.

Today's jet fighter aircraft may —

flashback to World War II prop airplane —

or flashforward to future Space Liner.

Or, a completed project may be presented at the start of the story. How it was researched, designed, and constructed can be told in flashback.

Flashbacks have these *advantages*. They permit several characters to tell their portions of the story. They allow narrators to regress in time, and present historical or background material. Different factual or fictitious aspects may be presented from various viewpoints by flashbacks. The story may depict an earlier period. Story-telling is not restricted to the present, but may move back and forth in time to describe or explain events significant to the narrative.

Flashbacks have certain *disadvantages*. They tend to break up chronological continuity and confuse the viewer. They often demand greater audience attention, particularly if several flashbacks are employed. Viewers may become "lost" in a lengthy flashback, and become disoriented; the story may move backward instead of forward, so that the normal progression of building toward a climax is impeded. Sometimes, the audience knows the outcome of the story in advance, because they have seen the end. The latter problem may be solved by beginning narrative just *before the ending*; then going into the flashback to tell the story up to the point where the picture began. Then, the story returns to the present for its denouement.

Employment of flashbacks, or telling a story entirely in flashbacks, should be carefully considered. Flashbacks should *not* be used unless their advantages in story-telling greatly outnumber their disadvantages. Use of an occasional flashback, however, can be a tremendous aid in both theatrical and documentary films; whenever regressing in time supplies the picture with a missing ingredient, provides background material, or allows a novel portrayal of events.

Future-time continuity may fall into two categories: occurring in the future; a *flashforward* from present to future.

Events occurring in the future may be predicted, projected or imagined. A story transpiring in the future may thus involve a science-fiction prediction, an industrial projection, or epilogue of the present story, or events imagined by a character

in the present story. The viewer is transported into the future, so that he is seeing the event "as it will or could happen." The event is presented with present-time continuity, as if happening now. The audience should be kept aware of the time element, so that they are not confused. A future time continuity may involve space ships on route to the moon; the projected growth of a company; or tomorrow's happenings, imagined by a player.

A *flashforward* is the opposite of a flashback. It

Future events — such as flashforward depicting first moon landing — may be predicted. Audience is transported into future, and sees event as it could happen.

Lockheed-California Co.

Flashforward — such as this depiction of interplanetary refueling — adds future dimension to present-day documentary film on space travel.

moves ahead into the future to describe events that will, may, or could happen — and then returns to the present. A scientist *will* project how present pollution of streams and rivers will affect our future water supply. An air force officer describes what *may* happen in a future nuclear war. A space scientist explains how a manned satellite *could* reach the moon. The difference between a flashforward and a story occurring in the future, is that the former is a fragmentary leap ahead which returns to the present, and the latter is a futuristic story in itself.

The flashforward possesses few of the disadvantages of the flashback. If not properly presented, however, flashforwards may confuse the viewer. By jumping ahead of the present story, the flashforward may add a future dimension to a documentary fact film. This technique shows what could happen if a different course is followed in research, development or design of a new missile, an electronic brain, or a color television set.

A flashforward may be filmed and edited in a follow-through continuity, similar to present-time continuity. Or it may be depicted in impressionistic fragments, as if in a dream or imagination.

Conditional time continuity does not deal with real time. It is the depiction of time as conditioned by other elements, such as the mental attitude of

Harann Prod.

Conditional time depicts events as assumed by mental attitude of player through whose eyes audience views happenings.

player viewing the event; or the memory, imagination or thoughts of a person who may "see" an event in a distorted manner in his mind's eye. Since conditional time is unreal, it is unlimited by boundaries or manner of presentation.

This does not imply that conditional time need not make sense. The audience must comprehend what is happening. A switch to conditional time must be properly established or explained with appropriate pictorial transitions and/or audio effects. Straight cuts may be employed, viewers must be made to understand why the setting is suddenly switched to a scene existing only in the player's distorted mind.

Time may be eliminated, fragmented, compressed, expanded, distorted, or combined in any manner, so that one or more event may be presented in a continuous manner — impossible in real life. Conditional time continuity may be employed to express a nightmare, delirium; drunken or other distorted thinking by a player. Or, it may be used to portray a player's musing, memories, or an imagined event.

Conditional time may be used for a single scene, a sequence or an entire picture. This technique may be compared to a stream of consciousness, in which unrelated real and fanciful events, clear and distorted thoughts — present, past or future — are all intermingled in jumbled continuity. Events may be depicted in slow nightmarish motion, or in a series of flash shots, in which images are changed at high speed. Or, an image may be frozen for a long interval.

Conditional time may also be employed to introduce a flashback in which a drowning person views his entire life, depicted in a straightforward continuity requiring several reels — in a few moments! If conditional time is properly presented, the audience will interpret and accept the situation under conditions depicted.

SPACE CONTINUITY

Telling the story as the action moves from one place to another involves *space continuity*. An expedition documentary, an auto trip or a travel picture are typical examples. To be acceptable, a logical pattern of movement must be shown. It is

also possible — as with time continuity — to move back and forth in space, to speed or slow travel, or to be instantly transported to another location; providing that the abrupt change in continuity is understood by the audience. Viewers should always be aware of *location* of action, and the *direction* of the movement. That is the only way the audience will know "*from* where the moving players or vehicles are coming, and *to* where they are going."

Space is rarely portrayed in a motion picture as it actually exists, except in a single setting; and then it may be condensed or expanded by physical, optical and editorial techniques. Illusions of space may be created in various ways. Space may

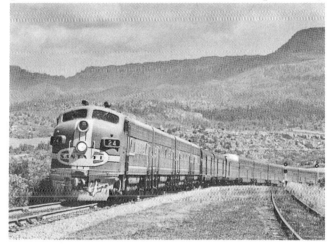

Santa Fe Railway

Space continuity is used to tell story which moves from one place to another.

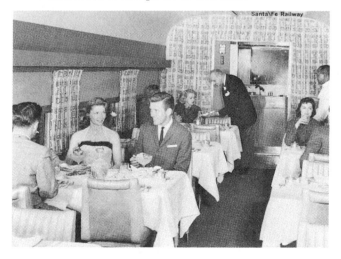

73

be stretched or shortened through employment of optical transitions. This result can be attained by simply skipping unimportant areas; by altering spatial relationships; by ingenious editing and by imaginative story-telling. A simple dissolve may cover hundreds of miles. Filming only areas of special interest, or different types of terrain, may give the audience the impression they are seeing the entire trip — although only highlights are actually shown. Choice of lens focal length may drastically change perspective, the distance between objects or the relationship of the players and the background. Clever editing may convince the audience that they are viewing all the travel. Inventive story construction may provide means of moving about in space, so that a great deal of territory is covered; while the viewer is unaware that much of the travel is really missing.

Audiences have been conditioned to accept the removal of needless travel, so that a player may be shown leaving his office on the tenth floor and immediately dissolve to the street entrance. There is no need to show him walking down the hall, taking the elevator, emerging and walking through the lobby, etc. Or, space may be *lengthened* in a subtle manner, so that the audience is not aware that part of the travel is repeated; for instance, by overlapping several shots of a walk down a short flight of stairs to make the flight appear longer on the screen.

Universal City Studios

Subject travel need not be shown in its entirety. Space may be shortened by depicting only highlights of a journey.

TIME & SPACE CONTINUITY

A film taking place in a single setting may be told with *time* continuity only. A constantly-moving film depicting a race, a journey or a chase may be told with *space* continuity only. Most stories employ *both* time and space continuities alternately. A picture may start out with space continuity by transporting the audience to a foreign land. Then it settles down to tell the story in time continuity. Even an expedition picture must pause at the various locales and switch to time continuity as the explorers make camp, study native habits, and carry out their assigned duties. Time and/or space stories featuring simple, straightforward, chronological continuities present few filming problems. A complex picture, in which the story moves back and forth in time, and here and there in space, must be handled carefully — so as not to confuse the audience. Most important — the viewer must never be left in doubt *where* the event is taking place, and *what* is happening. Only suspense stories are designed to confuse the audience, until explanation of the mystery in the last reel.

FILMING THE ACTION

TYPES OF ACTION
CONTROLLED
UNCONTROLLED

CONTROLLED ACTION

Filming of any event which the cameraman can direct or regulate is known as controlled action. In this category, the best examples are theatrical motion pictures. Sequences are planned, rehearsed and staged for the camera. Each scene is filmed from as many angles, as many times as required; until a satisfactory take is recorded. All esthetic and technical elements involved in filming the picture are under complete control of director and cameraman.

UNCONTROLLED ACTION

Events which cannot be staged for the camera constitute *uncontrolled action*. A newsreel of a

Although parades cannot be controlled by cameraman, camera angles should be carefully planned in advance. All shots should be filmed from same side of action axis, so that line of march moves in constant direction.

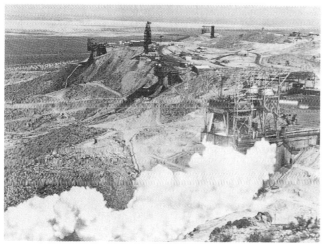

North American Aviation

Some scenes in engineering films — such as this static test of rocket engine — cannot be controlled. Multiple cameras should be used for complete coverage.

natural or man-made disaster, such as a hurricane or a fire, is recorded just as it happens. Without control over the subject, the cameraman is merely an observer with a motion picture camera. At worst, uncontrolled filming is a one-take affair. At best, it is filming of previously-announced events, such as parades, beauty contests, air

shows. The cameraman knows what will happen, but has little or no control over action or staging.

Many shots and sequences in non-theatrical films cannot be controlled by the cameraman, and are best treated in newsreel technique. Engineering trials, field problems, flight tests, missile firings, military maneuvers, historical pageants, and similar events must be filmed just as they happen. When filming uncontrollable action, the cameraman must adapt his efforts to prevailing conditions, to record best coverage available. Standard filming procedures should be followed as much as possible to obtain technically excellent results. In completely uncontrollable filming situations, the cameraman may be able to choose little more than the camera-angle and lens focal length. Choice may be further limited by lighting and space restrictions, and physical dangers.

FILMING TECHNIQUES

MASTER SCENE

TRIPLE-TAKE

MASTER SCENE TECHNIQUE

A *master scene* is a *continuous take* of an *entire event* occurring in a single setting. It is a complete chronological motion picture — silent or sync-sound — of over-all action, from beginning to end.

Universal City Studios

Dramatic theatrical features are generally filmed with one camera; which records master scene of overall sequence and later closer cut-in medium shots and close-ups of individual players.

If filmed with a *single camera*: portions of the action are later *repeated* to obtain inter-cutting closer shots.

If filmed with *multiple cameras*: inter-cutting closer shots are filmed *simultaneously*.

HOW TO USE MASTER SCENE TECHNIQUE

Theatrical films: Generally filmed with a single camera because the action is staged, and may be repeated any number of times; in order to shoot medium shots, two-shots, over-the-shoulder shots and individual close-ups required for inter-cutting. Closer shots are set up and lighted to portray the players best from that particular angle. Both action and dialogue are overlapped for each shot.

Television films: Dramatic television films are generally filmed in the same manner as theatrical pictures. Situation comedies and similar "stage-front" material — in which actors perform for audience as if on-stage — are filmed with multiple cameras, to record all angles simultaneously.

Non-theatrical films: Controllable action, such as staged scenes, may be filmed in a theatrical manner with a single camera and action repeated for closer shots. Uncontrollable action, such as field tests, may be filmed with multiple cameras, to record all angles simultaneously.

Non-theatrical films — such as this report of Titan IIIC checkout activities being photographed by RCA cameramen — may be filmed with single camera, when action is under control of camera crew.

U.S. Air Force

Non-theatrical films, which the camera-man cannot control — such as missile launching or flight of prototype airplane — should be filmed with multiple cameras, to obtain various shots required for sequence.

Single cameras vs. multiple cameras: The choice lies not only with nature of material, but with *people* being filmed. Closer shots require precise duplication of action performed and dialogue spoken in the master scene. Professional actors are able to repeat their performance any number of times for various shots required. Amateur actors, company personnel, people performing in a documentary film, may not be able to duplicate their action or speech. Therefore, it is better to employ multiple cameras whenever subsequent matching of inter-cutting scenes may be a problem. There is no question about using multiple cameras to film one-time events that cannot be repeated — a missile launching, a static rocket engine test, an ad lib speech — so that all angles are covered. Sequences in a documentary film utilizing amateur actors, may often be advantageously filmed with multiple cameras, to insure editorial matching.

Single camera should be used on any staged action which can be precisely duplicated for closer shots. Multiple cameras should be used for news events, quiz shows, panel programs, round-table discussions, question-and-answer sessions, engineering tests; or whenever people being filmed may not be capable of exact repetition of their

Round-table discussions, quiz shows, panel programs — or other question-and-answer type sound sequences — should be filmed with multiple cameras to record simultaneously overall scene, and close-ups of individuals as they speak.

Lockheed-California Co.

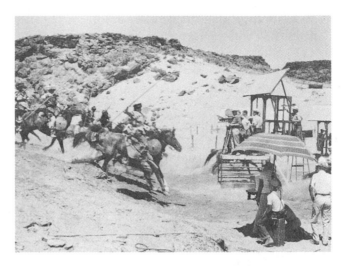

Theatrical cinematographers employ multiple cameras to film tricky stunts — such as this simultaneous fall of six horses and riders — so that the feat need not be repeated for additional coverage.

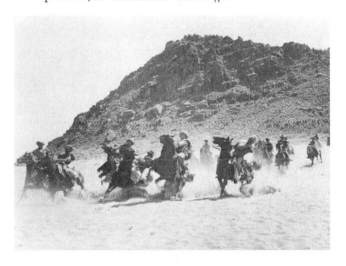

performance. Directors of theatrical features often use more than one camera to film complicated action sequences, highly emotional scenes, or tricky stunts which may be difficult to duplicate.

ADVANTAGES OF FILMING MASTER SCENES

The master scene and inter-cutting closer shots supply the film editor with all action and dialogue in a sequence in duplicate — both in long-shot and various kinds of close shots from different angles. Thus, the editor has wide choices in cutting the sequences, since he may "open" up the picture and return to the long shot whenever he wishes to re-establish setting or actors, or move actors to new positions. Or, he may cut to a closer shot or another angle when he desires to emphasize a particular player's action or speech, or a fellow player's reaction. He may cut-on-action to move players into or out of closer shots. Since the action is covered in duplicate from several angles, editing decisions are facilitated. If unsatisfactory for any reason, the sequence may be re-edited in an entirely different manner.

The editor may even "improve" an actor's performance — if required — by inserting a reaction shot of an opposing player; or go to another shot, if a particular portion of a player's performance is weak. Or, dramatic emphasis may be shifted to a player other than the one indicated in the script. The editor will encounter few problems in matching action and dialogue when performed by professional actors. Or, when multiple cameras are used to film uncontrollable action.

Theatrical production personnel prefer the single camera master scene technique because it insures complete coverage without costly holdups on the set, necessitated while editorial decisions are being made. Closer shots of portions of the action are easily repeated. Single camera coverage

permits filming the entire action in long shot; and each cut-in shot with *individual* attention. Duplicating action from two or more angles permits re-lighting for each camera set up, so that best photographic results are obtained.

The single camera master scene technique is preferred by professional actors, because it allows them to carry out a complete performance without interruption. It is often difficult — particularly with highly dramatic material — to obtain a satisfactorily sustained performance, when filming

Harann Prod.

Professional players prefer master scene treatment because it permits complete performance without interruption. Later, cut-in close-ups (below) are filmed by repeating necessary portions. Action and dialogue must be precisely matched wherever they flow across cut from master to closer shots.

Harann Prod.

stop-and-go in small bits. Even though the scene is repeated later in short pieces for closer shots, the actors are allowed one complete run-through. It is much easier to record a performance in this way, since actors can repeat portions of the master scene, once a satisfactory long shot is obtained.

Precise repetition of action and/or dialogue in closer shots is not always necessary, if cameramen or director make a change *after* the master scene is filmed. If the player is moved into or out of position, and both ends of the closer shot are matched where they cut into the master scene, the heart of the individual shot may be cheated. This is possible because *either* the master or the cut-in shot is used — *not* both. Action and dialogue must overlap *only* where scenes are inter-cut. It is important that player movement out of and back into the master match-cut. This allows for second-guessing when filming closer shots. Editors should be notified of any script changes.

Multiple camera master scene coverage assures perfect matching of action and dialogue, without regard to performers' ability to repeat scenes exactly. Uncontrollable action may be covered from all angles simultaneously. Lighting must be a compromise and camera set-ups are best when shooting more or less from the same angle with different focal length lenses. Amateur actors, or company personnel, need not be concerned with repeating their performance, because every angle is filmed in a single run-through. Salesmen, lecturers, company executives, engineers, may all be

Harann Prod.

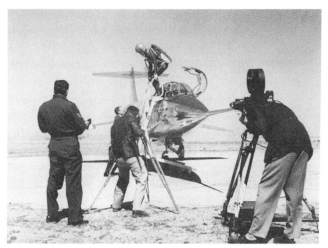

Lockheed-California Co.

Multiple cameras should be used to shoot long shot and medium shot, or close-up, on uncontrolled action — such as flight test of prototype airplane. All cameras should be positioned on same side of action axis.

Bob Jones University-Unusual Films

Players' positions, movements and looks must be carefully blocked out in master scene, so that they may be matched in closer cut-in shots filmed later. Players should move into and out of closer shots.

filmed in least time and effort. Yet, sufficient coverage is obtained for editorial purposes.

DISADVANTAGES OF FILMING
MASTER SCENES

The several disadvantages in filming single camera master scenes are far outweighed by editorial benefits.

Single-camera theatrical filming requires players to memorize entire sequences; and to be capable of delivering their lines, making their moves, hitting their marks precisely — and repeating their performance a number of times for matching closer shots. Long or complex sequences should be attempted only by professional actors, capable of sustained exact performances. Player and/or camera movements must be precisely blocked out and followed. Closer shots must be carefully planned. Once player positions are captured in the master scene, they must be duplicated in medium shots and close-ups. Looks must be correct; and props, such as cigarettes, hats, papers, must be held or placed in the same manner, in closer shots. As previously explained, a limited amount of cheating is permissible; but generally it is best to adhere to the master scene as closely as possible.

The single camera master scene technique does not readily lend itself to improvising as shooting progresses, because closer scenes may not intercut with the over-all long shot. Radical changes in positions, looks, moves, will result in jarring jump-cuts. Since flawless master scenes call for more rehearsals, they require more re-takes than shorter, less complicated scenes. However, a mistake may be disregarded if the editor uses a closer shot for that portion of the action.

In master scenes, the ratio of film exposed to film used in finished pictures is greater than in recording a series of individual consecutive shots. For instance, in a scene lasting several minutes, the film editor may use only the opening, re-establish once during the sequence, and return to the master for the closing.

If editorial requirements can be pre-determined when filming, there is no need to shoot a master scene all the way through on every sequence. Required portions should be filmed; and remainder of the sequence walked through for positions, and movements into and out of closer shots. If heart of closer action will definitely not be used, there is no need for these portions to be filmed in long shot. Thus, much shooting time, raw stock and

79

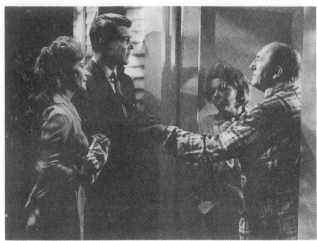

Harann Prod.

Master scene need not be filmed in its entirety — if most of scene will definitely be covered in finished film, with closer shots. Doorway sequence may require entrance and exit only.

processing can be saved. While all these costs may be insignificant in theatrical pictures, they are worth considering in limited budgets of non-theatrical producers.

Multiple camera filming of staged action — such as television shows — requires much planning and rehearsal, so that both players and camera crews hit their marks on every position. Camera set-ups, lighting and player movements must be blocked out, to enable various cameras to record all necessary shots in one run-through. Cut-in cameras must use long focal-length lenses in order to remain out of line-of-sight of the wide-angle long shot camera. Some cameras must be dollied, or moved to other positions, *during* filming. Lenses must be changed, cables kept clear, lighting varied, cameras moved — *noiselessly!*

Because of many camera angles and various player positions, lighting must be a compromise. Fully-illuminated action may be most successfully filmed in this manner. Low-key dramatic lighting can rarely be used, since it must be precisely tailored to each shot. Multiple camera filming is ideal for comedy, panel, quiz or similar shows. Disadvantages of employing multiple cameras on artificially-lighted interiors are minimized whenever cameras may be operated from approximately

the same angle, with different focal-length lenses.

There are few disadvantages in filming multiple camera master scenes outdoors on uncontrollable action — such as field tests or new equipment demonstrations — except additional film and processing costs. Ordinarily, this is the only way such events may be properly covered, so that the editor can be supplied with all shots required to put together a satisfactory sequence.

TRIPLE-TAKE TECHNIQUE

The simplest method for obtaining shot-to-shot continuity, particularly when filming without a script, is by *overlapping* the *action* at *beginning* and *end* of each shot. In this filming technique — commonly termed *cutting in the camera* — the cameraman thinks of *three* consecutive shots, regardless of the number of scenes being filmed.

Action at the *end* of the *first shot* is repeated at the *beginning* of the *second shot*; and action at end of *second shot* is again overlapped at beginning of the *third shot*. Triple-take technique is very simple in operation. The cameraman need refer only to ending of the previous shot; and repeat a small part of that action, to match beginning of the shot being filmed. Then, the end of the present shot is noted; so that its final action may be carried over to beginning of the next shot.

Raco Machine Products

Triple-take technique requires that action occurring at end of first shot — such as picking up cutting tool — be repeated at beginning of second shot.

Raco Machine Products

Action continues into medium shot as tool is brought into frame. Scene progresses until machinist begins positioning cutting edge of tool. Action at end of medium shot is repeated at beginning of close-up.

Raco Machine Products

This link-chain procedure produces a series of interlocking images, planned to convey the impression of uninterrupted action when edited. Overlapping action assures perfect continuity, because scenes may be match-cut. The triple-take automatically preserves cine continuity, since it forces the cameraman to be constantly aware of the action at the *beginning* and *end* of *each shot*; and eliminates possibilities of jump-cuts caused by missing or mis-matched action *between* shots.

While the middle portion of the scene is very important for story-telling purposes; start and finish of each shot cause most editorial problems.

Therefore, it is *not* the heart of the action *during* the shot that must be most closely observed; but movements at *beginning* and at *end* of each shot which must be matched to bracketing scenes.

Motion pictures are presented in sequences, not shots. While individual shots have their own value, each must be considered a portion of the sequence, serving only to advance the story. A series of shots must be woven into a coherent sequence, without distracting jumps or breaks in the continuity. The audience should be barely aware of changes in camera angle or image size. As in life, the sequences must appear as a *continuous flow* of movement, from start to finish. While cheating of both time and space during filming and editing is permissible, it should not be apparent to the audience.

HOW TO USE TRIPLE-TAKE TECHNIQUE

The triple-take technique may be used *only* on *controllable action*, which the cameraman may *start* and *stop* at will. While it generally requires a single camera, multiple cameras may be used on occasion to film additional angles, time-consuming or difficult action; or scenes impossible to repeat. Both theatrical and non-theatrical pictures may be filmed in this manner with the assurance that all shots will match-cut.

The triple-take technique calls for *thinking in threes*. As filming progresses, the cameraman thinks *back* to the *last* shot before filming the *present* shot; and also *ahead* to the *next* shot.

First the cameraman should acquaint himself with the sequence by having players walk through the entire action from start to finish, without actually performing the task involved. If a mechanic is going to assemble a jet engine, he should explain the work step by step — to acquaint the cameraman with the operation. Careful analysis of work and mechanic's movements will suggest the *types* of shots required for the various steps; *camera angles* that will best portray each part of the action; and *where to cut* the camera, and overlap the action.

It is usually best to begin and end the sequence with a long shot. It is also advisable to re-establish the long shot whenever the audience should be

81

TRW Systems

Long shot should be used to establish geography of setting. It is advisable to re-establish long shot whenever audience should be re-oriented, because of major changes in players' positions.

Lockheed-California Co.

Movement at end of previous shot should be repeated at beginning of following shot. Action should be carefully matched so that film editor may cut on action.

with a long shot. It is also advisable to re-establish the long shot whenever the audience should be re-oriented, because of a change in the mechanic's position in relation to the engine; or the introduction of new tools; or for other narrative reasons. If the camera stays in close, the audience soon becomes "lost", and forgets location of the work being performed. The camera should begin far back for a full shot, from a higher angle. Then the camera should move in, lower and around to the side, for medium shots and close-ups.

By establishing and re-establishing with long shots, depicting the heart of the action in medium shots, emphasizing the important portions with close-ups; good continuity will be achieved. Closer shots will automatically suggest themselves whenever the action becomes concentrated in a smaller area. Moving in closer satisfies the audience's curiosity for a more intimate look.

It is natural to view the scene first from afar, and then approach the subject as interest increases. This is equally true whether viewing *people, places* or *objects. Players* are first shown in long shot, in relation to the setting; then in closer shots; and finally in close-ups, as they relate with each other, exchange dialogue or perform some action. *Cities* are first seen from a distance, then

explored street by street, and building by building. *Objects* are first viewed in relation to their surroundings, or as parts of a larger group, and then, perhaps individually.

Obviously, it is best to cut *after* completion of a movement — such as opening a door, sitting in a chair, picking up a tool, moving into a new position, etc. The entire movement is then *repeated* at the *beginning* of the next shot, from a new camera angle. The film editor is thus given a choice in matching the shots, since he may cut *before* or *after* the movement, or cut *on action during* the move. Certain movements should not be interrupted by cutting, because the natural flow of action may be disturbed. Usually, however, a cut between shots can be carried by the movement for a smoother visual effect. The movement makes the splice less evident, since the viewer is watching the action, and will be less aware of a change in image size and/or camera angle.

The cameraman should overlap all movements and not attempt to decide on editing during filming. Such decisions are best made later on the cutting bench, where various possibilities may be studied for best screen effects. The cameraman should overlap complete movements at *end* and *beginning* of *consecutive* shots.

Lockheed-California Co.

Overlapping action — from one shot to next should be performed in precisely same manner, to assure a match-cut.

For instance, an individual may sit down at the *end* of a medium shot. He should again sit down at the *beginning* of the following static close-up. A worker may pick up a tool in a long shot. He should again pick up the tool for the following medium shot.

The cameraman should be sure that the action is performed in exactly the *same* manner each time: sitting the same way, reaching with the same hand, turning in the same manner, looking in the same direction. If overlapping portions of the action are not performed in precise duplicate, they are useless. The editor cannot make a *match-cut* on *mis-matched* action! Professional actors understand this problem thoroughly, and can be relied upon to repeat their exact actions every time. Amateurs or factory personnel, lab technicians, engineers — and others recruited to perform in a documentary film — must be instructed to repeat their actions in exactly the same way, and observed closely to be certain that they do so.

If there is no perceptible movement between people involved in the shot, or if an individual is performing a solitary task, it is best to "freeze" him in position at proper intervals; and to move the camera to a pre-determined angle before continuing filming. Such freezing and unfreezing must be deftly accomplished, since it interrupts the natural flow of action; and may appear jerky

when edited. This can be handled most expediently if cameraman and players walk through the entire action, so that camera starts and stops may be pre-determined; and camera angles blocked out for the various portions of the sequence. Camera stops should *not* be made impulsively, and camera moves should *not* be decided *after* the scene begins; otherwise confusion will result. Players may have to hold frozen positions for an unduly long time, while awaiting decisions for the next move.

The triple-take technique requires the utmost concentration by the cameraman if he is filming alone; or by the director assigned to the task. The cameraman, or director, should attempt to develop a "stream-of-consciousness" thinking process, which projects the finished sequence in individual shots in the mind's cine eye *before* filming. Only in this way can the entire sequence be visualized, and player and camera positions blocked out properly.

While the triple-take technique is basically a single camera method of filming, there are occasions when a second camera may be successfully employed to film an additional angle, or a cut-in close-up. Two — or more — cameras may be used for a particular *portion* of a sequence, to record all shots required simultaneously. A tricky, time-consuming operation may be required in assembling an intricate machine part; a lengthy demonstration may have to proceed without interruption; a rocket engine may be fired only once. Under such conditions, additional coverage is obtained only by using another camera or two, to film extra shots.

ADVANTAGES OF TRIPLE-TAKE TECHNIQUE

The triple-take technique permits greatest freedom while filming, because action may be broken down into small parts, and improvised if necessary as shooting progresses. Only beginnings and ends of shots require matching, so duplication of the entire sequence is avoided. Film waste is held to a minimum, and a higher proportion of film exposed to film utilized in the edited picture is attained. Off-the-cuff filming of difficult or long-drawn subject matter is more easily handled, because the cameraman need only concern himself

with three shots at any time. If all shots are properly overlapped and action matched, editing problems will be minimized.

If the subject makes a mistake, the cameraman stops shooting, switches angles, and overlaps the action transpiring *just before* the mistake occurred. The entire shot need not be retaken, because footage up to the mistake may be saved, and only the faulty action discarded. Only *mis-played* portions of action need re-take coverage.

The triple-take technique allows filming the sequence in consecutive continuity, as action progresses. Many industrial operations, military tests, assembly "nuts-and-bolts" training films, progress reports — and similar documentary subjects — will present few problems if filmed in this way. A complex machine need *not* be assembled, and dis-assembled and reassembled for close-ups. A chemical, electronic or mechanical test, demonstration or experiment, need not be repeated in its entirety for both long shots and closer matching shots. If can be filmed under the cameraman's control in chronological order as it is conducted; providing the work can be stopped at any time, and the personnel will perform as instructed, and overlap their actions for various shots and angles.

Through the triple-take technique, the cameraman gains opportunities of moving in and around

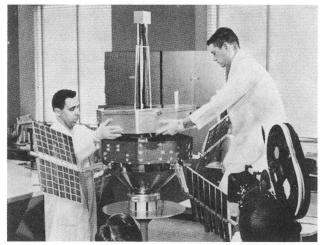

Charles O. Probst

Assembly of a complex unit — such as Explorer XII space satellite—may be filmed with triple-take overlapping technique.

the subject, and shooting required scenes with least inconvenience to those being photographed. Filming in continuity preserves natural flow and rhythm of an event, and is almost always easier for performing personnel unfamiliar with professional motion picture production procedures.

DISADVANTAGES OF TRIPLE-TAKE TECHNIQUE

While the triple-take technique permits filming perfectly matched shots, it may get out of hand in complex off-the-cuff shooting. This can result in a hodge-podge of odd camera angles, shots of varied lengths, mis-matched cuts, poorly-chosen medium shots and close-ups, and other unsatisfactory procedures based on spur-of-the-moment decisions. Cutting in the camera, and mentally carrying both action and camera treatment, demand concentration and adequate planning.

Impulsive filming can create pitfalls. If the sequence is not properly planned, and the camera is frequently moved merely to get away from the previous angle, the shot ends whenever there is a mistake; and the length of individual shots depends on how far performing personnel can go before they make a mistake!

If the cameraman concentrates on overlapping movement from scene to scene, the principal action of the scene may be deprived of proper attention. The result may be perfectly-matched footage with lifeless character.

Constant shifts in camera angles and changes in image size may be more easily handled outdoors, where daylight problems are minimal. Interior lighting continuity, however, may be very difficult to preserve, especially on location-filmed documentary subjects, since lights may have to be changed for each shot. Matching lighting becomes involved whenever camera is moved back and forth for long shots and closer shots of the same general area.

If sufficient lighting units are available, the long-shot lighting should not be disturbed. Closer shots should be illuminated with other units, so that a re-establishing shot with the original lighting set-up may be made whenever required. If the lights must be moved, their previous positions

should be chalked or taped on the floor; so that they can be returned to the long shot lighting arrangement.

The cameraman, or director, filming improvised action without a script to guide him, must be well-versed in both filming and editing techniques. He must thoroughly understand the art of cheating from both shooting and editing standpoints, so that he instinctively knows how far he can go in changing action, angles, players' positions, props and other cinematic elements. Yet he must shoot scenes that will match-cut when edited.

MASTER SCENE VS.
TRIPLE-TAKE TECHNIQUE

The *master scene method with single camera* should be used whenever a sequence is filmed from a shooting script; whenever professional actors are employed; whenever all production elements are completely under control; whenever sufficient time and unlimited film are available; whenever the director wants greatest range of choices in editing the sequence; and whenever all of the action should be covered in long shot.

On the surface, disadvantages of filming master scenes may appear to outweigh advantages; but a properly-executed master scene, with complete coverage in matching closer shots, provides

the film editor with the greatest possible variety in assembling the sequences. The master scene method is truly professional and should be used whenever filming from detailed shooting scripts.

The *master scene method with multiple cameras* should be used whenever the action is *not* under the cameraman's control; whenever an event cannot be interrupted; whenever it is desirable to stage a sequence in its entirety only once; whenever amateur actors or working personnel, who cannot duplicate their actions, are filmed; whenever long shot and closer shots must be recorded simultaneously.

The *triple-take technique with single camera* should be used whenever it is advantageous to film an event in a stop-and-go pattern; whenever inexperienced personnel perform a series of actions which are best filmed individually; whenever film costs are a factor; whenever shooting off-the-cuff on an improvised basis; whenever the cameraman can *control* the event, start, stop and repeat any portion at will; whenever it is difficult to light, stage, or otherwise shoot the entire event in long shot; and whenever the cameraman and/or director have sufficient editorial ability to cut the picture in the camera.

The triple-take technique may also utilize multiple cameras for any *portion* of the action that

Martin Rackin Prod.

Properly filmed master scene, with matching medium shots and close-ups, provides film editor with greatest variety in assembling sequence.

Lockheed-California Co.

Triple-take technique should be used whenever filming industrial operation; which may be started, stopped and repeated — for overlapping action from shot to shot.

the action may be staged in its entirety in long shot — such as the beginning and end of a sequence — and the in-between action is best filmed in an overlapping manner. This means shooting partial master scenes, or certain portions of the long shot action with a single camera set-up. The remainder should be picked up with triple-takes. This will save considerable film.

Or, a master scene may run until the actors fluff their lines, or miss a cue. Then a switch made to triple-take overlapping filming — returning to the master, perhaps, for re-establishing the over-all setting, or for an exit at the end of the sequence. Many possible combinations to meet prevailing conditions can be worked. When in doubt, a master scene may be attempted, with the assurance that a switch may be made to the triple-take technique, if required. The cameraman need not feel committed to one method or the other for the entire filming. The event should be analysed in its entirety. All factors involved — people, types of action, length and complexity of event, lighting, editorial requirements, time available, budget, etc. — should be considered. Size of camera crew and availability of camera equipment may also be important, if multiple cameras are required.

Since the cameraman using the triple-take technique has already cut the sequence in the camera, little or no choice is left the film editor. The editor may either use a shot or discard it; or he may dissolve to cover a jump-cut created by eliminating footage which is undesirable. Other choices are the use of protection or reaction shots which the cameraman may have seen fit to film.

The master scene technique offers the editor unlimited selection to cut the sequence in any number of ways, because each portion of the action is covered in long shot as well as medium shots, close-ups and additional angle shots. In either case, the cameraman should furnish the film editor with sufficient cut-in and cut-away close-ups, to help shorten the sequence, or to cover continuity lapses.

In the final analysis, the triple-take technique allows more leeway during filming; but the master scene technique provides greater editing freedom.

DIRECTIONAL CONTINUITY

IMPORTANCE OF ESTABLISHING DIRECTION

The *direction* in which a person or a vehicle *moves,* or the direction in which a person *looks,* can cause the most vexing problems in motion picture continuity. If a complete production could be photographed in a single shot there would be no directional problems!

A motion picture is made up of many shots, filmed from different camera angles and put together in a sequence — a series of shots — which becomes a chapter in the story. In turn, a series of sequences is combined to make up the complete narrative. If an established move or look in a particular direction is unaccountably changed in consecutive shots, the picture's continuity will be disrupted, and the audience will be distracted or even confused.

An unexplained change in screen direction can result in a serious mis-match, in which players are suddenly looking *away from* rather than *toward,* each other; and vehicles suddenly *reverse* their screen movement, and appear to be going in the *opposite direction!*

Even veteran directors working from a detailed shooting script will often rely on the director of photography for screen direction, so that actors and vehicles are sure to look and move in the correct direction. A cameraman shooting off-the-cuff can get into serious directional trouble if he fails to pay particular attention to this highly important filming problem. Once it is thoroughly understood and given proper attention, directional continuity can be easily mastered. There is no better way for a cameraman to win the respect of a film editor than by delivering footage which will "cut together" without the need of optical *flop-overs,* or other reversing editing tricks — necessary for salvaging carelessly-filmed footage.

A motion picture lives in a world of its own. There is only a single viewpoint: the *lens of the camera.* How the *camera* sees the subject is important — *not* how it appears in actuality. In certain instances, it is necessary to film the subject

tain instances, it is necessary to film the subject traveling in the *wrong direction*, so that it will appear correctly on the screen! Action is judged only by its screen appearance; by the way it *should* look — and not the way it actually appears while being filmed.

SCREEN DIRECTION
There are two types of screen directions:
DYNAMIC (Bodies in motion)
STATIC (Bodies at rest)

DYNAMIC SCREEN DIRECTION
Constant; either left-to-right or right-to-left
Contrasting; both left-to-right and right-to-left
Neutral; toward or away from the camera
Constant screen travel depicts subject motion in *one direction* only. A series of shots of a person walking, a car driving, a plane flying — should move in the *same* direction to show progression. If a shot suddenly depicts the person or vehicle moving in the *opposite* direction to that previously established, the audience will receive the impression that the moving subject has *turned around,* and is *returning* to the starting point!

Once screen direction is established for a particular travel pattern it should be maintained. This holds true for two shots, a series of consecutive shots, or a single shot inserted at intervals in the narrative. The narrative may be concerned

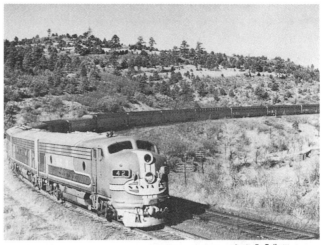
Santa Fe Railway

Santa Fe Railway

QM Prod.—ABC-TV

Subject should move in a constant direction — either left-to-right or right-to-left — to show progression.

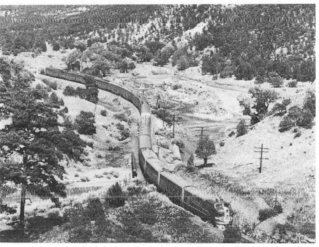
Santa Fe Railway

Established screen direction should be maintained throughout a travel sequence, regardless of camera angles.

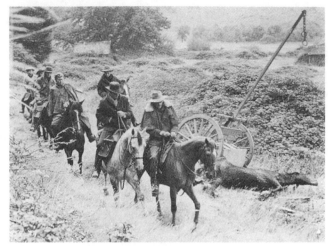

Universal City Studios

Universal City Studios

Contrasting screen travel may be used to show subject going and returning.

Left scene depicts group traveling from home to town.

Group at right is returning home — in opposite direction.

solely with activity inside a train, but whenever the moving train is shown — it *must* move in a constant direction. The train may enter from screen left, move across the screen in a left-to-right direction, and exit screen right. Camera angles may be varied, long shots of the train may be intermingled with close-ups of its drive wheels — but direction of movement must not be changed.

When cutting from an exterior of the moving train to an interior shot, the camera should shoot from the same side of the train for a smoother transition. Later, the camera angles may be varied as the interior sequences continues. If, however, the camera were to cut abruptly from an exterior shot of the train moving in one direction to an interior shot showing the people (and the view through the window) moving in the opposite direction — it would create the impression that the train were suddenly going backwards!

Contrasting screen travel depicts subject motion in *opposite directions* when necessary to show a person or vehicle *going* and *returning;* or whenever *two subjects* must be shown moving *toward each other.* In order to establish and maintain both directions of travel, think of screen travel in terms of "comings and goings" (a descriptive phrase used by early film makers) which must be strictly followed. The subject may go and return

— perhaps from his home to town and back again. Both travel directions should be decided *before* the scenes are filmed, so that whenever the subject appears walking or riding, he comes and goes in opposite directions. Home to town may be established as left to right. Town to home would be filmed right to left.

This would apply regardless of camera angles, whether long shot or close-up — or if only player's horse's feet are shown! The audience will be oriented that town is toward the right and home is toward the left.

Later, a group of men may be shown leaving town and going right to left. The audience will automatically assume that they are headed for the subject's home because they are riding in that direction. Travel direction for both coming and going must be consistently the same, however many times the action returns to the same locale. This is just as important in documentary films showing airplanes leaving their base and returning. Or, in depicting raw materials arriving at a plant and finished products being shipped out to market. Camera angles and types of shots may be varied, but the subject must come and go in an established directional pattern, maintained throughout the picture. An oriented audience will be confused if travel movement is switched.

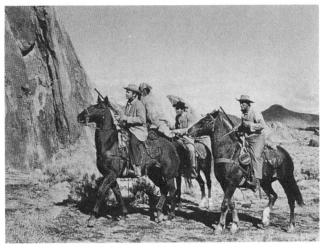

Universal City Studios

Audience will assume that group of men shown leaving town, traveling right to left, are headed for subject's home — because they are riding in that direction.

Contrasting screen travel is also employed to depict *opposing* subjects moving *toward each other*. Opposing screen movements are generally edited in an alternating pattern, to portray moving subjects that will meet or clash. The hero leaves his ranch, riding left to right. Next, the heroine is shown leaving town, right to left. The audience will correctly assume that they are riding toward each other, and will meet. This effect is achieved through opposing movements, and

also because the audience is properly oriented through earlier establishment of directions — town toward right and ranch toward left. By judicious use of opposing screen travel, the audience will always assume that the two opposite moving images will meet — unless otherwise informed through dialogue or other means.

Contrasting screen direction may employ *moving opposition* to build suspense, predict a clash, or contribute dramatic impact to the narrative. Suspense can be built by showing hero and villain *approaching* each other for a show-down. A clash can be predicted by showing Indians and cavalry galloping *toward* each other. Dramatic impact can be increased by introducing two football teams trotting on to the field from *opposite* directions.

While individual shots may not be suspenseful, clashing or dramatic in themselves, they will help build toward climactic meetings. This can be accomplished with visual simplicity, without need for forceful dialogue or narration. A cameraman filming on his own, or a director shooting from a detailed script, should use contrasting directional continuity. Thus, the film editor is supplied with a dramatically-fashioned series of scenes, filmed to fit a definite editing pattern.

Series of opposing action shots, such as Indians and cavalry, should be filmed with progressively closer shots as the action reaches its climax. Such

20th Century-Fox Film Corp.

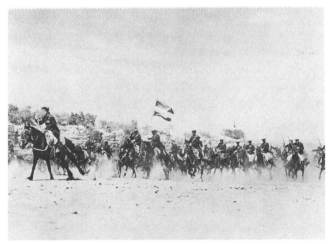

20th Century-Fox Film Corp.

Contrasting screen travel may be used to show opposing subjects moving toward each other. Moving opposition—edited in alternate pattern—may predict a clash.

89

closer-and-closer shots may be cut shorter and shorter, so that the sequence builds from lengthy long shots to shorter medium shots, to clipped close-ups and a frenzied finish. The viewers' emotions are excited by the acceleration editing pattern; and involved even more deeply as the camera moves into the clashing climax.

Neutral screen direction depicts moving subjects traveling *toward* or *away* from the camera. Since neutral movements are non-directional, they may be inter-cut with scenes showing movements in either direction. The following are neutral screen movements:

Head-on and *tail-away* shots, in which the subject moves directly *toward* or *away* from the camera. Such shots are neutral only as long as the moving image remains centered in the frame. An entrance or exit will denote direction. The front or rear of the moving subject should be depicted for an absolutely neutral effect. If one side is seen, such as the side of a horse or a car, the direction of travel will be indicated. A head-on shot may begin neutral and then exit one side of the picture to match-cut with a following directional shot. Or, a tail-away shot may enter one side of the picture and then become neutral as it moves away from the lens. Such shots may be used deliberately to switch screen direction, by presenting a temporary

neutral condition between two shots moving in opposite directions.

Head-on and tail-away shots, in which a person walks or runs *directly toward* the camera and *covers* the lens, so that the screen is blacked out — or, walks *directly away* from the camera so that the lens is *uncovered* and the setting is revealed — have limited use for chase sequences, or for providing fade-in or fade-out effects.

Tracking shots, in which the camera moves *directly ahead*, or *directly behind* the player or vehicles, are neutral if the subject does not enter

Universal City Studios

If head-on subject exits frame — proper exit side is important to preserve established screen direction. Rider, above, must exit right side of frame in order to travel left-to-right in next shot, below.

Universal City Studios

ABC-TV

Head-on shots — depicting subject moving toward camera — are neutral in screen direction.

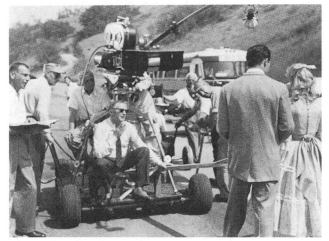

Universal City Studios

Subject movement is neutral when camera tracks directly ahead of walking players.

Travel movement is neutral when filmed from high downward angle so, that subject exits bottom of frame.

or exit the frame. Either a front or rear view is depicted. If a side or three-quarter angle is filmed, one side of the subject is favored, so that the shot will indicate direction of travel.

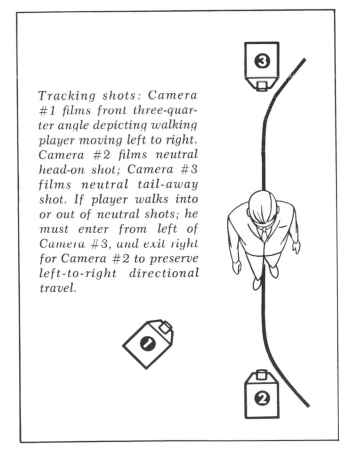

Tracking shots: Camera #1 films front three-quarter angle depicting walking player moving left to right. Camera #2 films neutral head-on shot; Camera #3 films neutral tail-away shot. If player walks into or out of neutral shots; he must enter from left of Camera #3, and exit right for Camera #2 to preserve left-to-right directional travel.

High or low angle shots in which the moving subject travels *directly toward* and *under* or *over* the camera, so that it exits either *bottom* or *top* of the frame. A car filmed from a high angle may travel directly under the camera. A train or a jumping horse may travel directly *over* the top of a low-angled camera.

Directional travel is neutral when two or more players walk abreast toward camera, and then split up to exit both sides of frame.

91

Directional travel is neutral when several players enter frame from both sides of camera and join up going directly away.

Shots of groups of people, or two or more vehicles, traveling abreast — which advance *toward* the camera and *split up* to *exit both sides* of the frame. Or, *enter* from *both sides* of the frame and *join up* going directly *away* from the camera. An army may march *toward* a centered camera; and half the men may exit left, and the other half may exit right. A crowd may enter from *both sides* of the picture, and rush *away* from the camera.

USE NEUTRAL SHOTS

To provide visual variety. A constant left-to-right or right-to-left series of shots may be broken up with neutral subject movement. A head-on shot may be used to open a sequence by bringing the moving subject from a distant point toward the audience. A tail-away shot may be used to close a sequence, or a picture, by having the subject recede from the camera by walking, riding or otherwise moving away. Such shots present moving images which *increase* or *decrease* in size as they *advance* or *retreat* from the viewer, and thus

effect a greater depth than cross-screen shots. Head-on and tail-away tracking shots offer welcome changes from the usual three-quarter side angle. High or low angles, in which the moving subject goes under or over the camera, furnish contrast to eye-level shots.

To provide greater audience impact. Head-on shots place the viewer dead center, with the action advancing toward him. An on-rushing train or a jumping horse, which exits at top of frame, will jar the audience into increased involvement with the screen action.

To distract the audience. A sequence depicting subject travel in a constant direction, is often filmed with one or more shots moving in the *opposite direction.* This may be due to carelessness, light conditions, backgrounds, poor planning — or it may be intended by the director or cameraman. A neutral shot inserted *between* shots moving in opposite directions will *distract* the audience momentarily. Head-on, tail-away, or front or rear tracking shots will allow the editor to reverse completely the original screen movement; without the abruptness of a direct cut from a shot moving in one direction, to another shot traveling in the opposite direction.

Universal City Studios

Neutral head-on shots provide greater audience impact than angled travel shots, because subject increases in size as it advances.

ACTION AXIS

A simple method for establishing and maintaining screen direction is by use of the *action axis*. Subject travel may be considered as a line on a map, or an imaginary line made by an individual walking down a hall; or a vehicle driving on a road, or a plane flying through the air. This *travel line* is the *action axis*.

If *all* camera set-ups are positioned on *one side* of this line, screen direction will remain the same throughout a series of shots, regardless of camera angle. The subject may travel cross-screen, or toward, or away from the camera. Directional movement will be *constant* when the subject moves in a *constant* direction; and *contrasting* when the subject moves in *opposite* directions. The relationship between camera and subject movement remains the same, providing the camera *never crosses the action axis*.

A picture shot from script should have *all* its travel mapped out *before* production begins. A cameraman shooting off-the-cuff should take particular care to establish and maintain screen direction, so that all travel will match-cut. If travel shots are not filmed according to pre-conceived plan, the resulting series of scenes may be a hodge-podge of opposing movements, which will prove difficult to edit. Matching movement is just as important in two shots of a person walking down the street, as in a long series of scenes.

Once the left-to-right or right-to-left directional movement is established, it can be maintained throughout a series of shots, by remaining *on the same side of the action axis*. A new location will require drawing a new axis, and *remaining* on the same side as the original axis to preserve established travel direction. Many cameramen and directors think of the axis as a directional left-to-right or right-to-left movement, rather than an imaginary line. While this is the same, it complicates the work; because the travel movement must be considered every time the camera is moved to a new set-up. If the camera is *always positioned* on the *same side* of the axis, the proper travel direction will be filmed automatically.

Bob Jones University-Unusual Films

Girl travels along path to house left-to-right. All camera set-ups should be positioned on same side of travel axis to depict progression in a constant direction.

Bob Jones University-Unusual Films

Tail-away shot of girl walking up porch steps shows her entering frame from screen left — to preserve established left-to-right travel direction.

An exception to crossing the action axis occurs when two or more players walk abreast or ride side by side. The camera may track directly ahead or behind the moving players, to film neutral shots. Or, it may track alongside to shoot a three-quarter front angle — which will depict travel direction. Whenever the players *look at each other,* an axis may be drawn through them (based on two-shot axis explained in *Static Screen Direction*).

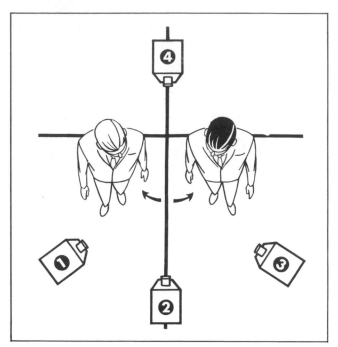

Exception to crossing action axis occurs when two players look at each other as they walk or ride. Two-shot static action axis should be drawn through moving players. Camera may be positioned on either side of travel axis to shoot opposing shots of moving players — in the same manner that they would be filmed standing still.

The camera may then be switched to the opposite side of the travel axis, to film the players from an opposing angle. Although consecutive shots of the players may show them moving in opposing screen directions, the audience will not be confused. The camera may be safely switched to opposing angles when filming walking players, or players seated in a vehicle. It is best to establish the moving players or vehicle in a long or medium shot; and then move in for a two-shot from the same side of the axis. An opposing two-shot from the other side may then be filmed, based on the axis drawn through the players. Individual opposing close-ups may also be filmed, if desired. The camera should return to a two-shot from the original side of the axis, before filming a final long shot or medium shot. Thus, shots moving in the opposite direction — filmed from the other side of the travel axis — are sandwiched between two series of shots moving in the established direction.

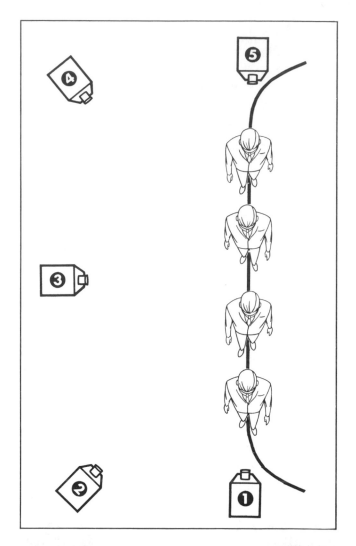

Camera #1 films head-on shot of walking player. Player exits screen right to establish left-to-right directional travel.

HOW CAMERA SET-UPS CAN BE USED
TO ESTABLISH & MAINTAIN
PROPER SCREEN DIRECTION
ON MOVING PLAYER OR VEHICLE

Camera #2 shows player in front three-quarter angle as he enters from screen left, crosses screen and exits screen right. This angle is excellent for tracking a moving player or vehicle.

Camera #4 films rear three-quarter angle of player, who enters left, exits right.

Camera #3 records player moving left to right across screen. Shot may be static, or camera may be static for entrance, pan player for short distance, and hold static for exit — screen right.

Camera #5 depicts player entering frame screen left and walking away from lens in tail-away shot, as he enters building. Player may be filmed with any or all of these camera set-ups; with assurance he will travel left-to-right — regardless of whether static or moving shot; long shot, medium shot or close-up; or whether player is moving toward or away from camera.

Santa Fe Railway

Camera should remain on same side of travel axis to show player leaving building for return to starting point. Player moves in contrasting right-to-left screen direction. Head-on or tail-away shots may be filmed in same manner.

ACTION AXIS ON CURVES

Preserving the directional movement on curves requires careful camera placement. Curves can be tricky because the camera may shoot *across* a curve, and place the lens *viewpoint* on the *opposite* side of the axis. If this occurs, it is the same as placing the camera on the *wrong side* of the line. A subject moving left to right would be filmed *across* the curve moving right to left. This would be all right if a long shot is filmed in which the *entire* curving movement is included, so that the subject is shown turning in front of the camera — and then resuming the proper left-to-right direction — exiting screen right. A closer shot of the moving subject filmed across the curve would depict opposite screen travel.

A long shot, or a pan shot, in which the subject is seen in a long curving movement, may show an opposite movement *during* the shot; but it should right itself and curve back, so that the original direction is again filmed when the subject exits the frame. A moving subject may be filmed moving in opposite directions as it follows the curve, providing it enters *and* exits the frame correctly. A camera set-up on a curve — filming the

Constant care is required when filming curving movement. If camera viewpoint is allowed to cross travel axis, camera photographs moving subject from opposite side — moving in the wrong direction. Viewpoint should cross axis only when subject movement curves back and rights itself.

subject entering and exiting the *same side* of the frame — should be avoided. It will not inter-cut with other shots moving in a constant direction.

A curve may be utilized, however, for a *deliberate switch* in screen direction when required. The switch may serve as an editorial transition between two series of travel shots moving in opposite directions; yet intended to depict constant screen direction. In this case, the entrance would be correct, but the subject would curve around and exit the *same side* of the frame; and inter-cut with the following shot going in the opposite direction. The audience will accept this natural change in screen direction.

Curves may be an asset or a liability. Curves offer the cameraman an opportunity for filming beautiful curving movements offering variety from straight-line travel. Film a correct entrance, a complete curving movement, and a correct exit — to maintain established directional continuity. A closer shot records a portion of the movement across the curve. It will depict the subject moving in the opposite direction. Do shoot across a curve, however, to film the subject moving correctly, and then curving around and exiting the wrong side — if a change in screen direction is required.

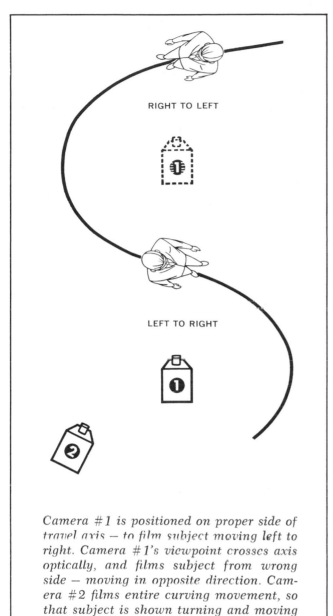

Camera #1 is positioned on proper side of travel axis — to film subject moving left to right. Camera #1's viewpoint crosses axis optically, and films subject from wrong side — moving in opposite direction. Camera #2 films entire curving movement, so that subject is shown turning and moving correctly when crossing camera and exits.

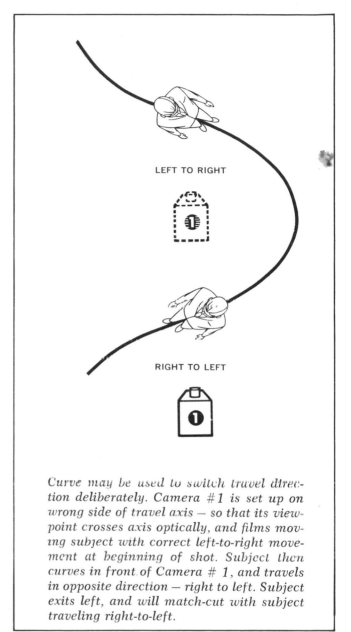

Curve may be used to switch travel direction deliberately. Camera #1 is set up on wrong side of travel axis — so that its viewpoint crosses axis optically, and films moving subject with correct left-to-right movement at beginning of shot. Subject then curves in front of Camera #1, and travels in opposite direction — right to left. Subject exits left, and will match-cut with subject traveling right-to-left.

A curve may be utilized, however, for a *deliberate switch* in screen direction when required. The switch may serve as an editorial transition between two series of travel shots moving in opposite directions; yet intended to depict constant screen direction. In this case, the entrance would be correct, but the subject would curve around and exit the *same side* of the frame; and inter-cut with the following shot going in the opposite direction. The audience will accept this natural change in screen direction.

ACTION AXIS ON CORNERS

A person or vehicle turning a corner may be filmed head-on, so that the moving subject turns in front of the camera. If filmed tail-away, however, the turn will require two shots — to depict the subject going away from the camera, turning the corner and being picked up in a head-on shot around the corner. The axis should be drawn around the corner, and the camera positioned on the same side for both shots. In a tail-away shot the lens may view the turn *across* the axis, as on

a curve. This can be handled editorially by cutting on the turn. The moving subject may begin the turn in the tail-away shot, and be picked up around the corner in a head-on shot. The reverse travel at beginning of turn is of no consequence.

A corner may be used in the same manner as a curve, to switch directional movement deliberately. If a change in direction is desirable for editorial or other reasons, the moving subject should be allowed to exit the frame as viewed from across the exit, so that subject moves in the opposite direction to that established. This will work best on wide turns, where the moving subject will travel enough distance to establish the new direction before it exits.

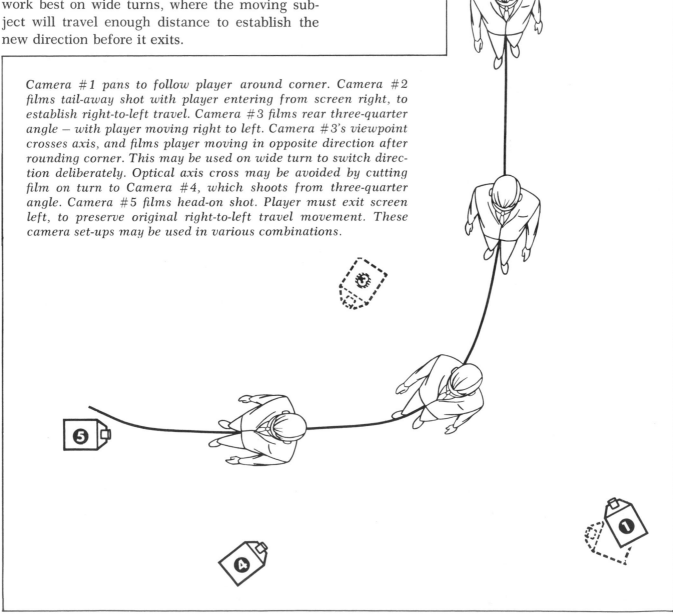

Camera #1 pans to follow player around corner. Camera #2 films tail-away shot with player entering from screen right, to establish right-to-left travel. Camera #3 films rear three-quarter angle — with player moving right to left. Camera #3's viewpoint crosses axis, and films player moving in opposite direction after rounding corner. This may be used on wide turn to switch direction deliberately. Optical axis cross may be avoided by cutting film on turn to Camera #4, which shoots from three-quarter angle. Camera #5 films head-on shot. Player must exit screen left, to preserve original right-to-left travel movement. These camera set-ups may be used in various combinations.

ACTION AXIS THROUGH DOORWAYS

Established directional movement need not be maintained when subjects go through doorways. Many cameramen and directors feel that this creates a "new deal" because the moving subject enters a new setting. If the movement is filmed cross-screen, it will appear smoother if the camera remains on the same side of the axis on consecutive shots — filmed on opposite sides of a door. If the moving subject exits one room in a tail-away shot, and enters another room in a head-on shot; the directional movement may be switched without difficulty. Rooms and doors in actual buildings and studio sets should be checked, to be certain that sufficient room is available for positioning the camera properly on cross-screen exits and entrances. Whenever difficulty arises, it is fairly simple to bring the subject into the new setting in a head-on shot, and switch direction if desired.

For precaution, players' exits should be filmed *before* breaking down interior long-shot lighting and moving in for close-ups. This is also important in exterior shots where lighting changes constantly as filming progresses. Don't discover after a series of medium shots and close-ups are filmed that an exit is required, and the long shot must be filmed again. When in doubt, it is best to shoot an exit immediately after filming the entrance. It is better to discard the shot — if not needed — than to set it up again.

CHEATING THE ACTION AXIS

At times, it is expedient to have the subject move in the direction *opposite* to that established; because of light, background or other production factors. This may be done if *both* the *camera viewpoint* and *subject movement* are transposed, so that they remain the same in relation to each other. If the subject movement is reversed, *or if* the camera is switched to the opposite side of the axis, the screen movement will be in the wrong direction. *Both* elements must be changed, so that when the movement is reversed, the camera is photographing it from the *opposite* side: resulting in preservation of the original travel direction.

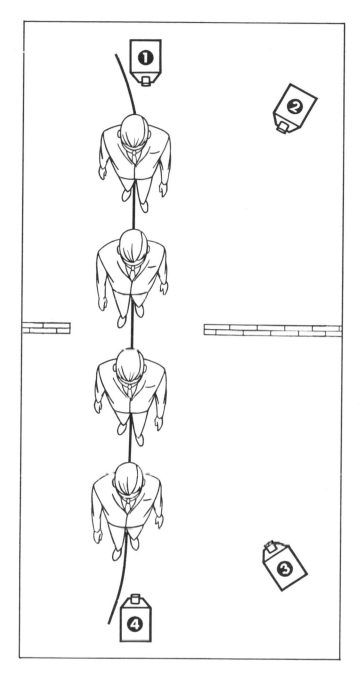

Since doorways create a new deal, directional continuity may or may not be maintained. Neutral tail-away (Camera #1) and head-on (Camera #4) shots may be used — with proper entrance and exit, to maintain screen direction — or wrong exit (Camera #4), to create a new directional movement. Three-quarter side angles may be used (Cameras #2 and #3) — if player is filmed cross-screen, and directional continuity is maintained.

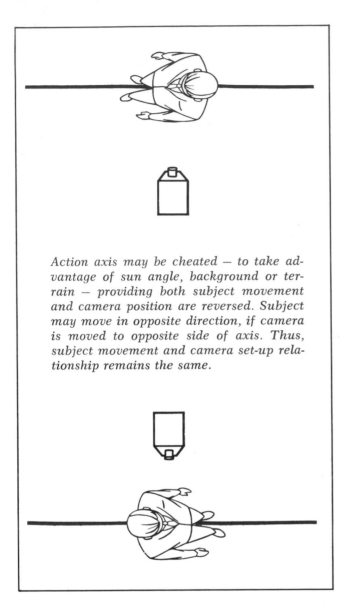

Action axis may be cheated — to take advantage of sun angle, background or terrain — providing both subject movement and camera position are reversed. Subject may move in opposite direction, if camera is moved to opposite side of axis. Thus, subject movement and camera set-up relationship remains the same.

Cheating the action axis on outdoor shots must be handled carefully, so that sun angle and shadows do not disclose the cheat. Considerable cheating may be done outdoors around noon, or on close-ups when reflectors or booster lights are used to illuminate shadow areas on faces. Long shots, made early or late in the day, may show long shadows in a direction opposite to that already established. A late afternoon shot, for instance, may depict the players walking westerly into the sun with long shadows toward the camera. A reverse cheat filmed elsewhere would have to be shot in the morning in an easterly direction, to match established sun angle and shadow pattern.

ENTRANCES & EXITS

A moving subject *should* enter and/or exit the frame under the following conditions:

Whenever a series of moving shots are filmed against *different* backgrounds. An entrance-and-exit provides the editor with progression from one shot to another. Players walking from one room to another — or cars in a chase sequence — should exit one locale and enter the other. It is impossible to depict progression if the moving subject is already in the center of the frame when the scene starts, and does not exit the frame during the shot. A series of different shots cannot be edited in sequence, because the moving subject is constantly center-screen — panned or tracked for a while — and left there when the shot ends. The moving subject would be suddenly somewhere else in the next shot, against a different background!

This is particularly undesirable when the subject — such as a moving car — is filmed in the same manner; with same image size and same image angle, in both shots. In the resulting jump-cut, the subject seems to remain the same; but the background abruptly changes. Non-theatrical cameramen occasionally try to save film by shooting a moving subject in a pan shot, minus entrance or exit. The camera should be started *before* the subject enters the frame, and cut *after* the subject exits. Entrances and exits should be shot "clean" — not just as the subject enters — and cut just before a complete exit. Cutting the film is the editor's function — not the cameraman's.

An *exit* made *close* to the *side* of the camera should be followed by a shot showing the subject *entering* the frame in a *similar* way. If the subject enters the *far side* of the frame in the next shot, the audience will be distracted; because the distance is too great to cover between straight cuts.

Exits and entrances *through* doors should be carefully matched when straight cut. Two or more players should follow in the same progression, if filmed going through doorway outside to inside a building; or from one room to another. This may seem obvious, but during a long interval between such camera set-ups, a mis-match may occur, unless notes are carefully taken and observed.

Exit made close to side of camera —

should depict subject entering frame in same manner. Exit to screen left would be followed by entrance from screen right.

Moving player should not exit close to side of the camera, and enter next scene at far side — and walk cross-screen. Off-screen distance is too far to travel between consecutive shots.

A moving subject *should not* enter or exit the frame under the following conditions:

A series of consecutive shots against the same background may be inter-cut if the moving subject remains center-screen. Since the background remains the same, there is no progression — other than that shown within the shot. Thus, a medium shot or close-up may inter-cut with a long shot, while the subject remains centered. In this case, it is best editorially to have the subject enter the frame in the first shot of the series; and exit the frame in the last shot — to provide progression with bracketing sequences.

Individual shots of moving action — such as a man on horseback or a car in motion — may be filmed center-screen without an entrance or exit, if edited in alternate pattern with other scenes. Progression will be shown by the changing background in different shots. It is advisable to make occasional entrances or exits for visual variety, but it is not necessary for editorial purposes, because moving shots are cross-cut with other scenes.

When in doubt, an entrance and/or an exit should be shot to provide editor with cine choice.

REACTION CLOSE-UP
FOR SWITCHING SCREEN DIRECTION

There are differences of opinion regarding direction in which a player should turn his head, following moving action in reaction close-ups. This often results in shooting it both ways.

The player should follow the moving object with his head, as though it were *behind the camera.* The player may be considered a member of the audience, viewing action on the screen. An airplane, flying left-to-right on the screen, would be followed by the viewer turning his head in the same direction. Since the camera is shooting a *reverse shot,* this results in a right-to-left screen movement in the reaction close-up. While this may seem illogical, it is correct!

Before close-up is shot, directional movement of the matching scene must be confirmed. Player should follow the action as if it were occurring behind the camera. Often, better reaction results if somebody walks, or runs — behind the camera, so player has moving target and speed to follow.

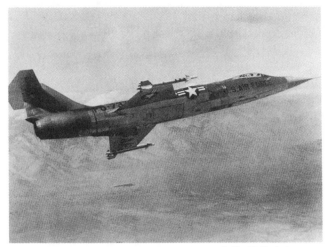

Player observing moving action should turn his head as if following movement occurring behind camera.

Reaction shots may also be used to *distract* the audience, so that screen movement may be *switched* to the opposite direction. In this case, the player would follow the movement occurring in the *second* series of shots. A sequence may begin left-to-right and later move right-to-left. If a turn around is not shown, the change may be covered by cutting to a head-on or tail-away shot; followed by a reaction close-up of a player supposedly watching the moving action going in the new direction. The neutral shot will aid in breaking up the directional pattern established, and the reaction shot will distract the audience by "explaining" the directional switch. Such reaction shots may be filmed after the picture is completed,

if necessary to polish the sequence. They may be filmed against sky or trees, without a background matching problem.

REVERSING SCREEN DIRECTION

Established screen direction should be preserved, if at all possible; or explained, if necessarily reversed. Contrasting screen directions cannot be changed without confusing the audience. Once a directional pattern is set, it should be rigidly maintained. Constant screen direction, is often altered inadvertently; or by production factors which do not permit strict directional continuity.

Whenever possible, a switch in constant direction should be shown on the screen — to inform the audience of the change. Cutting from a person or vehicle moving in one direction, to a shot depicting the movement in the opposite direction, will confuse the audience. The switch in screen direction may be explained in the following ways:

Show the person or vehicle turning around.

Shoot across the action axis on a curve or corner, to allow the moving action to exit the *wrong side* of the picture.

Insert a reaction close-up of an observer viewing the movement in the new direction.

Use a head-on shot which exits the *wrong side*

Established screen direction of moving subject may be reversed by inserting a cutaway close-up of someone supposedly observing the directional change.

Screen direction may be reversed by filming head-on neutral shot, which shows subject exiting wrong side of frame. This will serve to introduce new series of travel shots moving in opposite direction.

of the picture, to match-cut with the moving person or vehicle going in the new direction. A tail-away shot would only distract the audience momentarily, and is not nearly as effective because it does not exit the scene.

Effectiveness can be gained by cutting to the interior of a car, train, boat or airplane; and then cutting to the exterior moving shot going in the opposite direction. If only one shot is used, it is best to cut to a head-on view of the players. If a series of shots are used, the camera angle may be worked around so that the final shot has the players facing in the new direction — which will match-cut with the exterior scene.

MAP DIRECTION

Travel over great distances should employ diagram *map direction* with East always on the right, and West always on the left. That is how a map is established in the human mind. Since North and South are usually depicted as up and down, such directions are difficult to handle on a horizontal screen. If possible, northbound travel should be staged on a line ascending from lower left to upper right; southbound travel, on a line descending from upper left to lower right. This is in keeping with the accepted compositional concept of up or down movements.

An airliner flying from Paris to New York should be shown heading screen left, or West. A ship sailing from Hawaii to continental United States should be depicted moving left to right, heading East. The initial shot of the airliner pilot, ship captain, or passengers, should show them facing in the established travel direction. This preserves continuity of the action axis. Later, the camera may move around and show crew members or passengers from either side.

This may seem unimportant to inexperienced directors or cameramen, who question the validity of this proven theory. "Why can't the moving car, plane or ship be seen from the other side, going in the opposite direction, and still be traveling correctly?" It can! But, why not take advantage of a pre-established concept, already planted in the audience's mind? This will make it as easy as possible for viewers to understand happenings.

Moving an airplane, ship, train or car in an opposite map direction sets up — in the viewer's mind — a subconscious disturbance, which warns him that the movement is wrong. The viewer will be momentarily distracted. It is wise to keep the audience properly oriented, by establishing and maintaining map direction on all travel shots.

LOCATION INTERIORS

Shooting through the open side of three-walled studio sets helps maintain directional continuity of players moving about the set, or going from room to room. Filming in multi-floored, complex, natural location interiors with a maze of rooms, hallways and stairways often complicates directional continuity. If much room-to-room, floor-to-floor or stair travel is involved; it is smart to keep *all* camera set-ups on the *same side of the building* — so that the lens viewpoint is always in the same general direction, and the camera never crosses the action axis.

Travel in any direction, even up and down stairs, should always match, and players will always move in a similar direction, in any part of the building. If physical or other limitations prevent positioning the camera on the same side, head-on or tail-away shots of the players should

This ocean liner is traveling from Hawaii to continental United States — west to east.

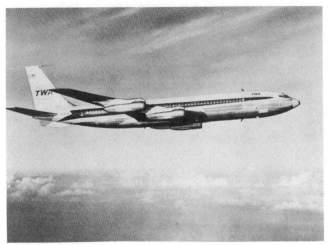

Jet airliner is flying toward screen right — west to east — New York to Paris.

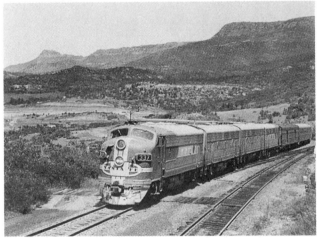

Train going from Chicago to Los Angeles should move right to left — east to west.

be shot; but they should enter or exit the frame on the side which preserves the established travel direction. Thus, travel toward the front of the building may always be from left to right — for instance – and toward the rear, from right to left.

PLANNED SCREEN TRAVEL

All screen travel must be thoroughly analyzed before a foot of film is exposed. If shooting from a script, marginal notes should be used. Outlines, or diagrams, are most important if filming off-the-cuff. It is essential to work from a definite plan — so that both constant progression and contrasting movements will be photographed in established directions. Established direction should be maintained throughout the filming.

While preservation of directional travel continuity may seem like a simple task, it has pitfalls. Long shots may be photographed one day, with inter-cutting close-ups made several days later. Or, an entire series of traveling shots may be

The following sequence from Martin Rackin's production of STAGECOACH (released by 20th Century-Fox) illustrates how Dynamic Directional Continuity is established and maintained.

Stage coach is established moving left to right in a front three-quarter angle.

Stagecoach continues traveling left to right in cross screen shot.

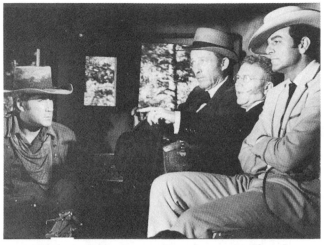

Reverse shot of opposite players is filmed from same side of action axis.

Players are filmed from exterior camera angle, from same side of travel axis.

Coach continues on its way. Vehicle enters screen left, and exits screen right.

Interior shot shows players from similar angle.

Pursuing Indians move left to right.

Driver is filmed in three-quarter angle medium shot from same side of axis.

Three-quarter angle shot shows attackers.

Stagecoach must exit screen right to preserve established travel direction.

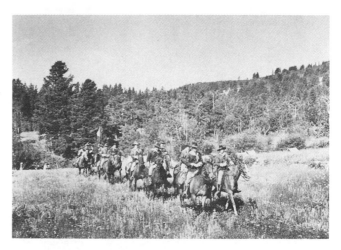

Cut-away shot reveals U. S. Cavalry coming on scene.

Coach filmed in three-quarter angle.

Shot of troopers maintains direction.

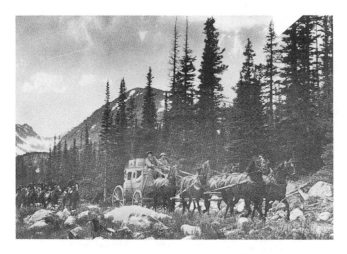

Indians are driven off, and cavalry escorts stagecoach to destination.

Stagecoach enters town — still traveling left to right.

Coach pulls up to depot — left to right.

filmed at one time in both directions. The cameraman, or the director, who becomes overly concerned with background, sun angle or camera angle, may forget established screen direction.

The action axis is sometimes overlooked, in order to film a pictorially beautiful *individual* shot. This oversight can be avoided if all shots in a sequence are thoroughly mapped, and the action axis established to favor the best camera angles, sun angles and backgrounds.

There is no need to sacrifice a particularly good shot in order to preserve directional continuity. Sequences involving a great number of shots may be best planned by working *backwards*, and studying the terrain where the climax will be staged. A particular location site or building may require filming from a certain angle, which will decide the screen direction for the entire sequence. If this is overlooked, a switch in screen direction may be made when the location is reached. The moving subject may be picked up in a head-on shot and simply panned around in the new direction. Or, it may be shown exiting the wrong side of the frame a shot or two earlier, and switched to the new direction before it arrives, so that subject is moving in the proper direction for entering the setting.

The entire terrain covered by travel shots should be studied for sun angles, camera set-ups and backgrounds, at the time of day that the various shots will be filmed. Only then can the cameraman be positive that he can keep obstacles at a minimum, while filming the entire sequence.

Travel sequences which include interior scenes of cars, buses, trains or airplanes, must be carefully planned with *both* interior and exterior camera set-ups in mind. A studio film may involve a mock-up of a vehicle which has an open side — requiring that all action be staged against one side only. Or filming in an actual airplane may permit little room for camera angling.

A transition from exterior to interior — or interior to exterior — particularly the former, should be filmed from approximately the same camera angle — as if the camera moved through a window or side of the vehicle to look inside. The original travel axis is maintained for a smooth match-cut. Interior shots may be filmed from various angles.

107

20th Century-Fox Film Corp.

This sequence — depicting landing on Omaha Beach of Allied troops on D-Day
— demonstrates right-to-left progression (in this instance dramatically stronger
than left to right) throughout a series of shots — from landing craft being
beached, to officers and men moving up into battle positions.

STATIC SCREEN DIRECTION

Static screen direction is concerned with the way in which players *face* and *look* on the screen. The screen treatment of motionless bodies may seem incongruous, but even action pictures present the players at rest, or at least in a static position while they talk or perform.

The principle of the action axis is just as important in filming static set-ups of players as in shooting traveling shots of moving subjects. Established directional continuity must be maintained, not only when players move about, but also when they are at rest, so that *direction* in which a player *moves*, and *direction* in which he *looks*, match throughout a series of consecutive shots.

The position in which a player *faces* may not necessarily be the same direction in which he *looks*. A player may face the right side of the screen, but his eyes may look over his shoulder toward the left. It is important, therefore, to refer to *matching the look* when discussing static screen direction, rather than simply matching facing positions. A single player — or two or more players — must look in the same direction on each side of a match-cut, so that the edited shots will present a consistent appearance. A player may not look left in one shot, and then suddenly look right in the next shot — unless he is shown shifting his look.

The action axis could be disregarded on static set-ups *if* motion pictures were filmed *stage front* — with the camera viewpoint *always* from the audience angle, and the players and setting visible only *from one side*. A camera placed anywhere in the audience, shooting from any angle and distance, would record perfectly matching shots; since the lens would remain on one side of the axis, and the players would be seen from the audience viewpoint *only*, never from the opposite side. Most live television shows and many filmed television plays, particularly situation comedies, are presented in this manner, so that they may be filmed continuously with multiple cameras.*

*This applies only to dramatic or other story type teleplays where the players relate only with *each other* across a stage. It does not apply to a live or filmed television show, where the master of ceremonies faces front and relates with *the audience*.

Modern motion picture production techniques, however, require filming with a single camera *shifted between shots*, so that each portion of the action is presented from a different camera angle. In spite of the moving players and repositioned camera, it is necessary that matching shots be filmed with a *one-sided viewpoint*. The axis is a means of remaining on one side of the players, so that the players' positions and looks appear consistent from shot to shot as the sequence progresses, regardless of the player or camera movement involved.

The *action axis* is established by *drawing an imaginary line through the two players nearest the camera on opposite sides of the picture*. The *camera viewpoint and the players' looks* must remain on the *same side* of this imaginary line in *consecutive matching shots*. A sequence of shots may be filmed by placing the camera anywhere within the 180 degree arc which may be described on one side of the players.

The camera may be placed near or far, film any number of players or a single individual, but it must *not* cross the line. The camera may *not* be moved 180 degrees from one set-up to another. It may be moved *within* 180 degrees, a complete semi-circle, on *one side* of the axis *only*, every time the camera is positioned for a matching shot. If the camera crosses the line and views the players from the opposite side, they will be transposed on the screen so that a player seen on the right will suddenly appear on the left. A close-up of an individual player filmed from across the line will be recorded with a "fake reverse" or a look in the *opposite* direction to that previously established. A close-up filmed in this manner will appear on the screen as if the player is looking away from, rather than toward, the other player.

Note that the camera angle, or point of view, must *not cross the axis*. The camera itself may cross over, however, to film a player in the *rear* of the set, providing that the camera angle is in keeping with the established action axis. This amounts to drawing a *new action axis parallel to the original axis;* and positioning the camera on the same side. A simple method for shooting across the axis is to remember that the camera may move across

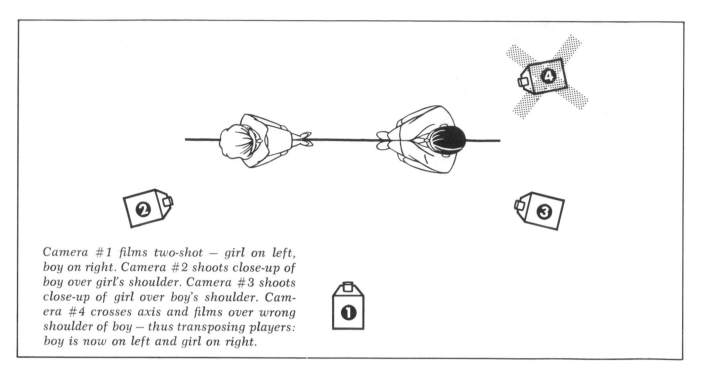

Camera #1 films two-shot — girl on left, boy on right. Camera #2 shoots close-up of boy over girl's shoulder. Camera #3 shoots close-up of girl over boy's shoulder. Camera #4 crosses axis and films over wrong shoulder of boy — thus transposing players: boy is now on left and girl on right.

Camera #1: Two-shot — girl on left, boy on right.

to film *any shot* that it could shoot from the original axis with a *telephoto* or *zoom* lens. Thus the camera actually crosses the axis *optically*, rather than physically, and the viewpoint remains the same. The shorter focal length lens simply allows the camera to move in closer and film the same shot that could have been photographed with a longer focal length lens.

MATCHING THE LOOK

The reason for the camera remaining on one side of the axis when filming two or more players is readily understood, since it is apparent that crossing the line will result in transposition of the scene. The player on left will suddenly appear on right — the player on right will appear on left. Such an obvious mistake should be avoided.

Mistakes do occur, however, in filming *individual opposing close-ups* of two players because the *look* may *cross* the *axis*. This may happen in a close-up in which the player is *facing* the camera. Such oversights can be prevented by positioning the *off-screen* player on the proper side of the camera, to preserve the established two-shot relationship. The *on-screen* player will always look on the proper side of the axis if this is done. If the on-screen player simply reads his lines to an imaginary off-screen player he may look on the wrong side of the camera and be filmed with a look in the wrong direction.

Little or no difficulty will be encountered with a three-quarter angle, since the position the player is facing will generally govern the look. A flat-on p.o.v. angle may result in a wrong look, because the eyes may inadvertently shift to the wrong side.

Camera #2: Over-shoulder close-up of boy.

Camera #3: Over-shoulder close-up of girl.

Camera #4: Over-wrong-shoulder close-up of girl. Players are transposed.

The eyes govern the look. A perfectly centered person facing the camera may look either right or left, up or down, or straight into the lens — without moving his head! Or, the head may be turned in one direction and the person look over his shoulder in the opposite direction. It is most important that the look be correct, so that opposing players relate with each other smoothly in a series of consecutive shots. Any change in look must be shown. It must not occur *between* shots, so that it is suddenly opposite to the look shown in the previous shot. Matching players' positions and looks is an absolute requisite if a series of consecutive shots must be match-cut, so that an entire sequence is to appear as continuous action.

Particular attention must be directed to high and low camera angles, which may be required to film back-and-forth point-of-view shots of grown-ups and children; or, if one player is seated and the other standing. The look must always be to the *side* of the camera, but it should be directed slightly *above* the lens by the player looking up, and slightly *below* the lens by the player looking down. Considerable cheating can be employed in positioning the camera for height; but care must be taken not to cross the action axis by looking on the wrong side of the camera.

Player movement into or out of a close-up must also be properly handled, or the axis may be

University of So. Calif. Cinema Dept.

Player may be given reference point for look by holding fist at side of camera.

111

Camera #2 films girl from boy's point-of-view.

Camera #1 films boy from girl's point-of-view.

Girl's look has crossed axis, and created new look in opposite direction.

Camera set-ups for opposing p.o.v. close-ups should be very close to side of players, so that look is to side of lens.

crossed. This is particularly important when the camera is very close to the line — such as in the filming of a point-of-view close-up where a player is looking close to the side of the lens. Cross-screen movements will give little trouble, because they point obviously toward right or left. Head-on movement sometimes appears neutral to the player, cameraman or director; and it is very easy to make a mistake, and look in one direction and then exit in the opposite direction! To preserve screen direction in close-ups, where the player enters or exits the scene close to the side of the camera, movement should always occur *between* the lens and the action axis.

LOOK ON
BOTH SIDES OF LENS

A player may turn his head from one side to the other, and look past the camera lens — to relate with players on either side of him; or to look from an on-screen player to an off-screen player. The trick in sweeping a look past the lens is to avoid looking directly *into* the lens. The look must pass just *above* or *below* the lens, depending on whether the camera is below or above the player's eye-level. A professional actor will have

112

Camera #2 films girl.

Camera #1 films boy.

Camera set-ups for opposing three-quarter angle close-ups are made from impersonal objective angles.

Player in close-up relating with off-screen player must exit scene between camera and action axis. This is particularly important in p.o.v. close-ups because player is working close to the axis and filmed almost full face to the camera.

no difficulty in sweeping his gaze past the camera without actually looking into the lens. Without careful instruction, an amateur may "sneak" a look into the lens, out of the corner of his eye!

Inexperienced cameramen and directors often hesitate to allow a player a sweeping look; because they fear the look may be into the lens, or the shot will not match bracketing scenes. The player may turn and look on both sides of the lens any time he is positioned between two or more players; or, any time he switches his gaze from an on-screen player to a player or action off-screen. For instance, he may turn to watch a player enter a

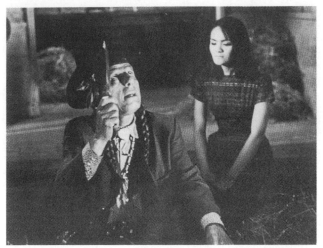

Examples of axis cross: Camera set-up #1 depicts player with knife on screen left — girl on screen right. Camera set-up #2 has crossed axis, and transposed players on screen.

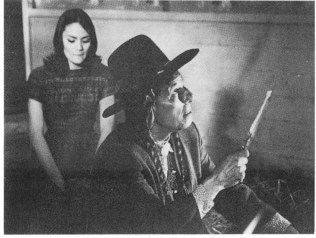

room, or a car arrive. A new axis is created whenever a player switches his look at the end of a shot. The next shot must be based on the line drawn between the player and the subject with whom he relates. This is important whenever a player looks at an off-screen player, who is then shown in a cut-away reaction close-up.

NEUTRAL LOOK

Whenever a person looks *above* or *below* the lens, the resulting look is *neutral*. A neutral look must be used with discretion, because it suddenly breaks up the normal right-and-left looks and

Neutral look — above or below lens — may puzzle audience, unless player is looking up or down at another player, object or action. Neutral look breaks up normal right or left directional look toward opposing player. Up or down look should be to side of camera, to preserve direction.

thrusts a puzzling *non-directional* look at the audience. The neutral look is so close to a look directly into the lens that it may be misinterpreted. Cameramen and directors sometimes resort to a neutral look, to cover an inadvertent mis-match due to wrong player or camera movement. The neutral

CAMERA VIEWPOINT
MAY CROSS ACTION AXIS

Martin Rackin Prod.

Camera viewpoint may cross action axis to film players in rear of set. Camera #1 films full shot. Camera #2 may be positioned across axis to film medium shot of rear players. This is same as drawing parallel axis or shooting across original axis with longer focal length lens.

Martin Rackin Prod.

look is rarely successful if both players are the same height; since they must look at each other in opposing close-ups, and cannot look up or down. It can be used if one player is seated, or if a player is knocked down during a fight, or if a player is at another level — such as the top or bottom of a staircase or a mountain. A player looking up, in such instances, would look just above the lens. One looking down, would look just below the lens. Even in these cases, however, the up or down look should be to the *side* of the camera, to preserve the action axis. The neutral look should be used only in emergencies when retakes cannot be filmed, or when a cameraman or director must film a player looking up or down to match stock footage which has not been chosen, or whose directional look is unknown. If only a shot or two are involved, it is best to shoot the scenes twice, with both a left and right look — rather than a neutral look — so that the film editor may have his choice.

115

MATCHING LOOK ON MOVING PLAYERS

Matching the look on statically-positioned players presents few problems, because the action axis remains fixed. When players move *during* a scene, the *action axis moves with them*, and must be redrawn at the *end of each shot*. Thus, the action axis may be further defined as a line drawn through the nearest players on opposite side of the frame *each time the camera is cut*.

Opposing close-ups of players with lamp — or other object — between them, should not include portion of object, because it will appear on right in one close-up and on left in opposing close-up. Object should be cheated out of close-ups or moved closer to one player so that it appears in one close-up only.

This is necessary because the players may change their positions, or camera may pan or dolly so as to originate a *new* look in a direction different than that with which the shot began. The players, the camera, or both, may cross the axis *while filming is in progress* because the audience observes the moving change in their positions. However, the player, *or* the camera, may *not* cross the axis *between camera set-ups*, because player positions would be changed unaccountably, and the following shot would not match.

Anything may happen *during* a scene — *nothing* must be altered *between* scenes. Drawing a fresh axis at the end of each shot will automatically maintain matched looks, because the camera will always be positioned on the proper side of the line. To avoid a jump-cut, care must be taken to duplicate players' positions.

MATCHING LOOKS ON
MASTER SCENE CUT-IN SHOTS

When consecutive shots are filmed in chronological order, it is fairly simple to match the look on moving players. Difficulties sometimes arise when several cut-in shots must be matched to a master scene. Matching the look on closer shots may be tricky if a great deal of player and/or camera movement occurred in the master. Since the action axis moves with the players, and can be altered by camera movement crossing the original axis, it is necessary that the axis be drawn through the players at the particular point in the master scene

where the closer shot will be cut in. If all player and camera movement is blocked out and filmed with the aid of chalk or tape marks on the floor, returning to any position and duplicating the axis at that point, is fairly simple. The Polaroid camera is a valuable aid in matching precise positions and looks. Stills may be shot during the master scene to aid the players and the cameraman. Particular care should be taken in shooting close-ups which may call for the player looking in one direction at one point in the master, and in an opposite direction later for a separate cut-in shot. Although such close-ups are filmed at one time, changes in direction should not be disregarded.

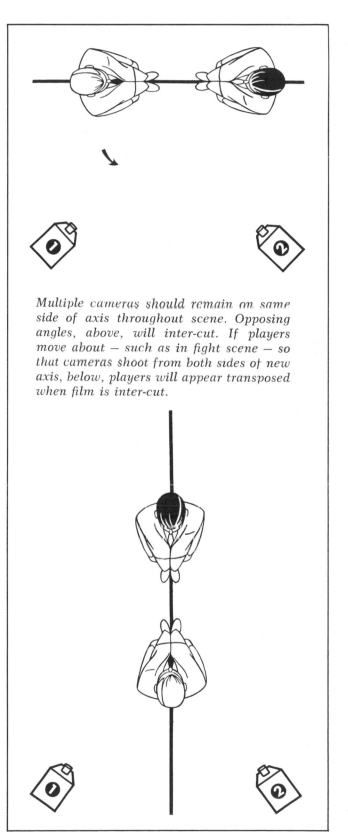

Multiple cameras should remain on same side of axis throughout scene. Opposing angles, above, will inter-cut. If players move about — such as in fight scene — so that cameras shoot from both sides of new axis, below, players will appear transposed when film is inter-cut.

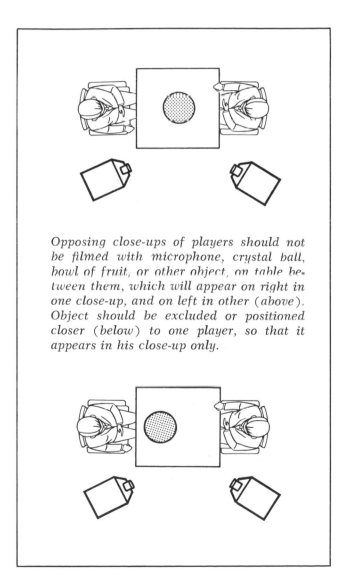

Opposing close-ups of players should not be filmed with microphone, crystal ball, bowl of fruit, or other object, on table between them, which will appear on right in one close-up, and on left in other (above). Object should be excluded or positioned closer (below) to one player, so that it appears in his close-up only.

ACTION AXIS
FOR CUT-AWAY CLOSE-UP

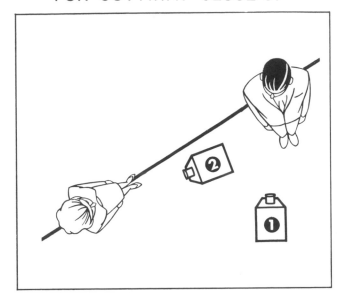

Action axis for cut-away shot is drawn from on-screen to off-screen player. Camera #1 films on-screen player. Camera #2 films off-screen player. Looks will oppose each other when on-screen and off-screen players are filmed from same side of axis.

MATCHING LOOK WITH SINGLE PLAYER

An individual — sitting at a desk, working at a machine, or operating an instrument panel — should be filmed with a consistent look in a series of consecutive shots. The fact that he is alone and not relating with anyone else in the scene makes no difference. The principle of the action axis holds true when filming an individual because the look must be consistent on each side of a cut unless the player or the camera crosses the axis *during* a shot and begins a new look. A worker operating a machine should not be shown first from his left side and then from his right, unless he necessarily turns during the shot.

Harann Prod.

Harann Prod.

Player looking screen right turns his head to observe other player entering room. Action axis is drawn between on-screen and off-screen players. Camera should be positioned on same side of axis for cut-away close-up so that both players look toward each other.

The featured person should first be considered in relation to his work, so that the axis is drawn in the direction he is facing. If sitting at a desk signing papers, for instance, he may be filmed in a front three-quarter angle facing screen *left*. The axis would be drawn through him in the direction he is looking. The camera may be positioned anywhere within a 180 degree arc on the right side of the line. An over-the-shoulder shot — such as signing papers or reading a report — would be filmed

Harann Prod.

Matching players' looks on master scene and cut-in shots is easier when players remain in static positions. Looks must be carefully noted if master scene contains considerable player and/or camera movement.

over the *left* shoulder. If the camera were to shoot over his right shoulder, it would cross the line and suddenly present the player transposed — facing in the opposite direction — on the screen. The camera may be moved to the front for a head-on shot, but the look should still be toward screen left. If the camera were moved too far, it would cross the line and transpose the player — because he would be facing screen right.

The person may turn his head in any direction during the scene. The camera may dolly across the axis during the scene. But, any shot that ends with a new look requires a corresponding axis for filming the following shot. Such a situation may arise if another person were to enter the scene, and stand or sit in a position that would create a new axis. It is wise, however, to remain with the original axis when filming one person in a static position, particularly for a short sequence involving only a few shots.

Before the long shot is filmed, it is best to check whether the individual is right- or left-handed. Otherwise, the close-up may require shooting over the wrong shoulder to avoid hiding the action. A right-handed person, for example, should be filmed over his left shoulder; so that the audience may see what he is signing, or view what he is doing with his right hand. Shooting over his right shoulder would obscure the action if it covers the act of signing his name.

Harann Prod.

Harann Prod.

Camera set-ups are positioned on same side of axis, and players' looks are precisely matched in these objectively-filmed opposing cut-in closer shots.

Person looking through window should have action axis drawn in direction of look. Both interior and exterior camera set-ups should film from same side of axis.

University of So. Calif. Cinema Dept.

Man at desk may be filmed with neutral head-on camera for subjective into-the-lens shot; or for objective shot, in which he sweeps look left and right.

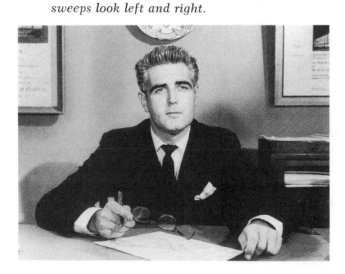

Multiple camera filming of machine operation should be based on action axis drawn in direction of worker's look. Cameras #1 and #2 film worker with same directional look. Camera #3 crosses axis and films opposing look.

Camera #2 films over left shoulder. Man is still facing screen left.

Camera #1 films three-quarter angle of man facing screent left.

Camera #3 is positioned across axis — films over right shoulder. Man is transposed — now faces screen right.

Employing multiple cameras to film an individual at work requires careful placement of *all* cameras on the *same* side of the axis, so that the person is not transposed in some of the shots. A machine operation, engineering test or field trial, should be filmed so that the featured individual looks and works in a single direction.

Even when shot with a neutral camera shooting straight on, the look should be on the proper side of the lens, to preserve the action axis. Cameras may be positioned behind, in front of and at the side for all types of single shots — but should *not* be placed on the *opposite* side of the axis. Then, the entire operation would be reversed. Careful camera positioning is required if the event involves a large area — such as a rifle range. Although far apart, the rifleman and target form the axis. The target may be filmed head-on — from the rifleman's point-of-view — but all camera positions on the range should be from the same side of the axis, so that the gun always points in the same direction on screen.

MATCHING LOOKS ON
SPEAKER & AUDIENCE

Handling the action axis when filming a speaker — such as a master of ceremonies, an instructor, a lecturer — *talking to an audience*, differs from shooting a play or television show performed *for* an audience.

The actors relate with *each other* across a stage in a play. A speaker *relates* directly with the *audience*, when addressing them. An instructor speaks to his class, as if engaged in a two-shot with each individual. Therefore, the *speaker* and *each member* of the audience should have *opposing* looks, the same as in a two-shot. Difficulty in matching opposing looks may arise because the audience is spread out in a row, so that the speaker must look both right and left to relate with members. The audience forms the base of a triangle with the speaker at the apex.

There are two ways to film a speaker and an audience. Either method may be employed individually or in combination.

The *action axis* may be drawn down the center aisle. If there is no aisle, a center line may be drawn. The camera may be positioned on *one side*, shooting toward the centerline. This is the simplest method for presenting master of ceremonies,

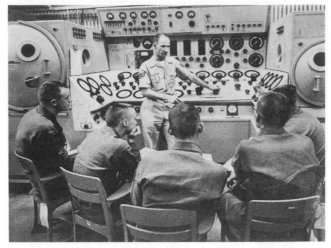

North American Aviation

Neutral head-on shot of instructor and class. Instructor may look either left or right. Individual shots of students should be inter-cut in an opposing manner — when instructor looks left, student looks right; when instructor looks right, student looks left. This is similar to a three-shot which breaks up into two two-shots — with individual opposing close-ups.

teacher or lecturer — and audience or class — with opposing looks, as in a two-shot. Profile close-ups of speaker and members of the class may thus be filmed. Three-quarter angle and point-of-view close-ups — similar to those in a two-shot — may

QM Prod.— 20th-Fox—ABC-TV

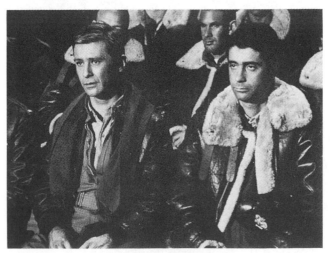

QM Prod.— 20th-Fox—ABC-TV

Speaker and audience are depicted with opposing looks. Camera positions were set up on same side of centerline axis. Speaker may also be filmed with neutral head-on camera and look either left or right. Film should be edited in an opposing manner, so speaker and members of audience appear to look at each other.

20th Century-Fox Film Corp.

In theater scene filmed from right side of centerline axis, band conductor faces screen left. Reverse shot of audience should be filmed from same side of axis — for opposing look. In an extended sequence, the camera may be positioned for neutral shots or opposing shots looking in either direction. Speaker on stage should be inter-cut with opposing shots of members of audience for smoother continuity.

stage toward the audience — with the camera close to the axis, or from the corners of the room — for angle shots, with the same opposing looks. This method is recommended for classroom or short theatrical sequences. Such treatment may become monotonous when drawn out, because it lacks visual variety.

The alternate method is to draw the *action axis across* the audience, *parallel* to any *row of seats*, or base of the triangle. The camera may be positioned anywhere *within the triangle* formed by the speaker at the apex and a row of people along the base. This is similar to a three-shot. This permits freedom to shoot speaker or audience looking in *either* direction. The speaker may be filmed straight-on and sweep his look past the camera, so that he looks both right and left at the entire audience. Members of the audience on one side will look left, on the other side they will look right. Editorially, it is wise to inter-cut the shots, so that a look by the speaker is followed by a look by a member of the audience in the opposite direction. Or, if several close-ups of the audience follow one another with opposite looks, the final audience shot should oppose the next shot of the speaker. This should make for smoother continuity, as the opposing-look treatment is employed for matching *consecutive* shots of speaker and audience.

also be filmed with the assurance that the speaker will always look in one direction and members of the class in the opposite direction. Long and medium shots of the auditorium or class may be filmed from the rear toward the stage, or from the

ABC-TV

ABC-TV

Master of ceremonies may relate with performers on stage and also relate directly with audience. He may look left and right. Members of audience may look in either direction. Consecutive shots of M.C. and audience should oppose each other for smooth effect.

Since stage speaker relates directly with audience, theater sequence should be filmed with centerline axis for opposing speaker-audience treatment — similar to filming two players in opposing close-ups. Camera #1 shoots toward stage for long shot of audience and speaker on stage. Camera #2 films opposing long shot of audience from same side of theater. Camera #3 films speaker facing screen left. Camera #4 films audience facing screen right. Camera #4's viewpoint may cross axis optically — to film close-ups of individuals. Camera #5 films individuals on opposite side of theater with screen right look. All camera set-ups shoot toward centerline, to present speaker with look toward screen left; and members of audience with opposing look toward screen right.

Theater sequence may be filmed with parallel axis (line running parallel with rows). Camera #1 films speaker, who may sweep his look left and right — to relate with members of audience on both sides of theater. Camera #2 shoots members of audience on left side of theater, with look toward screen right. Camera #3 shoots those on right side, with look toward screen left. Shots of audience and speaker should be inter-cut with opposing looks for best pictorial effect. Camera #4 films neutral shots from rear of theater. Centerline axis and parallel axis may be combined in lengthy sequence — for visual variety.

Medium shots of several people or individual close-ups should look in accordance with their locations. Those seated on the left side of the auditorium should look right; those on the right should look left. Thus, each member of the audience and the speaker are engaged in a two-shot, with opposing looks. Or, the speaker and any two members of the audience at opposite sides of the room, may be considered engaged in a three-shot which becomes two two-shots. The speaker turns from one to the other, so that his look creates a new axis for the following two-shot.

Neutral shots may be inserted between shots of speaker and audience — which do not present opposing looks. Neutral shots also break up the back-and-forth opposing treatment of directional shots. The speaker may switch his look in a neutral shot from one side of the auditorium to the other; and the scene may cut with medium shot close-up of audience members with opposing look.

Individual long shots of either the stage or the audience should be filmed head-on for a neutral treatment; or, from the same side of the centerline for an opposing effect. Long shots toward the stage and toward the audience filmed from opposite sides of the centerline should be avoided, because speaker and audience will face in the same direction — *not* toward each other!

The centerline treatment is best for simple sequences, as in a classroom. The parallel treatment, or a combination of both treatments, may be employed whenever greater freedom in positioning camera or more visual variety is desired.

Either, or both, these treatments may also be employed to film any type of play, demonstration, or staged action; where people on stage do *not* relate with the audience. Such filming is less complicated, because the people on stage relate only with each other, and the audience merely observes. Opposing looks are not required.

The important point to remember is that the camera must remain on one side of the centerline axis whenever opposing looks are required. Or, it may remain neutral for head-on shots. The camera may not cross the centerline axis in consecutive shots — because looks will be in the same direction, rather than opposing.

In a long sequence, the camera may go anywhere, if mis-matched shots are spaced a scene or two apart when edited. This can be handled because an auditorium is a fixed situation with a definite front and back, and the people are seated and facing in one direction only. The viewer will not be confused, no matter what type of shots are screened, or how they are edited. Results are pictorially more effective, and easier to view when opposing looks are presented so that speaker and audience relate in consecutive shots.

ACTION AXIS FOR THREE PLAYERS

Three-shots require special consideration in accordance with their staging. There are two types of three-shots: with one dominant player who relates with two others, who are close together; with three players who are spread apart and take turns in dominating the scene.

The first type occurs when a minister relates with a bride and groom; a teacher speaks to two pupils; a bartender serves a couple. Under these conditions the dominant player should be positioned on one side of the screen, and the other two players on the opposite side. The supporting players are treated as a unit, and the set-up is handled

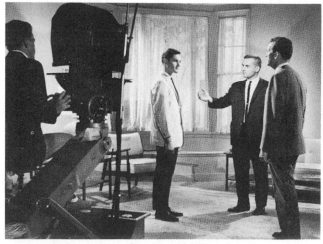

University of So. Calif. Cinema Dept.

Camera shoots three-shot with players spread apart, and equally dominant in turn. Camera may cross axis optically to film rear player — who may relate with either foreground player — by switching his look from one to other.

in an opposing manner — for example, with the dominant player facing screen right, and the others facing screen left. Over-the-shoulder, objective or point-of-view close-ups may all be filmed — with the same treatment as a two-shot — with the camera positioned on the same side of the action axis drawn through the two players nearest the camera, on opposite sides of the screen. The supporting players may be filmed together or in individual close-ups — both with the same screen left look.

When the dominant player — on the left — looks

Universal City Studios

Minister dominates marriage scene — so that it may be filmed from both centerline axis (above), and a parallel axis (below). Minister looks toward right, at groom, at beginning of shot (below), to preserve screen right look for smoother transition. Then, he may switch his look to bride.

Universal City Studios

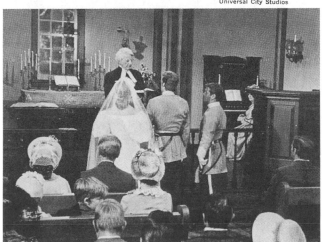

at the player in right background, the *look* creates a new axis between them. The camera may now be positioned *between* the two players on the right, to film a front-face close-up of the dominant player. It is important that the look be directed screen right — toward the far player — so that a smooth cut results from the side angle to the in-between rear angle. Many directors and film editors prefer a strong speech or action, which depicts a definite connection between the dominant player and the far player. An action — such as serving a drink — is preferred, so that the two shots may be cut on the move, with an action toward the right to preserve the dominant player's right look. In weaker situations, the camera should not be brought completely around between the supporting players — it should remain on the same side of the original axis.

The second method — with players spread apart and each dominant in turn — should be filmed with a single axis. Thus two players will be in the foreground and one in the background. If the camera should cross the axis, one of the foreground players will suddenly appear on the opposite side of the screen and the rear player on the other side! The camera may cross *optically* to film the rear player in close-up, and he in turn may relate with each of the players in separate shots. Each two-shot may be handled individually with over-the-shoulder, point-of-view or objective close-ups, as desired.

When two players are close together, they should be treated as a single unit. Either or both should be filmed from the same side of the axis, so that they present the same look toward the opposing player. A three-shot with a dominant player and two supporting players may thus be treated as a two-shot, since the dominant player and the supporting players are at opposite ends of the axis.

When three players are spread apart and each dominates in turn as he speaks or reacts, each must be treated individually and present an opposing look to the player he is relating with at the time. The three-shot thus becomes a series of two-shots — with each two-shot creating its own axis as players switch their looks.

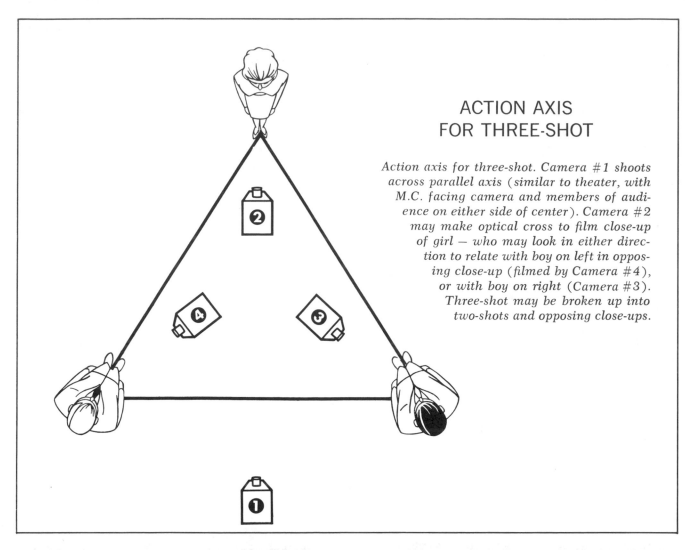

ACTION AXIS
FOR THREE-SHOT

Action axis for three-shot. Camera #1 shoots across parallel axis (similar to theater, with M.C. facing camera and members of audience on either side of center). Camera #2 may make optical cross to film close-up of girl — who may look in either direction to relate with boy on left in opposing close-up (filmed by Camera #4), or with boy on right (Camera #3). Three-shot may be broken up into two-shots and opposing close-ups.

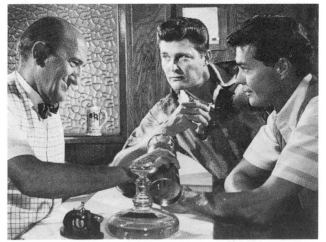

Camera #1 films side angle — bartender turns toward player in right background.

Cut to Camera #2 may be made when bartender turns toward player in right background — creating new axis.

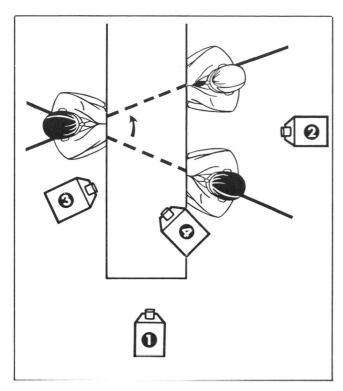

Three-shot in which one person dominates, may be filmed from side angle; with dominant player facing right, and supporting players facing left. Camera #1 films entire group. Cameras #3 and #4 may film opposing close-ups. When bartender looks or serves drink — to player in right background, new action axis is created. Camera #2 films bartender looking right to preserve original look.

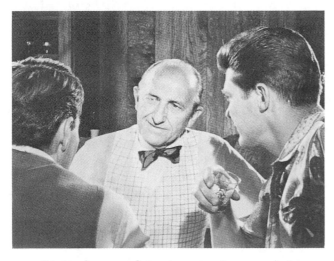

Bartender may later turn to player on left as scene progresses.

MATCHING LOOKS ON GROUP SEATED AROUND A TABLE

Difficulties may be involved when filming a group of players seated at a table, particularly a round table. A closed circle of players, looking inward toward each other, requires filming scenes that are staged with the editorial pattern in mind. Such scenes should be well established, so that the viewer is not confused when two or more players — shown in two-shots or individual close-ups — speak to off-screen players.

The axis should be drawn through the two players nearest the camera on opposite sides of the screen. The camera may cross the axis to film a far player — or several players — by drawing a parallel axis. An individual player may look at an on-screen or off-screen player by drawing the axis from one to the other, so that they are filmed from the same side with opposing looks. If a number of close-ups follow one another, it is best to pull back at intervals and re-establish the scene.

The camera may move around to film individual close-ups of players across the table from each other; because the look of an on-screen player

20th Century-Fox Film Corp.

Players seated around table should be properly established, so that audience is not confused when camera moves in for medium shots and close-ups. Axis should be drawn between players relating with each other, so that they are presented with opposing looks in individual close-ups.

If three-shot is broken into two-shots — centered player will appear on right in one two-shot and left in other.

toward an off-screen player creates a new axis. A player may look in one direction, and relate with a player who is shown with an opposing look. Then the original player may switch his look and relate with another player on the other side of the table. No confusion will arise in the viewer's mind if the scene is established and each set of players are shown with opposing looks.

Shooting a three-shot — followed by a *pair* of two-shots which places the middle player on one side of the screen in one shot, and then on the opposite side in the following shot — is not advisable. It is better to break up such shots into two-shot and close-up; or into individual close-ups.

RE-POSITIONING ACTION AXIS FOR BACKGROUND CHEAT

Often, it is impossible to shoot a reverse close-up of a player because of space limitations on a location interior, or the absence of a background on a two or three wall set. In such instances, the player may be positioned against *another* wall, providing camera angle and player's position and look match the original set-up. First, the camera set-up should be plotted in the original position. Then, *both* camera and player should be turned around — as if both were on a turntable — so that the relationship is unchanged. In this way, the camera and the player's look remain on the same side of the new line as they were in the original axis. The opposing off-screen player should be posi-

tioned on the proper side of the camera to exchange dialogue. The background may require re-dressing — with a picture — to suggest another wall, if it appears in other shots.

MATCHING LOOK ON STOCK SHOTS & PRODUCTION SCENES

It is often necessary to match stock shots with production scenes. A stock library shot of a large audience may be used with production scenes of a speaker on stage. Or, a picture may be made up almost entirely of stock shots with freshly filmed cut-away reaction shots, or other scenes needed to provide continuity or transitions. In either case, it is wise to study the stock shots before filming the production scenes, so that properly oriented opposing or matching looks may be recorded. It is advisable to project the stock shots; or to study them on a film viewer, and make a detailed listing with small diagrams depicting the angle and look. If possible, short lengths of film should be studied on the set when shooting the inter-cutting scenes.

The best way to assure matching is to make a mental pan from the look in the stock shot to the shot about to be filmed. This will automatically suggest the correct look. If an audience is looking screen right, the mental camera is panned to show — in the mind's eye — the opposing look of the speaker, as well as the proper opposing camera angle. If a missile or an airplane soars into the air, the reaction shot is filmed by having the player

Three-shot should be followed by two-shot and close-up of single player; or individual close-ups of each player.

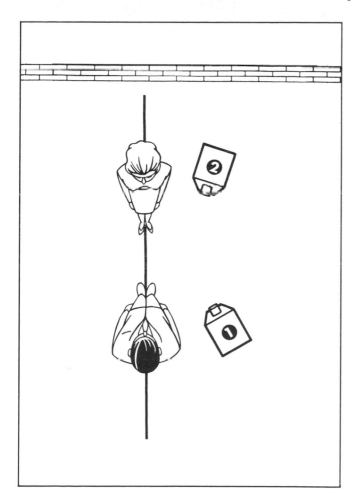

Camera #1 films girl. Camera #2 cannot film boy because of absence of set. Both camera and boy are turned clockwise, so that boy may be positioned against available wall and filmed from original opposing angle. Player's position may be cheated, providing original player-camera relationship is maintained.

imagine he is seeing the action happening behind the camera. If a take-off or landing of an airplane must match a stock flying shot, the plane must take off or land in the same direction. If a close-up of the pilot is filmed for insertion in a stock flying shot — the pilot should be faced in the direction of travel.

REVERSE SHOTS

Because of matching problems they may cause, reverse shots seem confusing on occasion. Positioning a camera on the opposite side of a set or room — or otherwise turning a camera around so that it points in the opposite direction — deserves serious consideration, because it may transpose the players. Reversing the camera also introduces a new — and sometimes completely different background. This may confuse the viewer because players' positions must be re-oriented in relation to the setting.

Matching and editorial problems can be eliminated if the principle of the action axis is followed. Opposing over-the-shoulder and point-of-view close-ups, and head-on and tail-away travel shots, are filmed from diametrically opposite reverse angles. Yet, through use of the axis, the players' looks and the subject's travel direction remain consistent. Accordingly, the simple expedient of the action axis will automatically insure success on reverse shots.

The camera angle may be freely reversed in theaters, churches, courtrooms, or in vehicles — autos, buses, trains, airplanes — because the people are positioned in fixed seats. Such settings have in common distinctly different fronts and backs — stage, altar or judge's bench; or front and rear ends of vehicles.

Seated persons may be photographed from the front, rear or side. The viewer becomes immediately aware that the camera — not the people — has changed positions. Even under these conditions, however, it is wise to stay on the same side of a centerline axis whenever possible — so that a uniform directional look is presented in all shots. The camera should shoot either neutral straight-on front or rear views; or shoot toward the front or back of the setting or vehicle — from the same

side of the axis. Or, a neutral shot may be inserted between scenes filmed with opposite looks, due to crossing the axis.

Reversing the camera may be safely accomplished without confusion in any setting or room with a distinctive feature — such as a staircase, a large doorway, a fireplace, bookshelves, etc. A nondescript room, with similar walls, undistinguished furniture, drapes, or other accoutrements, may confuse the viewer. While a reverse shot in this situation may depict the actors from a new angle, it will present a similar background.

Camera set-up may be reversed in any setting with fixed seats — such as airplane or train. Neutral head-on or tail-away shots may be filmed. If camera is positioned, on one side of the centerline — it should remain on same side for reverse shot, to preserve directional look.

Santa Fe Railway

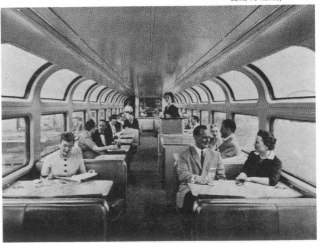

It is usually safest to establish the overall setting. In that way, the audience will know the geography of the room, and will readily comprehend the change to a reverse angle.

A reverse where a player, or group of players, walks toward the camera and exit — and are then picked up in a reverse shot entering and walking away from the camera, to cross the room — should be based on a mental pan. This would show that if the subject exits right, he should enter left. Travel in a constant direction will show progression only when it is filmed from the same side of the action axis. This is the same as filming head-on and tail-away shots for a travel sequence.

If a group of players remains fixed, and the camera films them first from one side of a room and then the opposite side, a different situation is presented. The players may look off-screen to observe a new player entering the room. Then, the camera may be placed behind them on the opposite side of the room — to show the player coming through the door toward them.

The players looking off-screen create a new axis between them and the player entering. If the camera remains on the same side of the axis for the reverse shot, players' directional look will be the same in both scenes. The camera may be positioned to shoot the entering player between two other players — from a reverse angle — providing the new player walks toward the group's look.

A reverse may be accomplished with a player's off-screen look — which allows the camera to be turned around to show what he sees. A player may look past the camera toward the opposite side of a room — and the camera reversed to show the scene from his point-of-view. This should be filmed from the same side of the axis if the player relates with another player, so that they present opposing looks. This is equivalent to a pair of objective or point-of-view close-ups filmed as part of a two-shot — except that it covers a wider area.

Most important, in reversing the camera, the viewer should not be confronted with transposed players against new backgrounds. The scene should be established so that the audience is immediately aware of the type of setting — church,

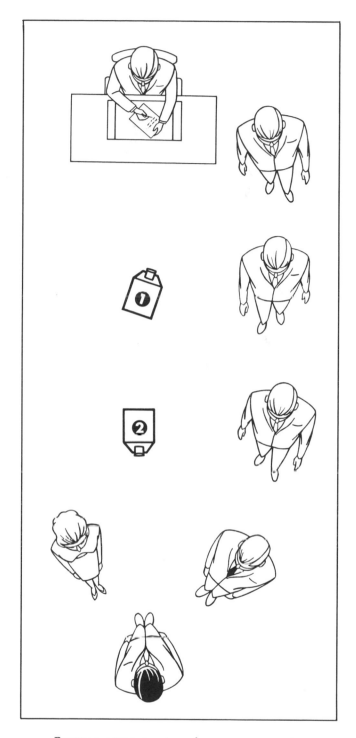

Reverse camera set-up for person crossing room should be based on mental pan. Camera #1 films player, who rises from desk and exits screen right. Camera #2 films reverse angle — as if panned around — as player enters screen left, joins other players on opposite side of room.

133

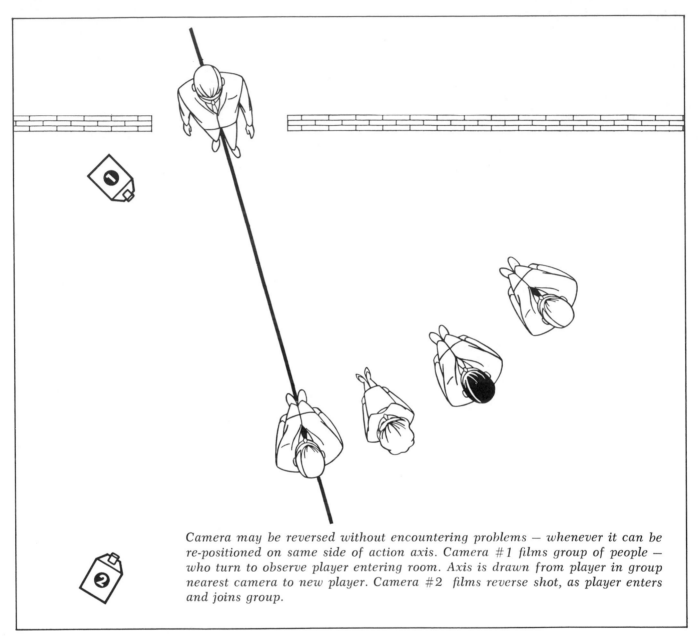

Camera may be reversed without encountering problems — whenever it can be re-positioned on same side of action axis. Camera #1 films group of people — who turn to observe player entering room. Axis is drawn from player in group nearest camera to new player. Camera #2 films reverse shot, as player enters and joins group.

bus, auto. Or, the camera should be positioned so that a distinctive setting feature is seen in an overall view. Thus, later reverse will not cause confusion.

CONCLUSION

Directional continuity must be maintained throughout a sequence depicting continuous action, without a time lapse. Player movements, positions and looks must match on each side of a straight cut. Movement of players into or out of various set-ups must be filmed with entrances and exits which match the established directional continuity. All players — whether on or off screen — must be presented in both cut-in and cut-away shots with properly matching looks, which leave no doubt in the audience's mind where players are positioned, and to whom they are relating. The action axis must be redrawn at the end of any shot where player and/or camera movement has caused it to change from the original axis.

The action axis encourages rather than stifles

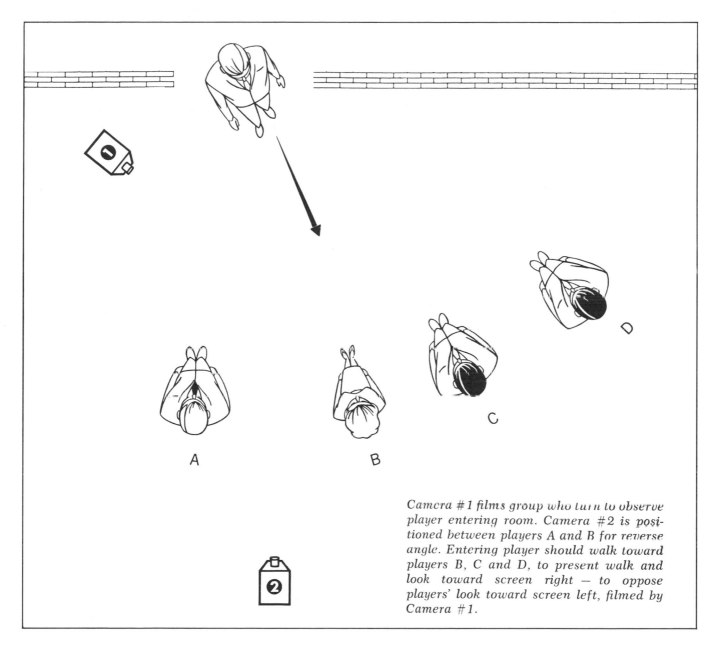

Camera #1 films group who turn to observe player entering room. Camera #2 is positioned between players A and B for reverse angle. Entering player should walk toward players B, C and D, to present walk and look toward screen right — to oppose players' look toward screen left, filmed by Camera #1.

the use of camera angles. By use of this principle, camera and subjects are free to roam the set, or look in any direction — without fear of the wrong directional look. There are no restrictions on either camera or player movement. *The most important fact to remember is that player movement or player looks must be the same on each side of a match-cut.* Therefore, the movement or look at beginning and end of each shot must be noted, and new axis drawn through players at the end of shot, if it differs from axis which shot began.

Anything may change during a shot: the players *may* reverse direction or change looks or positions; the players *may* cross the axis; the camera *may* pan or dolly in any direction; the camera *may* cross the axis; both camera and players *may* move in any manner in any direction, in any combination. *Nothing should be changed between shots:* the players *may not* change direction of movement or change looks or positions; the camera *may not* cross the axis established by the players at the end of the last shot. All this applies

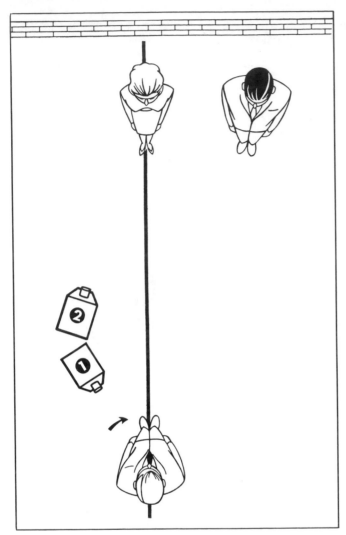

Player's look may motivate reversing camera. Camera #1 films player, who turns to look across room. Action axis is drawn between player and girl on opposite side of room. Camera #2 films reverse shot from same side of axis — in a similar manner to opposing angle close-up, except for wider angle.

only to match-cuts, in which the action is continuous from shot to shot. It does not apply to scenes connected by dissolves or other optical effects; or to scenes edited into other scenes occurring elsewhere, or to cases where both centerline and parallel axes are used. Whenever the action is interrupted editorially or optically, it is possible to assume that changes may have occurred in the meantime. Established screen direction should be preserved in a series of shots — such as a chase —

which are edited alternately with other shots, since, for practical purposes, these scenes are continuous. In the final analysis, directional continuity consists of remaining on the same side of either moving or static players or vehicles, so that the established movement or look is maintained in consecutive shots.

BRIDGING TIME & SPACE

Ordinarily, motion picture continuity should flow in an uninterrupted sequence of images. It may not always be practical or desirable to depict an entire motion picture story in a continuous manner. This may entail meaningless passages, which would detract from the story-telling, and slow down — rather than accelerate — the narrative from introductory opening scenes, through developing sequences and on to the climax.

Real, by-the-clock, time may be used in a continuous sequence. However, cut-in or cut-away shots permit removal or inclusion of action; without the audience realizing that time has been compressed or expanded. Since motion pictures are an illusion, no fixed rules can be laid down for depicting time or space.

Regardless of how these elements are handled, the audience should receive the distinct *impression* of viewing events in their entirety. Even compilation films should present a continuous picture whenever a series of consecutive scenes are to be presented. Such an illusion must be properly conveyed, or the story-telling spell may be broken. Whenever a *time lapse* or a *change of locale* must be explained, either *within* a sequence or *between* sequences, various transitional devices may be employed to *bridge* time or space.

TRANSITIONAL DEVICES

PICTORIAL

SOUND

These methods may be used, individually or in combination, to bridge time and space.

PICTORIAL TRANSITIONS

The simplest method for achieving smooth pictorial transitions is by use of introductory titles;

stating place and/or time to set the stage. Place name and calendar time, such as *Omaha Beach, June 6, 1944*, would introduce a sequence showing the invasion of Europe by Allied Forces in World War II. Dateless elapsed time may also be conveyed with the title: *Five Years Later*. A map may show progress at intervals during a journey, or location of the event that follows. The scene may open on a place name at port of entry, airport or train or bus depot. Or, it may open on a newspaper, clearly focusing on date.

Pictorial transitions may employ any of the following optical devices:

FADES

DISSOLVES

WIPES

FADES

A *fade-in*, in which a black screen gradually brightens into an image, is used to *begin* a story or sequence. A *fade-out*, in which the image gradually darkens to black, is used to *end* a story or sequence. Fades may be of any length required to fit dramatic tempo of the action.

While fades are generally employed in pairs — fade-out followed by fade-in — this is not a strict rule. An individual sequence, several sequences, or a complete picture, may be bracketed by fades. This will segregate the various narrative units. Sequences separated by fades are similar to chapters in a book; or acts in a play. Fades between sequences occurring in the same locale, indicate a passage of time, such as from one day to the next, or weeks or months later. Or, fades may be used to indicate a switch to another setting. Fades should be used sparingly, or they may produce a choppy or episodic effect, which disrupts the narrative flow. Fades should be used only at beginning and end of a picture, unless the subject matter is divided into distinct time intervals, or narratively separated in space.

DISSOLVES

A *dissolve* blends one scene into another. Technically, a dissolve is a fade-out superimposed upon a fade-in, so that a loss of image density in the

first scene is balanced by a gain in image density in the second scene. Dissolves are used to *cover a time lapse* or a *change in locale;* or to *soften* a scene change that would otherwise be abrupt or jarring. Consecutive titles are generally dissolved so that one blends into the other. Scenes that would appear as jump-cuts because of sudden shifting of the center of interest, may be dissolved. Length of dissolves may be varied to match dramatic tempo.

Matched dissolves, in which the two connected scenes are similar in form, motion or content, may be utilized to effect a smoother transition; or to preserve the narrative flow, by making the image

Santa Fe Railway

Dissolve may be used to cover time lapse — such as depicted in sequence of Navajo women carding and spinning wool to be woven into blankets.

Santa Fe Railway

change less abrupt. Similar forms, such as flowers and jewels; like motions, such as wheels and propellers; similar content, such as a match flame and a forest fire; are effective combinations. Matched dissolves should not be too tricky. Nor should they draw attention away from the narrative. Unless their images stem from story, matched shots should not be used for transition dissolves.

Distorted dissolves, in which the blending images shimmy, ripple, shiver, shake, twist, turn, go in and out of focus, or are otherwise blurred; may be employed to denote a sudden switch to a player's subconscious, retrospective, mentally-unbalanced, drunken, doped, or other abnormal state of mind. Such dissolves, often accompanied by eerie sound, may be used to introduce a flashback.

A pair of dissolves should generally be used to bracket a flashback, flashforward or other abnormal condition. A return dissolve may *not* be required in situations where the audience comprehends the change; or it is desirable to startle or shock the viewer. If the same person, or group, tells several stories and always returns to the same setting, the audience may only need a dissolve *into* the story, and will not be confused when the flashback ends and is straight-cut to present narrative. Or, a player describing a weird experience, may be straight-cut to the present with a sudden shock; as if waking from a nightmare!

Frozen dissolves, in which both the last frame of the first scene and the first frame of the second scene are frozen *during* the dissolve, may denote time standing still between scenes. A highly pictorial variation of the frozen dissolve may employ matched paintings or drawings. The moving photographic image is frozen, and dissolves to a painting or drawing. This in turn, dissolves to another painting or drawing; which then dissolves to a frozen photographic image; which then moves and continues with the story. The match between picture and painting or drawing is accomplished by photographically enlarging the film frame, and either painting or tracing the image. Such optical effects must be handled by an optical camera/enlarger set-up, equipped for holding precise registration through various steps.

If the story involves a news event, such as a trial; the image may be frozen by a still photographer's flash bulb. The frozen frame is then dissolved to the still picture, revealed as part of a newspaper story — when the camera pulls back.

WIPES

In their simplest forms, *wipes* are moving optical effects in which one scene seems to push another scene off the screen. The wiping motion may be vertical, horizontal or angular. Demarcation between the two scenes may be a distinct line, or a soft blend. Wipes are also available with circular, expanding, contracting, swinging, spinning, rolling or twisting motions. Or, they may be shaped like stars, flames, lightning, keyholes, hearts, spades, diamonds, clubs, etc.

Wiping patterns may be continuous, or broken up into several shapes within the frame — such as a series of expanding circles which merge to reveal the new scene. Wipes are mechanical transitions. Other than the simple vertical, horizontal or angular traveling varieties; wipes are rarely employed in dramatic films. Wipes were frequently used in early sound pictures, particularly in musicals. They are now used mainly in trailers, advertising films and television commercials.

Since wipes require the production of a duplicate negative, or dupe reversal film, their use is ordinarily limited to 35mm motion pictures. A few 16mm labs have available printers which will print simple traveling wipes from "A & B" rolls. If elaborate wipes are required, the picture should be shot in 35mm, and a 16mm reduction internegative made.

MONTAGE TRANSITIONS

A montage transition is a series of short scenes — connected by straight cuts, dissolves or wipes — used to condense time or space. This rapid editing technique may depict portions of the story — when events need not be shown in detail — but must be included for continuity, editorial or narrative purposes. Since the audience receives the impression that a journey, industrial operation, or any lengthy, complex event, is being shown in en-

Lockheed-California Co.

IBM

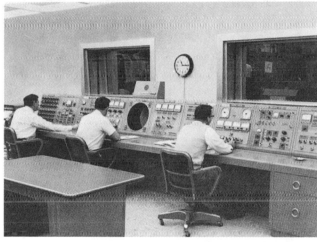

Lockheed-California Co.

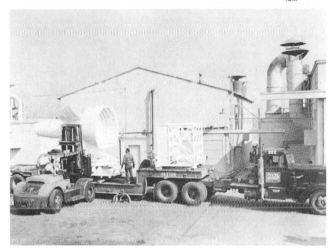

North American Aviation

Montage depicts series of short scenes compressing time. These representative shots show design, computing, testing, shipping of space capsules.

tirety — rather than in pieces — the visual effect is often psychological.

The research, design and development of a complicated electronic system; a new missile; or a giant dam may be depicted in a series of short scenes of drawings being sketched; blueprints being processed; computers working; models being tested; electronic brains flashing data; engineers in conference; components being assembled, transported to the site and placed in position; and finally, views of the completed unit in operation. While some of these individual shots may have little connection with the event, combined they create a cumulative effect of extensive effort. A montage assembled in this manner may compress

months of time, or miles of space into a few moment on the screen. Some of the scenes may be stock shots or scenes filmed for some other purpose! An engineer could be working on almost any project; a conference could suffice for any narrative purpose; scenes depicting office work, transportation, computing, etc., could serve for many different subjects.

A short montage may show an expedition traveling to a remote land by modern modes of transportation. Upon reaching its destination, the expedition may resort to dugout canoes. Then the narrative proceeds to tell the story in a straightforward manner. In this case, the montage sets the stage for the main event.

Superimposed images may be used in a montage to connect two or more ideas. Circus or concert posters may be changed continuously over shots of speeding trains. Newspaper headlines may spin into focus over a trial sequence, to show day-to-day developments before reaching the final verdict. Ticker tape may move across the screen, over scenes of frenzied stock market activity. A rising graph line may be laid over scenes of a new product moving off the assembly line, being shipped, displayed for sale. Progress reports on tests of new equipment may be moved across the screen against scenes of field trials. The oscilloscope pattern made by a heartbeat may be superimposed over a patient undergoing a heart test.

Several separate shots may be individually positioned within the frame, in any number of patterns. The frame may be divided into four or more parts, or a center image may be surrounded by several others. The shots may change simultaneously, or in a round-the-clock manner, to depict various sporting activities, industrial operations; or summing up of a test, report or sales campaign. A many-imaged montage may be used for a title background to introduce the subject. Several images may also be combined within a single frame, when important to show what is happening in several places simultaneously. The effect of rapid decompression upon a pilot in a test chamber may be shown with instrument readings.

Stock shots are often used in a montage, because of budget limitations; or need of depicting historical, foreign, or other scenes which are impossible or impractical to film. If montage shots are filmed, it is wise to work closely with the film editor, to establish an over-all tempo for all action scenes. A metronome may be employed while shooting, if a precise beat is essential for matching action in all scenes. A hand may punch a time clock, punch out a pattern, punch a button to operate a punch press — all these actions will convey greater impact if punched to a definite beat. Subject movement, or camera movement—whether pan, tilt or dolly — should be similar or contrasting throughout a series of montage shots, for most effective results. Many other factors — camera angles, lighting, camera speed, editing pattern,

etc. — should also be considered in planning a montage sequence.

HOW TO USE PICTORIAL TRANSITIONS

Pictorial transitions may be used in many novel ways. While simple titles announcing time and place may suffice when introducing a new sequence, creative thinking will usually develop more interesting visual methods. By studying story, setting, people, props; and looking about for a moving transition stemming from the narrative, various sequences may be tied together.

The two key shots depicting beginning and end

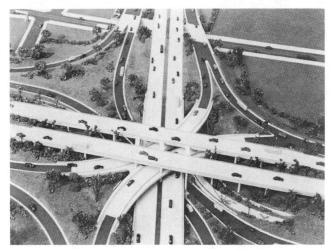

Calif. Div. of Highways

Pictorial transitions may cover time lapse from start to finish of project — such as this model of freeway dissolving to complete road complex in operation.

Calif. Div. of Highways

of a particular interval are most important. A dinner party may be dissolved from soup to nuts. A baby's toddling steps may dissolve to a man's sturdy stride. A miniature airplane model dissolves to the actual full-size aircraft. A roaring fire dissolves to dying embers. A tiny flame becomes a raging forest fire. A few raindrops falling into a puddle may dissolve to a roaring flood. Raw material can become the finished product. Whatever may be consumed or changed by time, may be filmed to cover elapsed time.

Repetitious action may be removed from a lengthy industrial process by dissolving highlights of one repeated operation to those of the next step. Dissolves are particularly useful when the entire processing takes place on a machine — such as a turret lathe — which requires few changes in camera angle or image size. Progress of tool cutting metal may be shown at intervals without jump-cuts, by utilizing dissolves or wipes. Any repetitious mechanical operation; such as tightening a series of similar bolts, throwing a number of switches, or performing other routine tasks, may all be covered by dissolving from the beginning to the end of the action. Years of watching motion pictures, have conditioned audiences into accepting such time bridges as continuous action. A person may walk out of his office, and then be dissolved to the street entrance as he leaves the building. Or, he may enter an elevator and be wiped to the desired floor. Any insignificant time interval may be effectively covered in this manner.

Flashback transitions may employ historical events to pinpoint the time. Newspaper headlines such as: *LINDBERGH FLIES ATLANTIC!*, *LINCOLN ASSASSINATED!*, or *PROHIBITION REPEALED!* — all convey easy-to-recognize periods.

Space may be bridged by cutting or dissolving to signs, names on doors, plaques on buildings, city names on rail, bus or airport terminals, etc. The identifying name will immediately inform the audience of the new locale. A journey may be dissolved from beginning to end with two simple shots, showing departure and arrival.

Wipes should be considered whenever screen movement would be enhanced by pushing one scene ahead of the next in the direction of travel.

Santa Fe Railway

TWA

Matson Lines

Series of left-to-right vertical wipes may depict long journey by train, plane, ship.

141

This is excellent handling for train shots, because the length of the train keeps it moving across the screen for a considerable period. A series of shots showing different modes of travel may be continuously wiped. A player may also be wiped as he walks, rides or drives from one setting to another.

Lengthy travel may be depicted by a montage of scenes showing spinning car wheels, changing odometer figures, thick line moving on a map, passports being stamped, hotel labels being slapped on luggage, travel folders cascading down, road signs flickering by, changes of terrain, tickets being punched; arriving and departing buses, trains, airplanes and ships. These actions may be individual, or superimposed over the traveler's face, or over other scenes.

Well-known symbols may be used to depict countries or cities. Big Ben is England, or London in particular; the Eiffel Tower is France, or Paris; the Statue of Liberty is the United States, or New York; the Coliseum is Italy, or Rome; the Sphinx or the Pyramids is Egypt; the Acropolis is Greece, or Athens; cable cars denote San Francisco; the Liberty Bell says Philadelphia; the Capitol or the White House is Washington.

Camera movement may also be utilized to switch from one setting to another. The camera may tilt up to the sky, dissolve to another sky, and then tilt down to reveal a new scene. Or, the tilt may be downward to water or ocean waves, and upward to the new location.

Through repetition, many pictorial transitional devices have become hackneyed. A fresh photographic treatment, a novel production technique, or a new twist by a creative cameraman, director or writer will enhance the production and stimulate continued audience interest.

SOUND TRANSITIONS

Narration may cover a switch in locales, or explain a time change. This would be a sound version of a pictorial title. Newsreel narration accomplishes this through a series of scenes,

TWA

Well-known symbols may be used to introduce countries or cities — such as pyramid and sphinx for Egypt —

TWA

Acropolis for Greece, or Athens —

Santa Fe Railway

cable car for San Francisco.

jumping about from place to place. The entire sound track of a compilation film may be transitional, to cover the lack of pictorial continuity. A documentary film may use simple narration to link sequences; moving about in time and/or space.

A monologue may move the story forward or backward, to a different time or place. A tape-recorded confession, being played back by the police, may continue narrating events as the picture dissolves to a flashback of the crime being committed. A shot of an archeologist, reading an ancient manuscript, may dissolve both sound and picture to original dictation and writing of the document. A company executive may read an engineering field report aloud to his colleagues. As he continues reading, the picture dissolves to the activities being described. A scientist may imagine life on earth a thousand years from now. The picture may dissolve forward in time as he talks.

Picture and/or dialogue may dissolve. The person speaking may dissolve to another person who continues the speech. A player's voice may be heard as he writes a letter. Both picture and sound may dissolve to the recipient reading the letter aloud. Or, the voice of the original person may continue as the picture dissolves to the recipient silently reading the letter. A business report may be used to bridge several persons in different places; by depicting the announcement being dictated, and then dissolving to report being read aloud by other people in turn.

Dissolves are not always necessary. Dialogue may activate a straight cut to another shot, such as a player exclaiming: "We'd better fly!" and then cutting to a plane in flight. The foreman of a jury may declare: "Guilty!" Shots follow of barber, butcher and baker shouting: "Innocent!" Since such shots may be located anywhere, dialogue reactions of various individuals may provide a dramatic method for moving the story across straight cuts. A missile countdown could include ten individual shots of engineers in various locations on range, or even throughout the world, each counting down until "one" is reached — and the chief engineer orders: "Fire!"

Monologues may bridge an individual player's movement from one setting to another. A lawyer,

practicing a jury address in his office, may be shown actually delivering his speech, by dissolving to a courtroom. Or, he may continue talking as he walks in his office — out of the picture; and into the picture — in the courtroom. Such transitions are best made with close-ups, so that the featured individual fills the frame during the switch from one setting to another. The camera should either cut to, or move into, a close-up at the end of the first scene. Then it should pick up the next scene with a close-up, and either cut-back or pull-back to reveal the new locale. Straight

U.S. Air Force

Count-down may be used as sound transition, by cutting from control room to trucking stations, with engineer in each speaking one number until "Fire" is reached and missile is launched.

U.S. Air Force

picture cuts, which transport the moving player from one setting to another, would have been considered poor editorial technique a few years ago. With today's faster-paced story-telling, locales can be switched abruptly *without* opticals, provided the audience comprehends what is happening.

Non-essential action may be skipped, and significant highlights shown, by bridging scenes with dialogue, narration and/or sound effects. A builder discussing blue-prints or model of a new house, could dissolve into actual construction — as he continues the description. The scream of an on-looker at a traffic accident could be blended into the wail of an ambulance siren. A highway engineer proclaiming: "We'll blast!" could pound his fist on a conference table as the picture abruptly shows tons of earth exploding!

Telephone conversations provide excellent means for switching the story to another locale. Radio and television may also be used as sound transitions. The program may be shown originating in the studio; then cut to reactions of people listening or watching in their homes, on the streets, in their cars. Reactions to a presidential address, stock market reports, or a news flash, may switch from one person to another — regardless of their locations.

Familiar songs provide excellent opportunities for establishing location. Well-known Irish, French, Italian or Russian folk music, or other

Santa Fe Railway

An engineer may pound desk, and exclaim "We'll blast! — followed by explosion.

national airs may be used to introduce a country. American cities may be identified by popular songs specifying locales: *Shuffle Off to Buffalo, Chicago, San Francisco* and *Meet Me in St. Louis*. States and regions may be identified with *California, Here I Come!, The Eyes of Texas, Dixie, Oklahoma!* and similar favorites. Available songs can cover most situations: wars, military groups, occupations, courtship, marriage, flying, sailing, motoring, cowboys, etc. A switch to a new setting may be quickly established by including a few bars of an appropriate tune. Music bridges simplify identification when a different location is shown, without need of introductory titles, or other explanatory inserts.

Music is also useful for time lapses. Songs such as *It's Three O'Clock In The Morning,* may be used to climax a long evening of dancing or night clubbing; and, the New Year is almost always introduced with *Auld Lang Syne.* Music of a particular period may aid in establishing a flashback. *John Brown's Body* will identify the Civil War; and *Over There!* — World War I. Use of music must always be cleared with copyright owners.

Sound effects, unaccompanied or blended with music and/or dialogue, offer a variety of possibilities for imaginative sound transitions. Success of a venture, growth of a project, transfer from one time or place to another, may all be expressed by sound effects. A gushing oil well rumbles into a squirting champagne bottle. A splashing water faucet blends into a waterfall. Typewriter, teletype or stock ticker clattering dissolves into a machine gun firing. Baby birds chirping softly merge into a baby crying. The clickety-clack of a train becomes a repetitious phrase or slogan. A human cry becomes a wailing whistle. Train and boat whistles suggest travel over land and sea.

Sounds may be faded in or out; dissolves (blended, segued or merged); or distorted (echo chamber); made faster or slower, multiplied, combined, etc. Both picture and sound may thus be similarly treated for special effects or transitional bridges. A distorted dissolve — which introduces a flashback — may be accompanied by distorted music and sound effects. Narration may be dramatized by use of echo chamber.

It is often better to prepare the audience by introducing the sound *before* the picture appears. Since the ear takes longer than the eye to note what is transpiring — hearing should be given a head start. A sound can be heard before its source is sighted. An ambulance siren can wail long before the vehicle approaches the camera. A ship's fog horn can be heard before the vague outline of the vessel can be discerned in the mist. Factory din is heard before machines are shown.

Music or sound effects may introduce a flashback. The sound may be "heard" by the mind's ear before the image is recognized. A tinkling piano may be heard in the distance and gradually brought up to full volume. Then, setting and people are revealed. French taxi horns may be heard before the flashback dissolves to a Paris street scene. A setting may bring back memories in which the sound precedes the images evoked. A veteran pilot wandering around an airplane grave-yard may seem to "hear" the roar of airplane engines. This introduces a flashback of a bombing mission. Or, an actual sound — such as a train whistle — may trigger remembrance of a vacation incident.

APPROPRIATE TRANSITIONS

Pictorial or sound transitions should be handled in keeping with the event being depicted. Materials on hand will often suggest a transitional device. Props foreign to the setting should not be introduced. A grandfather clock would be out of place in a scientific laboratory. Players, story, setting, action, available props, should be imaginatively blended into an appropriate transition — seeming to grow out of the event. Elaborate props, or false action — staged only to introduce a transition — should be avoided. Any transition that attracts undue attention to itself, distracts from the story. Transitions should supply logical means to an end; devices for interlocking sequences, covering time lapses, changes of locale.

CONCLUSION

Continuity is merely common sense in coordinated action. It requires thinking in *sequences* — instead of individual shots. Careful planning, con-

Lockheed-California Co.

Directional continuity should be established and maintained, even on uncontrollable action — such as aerial flight test — by choice of camera set-ups on correct side of action axis.

centration while filming, and avoidance of pitfalls build better continuity — whether shooting from a prepared script or off-the-cuff. Good continuity is *expected* by the audience. By drawing attention to itself, poor continuity *detracts* from the narrative. Nothing should interfere with the illusion through which the audience becomes involved in the story.

These steps are advisable for better continuity:

Learn how to analyze and handle cinematic time and space. Establish and maintain dynamic and static directional continuity by proper employment of the action axis. Recognize differences between controlled and uncontrolled action. Decide when to shoot single or multiple cameras for best results. Choose between master scene and triple-take techniques; or utilize a combination of both, to fit the filming situation. Overlap and match action from shot to shot, so that it can be edited in a continuous manner. Allow the editor sufficient overlapping footage to facilitate cutting on action. Film pictorial and sound transitions to bridge time and space.

A motion picture is a constantly-changing series of images. By keeping the images as close as possible to real-life action, good continuity should be assured. *Thinking continuously* will make *thoughtful continuity*.

CUTTING

INTRODUCTION

Film editing may be compared with cutting, polishing and mounting a diamond. A diamond in the rough state is barely recognizable. The raw diamond must be cut, polished and mounted so that its inherent beauty can be fully appreciated. In the same way, a film story is a jumble of odd shots until, like the diamond, it is cut, polished and mounted. Both diamond and film are enhanced by what is *removed!* What remains tells the story. The many facets of the diamond, or the movie, are not apparent until the final cut.

This chapter is not intended for film editors. It is aimed at the non-theatrical cameraman filming without benefits of a shooting script, a script girl or a director to guide him. It is aimed at the cameraman/director who may edit his own films. It is aimed at production personnel who want to appreciate the editor's problems. Everyone involved in filming a motion picture should understand the editorial requirements, and should consider each shot from that standpoint. Every editing decision possible should be left to the editor.

Only good editing can bring *life* to a motion picture! The various shots are just so many odd pieces of film until they are skillfully assembled to tell a coherent story. Cutting takes up the slack in the film, by removing all superfluous footage: false starts, overlaps, unnecessary entrances and exits, extra scenes, duplicated action, bad takes.

What is left must be woven into a continuous narrative; to present the screen story in a manner that captures audience interest and holds attention from opening scene to final fade-out.

The film editor strives to impart visual variety to the picture by skillful *shot selection, arrangement,* and *timing.* He recreates, rather than reproduces, the photographed event to achieve a cumulative effect often greater than all the actions in the individual scenes put together. It is the film editor's responsibility to create the best possible motion picture from available footage. Often, a good film editor can turn in a picture superior to the director's or the cameraman's original concept. Only after carefully considering the combinations of shots possible and the effects desired, does the film editor assemble the scenes.

A theatrical feature, shot by experienced production personnel, is filmed with editorial requirements in mind. Serious consideration is given screen direction, players' positions and looks, and matching action and dialogue from shot to shot. A theatrical film editor will generally encounter few editorial problems that he cannot solve. He is more concerned with dramatic values, rather than correcting shooting errors due to mis-matching or other wrong filming techniques.

Much of the film editor's work on non-theatrical films, particularly those filmed without a script, consists of covering or otherwise correcting

147

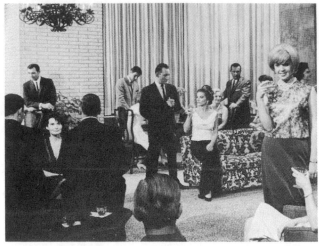

Harann Prod.

A theatrical feature is shot with editorial requirements in mind. Players' positions, looks, dialogue and action are matched from shot to shot.

shooting mistakes. Mis-matched footage, missing scenes, cutting on camera movement, covering jump-cuts, and solving other shooting problems may be traced to use of poorly applied filming techniques. Second guessing by the narration writer, director or producer, may also require editorial corrections to comply with the revised concept of the manner in which the story should be presented. By transposing shots, using opticals, and employing some scenes in a way not intended when filmed, an editor with a broad knowledge of documentary production problems will use editing tricks to aid in salvaging the show.

An experienced film editor can often cheat-cut a picture with such imagination that the completed film depicts a screen story that was conceived and created on the cutting bench, rather than in the camera. However, the cameraman should not let the editor's skill become a crutch when shooting. He should not depend upon the editor to "doctor" avoidable filming mistakes. In the normal course of his work a film editor must cheat a great deal. But he should not be expected to save every picture in the cutting room. A competent cameraman should thoroughly understand film editing from a *visual*, rather than a technical standpoint. He need not know how to assemble A & B rolls, or even make a splice, but he should

be able to break down an event into a series of shots that can be cut into a presentable sequence.

The non-theatrical cameraman should be familiar with cutting problems. He is either his own editor, or must make editing decisions during shooting stages. Many cameramen, working for small producers, do their own cutting. Some become adept at editing, but a good cameraman is

Lockheed-California Co.

Non-theatrical films — particularly those shot without a script — should be filmed very carefully, otherwise, unsatisfactory shooting techniques may cause editing problems.

rarely an expert film editor. While theatrical motion picture production demands utmost specialization, the non-theatrical field often requires doubling or tripling specialties, so that a cameraman/director/editor combination is not unusual.

The cameraman, working this way, can develop a greater appreciation of motion picture editing problems than one who merely shoots what is requested by a director. He has a greater opportunity, therefore, to become proficient in shooting scenes that will cut together, since he is closer to the over-all production of the picture than is the cameraman filming a theatrical feature. He soon learns that certain actions must be carefully observed to make them match in consecutive shots. Certain camera and player movements will cut together and others may not. Cut-in and cut-away close-ups and reaction shots can save the picture when jump-shots show up in a sequence.

Changing the camera angle and/or the lens every time a new shot is filmed provides best coverage.

TYPES OF FILM EDITING

CONTINUITY CUTTING, in which the story-telling is dependent upon *matching consecutive* scenes; and *COMPILATION CUTTING*, in which the story-telling is dependent upon the *narration*, and the scenes merely illustrate what is being described.

CONTINUITY CUTTING

Continuity cutting consists of *matched cuts*, in which continuous action flows from one shot to another; and *cut-aways*, in which the action shown is *not* a portion of the previous shot. A continuous sequence, or series of matched cuts, may consist of various types of shots filmed from different angles. The event depicted, however, should appear as a *continuous series* of moving images. Whenever action continues, the players' movements, positions and looks should match through shots spliced together. A mis-match, caused by change in body position or a switch in directional look, will result in a *jump-cut*. This occurs because the player will appear to jerk or jump across the splice between shots.

Whenever the camera is moved *straight in* from a long or medium shot to a closer set-up, a mis-match becomes most discernible. A minor mismatch, such as a slight difference in head position, may go unnoticed if the camera is shifted to a slightly different angle, as it is moved in for closer shots. It is always wiser, therefore, to move the camera closer and to one side of the subject, rather than straight in. Whenever a shot includes a portion of the previous scene — such as when cutting from a long shot to a medium shot — players' positions, body movements and looks should be duplicated as closely as possible. An arm should not be shown raised in the long shot, and then appear lowered in the following medium shot. A head should not be depicted turned in a different direction, so that the player's look does not match the previous shot. Such discernible differences in screen images will jar the audience. When the camera is moved back, or *cut back*,

Lockheed-California Co.

The non-theatrical cameraman/director/editor must make editing decisions during filming. By necessity, he is closer to over-all picture production than is the theatrical director of photography. The off-the-cuff cameraman must be particularly adaptable to filming uncontrolled action.

Lockheed-California Co.

from a closer shot to a longer view, it is necessary only to match the action shown in the previous close-up, because everything else was *outside* the frame. Cutting from a long shot to a close-up and *then* cutting back to the long shot again permits considerable cheating. The audience, being momentarily distracted, will accept any change in the last long shot as having occurred while the close-up was on screen.

Cut-aways need *not* match previous scenes, because they are *not a part of the main event*. Cut-aways are shots of *secondary action* — directly

149

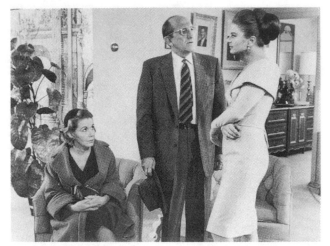

Harann Prod.

Harann Prod.

Theatrical motion pictures generally employ continuity cutting. An event is depicted in a sequence — a series of consecutive shots — in which players' movements, positions, looks and dialogue match across shots spliced together.

or indirectly related to the main action — used as a *reaction*, a *comment* or a *distraction*. However, cut-aways should be established when they appear as part of the original long shot and later moved off-screen, when the camera is moved in to film the principal players. A long shot may depict several players. Later, the action may be covered with a two-shot. The off-screen players' *reactions* are directly tied in with cut-away close-ups. In this instance, it is important that each player be shown with the proper right or left look, to match

Martin Rackin Prod.

When the camera is brought in for a close-up, it should be moved around to the side — not moved straight in, if the players relate to each other across the screen. Body movements and looks should be duplicated as closely as possible; but a minor mismatch will not be discernible if camera is shifted to a slightly different angle.

Martin Rackin Prod.

his established off-screen position in relation to the principal players. The wrong look will give the impression the player is now on the side *opposite* that shown in the establishing long shot.

Cut-aways need *not* be matched or established if they are scenes of players not shown in a previous shot. A series of *man in the street* cut-away close-ups may be used to *comment* on a verdict handed down in the previous courtroom scene. Unless alternating right and left opposing looks are desired for greater pictorial effect, a look in either direction would suffice for these shots.

A cut-away close-up may be used to *distract* the audience to cover a directional change in travel continuity, a time lapse or a jump-cut. These need not match. Nor need they be presented with a particular look, since they are shots of *outsiders*, not included in the general scene.

A close-up of a person turning his head may be inserted between two shots of a vehicle moving in opposite directions. A lengthy operation, such as the workings of a power shovel, may be shortened, and the missing portion covered by inserting a close-up of a sidewalk superintendent looking on. An inadvertent jump-cut or a jump-cut caused by

Harann Prod.

Since cut-away close-ups are never a part of the main event, they need not match previous scenes. However, if previously established, and later moved off screen, they should be shown with the proper right or left look to match their off-screen position in relation to principal players.

A "man in the street" cut-away close-up may be used to comment on a verdict. Unless alternating right-and-left opposing looks are desired for a series of such close-ups, a look in either direction will suffice.

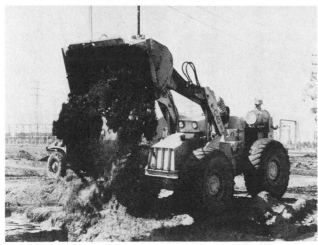

Calif. Div. of Highways

By inserting a cut-away close-up of an onlooker, lengthy sequence of power shovel action, as above, may be effectively shortened. Removal of repetitious footage may then be accomplished without jump cuts.

removing unwanted footage may be covered by distracting the viewer with a cut-away close-up of a spectator or bystander.

COMPILATION CUTTING

Newsreels and documentary-type films of surveys, reports, analyses, records, history or travelogs, generally use compilation cutting because of the animated snapshot nature of the visuals. These are connected by continuous narration. The sound track holds the narrative together and propels the scenes, which may make little sense if shown without audio explanation. Compilation cutting presents few matching problems since the individual shots simply illustrate what is being heard and need have no visual connection with one another. Compilation type films have no set form other than going from the general to the particular. Long shot may follow long shot, and close-ups which have no connection with the bracketing shots may be inserted. Every rule in the editing book may be broken if the narration makes sense and presents a coherent story. The shots themselves may move about in time and space if they are satisfactorily narrated.

CONTINUITY & COMPILATION CUTTING

Story films which utilize continuity cutting may also employ compilation cutting occasionally, such as a series of introductory long shots, a montage sequence which condenses time or space, or a series of disconnected shots to present an *impression*, rather than a reproduction of an

Photographs below and on facing page by NASA.

Progress reports and other documentary films employ compilation cutting. The various shots are connected by narration. "The Gemini Titan II Launch Vehicle arrives at Cape Kennedy where it is unloaded from the specially modified 'Guppy' aircraft."

"It is transported from the Checkout Building to the Launch Pad."

"The Gemini Spacecraft is lifted to Service Structure for mating with Titan II Booster."

"Gemini Titan II Vehicle Fuel sections shown just prior to erection and assembly."

"The Gemini Spacecraft is mated to adapter section of Titan II Launch Vehicle."

"Work on erection and assembly of Booster section continues through the night."

"Gemini Astronauts walk toward elevator which will take them to Gemini Spacecraft."

153

NASA

"The Titan II, with Astronauts on board the Gemini Spacecraft, is ready for launching. Vertical service structure in foreground is being lowered to its horizontal position. Umbilical tower, which provides power and various other remote functions to booster and spacecraft, prior to launch, is shown immediately to left of vehicle."

U.S. Air Force

"Engineers in control room listen intently to countdown: 10, 9, 8, 7, 6, 5, 4, 3, 2, 1—"

event. Such compiled sequences, particularly if used for introduction or transition purposes, may employ explanatory narration.

Compilation films may utilize continuity cutting whenever a sequence of shot is required to depict a *portion* of the story. A series of unmatched shots may introduce a sequence which tells a little story in itself which requires matching of consecutive scenes. Continuity cutting

U.S. Air Force

"Fire! The Fire button is pushed — and —"

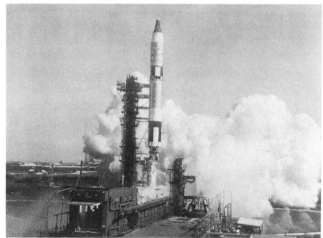

NASA

"—the Titan II lifts majestically off launch pad and heads for outer space. Months of coordinated efforts result in success."

should be employed in a compilation film whenever two or more consecutive shot necessitates matching action.

CROSS-CUTTING

Cross-cutting consists of *parallel editing of two or more events in an alternating pattern.* In studio parlance, this is known as the "meanwhile back at the ranch" treatment. Cross-cutting may be employed for any of the following purposes:

To *heighten interest* by depicting two or more separate segments of the story in an alternate manner. Audience interest may be revived by

cross-cutting to a related event whenever interest in the subject being depicted lags.

To *provide conflict* by editing of two actions which will come together in a smashing climax. Opposing armies may advance toward each other in a gradually faster-paced, closer-and-closer series of alternating shots until they clash.

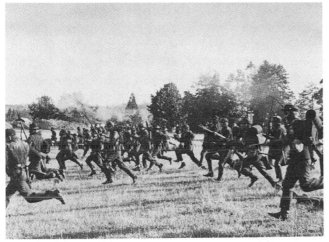
Universal Pictures

Cross-cutting may be used to provide conflict by alternate editing of two actions — such as Confederate soldiers advancing on Yankee position — with gradually faster-paced, closer and closer series of shots.
Universal Pictures

To *increase tension* by alternate editing of two events which have a direct bearing on each other. Editors of two rival newspapers may be shown planning and carrying out campaigns backing political opponents.

To *heighten suspense* by keeping the audience in a state of anxiety as events move toward a climax. Scenes of the police searching a building for a time bomb may be cut back and forth with close-ups of the bomb ticking in a closet.

To *make comparisons* among people, objects, or events. Cross-cutting may alternately depict each phase of an engineering test between two competitors manufacturing similar items.

To *depict contrast* among people, countries, cultures, products, methods or events. Contrasts may be shown between old and new methods of farming, manual and automated manufacturing procedures, life in the tropics and the Arctic.

Santa Fe Railway

Contrast between tiered dwellings of Pueblo Indians and metropolitan area of American city may be cross-cut.
Santa Fe Railway

155

HOW TO USE CROSS CUTTING

The uses of cross-cutting have one common characteristic: *Any event* happening *anywhere* may be connected with any other event. Cross-cutting may present:

Events occurring simultaneously, but separated in space, may be depicted by alternately showing the progress of each. Typical examples would include the classic last-minute rescue in which the hero races to save the heroine in dire distress, and the chase sequence which alternately shows progress of pursued and pursuers. Two or more facets of a dramatic story may be shown alternately to inform the audience of significant interdependent events as they occur. Documentary films may be cross-cut to depict, for example: the way people live in various countries all over the world; several methods of producing steel; or how an electronic center controls an automated assembly-line operation.

Events separated in time may be cross-cut to present a back-and-forth comparison of present events with similar events that have happened in the past, or may occur in the future. Methods of

North American Aviation

Events occurring simultaneously, but separated in space, may be cross-cut back and forth. The progress of a jet fighter may be tracked by a ground control station as aircraft approaches its target.

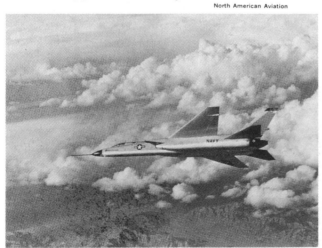

North American Aviation

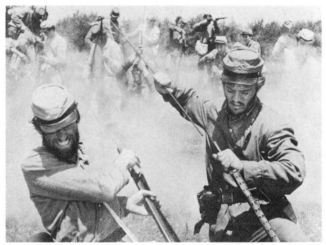

Bob Jones University-Unusual Films

Events separated in time may also be cross-cut for purposes of contrast or comparison. Civil War infantry may be compared with World War II soldiers.

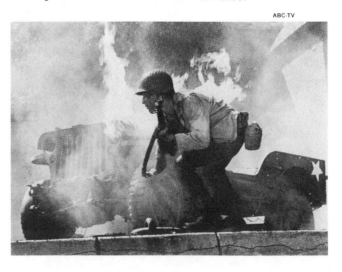

ABC-TV

modern warfare could be compared with those used in the War Between The States, and then compared with futuristic space warfare. Current news events may be cross-cut with historical happenings of a similar nature.

The first shot in a series of cross-cuts should be treated as an establishing shot and allowed slightly greater screen length than the following cross-cuts. This will give the audience a frame of reference with which to compare the cross-cut event. Introductory cross-cut shots should not be thrust on the screen without identification, unless audience confusion is an important story factor. In most cases, the audience should be immediately aware *what* is happening, and *who* is involved, and *where* the cross-cut event is occurring — if that is a pertinent story point.

Cross-cutting should *not* be regarded as a strictly theatrical fiction-film editing device. It may be used advantageously in documentary fact films, particularly when it is employed to *connect*, *contrast* or *compare* two or more actions or events. Parallel editing of two or more events provides a welcome departure from straightforward story-telling, because it heightens audience interest and moves the story about in time and/or space.

CUTTING ON ACTION

Many film editors prefer to make their cuts on movements, so that the actual switch from one shot to another is masked by the action, and not as apparent as the cut between two static shots. Such actions as: opening a door, taking a drink, sitting in a chair, climbing or descending stairs, picking up a telephone, or simply walking from one position to another; may all be cut on movement at the discretion of the film editor. The decision for cutting on action should be left to the editor, and *not* made by the cameraman. While many moving actions appear at their best when carried to completion in a single shot, others may be split and carried across two shots more effectively. An editor may, for instance, cut from a medium shot to a close-up as a player sits in a chair, but he may prefer to allow a player to finish his drink in a single close-up.

The cameraman should *never cut* during any

significant movement. All moving action should be filmed to completion. The end of the action should be repeated so that it overlaps at the beginning of the next shot. The film editor may then decide where to make the cut. Many non-theatrical cameramen pride themselves on their ability to cut on action in the camera. Such close overlapping may save film, but it severely handicaps the editor.

The film editor should always be provided with

Harann Prod.

Most editors prefer to cut on action whenever a player moves into a close up, or sits into a chair. However, it may be preferable for player to finish a drink in a single close-up. The cameraman should film all moving action to completion, and repeat the end action at the beginning of the next shot. The film editor decides whether or not to cut on action.

Harann Prod.

as much overlapped movement as possible in consecutive shots, so that he can study the action and make the most effective cut.

Cut-in close-ups should be made of all lengthy movements, such as climbing or descending stairs, or walking great distance. That way, the editor may *shorten* the long or medium shot by cutting to the closer shot, and eliminating as much of the movement as desired. Closer shots may *also* be used to *lengthen* the longer shots, if necessary, by *repeating* a portion of the movement without the audience being aware of the repetition. Always move players *into* and *out of* close-ups to allow cutting on action. The camera should be started *before* a player enters the frame and stopped *after* he leaves, to provide "clean" entrances and exits.

Statically positioning a player in a close-up forces the film editor to use the entire length of the movement in the long shot in order to arrive at the point where the player is shown in close-up. However, if the player moves *into* the close-up, the editor may cut the previous scene shorter by moving the player into the closer shot — without the audience being aware that part of the end movement in the long shot is missing.

CUTTING & CONTINUITY

Cutting is closely related to continuity. A motion picture is a custom-made jig-saw puzzle in which film makers fashion the individual pieces. Each piece requires special attention, so that it will merge harmoniously with pieces surrounding it. In order to fit properly, pieces may have to be made to fill out incomplete sections. All the pieces must be provided, made to fit properly and form a continuous, matched picture. The puzzle will be much easier to fit together if the various pieces fall into place without difficulty. If the individual shots were filmed with the editing pattern in mind, a film editor can assemble a perfectly matched sequence. A well-constructed screen story cannot be assembled from shots filmed haphazardly.

The cameraman must film series of shots that match visually and technically. Action must match across straight cuts; exposure, lighting, color and other technicalities must match from shot to shot. Unexplained gaps in continuity or technical variations will distract the audience and destroy the illusion necessary for effective presentation. While editorial and technical cheating can repair some mis-matching, the cameraman should deliver visually-perfect scenes, regardless of the number of shots required.

The experienced film editor, whenever possible, inserts distracting cut-away close-ups or uses other editing devices to salvage scenes which do not match in dynamic or static directional continuity. In extreme cases, an editor may have a shot optically "flopped" to reverse screen direction or a player's look. He may optically "blow up" a shot to produce a missing close-up from a two-shot. These desperate measures are resorted to *only* when all else fails. Generally, they are applicable only to 35mm films, since 16mm optical work introduces additional grain patterns, which can expose the trick. A film editor may do little or nothing, however, to correct technical errors which result in mis-matched visual or audio continuity. Editorial effort needlessly expended in attempting to salvage poorly-filmed footage could be better used in a more finished editing job — if the scenes were properly filmed! There is rarely excuse for pictorial or technical mis-matching, which make problems that the film editor cannot solve satisfactorily. *Filming all scenes with due consideration given all editorial factors involved is the best solution to cutting problems.*

The director, with the help of the script girl, is responsible for matching action from shot to shot. However, if the cameraman is working alone as a cameraman/director, matching can be a vexing problem, especially when shooting without a script. The easiest solution is carefully planning the places in the sequence where the camera will be shifted to new angles, and thoughtfully analyzing what the action will be at that time. If matching involves movement, make sure that the move is duplicated at the beginning of the next shot, so that the film editor may cut on action if he wishes. Players' looks and positions should be carefully duplicated in subsequent shots to prevent jarring jump-cuts. Professional actors can usually be relied upon to repeat a move or action, or match

a look countless times, or hit a mark, in precisely the same manner. Amateurs without acting experience should not be given a floor mark, because they may inadvertently glance at it when moving into position. Rather than a floor mark; an engineer, technician or company executive should be given a corner of a desk to lean against, or to feel for with a hand or foot, as he reaches his position. It is asking too much to expect a professional performance from an amateur actor, no matter how brilliant he may be in his particular field. Movement and staging should be restricted when dealing with non-actors; so that they may concentrate on their action and delivery. If motion or speech would be difficult to duplicate for the various type shots required for a matched sequence, use of multiple cameras should be considered.

The cameraman should "protect" a series of continuous shots by filming every possible cut-in and cut-away close-up that could be used to cover any jump-cuts which might crop up in editing. An extremely close cut-in close-up, in which little more than a face is shown, can be very useful for covering mis-matched action between a pair of uncontrollable or complex action shots, such as a fight or any other movement that is difficult to duplicate. Such tight close-ups eliminate the need for exactly matching positions or body movements, and need show only the correct directional look. They may be filmed in pairs, so that both a left and a right look are provided the cutter for insertion anywhere in a sequence where the players' looks vary as action progresses.

CUTTING & COMPOSITION

Compositional elements — players, furniture, props, background objects — should remain in the same relative area of the frame in a series of matching scenes. Shifting of compositional elements within the frame between shots may confuse the viewer. For instance, a table lamp appearing in the background on the left of a player in the long shot, should not suddenly appear on his right because of a vast change in camera angle. Players and objects will be positioned correctly if the principle of the action axis

is followed; but the *relationship* of players, furniture, props and background elements must be carefully noted when changing angles for consecutive shots. On occasion it may be necessary to remove or cheat an object's position to make it *appear* correct in a series of shots. This is most likely to happen in close-ups, where an intruding portion of a lamp shade or a corner of a picture frame appears in the picture. A lamp may seem too close to a player because of a change in lens focal length between long shot and close-up. Or, a

University of So. Calif. Cinema Dept.

When the camera switches to a new angle to film a close-up, it may become necessary to cheat or completely remove an object, such as the corner of a lamp. Such cheating will not be apparent if deftly performed. The object should be replaced if it appears in a subsequent wider angle shot.

University of So. Calif. Cinema Dept.

picture which seemed far away from a player suddenly appears behind him when the camera is moved around for a close-up. If the object cannot be removed because it will be obviously missed, it should be cheated so that it looks right. If the sequence requires a re-establishing shot, however, the object must be moved back to its original position.

Changing *both* the *camera angle* and the *image size* will aid in obtaining smooth cuts between shots, because the camera viewpoint is shifted as the image size increases or decreases. Shifting the viewpoint, rather than moving straight in or out, will cover minor mis-matches and changes in furniture, props or background objects. The scene is thus viewed from a completely new angle.

MOVING SHOTS & STATIC SHOTS

Moving and static shots may be inter-cut only under certain conditions. A series of moving shots will generally inter-cut without difficulty if the tempo of the camera movement is properly maintained. The series may be the same subject filmed from various camera distances and angles, or of different subjects filmed in a repetitious manner.

Movement may also be introduced in a static establishing shot and *then* filmed with a continuously moving camera. Two actors may walk down a street in a static long shot. The medium shot that follows may be filmed with a continuously moving camera. Individual close-ups of each actor may also be shot with a moving camera. The sequence may end with a static long shot as the actors enter a building. In this case, static shots would be cut directly and effectively with moving shots, because the movement was begun in a static scene and picked up *on the move*, with a moving camera.

This treatment would also work in reverse, by opening with a walking medium shot of the players filmed with a continuously moving camera, and then cutting to a static long shot to show their progress down the street. More moving shots may be made if desired, and the sequence ended with a static shot as they enter the building. Continuous player or vehicle movement may be carried *across* both static and moving shots. A series of continuously moving shots, of the same or different subjects, may also be inter-cut successfully. A continuously moving subject may be filmed

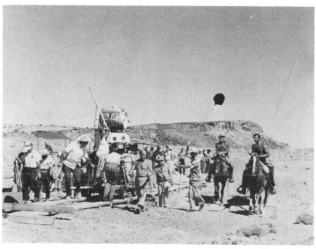

Warner Bros.

Movement may be introduced in a static long shot, and then filmed with a continuously moving camera. Any movement may be picked up on the move with a panning or tracking camera, and inter-cut with a static longer view. Continuous movement may flow across static and moving shots.

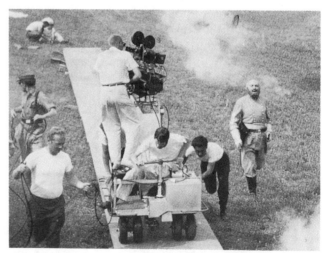

Bob Jones University-Unusual Films

A continuously moving camera shot may film the subject from various angles and distances. The camera may track alongside, in front of, or behind the player; filming a series of moving shots that may be inter-cut. Player movement should be precisely duplicated in various type shots.

from various distances and angles. Or, the camera may employ repetitious movement, such as a pan or dolly, on static subjects. The moving camera may film a moving car from the front, rear and side in long shot, medium shot and close-ups. Or, the camera may dolly toward a building, down a hall, through a room; or toward several similar objects, such as various types of tools, for comparison. The shots may thus be directly or indirectly connected with each other. Similar camera movement is used to tie subjects together.

However, inter-cutting static *and* moving shots of *static* subject matter is generally difficult, because the switch from a static shot to a moving shot (or vice versa) is abrupt and jarring due to lack of subject movement. As example, a static close-up of a dial on an instrument panel *cannot* be successfully edited into a continuous pan shot of the entire panel. In order to cut it into the moving pan, the close-up would have to be filmed with the same camera movement. Since it would sweep past the dial and provide only a fleeting glance at the reading; such a panning close-up would defeat the purpose. It would be best in this case to shoot both shots with a static camera; or to pan to the point where the close-up will be cut in. Then, static footage should be filmed, and panning continued.

A pan, tilt or dolly shot of a static subject, *preceded or followed by a static camera shot*, should always be filmed with a static camera at the beginning and end of the shot. Thus, the cut will be across static frames, with the movement sandwiched in between. It is very jarring to cut from a static shot of a static subject to a moving shot that begins moving immediately; or to go from a continuously moving shot of a static subject to a static shot.

A moving shot should always be considered in relation to the bracketing shots that precede and follow it. Shots of moving subject matter will generally offer little or no editing difficulties, because player or vehicle movement can be carried across either static or moving shots. Moving camera shots and static camera shots of static subject matter may result in editing problems, because the abrupt introduction or cessation of image

Lockheed-California Co.

Inter-cutting of static and moving shots of static subject matter may be difficult. It is best not to pan across an instrument panel, and then film a static close-up of a single dial. The pan shot should pause at the point where the close-up would be inserted; or the pan shot should be eliminated, and both long shot and close-up filmed with a static camera.

movement across a cut will jar the viewer. However, a combination of a *static* shot of static subject matter, and a *moving* shot of a moving subject will inter-cut if properly motivated. These combinations occur in cut-away shots, such as a cut from a static shot of the heroine tied down to the railroad tracks to a continuously moving shot of the hero riding to her rescue! This situation further reinforces the editing rule that it is possible to cut away to *anything* happening *anywhere* at *any time*.

TIMING MOVING SHOTS

The screen length of a pan, tilt, dolly or other moving shot should be considered in relation to its editorial value. The screen length of a moving shot is based upon the time the camera is in motion, while the screen length of a static shot is based on subject action. A moving shot must be used in its entirety (or any continuous portion) because it is difficult, if not impossible, to cut *during* camera movement. A static shot, on the other hand, may generally be trimmed shorter or cut into several shots. This applies particularly to

Lockheed-California Co.

A continuously moving shot of a moving vehicle, such as this F-104 jet fighter, may be trimmed to any desired length, since it depicts repetitious movement.

static subject matter or action performed by actors in more or less static positions. It does not apply to moving shots of travel action, such as a vehicle or player in motion, which may be cut to any desired shot length.

For example: a static long shot of a worker assembling a power tool may be edited in several ways. It may be used in its entirety; it may be cut into several shots; or it may be used as establishing or re-establishing shots to open and close the sequence. Medium shots and close-ups may be inter-cut at any point. A moving shot, such as a dolly in or out, or both, would be very difficult to inter-cut with other shots except where the camera is at rest. The editor may be forced to leave in a lot of superfluous footage, simply to *arrive* at a medium shot or close-up where the camera paused in its travel. Thus, useless action, which would be trimmed out in a static shot, may have to remain in a moving shot — to preserve the movement, or to avoid a cut during movement.

Paradoxically, *straight cuts are always faster* than moving shots, because they come to the point immediately. A moving shot, such as a long pan or dolly shot often contains much useless footage included simply to allow the camera to "go somewhere." The camera should record *significant* action en route — *not* at its destination.

Many cameramen and directors *mistakenly* believe that a moving shot contributes flow to the story-telling and speeds the screen action. In many instances, movement *slows* the screen story because it takes longer to come to the point! Unless the camera move is *dramatically* motivated, it is much better to shoot several static shots that may be straight cut, rather than a long moving shot which drags from one significant bit of action to another. Even when a moving shot is satisfactory from an editorial standpoint, it may be difficult to insert between static shots.

Moving shots, timed to a sync-sound or narration track, will generally present no problem because the movement is justified by length of sound track involved. Silent shots, however, are often poorly timed because the cameraman may pan, tilt, or dolly too fast or too slowly. A long, lingering pan of a machine may look fine in the rushes, but when the editor tries to fit the shot into the picture he may find that it is worth ten seconds in story value, and runs thirty seconds. A long, slow dolly may be worthless because it cannot justify its screen length in relation to the over-all sequence. Such shots may also alter the

IBM

If the camera dollies in from this long shot to a close-up of the man at the center control panel, the film editor may be forced to leave a great deal of excess footage in the picture, because the shot cannot be cut during the move. A moving shot should film significant action en route, not just at its destination.

Lockheed-California Co.

Silent dolly shots, particularly of static subjects, are often too long because their screen length cannot be justified editorially. Silent dolly shots should always be timed to narration, or — if shooting without a script — several shots should be made at different speeds. Or, the dolly shot should be protected with a static shot.

A player who moves into a static close-up should be filmed with a locked camera. Camera movement at the beginning of such a close-up may prevent the editor from cutting on action, because he will have to cut to the player in position after the camera settles down.

tempo of a sequence, and may not work with static shots, or with other moving shots made with different timing.

Use of moving shots, particularly silent shots of documentary subject matter filmed without a script, requires considerable forethought. This is especially important on static subject matter where the cameraman desires to inject movement by panning, tilting or dollying. The value of camera movement, in relation to the story-telling and editorial problems involved, should be seriously considered. Camera movement should be employed only where justified — providing its screen length does not restrict the film editor.

LOOSE CAMERA SHOTS

A *static* shot of a player moving into the frame, such as sitting into a close-up, should be filmed with a *locked* camera, not one that moves about nervously at the beginning of the shot until the cameraman is satisfied with the framing. The editor may experience difficulty in match-cutting such shots to a preceding scene filmed with a locked camera. Cutting on action may appear

jerky if it occurs across two static shots, such as a medium shot and a close-up if the end of the first shot or the beginning of the second shot, particularly the latter, is filmed with a slightly moving camera that tends to correct the framing.

It is much better to be *slightly* off center in framing than to move the camera. Sneak framing is particularly disturbing in a close-up where the player enters the frame and positions himself. In some instances slight panning motion is tolerable, but if the camera moves about with a panning and tilting motion to frame the player correctly as he enters, the editor may have to discard the entrance and cut to the player in position *after* player and camera have settled down. This eliminates cutting on the move, and necessitates using the complete movement in the *preceding shot* to the point where it settles down. Then, the finally-positioned player will match-cut in both shots.

Proper rehearsal, enabling actor to hit his mark, can eliminate sneak framing and allow the cameraman to lock the camera. This is a particular fault of documentary cameramen who shoot with an unlocked pan and tilt head to allow for any contingencies. This newsreel technique cannot be

tolerated in production filming. Such loose camera operation may complicate cutting on action and result in a less fluid film.

PROTECTION SHOTS

"Protection" or "cover" shots are extra scenes filmed to cover any unforeseen editing problems, *or* to replace any doubtful scenes that may present editorial difficulties because of wrong timing, excessive length, possible mis-matching, lengthy pan or dolly shots, etc. They may be additional shots not indicated in the script or duplicate scenes filmed in a novel manner. A particular scene may be editorially doubtful when filmed if there is a question concerning its cutting. Since editorial decisions are often difficult to make during shooting, and since the choice should be left to the editor, it is wise to shoot protection shots *if* the director or cameraman feels that a scene runs too short or too long; the camera is panned or dollied too slowly or too fast; a possible mis-match may exist in looks or screen travel; player, prop or camera angle is cheated too much; the background does not match that previously established; player's clothing, movement, position or look may be wrong; or the scene may be unacceptable for technical reasons.

Certain production situations automatically call for protection shots because it is difficult, if not impossible, at time of filming to pinpoint the film editor's future needs. A pan, tilt, or dolly shot may be filmed several times at various speeds, for instance, to give the cutter choices. Pans and tilts of static scenes may be made in both directions and the choice left up to the editor. Lengthy pans or dolly shots may also be protected with a pair of static shots of each end of the scene, in case the editor must cut the footage short and cannot cut in the midst of camera movement. Dutch angle shots may be tilted both left and right, particularly if several are filmed, so that the editor may use them in an opposing pattern or in any contrasting combination. Reaction close-ups should be filmed for insertion in lengthy scenes, particularly if filmed entirely from one angle, such as an industrial operation. In this way, unnecessary footage may be removed without a jump-cut. It is wise, particularly if filming off-the-cuff, to shoot "all-purpose" reaction close-ups in which the player looks in all possible directions. These may be cut in *anywhere* they are needed, and are particularly useful if they are filmed either to eliminate the background, or to place the player against a neutral background.

TRW Systems

Pan shot across these Environmental Research Satellites should be protected with a static shot, in case the moving camera shot runs too short or too long, or is otherwise unsuitable editorially.

Lockheed-California Co.

Cut-in reaction close-up is recommended for filming a worker performing a lengthy mechanical operation. This technique provides the editor with means of removing unnecessary footage without a jump-cut.

Matching problems concerning players' looks, or travel or clothing, often arise when matching scenes are filmed after long intervals, or insufficient notes are taken during the shooting session. Although time-consuming and expensive, it is wise, if the cameraman or director has the least doubt of matching scenes, to shoot the scene both ways. While shooting scenes both ways should be discouraged when no doubts exist, film and the few moments involved in re-shooting a scene from the same set-up, cost much less than later retakes. Differences among production personnel concerning cheating of players' positions, camera angles, furniture or props can best be settled by filming the scene both ways: in a straightforward manner, and with the desired cheat. Matching the original background for added cut-in close-ups or cut-away reaction shots filmed later, when the film is being edited, may produce problems, especially when original footage was shot on a distant location.

If, at time of filming, there are reasonable doubts about later need of additional shots, the original sequence may be protected by shooting against easily-duplicated backgrounds, such as sky, trees, neutral walls or drapes. Low-keyed backgrounds are easier to match because little or nothing is seen behind the actor in a close-up. A difficult background match may be attained by filming the added close-up as tight as possible, even a choker close-up, to eliminate most or all of the background.

Protection shots generally involve shooting a cover scene "just in case" the original scene may not work for any reason. Protection shots, may, however, consist of *added scenes* not called for in the script. These may aid the editor in unforeseen ways. Examples of added protection shots are: long shots of buildings; extreme long shots of factories, industrial complexes or other vast areas; close-ups of signs, plaques, markers; scenes of general activity, which may serve many editorial purposes; inserts of wheels turning, gears grinding, liquids flowing; in fact, anything of particular or neutral nature that could serve to introduce, establish or bridge sequences. The cameraman should always be on the lookout for such shots,

and be aware of their possible editorial use. A simple protection shot, filmed on impulse, may prove of value in solving an editorial problem.

DISSOLVES

Dissolves were originally employed by theatrical film producers to indicate time or space transition; change in a player's mental condition; or means of blending shots in a montage. Recent abuses of dissolves have been caused by indiscriminate use in live and taped television, and in documentary compilation films. The abrupt cuts between badly-staged or poorly-edited material, sometimes "softened" by dissolves, could have been prevented by thoughtful camera work and direction. Experienced theatrical film editors have actually speeded story-telling by eliminating dissolves wherever possible, particularly in television films. Some documentary editors, on the other hand, have increased use of dissolves to a point where they have become a cinematic "crutch" to cover jump-cuts, insufficient coverage, directional changes, missing scenes, sloppy editing and other cine shortcomings.

Dissolves should be used to blend credit titles, to provide time or space transitions, or to denote a flashback. They may be further employed in a montage or a television commercial to blend a series of short scenes of varied subject matter into

TRW Systems

Dissolves should not be used in continuity sequence where continuous action flows across consecutive shots.

smoother visual continuity. They should *not* be used because they are so readily available with A & B roll printing! There is no good reason for using a dissolve in a continuity type picture simply because the sequence was badly staged, and cannot be edited satisfactorily with straight cuts. Because of the nature of the material, there may be greater justification for dissolves in documentary compilation-type picture. If the producer would make the editor *justify* each dissolve he utilized, fewer would be used. Dissolves should be used only where properly motivated. Most often, poorly-filmed scenes cause the editor to say: *"If you can't solve it, dissolve it!"*

SOUND EDITING PROBLEMS

Match-cutting sync-sound scenes is inherently more difficult than cutting silent scenes. Action *only* need be matched in silent scenes. If the action depicted in the edited picture conveys the *meaning* of the original event, the result will generally be satisfactory. Shots may be switched, sequences condensed or expanded, action "doctored" and reactions inserted. Silent picture editing is limited only by the experience and ingenuity of the film editor. The edited version of the filmed event will be acceptable if it *appears* to

depict the original action. It need not faithfully reproduce the original event as it actually occurred in time and/or space. In other words, as long as the screened picture *looks right* the audience will accept and believe it. This allows the film editor much latitude in cutting silent pictures.

Narrated sound pictures offer considerable leeway in their editing, since they are basically silent pictures supplemented by descriptive narration, music and effects. However, lip-sync-sound pictures, in which dialogue *tells* the story, must be cut to the sound track. Since the audio record is *anchored* to the picture, the editor is limited in juggling the visual images. In so doing, he may alter or completely ruin the meaning of the dialogue. Cutting to sync-sound compels the editor to accept whatever is available for the particular section of sound track in question. His only choice is either to use the shot or discard it. It is possible, of course, to juggle the sound track itself by transposing words and using other editorial tricks, but this need not concern the cameraman.

Match-cutting dialogue scenes require that player action or movement across straight cuts

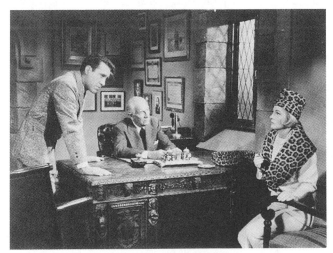

Universal Pictures

Sync-sound sequences must be cut to the sound track. Both action and dialogue must match across straight cuts. The editor cannot search for the frames where players' positions and looks are duplicated. Cutting on action — such as player sitting into close-up — requires precise duplication of dialogue and movement, as performed in the wider shot.

NASA

Action only need be matched in a series of silent scenes, such as this sequence of a Gemini astronaut being fitted into a spacecraft ejection seat for emergency egress training.

match precisely. The editor can choose *any* point in a silent shot where the turn of a head or the wave of a hand matches the end of the previous shot. Match-cutting dialogue shots offers no such choice. The editor *must cut to the sound track* and accept whatever action is portrayed. Strict visual and audio continuity must be maintained during filming, so that *both dialogue and action* are matched across straight cuts. Unless players' positions and looks are duplicated when camera is moved, a jump cut will result.

Dialogue scenes are almost always filmed from a prepared script, so that continuity of dialogue is easily maintained. Since, however, the emphasis is generally on what a player *says*, rather than on what he does; the cameraman and/or director must take great care to match player movements, positions and looks. Dialogue scenes should be carefully rehearsed with emphasis on *what* a player does, and *where* he stands or moves as he speaks his lines. This is particularly important if the master scene technique is used, and players must repeat their actions and dialogue in closer shots. If both action and dialogue do not match precisely, the film editor will have difficulties in match-cutting the sequence. Such action mis-matches may force the editor to cut to reaction shots of the listening actor, or resort to cut-away reaction closeups of other players, because they offer the only solution to covering a jump-cut. If the triple-take technique is used, and the sequence is filmed shot-for-shot, both action and dialogue should be overlapped to insure match-cutting.

SOUND FLOW

Sound and picture should *not* be edited in a parallel manner, in which the audio and visual elements begin and end together in each individual shot. Sound should *flow across* scenes to be most effective. Film editors generally prefer to continue the sound track of the player speaking over reaction shots of one or more of the listening players. This results in a back-and-forth treatment in which the speaking players take turns talking and listening to each other. It avoids the abrupt editing that would result if the player's image and

his speech start and stop simultaneously. The camera should rarely remain on the speaker for the duration of his speech, unless what he says is more important than reaction of listening players.

The editor should have *players' speeches* as well as *reaction shots of all concerned*, so that he may edit the sequence as he sees fit. Such silent reaction shots also allow considerable editorial cheating if dialogue must be removed, or additional "wild" (unsynchronized) lines inserted later. This alteration in dialogue will not result in a jump-cut, because the audience is watching reactions of listening players, rather than the

Harann Prod.

Dialogue and reaction of each player should be filmed in entirety when shooting pair of over-the-shoulder close-ups. Each should speak, listen and react to fellow player.

Harann Prod.

actor who is speaking. Thus, a player's speech may be *shortened* or *stretched*, regardless of where a change in dialogue is required. The editor uses the last few words of dialogue over the listening player's reaction shot. Then the editor subtracts original dialogue or inserts unsynchronized wild lines, as required. After the dialogue change is made, the editor may return to the original sync-sound picture and sound track.

Over-the-shoulder close-ups, in which two players talk back and forth to each other, should be filmed in their entirety on each player. This provides reaction shots of both players as they *actually listen* to each other's speeches. Each actor on-camera speaks his lines, listens and reacts to his fellow player; who has his back to the camera in over-the-shoulder close-ups, or is off-camera in p.o.v. close-ups. While this technique may appear wasteful of film, it provides matched reaction shots to thoughts expressed and results in better interplay between actors, because the actual dialogue is heard over the actor's reaction. Film saved by shooting a few all-purpose silent reaction shots for insertion anywhere needed may harm the actor's performance. Also, the film editor will be severely restricted in matching suitable reactions to the particular dialogue.

Lockheed-California Co.

Reaction shots of listening audience may be inserted in a sync-sound sequence of an executive addressing a group. This permits the editor to use highlights of the talk, without audience being aware that portions have been removed.

The camera should never be stopped in the middle of important dialogue. Although the cutter may have no interest in the picture at that point, he may want to continue the sound track over reaction, or other shots. If a particularly long speech is involved, and the script definitely states that the picture is not required; the camera should be cut, but the entire speech should be recorded. All camera cuts should be *predetermined* by the sound track content, and marked in the script.

Jump-cuts may be avoided whenever *portions* of a long speech are presented, such as a newsreel of an important person addressing a large group, by cutting to reaction shots of the listening audience. The screened picture may present only highlights of the speech, without the viewer being aware that large segments are missing. The only way the camera may remain on the speaker, and avoid jump-cuts caused by removal of portions of the speech, would be by dissolving each time a cut is made to smooth the change in the speaker's appearance or position.

EDITORIAL REQUIREMENTS

All footage submitted to a film editor must meet three requirements:

> *TECHNICAL*
> *ESTHETIC*
> *NARRATIVE*

TECHNICAL REQUIREMENTS

The technical elements of a film — such as photographic treatment, lighting, color, exposure, sound, etc. — should be uniform in production quality. No noticeable visual or audio differences should be apparent when the picture is assembled, and a properly timed and balanced release print made. A mis-match or distracting change, unless deliberately inserted for a special effect, may disturb the audience. A poorly recorded stretch of sound, a perceptible change in lighting, unbalanced color; or any other technical discrepancies are unacceptable. Excellent craftsmanship is taken for granted in professionally-produced theatrical films. If serious non-theatrical film makers expect their films to receive proper audience attention, they should strive for professional quality.

ESTHETIC ELEMENTS

The assembled picture should unreel in a series of moving images, pleasing to watch and easy to understand, unless the film maker desires — for story purposes — to shock or distract the audience; or otherwise create a violent or unpleasant audience reaction. Scenic compositions, player and camera movements, light effects, choice of colors, camera treatment and other pictorial aspects of settings, costumes, backgrounds and props should all be integrated on the basis of their cumulative result when the scenes are finally edited. The good cameraman strives to produce the most beautiful moving images possible. However, it is often better, under documentary conditions, to present a realistic rather than a pictorially beautiful picture. This does not imply that beauty and realism cannot be combined; or that non-theatrical films must be photographed in a dull, unimaginative, mechanical style. It simply means that documentary subjects should be *representational* rather than dressed up for picture purposes. Engineering, military, educational, business, industrial, in-plant, and other non-theatrical films should be as beautiful as possible, within realistic confines. Pictorial

North American Aviation

Non-theatrical films should be as pictorially beautiful as possible within realistic confines. This documentary shot of radar operators is enhanced by dramatic lighting.

elements involved should be handled in an esthetically suitable fashion, without stealing the show from the subject. The primary aim of a documentary is to "sell" the subject, not the photography.

NARRATIVE FACTORS

Technically perfect, excellently composed shots have little or no meaning if the picture is presented in an illogical, uninteresting or incoherent manner. The audience should neither be confused nor have to strain to follow subject themes, unless plot deviations will help for narrative purposes.

Story problems are not the main concern of cameramen shooting from prepared scripts. But the non-theatrical cameraman/director, shooting on his own from an outline, or a few notes, must be sure that his footage can be assembled into a story-telling motion picture. This calls for thorough understanding of story values, audience reaction and editorial requirements. Even the simplest documentary film must capture the audience's interest and hold its attention as the film unreels. After the theme or plot is introduced and developed, the narrative must build in interest as it progresses. Each shot should make a point. All scenes should be linked together so that their combined effect, rather than their individual contents, produces the desired audience reactions.

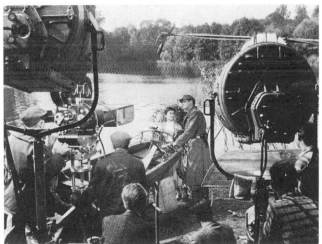

Universal Pictures

No noticeable visual or audio differences should be apparent in a professional film. Lighting, color, exposure, sound, etc., should be uniform in production quality in a properly timed and balanced release print. Technical discrepancies are distracting, and break the story-telling spell.

169

Santa Fe Railway

The audience should become involved in people and events depicted on screen.

Film editors have a motto: "Make them laugh or make them cry, but make them *care!*"

The all-important goal is to make the audience *care* about the people and events depicted. This means identifying with the performers in a fiction film, and being concerned in what happens to them. It also implies *caring* about the subject in a documentary film, and being interested in the message, theme, problem, propaganda, engineering test, sales pitch, project report, or whatever subject matter is being depicted.

A film editor always strives to be *on* the player, object or action in which the audience is most interested at that *particular moment* in the story. The cameraman should always keep this editorial requirement uppermost in his mind during production, so that he will automatically move in and make close-ups of important action, film the most meaningful portion of the over-all event, and follow the most significant of several actions occurring simultaneously. What the audience would be most interested in viewing should be considered. A cameraman thinking in this vein will shoot a picture more likely to capture and hold audience attention. To succeed in filming a narratively interesting picture, the cameraman must create a make-believe screen world in an acceptably realistic fashion. This is accomplished by using the motion picture camera as a story-telling tool, not merely as a recording instrument.

CAMERAMAN CAN LEARN FROM FILM EDITOR

A cameraman can learn much in the cutting room, either by observation or preferably from comments of an experienced film editor, who can provide constructive criticism of coverage. This procedure can be most helpful in filming off-the-cuff material. Such filming requires shooting individual shots planned to match-cut and heighten interest as the event progresses. The cameraman should learn how to break down an event into individual shots, first by deciding *what* type of shot is required for each particular portion of the event. Then he should consider *which* particular camera angle and player and/or camera movement, if any, should be used to portray best the particular portion of action being filmed. Next, he must decide *where* to insert significant cut-in and cut-away close-ups. These may be used to involve the audience more closely with the events depicted; to distract the viewer, if required to cover a jump-cut or directional change; or to shorten or lengthen scenes. Next, he should anticipate *when* it will be necessary or expedient to provide reaction shots for story-telling or editorial purposes. The cameraman should understand *why*

Lockheed-California Co.

Motion picture production personnel discuss story board for new film. A well-scripted, carefully-planned motion picture — with a definite editing pattern — will generally cut together with minor, easy-to-solve editorial problems.

170

it is important to supply protection shots, and why he should film additional cover shots which may be helpful to the editor. He should also learn *how* to film scenes so as to provide the editor with the greatest number of editorial choices. This can be accomplished by overlapping actions from shot to shot, filming clean entrances and exits, placing pauses in moving camera shots whenever possible to permit cutting-in static scenes, and other shooting tricks acquired as he becomes more proficient in *thinking editorially* before and as he films.

The cameraman should realize the importance of integrating esthetic, technical and narrative elements in a unified style, employing the camera in a way that will heighten audience interest. While film editors' criticisms will not correct past mistakes, they will provide a reservoir of cine knowledge for future use. Understanding difficulties involved in matching, timing and arranging scenes, will give the cameraman editorial insight on his next shooting assignment, and enable him to appreciate the editor's problems, and provide properly-filmed footage.

CONCLUSION

A motion picture is conceived in the camera and assembled in the cutting room. The better the conception, the better the assembled picture. A well-scripted motion picture, minutely planned and carefully broken down with a definite editing pattern in mind, will generally cut together with minor, easy-to-solve editorial problems. A film shot off-the-cuff, on the other hand, requires expert handling and should be photographed: with a rigidly-followed definite shooting plan; or with techniques that allow the film editor a wide range of selections in assembling the footage. Even when filming from a script or shooting plan, it is wise to give the editor cine choices.

Experienced directors and cameramen provide their editors with more than sufficient coverage to allow every possible editing choice. Budget and time limitations on theatrical feature films usually govern the number of camera set-ups that may be made, the number and kind of shots that

may be filmed, and the additional protection coverage that may be provided. There is no excuse, however, for shooting scenes that do not cut because of poor filming techniques. Editorial consideration, before and during production, will prevent many problems. The editor can assemble the picture only from the footage provided. If he needs unfilmed scenes, or finds it impossible to splice scenes that cannot be logically matched; the director or the cameraman failed to film the required scenes, or filmed them inadequately. Experienced film editors may perform wonderful feats in salvaging poorly filmed footage but they cannot work cine miracles.

The film editor *cannot**: change screen directions or players' looks; change tonal values or colors of costumes or sets; change composition; change lighting; change camera angles; speed up or slow down actors' and/or camera movement; insert non-existent close-ups; provide action in static scenes; cover jump-cuts without reaction or protection shots; successfully remove footage from the middle of a shot, unless cut-in or cut-away close-ups are provided; match consecutive shots if players are out of position, looking the wrong way or otherwise changed; correct visual or audio technical imperfections, beyond salvaging in film processing or sound dubbing; assemble a motion picture from shots filmed in a haphazard manner.

Only the cameraman — if he is working alone, or with the aid of the director and script girl, when filming from script — can see that all these requirements are met during filming. Thus, the editor is furnished action-matched footage, sufficient coverage and properly-staged shots, which permit every possible cine choice. A qualified cameraman does not attempt to "cut the picture in the camera" to the point where the editor has little or no choice in assembling the film. While the cameraman can greatly influence how the picture is presented, prerogative to make all editing decisions should be reserved for the editor.

* Except optically by flopping the picture, enlarging portions of the shot to full frame, skipping or repeating frames, or making dissolves to connect scenes that would be abrupt or mis-matched if straight-cut.

CLOSE - UPS

INTRODUCTION

The close-up is a device unique to motion pictures. Only motion pictures allow large-scale portrayal of a *portion* of the action. A face, a small object, a small-scale action, may be selected from the over-all scene, and shown full-screen in a close-up. Ordinarily, a play, an opera or a ballet must all be viewed from a fixed distance. Motion picture close-ups make possible depiction of detailed portions of such performances.

The close-up may transport the viewer *into* the

TRW Systems

The motion picture camera may depict a small scale action full-scale. Fingers provide viewer with clue to size of objects.

scene; *eliminate* all *non-essentials,* for the moment; and *isolate* whatever *significant* incident should receive narrative emphasis. A properly-chosen, expertly-filmed, effectively-edited close-up can add dramatic impact and visual clarity to the event. When improperly used, the close-up can confuse the audience and detract attention — thus neutralizing its cinematic effectiveness.

Close-ups are among the most powerful story-telling devices available to the film maker. They should be reserved for vital spots in the story, so that their intended visual impact upon the audience is assured.

Close-ups should be considered from both *visual* and *editorial* standpoints. A theatrical director of photography is primarily concerned with the visual aspects of close-ups. Ordinarily, the choice of a close-up in a feature film is made by the writer or director for valid story reasons.

The scriptless non-theatrical cameraman/director, who is required to make editorial decisions during filming, should thoroughly understand the use of close-ups. Close-up choice when filming off-he-cuff may be influenced by editorial, rather han visual reasons. For example, cut-away reacion close-ups may be filmed in *anticipation* of cutting problems that may arise later. The employment of a close-up to *distract* the audience in order to cover a jump-cut is as important editorially as its use for visual dramatic emphasis.

CLOSE-UPS

CLOSE-UP SIZE

Close-Ups may be designated in the script according to image size. Or, they may be listed as *close-up* or *CU*, and size left to the discretion of director or cameraman. Interpretation of actual area filmed for a close-up varies greatly, but is almost always considered in relation to the subject matter. Thus, close-ups of people, animals or objects would require different treatments.

The following are acceptable designations for close-ups of people:

Medium Close-Up: from approximately midway between waist and shoulders to above head.

Head and Shoulder Close-Up: from below the shoulders to above head.

Head Close-Up: head only.

Head Close-up

Medium Close-up

Choker Close-up

Head and Shoulder Close-up

Choker Close-Up: below lips to above eyes.

A close-up of a person, unless specified, may be regarded as a head and shoulder close-up.

EXTREME CLOSE-UPS

Tiny objects or areas, or small portions of large objects or areas, may be filmed in extreme close-up so that they appear greatly magnified on the screen. Insects, small machine parts, calibrations on an instrument dial; or a small action — such as applying a drop of solder to an electronic part — are very effective when photographed full-screen in extreme close-ups. Portions of a person's head, such as ear, nose, lips or eyes, may be featured whenever the connected sense warrants ultra-dramatic significance.

Claude Michael, Inc.

Action occupying tiny areas — such as application of drop of solder to an electronic part — is very effective when filmed full-screen in extreme close-ups.

OVER-THE-SHOULDER CLOSE-UPS

A typical motion picture shot, with no counterpart in still photography, is the close-up of a person as seen *over-the-shoulder* of another person in the foreground. Such over-the-shoulder close-ups provide an effective *transition* from objectively filmed shots to point-of-view close-ups. The camera is thus moved *around* from an objective angle to an intermediate angle which introduces the p.o.v. close-up that follows. The over-the-shoulder close-up may be eliminated if the players are shown in objective close-ups only. The cut to a p.o.v. close-up, however, becomes much smoother if *preceded* by an over-the-shoulder close-up.

Over-the-shoulder close-ups should be filmed in a similar manner on a pair of players, so that they present a uniform appearance. While it is not absolutely imperative that camera distance, camera angle and image size be precisely matched — they should approximate each other. An exact match is sometimes difficult, especially between a man and a woman; because of the differences in body contour, head size and height of players. A high hair-do on a woman player may also influence image size and framing. Most important — a back-and-forth series of over-the-shoulder close-ups must appear about the same to the viewer.

The foreground player nearest the camera —

Harann Prod.

The over-the-shoulder close-up has no counterpart in still photography. It is purely a motion picture device used to provide effective transition from objectively-filmed shots to point-of-view close-ups.

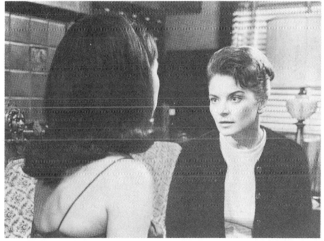

Harann Prod.

Over-the-shoulder close-ups should be filmed in opposing pairs. Both close-ups should appear uniform in size and angling. It is not absolutely imperative that camera distance, camera angle and image size be precisely matched — but they should approximate each other.

over whose shoulder the opposing player is being filmed — should be so angled and framed that his back and side are seen from a rear three-quarter view. His cheek line, but *not* his nose, should be seen, so that his facial features are not identifiable. No part of the nose should extend past the

cheek line. If the nearer player's features are visible, the scene is a two-shot, rather than an over-the-shoulder close-up.

If the two players are facing each other, the farther player will be shown in a three-quarter angled close-up. The foreground player may be treated in either of two ways: his entire head and a portion of his shoulder may be included; or the side of his head farthest from the camera may be

cut off slightly so that a portion of his head only is seen. The first method is preferred because it permits better framing. When players are closely grouped; or a larger close-up or a more compact shot — such as in television filming — is desirable, the second method may be employed.

Over-the-shoulder close-ups are designated in the script — or referred to while filming — by specifying the camera set-up in relation to the characters. The shot may, for example, be *over* Harry's shoulder, *on* Helen. The opposing matched close-up would be *over* Helen's shoulder, *on* Harry.

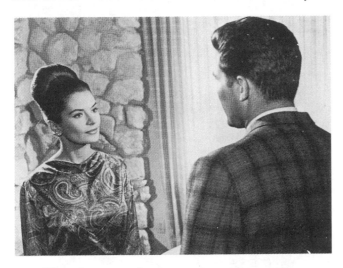

The foreground player, in an over-the-shoulder shot, should be angled so that his back and side are seen from a rear three-quarter angle.

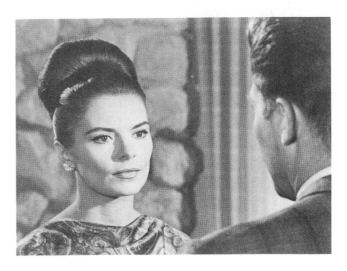

When players are closely grouped; or a larger, more compact over-the-shoulder close-up is desired — such as in television filming — the side of the near player's head may be cut off.

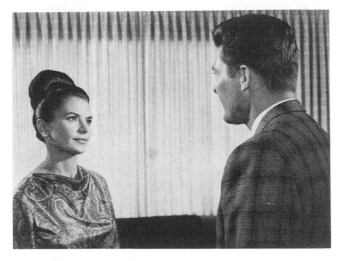

The camera is insufficiently angled on this over-the-shoulder close-up. Note the tip of the nose extending beyond the cheek line. If the nearer player's features are visible, the scene becomes a two-shot.

TYPES OF CLOSE-UPS
CUT-IN
CUT-AWAY

CUT-IN CLOSE-UPS

A *cut-in close-up* is a *magnified portion* of the preceding larger scene. It is *always* a part of the main action. The cut-in close-up *continues* the main action with a screen-filling closer view of a significant player, object or small-scale action.

Harann Prod.

This objectively-filmed cut-in close-up is a magnified portion of the preceding wider scene. Cut-in close-ups must match players' positions and looks, because they continue the action across a straight cut. Camera is moved in and around to film the close-up — because players are relating across the screen — not straight in.

Harann Prod.

Cut-in close-ups may be filmed from four camera angles:

Objectively, in which the camera films the close-up from an unseen observer's viewpoint; *not* that of a player personally involved in the scene. An objective close-up brings the viewer closer to the player, object or action, without becoming personally involved.

Subjectively, in which the person being filmed looks directly into the camera lens. This is employed on rare occasions in dramatic theatrical

Subjective close-ups — in which the player looks directly into the camera lens — are rarely employed in a dramatic film.

Harann Prod.

Over-the-shoulder close-ups — in which the camera films over the shoulder of another player — are generally photographed in opposing matched pairs.

films — so that a player or commentator may explain, describe or comment on the story as it unfolds. It is often used in feature comedies to allow a player to make an aside to the audience. It is most often encountered in television films featuring newscasters, commercials and narrators who appear on camera to explain the event to the viewer. Subjective close-ups are also employed in non-theatrical films so that the head of a firm may speak directly to the audience, or an engineer may explain the workings of a machine.

Over-the-shoulder, in which the camera films the close-up over the shoulder of an opposing player. Over-the-shoulder close-ups are generally filmed in matched pairs when two players confront each other for dialogue exchanges.

Point-of-view, or simply p.o.v., close-ups are filmed from the viewpoint of a player in the scene. The camera is positioned *at the side* of the player (as close to the action axis as possible) so that the audience views an opposing player, or an object or small-scale action, from his viewpoint. When two players are filmed in opposing p.o.v. close-ups it is wise to position the off-screen player at the side of the camera, or hold up a closed fist at the point where the player should look, so that the on-screen player's look will be correct. The *look* must *always* be to the *side of the lens* regard-

less of camera height or angling. When player's heights vary — such as one seated and the other standing — the look must be cheated to the side just *above* the lens for the player looking up; and to the side just *below* the lens for the player looking down.

The players involved in over-the-shoulder and point-of-view close-ups should first be identified with a two-shot so that the audience is not confused when the camera moves in for a series of close-ups. Both types of close-ups may be edited in any desirable pattern, although it is best to have opposing pairs of similar close-ups follow one another.

The off-screen player — in a pair of opposing point-of-view close-ups — should stand at the side of the camera to provide the player being filmed with the proper look.

A point-of-view close-up — in which the player is filmed from the point-of-view of an opposing player — is photographed from a camera position at the side of the opposite player.

When filming point-of-view close-ups of two opposing players whose heights vary such as one standing and the other sitting — the look must be to the side of the camera, just above the lens, for the player looking up; to the side just below the lens, for the player looking down.

A two-shot should precede a pair, or series, of over-the-shoulder and point-of-view close-ups; so that audience may first identify the players involved.

The p.o.v. close-up is the closest the objective camera can approach a subjective angle without having the player look directly into the lens. The look of the on-screen player is just slightly to the side of the lens. The side selected will be determined by the action axis at the end of the previous shot. The viewer is given the impression that he is actually seeing the on-screen player from the opposing off-screen player's viewpoint. Thus, the p.o.v. close-up involves the audience most directly in the screen action.

HOW TO USE CUT-IN CLOSE-UPS

To *play up narrative highlights*, such as important dialogue, player action or reaction. Whenever dramatic emphasis or increased audience attention is required, the subject should be brought closer to the viewer.

Cut-in close-ups should be employed to depict narrative highlights of the story — such as this player's reaction. Dramatic emphasis demanding increased audience attention should be brought closer to viewer.

To *isolate significant subject matter* and *eliminate all non-essential material* from view. Audience attention thus may be concentrated on an important action, a particular object or a meaningful facial expression. Close-up treatment presents *only* what *should be seen* at the moment, by *removing all else*.

To *magnify small-scale action*. A close-up may visually clarify what is happening, if the action is too small for the audience to view — without strain — in a medium or long shot. The audience's curiosity should be satisfied by bringing them closer, otherwise the viewer may lose interest.

To *provide a time lapse*. The time interval required by lengthy actions may be shortened by inserting a cut-in close-up. The close-up allows

Weber Aircraft

Cut-in close-ups concentrate audience attention on the important action by isolating significant subject matter, and eliminating all non-essentials.

Claude Michael, Inc.

Magnifying small scale action — such as soldering a tiny terminal — will visually clarify what is happening. Viewers' interest is heightened by bringing them closer.

Lockheed-California Co.

A lengthy manufacturing process — such as inserting large numbers of rivets — may be shortened and covered with cut-in close-up of worker. Viewers will get impression that they see the entire event.

removal of tedious or repetitious action. As instance, a person may begin typing. A close-up reaction shot of the player, and/or a close-up of his fingers striking the keys, may be followed with a shot of the finished letter being pulled out of the typewriter. Or, a lengthy manufacturing process; a repair requiring repeated operations, such as inserting many bolts; or a familiar action that

need not be depicted in detail, nor shown in entirety — may all be considerably shortened and covered with a cut-in close-up or two. The audience will accept the sequence as complete because they receive the *impression* that they are seeing the entire event and will not miss the removed sections.

To *distract the audience.* A cut-in close-up may cover a jump-cut caused by mis-matched or missing action. A long shot and a medium shot may not cut together because of differences in players positions, looks or movement. A close-up inserted between the two shots will allow the jump-cut to go unnoticed, since any change could have occurred *while* the close-up was on screen.

To *substitute for hidden action* which cannot be filmed for physical reasons — such as operations concealed or inaccessible inside a machine, a blast furnace, or an electronic computer. As raw pellets are dumped into a plastic moulding machine hopper, close-ups of control panel and machine operator handling switches and observing dials and gauges, may be filmed to indicate the plastic being moulded within the die. Then, the finished part may be shown emerging. Thus, a few seconds of exterior close-ups may be utilized

IBM

Hidden action — such as operation of an electronic computer — may be covered by cutting to close-ups of the operator and the control panel; or by depicting operation of switches and close-ups of dials, counters, gauges or other instrumentation.

Universal City Studios

Cut-in close-ups should always be established in the preceding wider shot, so that the viewer is aware of the location of the player in relation to the over-all scene. This is particularly important when several players are shown in a long shot.

to cover several minutes of invisible machine operation. The same close-up technique may be used on any subject that cannot be filmed because there is no image for the camera to record. These may be the action of electronic circuits; or events too dangerous to allow a camera in range.

ESTABLISH CUT-IN CLOSE-UPS

A *cut-in* close-up should *always* be established in a preceding long shot, so that the audience is aware of its location in relation to the over-all scene. A cut-in close-up of a player, object or action, not clearly seen in the preceding long or medium long shot, will confuse the audience.

One reason for presenting a long shot is to establish relative positions of players and objects in the setting. Since a cut-in close-up is a portion of the main event, it is important that the subject or action shown be immediately recognizable. The audience should be properly oriented *before* the camera moves into a close-up, and later re-oriented with a re-establishing shot; if a great deal of player movement occurs while the camera follows action in the closer shots. Player and/or camera movement in a tight close-up may cause the audience to lose track of the *present* whereabouts of the depicted player in relation to other

Universal City Studios

players. Whenever a viewer has to pause to locate a player in the set, narrative continuity is broken. The close-up may be over before the audience can comprehend its significance.

Properly orienting and re-orienting the audience is particularly important if the action involves close-ups of complicated devices. For example, a medium or long shot of a mechanic at work on a jet engine will leave no doubt in the viewer's mind of the location of the parts shown in a subsequent close-up.

CLOSE-UPS

The viewer may become confused if the camera stays in close, and *follows* the mechanic as he moves about various areas. A maze of wiring, tubing, or engine parts may look like an impenetrable jungle; conveying no specific area of action. In such filming situation, it is wise to pull back occasionally and re-establish the closer action in relation to the over-all object.

Following a player about a room in a tight close-up may produce the same dis-orientation problem. If too little of the set is seen, or if the player is not shown crossing other players, the audience will not know where he is located in relation to other players, or setting. Later, a re-establishing long shot can suddenly show the player on the other side of the room. This may completely mystify the audience!

There are rare occasions when a cut-in close-up is *not* established in a preceding shot. A close-up is sometimes used as a sequence opener. Since it is the *first* scene, it cannot be established. However, it should match cut with the following shot, or be revealed as a portion of the over-all action when the camera pulls back to continue depicting the event. While the cut-in close-up is not truly cut *into* the main event in this instance, it should be treated as part of the wider shot.

When stories require suspense or confusion, it is permissible to *avoid* establishing cut-in close-ups. The villain may be shown in a darkened room in pursuit of the hero. A cut-in close-up showing him moving about is intended to bewilder the audience, and provide additional suspense — because his proximity to the hero is not disclosed. A player may hide behind a pile of crates in a warehouse, but his exact location is not shown in the close-up. Because audience confusion is *intended*, the camera may follow the player in close-up.

CUT-AWAY CLOSE-UPS

A *cut-away close-up* is *related to, but not a part of, the previous scene*. It depicts *secondary action* happening simultaneously elsewhere. Whether cut-away close-ups are separated from the principal action by a few feet or by thousands of miles;

A cut-away close-up may be separated from the principal action by a few feet — such as a player reacting to other players across the room — or by thousands of miles. Cut-away close-ups, not part of previous scene, should be narratively connected.

they should always be — directly or indirectly — *connected to the narrative.*

Cut-away close-ups may be filmed from three camera angles:

Objectively, in which the audience views the close-up from an impersonal viewpoint. The viewer is simply brought closer to the subject without being involved.

Subjectively, in which the person being filmed looks directly into the camera lens. Cut-away subjective close-ups are rarely used in theatrical films; but their employment in newsreel, documentary reports and similar explanatory films, may capture greater audience attention. The narrative may cut-away from a field test to an engineer who may explain with charts, the operation of a new drilling rig. Thus, the viewer is directly involved, and feels that the engineer is reporting to him personally. This is stronger treatment than having the engineer talk to an interviewer, or to an off-screen narrator. An unseen speaker may supply the questions which the engineer may answer directly into the lens.

Point-of-view cut-away close-ups are filmed from the viewpoint of a player in the scene. An-

other player, a clock or a small-scale action such as cocking a gun, may receive increased audience interest when shown from the viewpoint of a player in the scene, rather than objectively. Such treatment creates stronger audience identity with the player and greater involvement in the event.

HOW TO USE CUT-AWAY CLOSE-UPS

Cut-away close-ups may be used in any of the following ways:

To *present reactions of off-screen players*. The reaction of an off-screen player may be more significant than the action of the principal player on-screen. How an off-screen player reacts to the dialogue may be more important, for instance, than showing the principal player speaking. Most often, the audience is more interested in various players' reactions than in the event itself.

To *cue the audience on how they should react*. A cut-away reaction close-up of a player portraying fear, tension, awe, pity or any other action, will stimulate a similar feeling in the viewer. This is a simple technique for inspiring a receptive audience mood.

To *comment on the principal event* by showing corresponding action. Related or unrelated visual comment may be made by a cut-away close-up

Harann Prod.

Cut-away close-up of player portraying particular emotion may be used to simulate similar feeling in viewers.

inserted to play up the main event. Symbolic cut-away close-ups of birds and animals may be shown to comment upon human behavior. Examples are: cut-away from a woman applying make-up, to a peacock preening its feathers; cut-away from a man eating a meal sloppily, to a pig wallowing in a trough. A series of *man-in-the-street* cut-away close-ups may be used to comment upon action, dialogue or narration of the principal

Harann Prod.

Reaction of an off-screen player — depicted in a cut-away close-up — may be of more interest to the audience than dialogue or action of a principal player on-screen.

Lockheed-California Co.

Close-ups of birds or animals may be inserted in a film to comment upon human behavior. This "smiling" porpoise imitates human characteristics.

Martin Rackin Prod.

Cut-away close-ups may be employed to distract the audience while covering a directional change in screen travel.

Santa Fe Railway

This cut-away close-up shows Indian, on distant vantage point, observing movements of cavalry troop.

event. Public reaction to a jury verdict, an election, or a comment made by the narrator, may be covered with a few fast-paced cut-away close-ups of several people expressing approval or disapproval of the event depicted; or dialogue or narration; or speaking a single word, such as "Guilty!"

To *motivate a sequence*. The principal action may be motivated with a cut-away close-up. A screaming siren may motivate a scene showing jet pilots scrambling toward their planes. A boat whistle could hurry passengers to board. A checkered flag being waved could start an auto race. Pushing a button could begin operation of an assembly line. The unique impact of such cut-away close-ups may open sequences effectively.

To *replace scenes too gruesome or expensive to depict*. War, accident or disaster scenes need not be shown in their entirety if they are too revolting for the average viewer. A shot of the reaction of a bystander to the event will put across what is happening. This can also be a practical solution to budget problems in filming auto accidents, airplane crashes or similar disasters, too costly to stage. For instance, filming of an auto crash may start by showing the cars approaching each other. Then, a series of short shots of the drivers, point-of-view shots of the advancing cars, glass breaking, hand-held shots simulating the cars twisting and turning as if rolling over, etc., may follow.

The actual crash may be covered by a horrified bystander's facial reaction, accompanied by a crashing sound effect, which may be obtained from a stock sound library.

To *distract the audience*. Because off-screen players, objects or actions are featured, cut-away close-ups offer greater possibilities for distracting the audience than cut-in close-ups. Since the camera is not limited to on-screen action, it may go *anywhere*. A shot of an on-looker may be used to cover a jump-cut in an excavating operation. A deliberate or inadvertent switch in screen direction may be covered by a reaction cut-away close-up of a person looking at the moving player or vehicle, as if watching the change occur.

DO NOT ESTABLISH CUT-AWAY CLOSE-UPS

Cut-away close-ups need *not* be established, since they are *not* a part of the main event and may occur anywhere. This rule does *not* apply, however, to players previously shown in a long or medium shot, or in a *cut-in* close-up, who are moved off-screen and later appear in *cut-away* close-ups. Three players may be shown in a long shot. The camera may move in on the two principal players as they converse. The off-screen player may then be depicted in a cut-away close-up. It is important to present such a cut-away

ABC-TV

Martin Rackin Prod.

Cut-away close-up of onlooker, above, conveys to audience that he is positioned on left side of street, watching stagecoach. Player in cut-away close-up must have "look" matching that previously established in wider shot.

close-up with the same look as previously established. If an opposite look is filmed, the audience may be led to believe that the supporting player has crossed to the opposite side of the principal players. Because the look is wrong, the audience would be confused. If the camera is positioned on the proper side of the action axis, the looks of both on-screen and off-screen players will always be correct.

A cut-away close-up may also be established by "planting" it earlier in the sequence as part of the over-all scene, so that its location will be recalled when shown. For example, a player may be filmed in a long shot, standing in the corner of a room. The audience will recall his presence later, when he is depicted in a cut-away close-up.

CLOSE-UP CHOICE

Where possible, it is *preferable* to use a *cut-in*, rather than a cut-away *close-up*. This will heighten interest, because it is more intimately involved with the principal action, rather than with related action elsewhere. While the cut-in close-up goes directly *into* the heart of the established scene, the cut-away close-up *moves* the audience *outside* the area depicted. Unless the cut-away close-up makes a significant story point, it should not be employed. Otherwise it may disrupt the narrative. An exception would be the insertion of a cut-away close-up *intended to distract* the audience, in order to cover a jump-cut or some other editorial necessity.

In choosing between a close-up from an objective or a point-of-view camera angle, the player's p.o.v. is usually best. This provides the audience with a more intimate view, since the subject is seen from the viewpoint of a player in the scene.

CLOSE-UP LOOK

Cut-in close-ups should *always* match the looks of the players in bracketing scenes. Because cut-in close-ups *move into and continue* the main action, rules governing the action axis should be used to preserve the players' looks throughout a series of consecutive scenes. It is expedient to film all close-ups of each player at one time, when they occur in the same area. If the look varies during the long or medium shots, the corresponding look must be filmed in the cut-in close-up used for that *particular* point in the sequence.

The look may vary *during* an individual close-up, if another player is being observed as he moves about off-screen. The look may sweep from one side to the other when a *background* player is positioned *between* two *foreground* players at opposite sides of the frame. The rear player may be shown in the three-shot, or in a close-up looking first at one, and then the other. The look may

also sweep across the screen when a player in a two-shot is shown in a close-up, and switches his look from the opposing player with whom he is relating, to an off-screen player not previously shown. When crossing the camera, the player must *never* look directly into the lens.

To insure a matched pair of looks in opposing point-of-view close-ups, each off-screen player should be positioned as closely as possible to the side of the camera. If physical limitations — such as lights or mike boom — prevent this, a closed

fist should be positioned at the proper place to provide the on-screen player with a reference point. If the off-screen player stands too far from the side of the camera, the opposing on-screen player will have to turn his head — spoiling the point-of-view relationship of both players.

A *cut-in* close-up filmed with the *wrong* look — right instead of left, *or* left instead of right — is editorially *useless* because the player will look *away* from, rather than *toward*, opposing player.

Cut-away close-ups *removed* from the main event, *or* intended to *confuse* the viewer deliberately, may look in *either* direction. A series of unrelated cut-away close-ups, such as various persons in different settings, may be more pictorially effective if filmed with alternate right and left looks.

Cut-away close-ups need *match* the look *only* when their location is narratively significant. When an off-screen player is positioned on the *right* of the principal players, he should be filmed with a look toward screen *left*.

Close-ups of players talking to each other by telephone should face in *opposite* direction, so that they present opposing looks. This presents the conversation as if the players were standing together, and talking to each other. The audience is conditioned into believing that opposing movements will meet, and that opposing looks infer that the players are relating with each other.

This three-shot demonstrates how players' looks may vary during a series of shots. When filming a series of cut-in close-ups, care must be taken to see look is correct for portion of event being filmed.

Player in center looks at player on right.

Player on right returns her look.

The look on *cut-away* close-ups may be neglected, because it is not considered as important a matching problem as that encountered with *cut-in* close-ups. Cut-away close-ups should be given as much editorial attention as cut-in close-ups, particularly when the location of the player shown is narratively significant.

CLOSE-UP CAMERA ANGLE & IMAGE SIZE

A three-quarter to front face camera angle is almost invariably best for close-ups. A three-quarter angle will show more facial facets, because it depicts the front and side of the head. At the same time, a flat front p.o.v. close-up can be equally effective, if lighted from a three-quarter angle, so that the face is roundly modeled. While profile close-ups offer pictorial variety, they require careful treatment to avoid a flat cardboard cut-out effect. The profile's single eye *lacks* the intimate eye-to-eye contact between player and audience characteristic of three-quarter angle, and particularly p.o.v., close-ups.

Much of the theatrical cinematographer's reputation is based on how he shoots close-ups, particularly those of actresses. A great deal of time and attention are devoted to camera angle, image size and lighting of theatrical close-ups.

The non-theatrical cameraman, however, may be guilty of "stealing" close-ups with long telephoto lenses from long-shot camera positions!

Player on left looks at player on right.

Player on right looks to player on left.

Player on left looks to centered player.

Centered player looks at player on left.

Players talking to each other by telephone should be photographed with opposite looks. Opposing looks infer that players are relating with each other.

Front-face to three-quarter angling is invariably best for close-ups. Point-of-view close-ups are best if roundly modeled with cross-lighting. Objective close-ups present more facial facets.

While this may save additional camera set-ups, and may be necessary when filming newsreels, it usually results in poorly-angled, flat, inadequately-lighted close-ups. Although such close-up filming may be tolerated on uncontrollable action, it is inexcusable on staged sequences. For instance, a pair of profile close-ups should *not* be filmed from the same camera set-up as was a preceding shot of two players facing each other. The camera should be moved *in* and *around* to shoot either objective or p.o.v. close-ups of each player.

In most *objective* close-ups, the camera should

be positioned at the *eye-level* of the *person photographed* (or slightly higher or lower to solve particular facial problems). Since the objective angle is that of an impersonal observer, however, the camera may be positioned practically anywhere. For example, if the long shot is filmed from a low angle, cut-in close-ups should follow from similar low angles. If the camera looks down at a crowd, a close-up could be filmed in like manner. The objective close-up should generally be filmed from eye-level; but it may be shot from a higher or lower height to match the camera treatment given a particular sequence.

Subjective close-ups are best filmed from the *eye-level* of the *person photographed*. In this way, the subject is on an eye-to-eye level with the camera lens, and—therefore—with every member of the audience. This relationship applies whether the subject is standing or seated. If the camera is higher or lower, the subject must look up or down to look into the lens. The resulting expression on the subject is distorted, and may discourage the viewer from relating with him. Since the subjective camera acts as the eye of the unseen viewer; a higher or lower than eye-level camera height places the audience above or below the subject. This creates an awkward relationship.

Point-of-view close-ups should be filmed with the camera positioned at the *eye-level* of the *opposing player,* whose viewpoint is being depicted. Thus, when one player looks at another; or when a player looks off-screen at a player, an object or an event; the view is presented as seen by the player involved.

Considerable cheating is permissible in point-of-view shots. The camera should be *higher* to *simulate* an adult looking down at a child or a standing player looking down at a seated player; and *lower* to simulate a child looking up at an adult or a seated player looking up at someone standing. The camera *position* need not be at the exact height of the person involved. The *up* or *down* viewpoint may be cheated in order to *suggest* difference in height. Or, it may be *exaggerated* for psychological effect — so that the adult appears taller than actually, to a small child.

Pairs of profile close-ups should not be filmed from same camera set-up as preceding two-shot. This treatment generally results in close-ups which lack intimacy, because players' features are flattened.

Martin Rackin Prod.

Objective close-ups are usually filmed from eye-level of player photographed. Here, camera is raised to eye-level of an impersonal observer positioned alongside subject.

University of So. Calif. Cinema Dept.

Subjective close-ups are best filmed from eye-level of person photographed. Subject should look directly into lens — as if looking at another person seated or standing nearby. This results in performer-viewer eye-to-eye relationship on same level. If subject has to look up or down — at higher or lower camera — effect may be strained, because relationship is awkward.

Over-the-shoulder close-ups are filmed as closely as possible to the *eye-level* of the player *depicted*, and as determined by the height of the player in the *foreground*. When two people of equal height are filmed, little trouble will be encountered. If

NASA

Point-of-view close-ups should be filmed with camera positioned at eye-level of person whose viewpoint is being depicted. Downward angle on this space missile control panel — used for training astronauts — allows the audience to trade places with trainee, and view dials from vantage point.

difference in height of players is involved, camera height will have to be adjusted to accomplish the best foreground framing, together with proper modeling and positioning of the featured player. Differences in height may sometimes be cheated by having a shorter player stand on a block, or a tall woman remove her high heel shoes.

The *CAMERA ANGLE* Chapter thoroughly discusses uses of *progressive*, *contrasting* and *repetitious* camera angles and image angles. A sequence may *progress* into a close-up or a series of close-ups; or a close-up may be *contrasted* with a long shot; or a series of *repetitious* similarly sized close-ups of various players or objects may be presented.

A series of close-ups should be filmed with corresponding image sizes; preferably from similar camera angles, so that their screen appearances remain uniform. Back-and-forth close-ups of opposing players in a two-shot should be matched in image size and image angle, whether filmed objectively or from each player's point-of-view. Various size close-ups, and different camera angles may be used; but it is best to present a matched pair before switching size or angle. If different types of close-ups, or different angles, are mixed, a hodge-podge of shots will result.

Player's head should not bob around in a tight close-up, so that cameraman must continuously move camera to keep it correctly framed. Controllable subject should be instructed to hold his position as he speaks or reacts. Uncontrollable subject should be photographed with shorter focal length lens, so that wider area is covered. This allows filming with a static camera.

Claude Michael, Inc.

Point-of-view close-ups — such as this close-up of soldering operation — are particularly important in training films. Camera should be positioned over-the-shoulder of worker performing the task, so that resulting close-ups depict action as trainee would see it if he were doing the job.

Claude Michael, Inc.

Unless for narrative reasons, close-ups should not be presented in a monotonous series; merely to maintain uniformity of size and angle. *Each* player should be filmed with the same change in image size, and from the same angle, so that the film editor may utilize matched pairs of close-ups.

A series of repetitious cut-away close-ups of *unrelated* players or objects, such as several *man-in-the-street* close-ups; or close-ups of various objects — such as tools or dials — should maintain the same image size, and similar or opposing camera angles. They may all face in the same direction, or face each other in pairs of opposing shots with alternate right and left looks. Dutch-angled close-ups, filmed for special effects, may be given opposing angled tilts so that they present counterpoint pairs.

It is advisable to make notes of lens focal length, camera angle, particularly whether left or right Dutch-tilt angles, and distances between camera and players or objects. It is best not to trust to memory, especially if a long interval occurs between the filming of matched close-ups. Such data will also be important if retakes are

needed later. With these precautions, uniformity of close-up image size and image angle can be maintained throughout a production.

Head movement is permissible in a moving close-up. If preferred, the camera may follow a player with a panning or dolly movement. But, a head should *not* be allowed to bob around in what should be a *static* close-up, so that the cameraman must pan and/or tilt to keep the head properly framed. This may be observed in newsreels and documentary films, where an over-long focal

Santa Fe Railway

Player movement — begun in this shot — may be completed in following close-ups, when players sit at table. Players should duplicate their movements by sitting into close-ups. This permits editor to cut on action with movement flowing across splice.

length lens — or a zoom lens set at the telephoto position — is employed to film an uncontrollable, restless subject. In such instances, it is best to use a shorter focal length lens, and film a wider area to allow static framing.

PLAYER MOVEMENT
INTO & OUT OF CLOSE-UPS

A player may move from a long shot or medium shot *into* a close-up. Such movement should be *duplicated* in both shots, so that the film editor is provided with a cine choice. The editor may cut *on* the move, or *after* the move, when the player is in close-up position. If the player is *positioned* in the frame for the close-up, rather than *moved* into position, the editor has no choice. He must move the player into position in the wider shot, and then cut to the already-positioned player in the close-up.

To assemble a more fluid film, editors prefer to cut *on* movement, rather than to a static close-up *after* movement is completed. While many movements should not be interrupted by a cut, a cameraman should leave these decision to the film editor. Cutting on movement will often mask the splice where the shots are joined, so that the cut is barely apparent. Allowing movement to begin

and end *within* each shot, often results in a "stop-and-go" appearance. Movement will flow throughout a sequence, or a series of shots, *if* cuts are made during movement. A player may begin to move in one shot, and complete the movement in the following close-up. For example, a player should *sit into* a *static* close-up. As he moves toward the chair and begins to sit down, the movement flows *across* the cut, from medium shot into static close-up, as he settles into the chair. Movement into and out of close-ups should, therefore, duplicate action of preceding or following wider shots — so that overlapping movement results.

It may be difficult for a player to *move* into precise position, for a static head close-up. A simple solution to filming a tight head shot is to keep the standing player's feet static, bend the upper body to the side, and then swing the body back into vertical position. In that way, the head may be moved into perfect framing when the player is standing.

While filming a move *into* a tight close-up may be difficult to frame, a move *out* of a close-up is fairly simple; and should *always* be filmed *if* the player is picked up on the move in the next shot. Should the player not be moved out of the close-up, he must *remain* in his close-up position for next shot; and *then* be moved, during following medium or long shot, in order to continue action.

The absence of moves into and out of close-ups may severely handicap the editor, particularly if he wishes to shorten the sequence gracefully. A good *rule* is to move players *into* and *out of* close-ups whenever such movement may be editorially useful. (See: CUTTING, Cutting On Action)

CLOSE-UP TEMPO

The timing of players' movements in close-ups should match that in bracketing scenes, especially if the movement flows across a cut. This is rarely a problem in theatrical films, where professional players follow the script and move about as directed. It can cause complications in non-theatrical films where industrial, research, training or scientific personnel operate control panels, lab apparatus or test equipment. Since greatly magnified movements — such as throwing a switch,

calibrating a meter or swinging a tool into position — appear highly accelerated on the screen, the person performing a small action in a large close-up should move with deliberate slowness, so that hands, fingers or tools do not appear to flash in and out of the shot.

It is important to stage bracketing wider scenes with matching close-up tempo. This requires thinking *ahead* to the close-up, if the action is filmed in continuity. Cutting-on-movement in such cases will appear smooth *only* if precautions are taken to match the tempo of movement from wider shots to close-ups. For example, a medium shot of an airplane pilot in a cockpit moving his arm with a *fast motion* toward the instrument panel *cannot* be cut-on-the-move with a close-up of an altimeter, as his fingers *slowly* enter the frame to set the instrument. Only the portion of this close-up *after* his fingers have settled in position on the calibration knob could be used. Differently-timed movements in wider shots and close-ups prevent cutting on action, and force the editor to resort to statically-positioned close-ups, *after* movement into the frame is completed.

CLOSE-UP CAMERA SET-UPS

Similar close-ups throughout a sequence are almost always filmed at the same time in theatrical pictures, to avoid duplicating camera set ups. This may not be possible on a technical film where assembly of a complicated machine, for example, may necessitate shooting in straightforward continuity as work progresses. When lengthy filming requires moving the camera in for close-ups, and then back again to original set-up, it is wise to mark camera position on the floor and to record lens focal length, and other technical data useful in duplicating shots. Positions of light stands should be chalked or taped on the floor, if they are moved, so that they may be returned to their first positions. Intricate lighting set-ups may require diagramming, or they may be photographed with a Polaroid camera to insure precise duplication. Technical matching of wider shots and close-ups can thus be assured, regardless of time intervals between close-ups.

TRW Systems

Movement in extreme close-ups must be slowed down, or it will appear highly accelerated when screened. If this wider shot is followed by tight close-up of technician's fingers, as she positions machine part for calibration, it must be filmed with matching slowed tempo. If tempo varies greatly between close-ups and wider shots, it prevents cutting on action.

BACKGROUNDS FOR CLOSE-UPS

Close-ups should not be filmed against "busy" backgrounds consisting of detailed designs, shiny surfaces, moving or similarly distracting objects, unless the subject matter justifies such treatment. Possible exceptions would include amusement parks, which would provide the gaiety of a ferris wheel, merry-go-round, or other rides moving in the background. Another exception is a television commercial with multi-facet reflections, out-of-focus highlights, or other blurred visual effects in the background. In a dramatic picture, however, players should *not* appear in close-ups against backgrounds which compete for attention. Even a lamp with an ornate shade can be a provoking influence!

Throwing the background slightly out of focus is effective; but it should be avoided if lights, shiny objects, or highly reflective surfaces distract the viewer's attention from the players. This can be particularly disturbing in color filming, if shiny colored objects — such as tinted light bulbs — show up in the background. Whenever possible, backgrounds should be nondescript, softly-contrasting

Harann Prod.

Harann Prod.

Close-up camera angles for dramatic sequences should be staged against non-competing backgrounds.

surfaces. Primary or advancing colors, such as "hot" reds or oranges, should be avoided. Receding pastel hues in "cool" blues, or neutral grays with a pale color tint, should be favored.

All camera angles should be planned for a sequence; so that players in close-ups will not be positioned against troublesome backgrounds. Lamps, picture frames, trees, poles, portions of furniture, or other props; may crop up awkwardly behind heads. Such objects should be kept away from players; or so positioned that they do not seem to protrude from a head. Camera and/or player movement during preceding wider shot can help maneuver players into suitable close-up positions. If a background object, such as a part of a frame or a lamp, appears where not wanted, camera angle may be changed, player may be moved; or the offending prop may be re-positioned. If only a small portion of the object shows, it may be best to remove it completely. It should be returned to its original position, should it appear in subsequent wider angle shots.

Newsreel interviews — or other documentary filming — may require shooting a close-up, or a series of close-ups, *without* introductory long or medium shots. Particular care should be taken in such situations to avoid backgrounds that may perplex or tease the audience. The viewer should not be shown a section of unfamiliar background in a close-up consisting of *portions* of signs,

place names, insignias, posters, etc. In trying to solve what is missing, the viewer may pay less attention to the subject. Wild designs in drapes or wallpaper may distract; particularly when enlarged behind a close-up of a person. The most suitable backgrounds for such close-ups are neutral grays, pastel tints or simple drapes, or other plain material.

CLOSE-UP FOR SEQUENCE OPENER

If it is desirable to startle, confuse or withhold information from the audience, a close-up may be employed as a dramatic device for introducing a sequence. An opener may show a gun firing in close-up, followed by a long shot of the start of a foot race! A man lost in the desert, a little boy trapped in a crowd, or a needle moving toward the *Danger* area on an instrument dial, may be shown *first* in close-up. Then the camera may be moved back to reveal the over-all picture.

A close-up may also *eliminate* a portion of the setting, so that the player's identity, location or situation may be concealed until the camera pulls back. A close-up may show a player sitting nonchalantly on a container. In the following wider shot he may be depicted astride a keg of dynamite! A close-up of a man behind bars may turn out surprisingly to be a teller in a bank. A close-up of a roaring lion pulls back to show him caged. Thus a close-up sequence opener may be utilized

to surprise or shock the audience when the full content of the scene is disclosed.

In order to motivate subsequent action, a sequence may open with a close-up of an *object*. A close-up of a ringing telephone can reveal, in an upward camera tilt, the person answering. A tape recorder playing back a confession may create suspense, until the camera pulls back to show the players involved. A close-up of a gun may hide the identity of the person holding it, until the camera tilts or pulls back to reveal him. If time is significant to story, a sequence may open with a close-up of a wall clock; then pan to a long shot, to depict the action. A close-up may also establish the locale. Examples: a drink being poured — bar; a tray of food moving along — cafeteria; a slot machine arm being pulled — gambling hall.

CLOSE-UPS FOR TRANSITION

Pairs of close-ups, similar in size, motion or content, make excellent bridging devices. A pair of close-ups may be optically blended or straight cut to furnish a pictorial transition between two sequences. A sequence may *end* with a close-up; and the next sequence *begin* with one. A player may be dissolved in a matched pair of close-ups to cover a time or space transition. Or, one player may dissolve to another player in a *different* setting. In that case, the players should be similarly sized and positioned to achieve a subtle blend of images. Similar motions may be used; such as a lawyer pounding his desk, and a judge hammering his gavel. Similar objects, such as wheels, typewriter keys, ash trays, may be filmed.

Sound will enhance a close-up transition because of its combination audio-visual effect. A line of dialogue, or a name may be spoken and repeated in a pair of bridging close-ups, to tie together different players or settings. Or, a question may be asked in one close-up and answered in the next; by another player in a different setting.

Camera movement may also be employed to *move into* and *pull back* from a pair of transitional close-ups. It may move *into* a close-up of a player or object at the *end of a sequence* and *begin* the *next sequence* with a similar type close-

North American Aviation

Screen-filling extreme close-ups of small objects provide dramatic emphasis. Resting electronic component on fingertip supplies clue to size.

up, and then *pull back*. The camera may tilt from a player to his shoes, as he walks across a room and through the doorway. Then it may dissolve to the same shoes walking on the pavement; and tilt up to reveal the player going down the street. (See: CONTINUITY, *Transitional Devices*)

CONCLUSION

Properly-planned, effectively-filmed, thoughtfully-edited close-ups are of prime cinematic importance. Close-ups add spice, the ingredient that enhances dramatic flavor of the finished film. Audience involvement is most successful when viewers are brought *into* the picture; when they see players, objects and small-scale actions in large screen-filling close-ups. A sequence may be built to move toward climactic close-ups. A sequence may open with a close-up that surprises, startles or shocks the audience into attention. Close-ups provide dramatic punch; point up story highlights; depict related action; comment on principal action; magnify the unseen; provide transitions; emphasize narrative by isolation of subject, and elimination of unwanted matter; *or* distract the audience to cover jump-cuts. Close-ups should be made to count. The stronger the motive for using a close-up, the more the close-up can help make the story-telling truly effective!

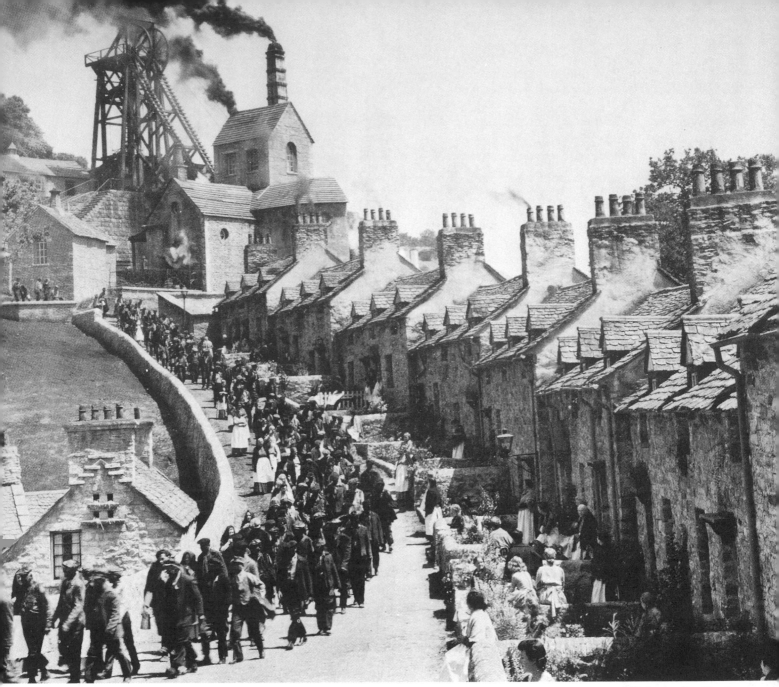

HOW GREEN WAS MY VALLEY 20th Century-Fox Film Corp.

COMPOSITION

INTRODUCTION

Good composition is arrangement of pictorial elements to form a unified, harmonious whole.

A cameraman composes whenever he positions a player, a piece of furniture, or a prop. Placement and movement of players within the setting should be planned to produce favorable audience reactions. Since viewing a motion picture is an emotional experience; the manner in which scenes are composed, staged, lighted, photographed and edited should motivate audience reaction, according to the script's intent. The viewer's attention should be concentrated on the player, object or action most significant to the story at that moment.

The camera mechanically records all properly exposed, sharply focused images with equal clarity. Stimulation of audience response — the *non-mechanical* factor — can be best conveyed by the cameraman through direction of dramatic emphasis where desirable. This is accomplished by accentuating the motions and emotions, which make the story *live* in the viewer's mind.

Composition should not be employed in a by-the-numbers fashion to record pictorially beautiful images devoid of character, meaning and movement. Of all rules by which motion pictures are made, compositional principles are the most pli-

able. The most dramatically striking scenes often result from rule breaking. To break the rules effectively, however, it is first necessary to comprehend the rules thoroughly, and to realize *why* they are being broken.

There are times when deliberately poor compositions will aid the story-telling. For instance, a film on slum clearance would actually be enhanced through employment of unbalanced, cluttered, poorly composed scenes. Such scenes would irritate the audience, and express the need for decent housing. Pictorial and psychological impacts upon the viewer would be doubly effective. He would not only want to see slum conditions corrected; he would also like to straighten the scenes that subconsciously disturb him!

Composition reflects personal taste. A cameraman with artistic background; inherently good taste; an inborn feeling for proper balance, form, rhythm, space, line and tone; an appreciation of color values; a sense of the dramatic; may create good compositions intuitively. Even a mechanically-minded cameraman with limited artistic inclination, can learn to apply the basic principles of good composition by developing better understanding of visual and emotional elements involved in recording story-telling images.

197

Lockheed-California Co.

Still photographs — such as these jet aircraft in flight — may suggest motion. Because they deal in space relationships only, stills may be well composed within singular frame of reference.

STILL vs. MOTION PICTURE COMPOSITION

Still photographs freeze the *decisive moment* in one stationary image. A *still* photograph may *suggest* motion, but it deals in *space* relationships only. It can, therefore, be well composed only within its singular frame of reference. A *motion* picture, on the other hand, is composed in both *space* and *time*.

The time dimension is just as important as linear dimensions and placement of the pictorial elements within the frame. A motion picture is a progression of varied size images. *Space* and *time* relationships between various elements may remain the *same*, or *change* as the picture progresses. The *size* of the various images may remain the *same*, or *change* from scene to scene; or *during* a scene, if the players advance toward or recede from the camera; or if the camera is dollied, panned, tilted or zoomed. This constantly-changing image pattern tends to complicate motion picture composition.

To produce a successful photograph, a still photographer must apply compositional rules correctly. A motion picture cameraman, however, can simply center a moving image in his finder and regardless of poor composition, improper placement in the frame, unsatisfactory background or

numerous other pictorial faults, holds the viewer's attention through sheer *movement* alone! If abused, however, movement—which should be the motion picture's greatest asset — can very easily become its greatest liability. Good motion picture scenes are the result of *thoughtful compositions and significant movements*, of players and/or camera. Unsatisfactory scenes are the results of thoughtless compositions and meaningless player or camera movements, which distract rather than aid in the story-telling.

Although the cameraman should be primarily concerned in telling the story with movement, he must guard against *insignificant movement* of a subordinate player or unimportant object, which may detract from the principal player, action or object. Such movement can be particularly distracting in quiet scenes that are more or less static in nature. Since the viewer's eyes is easily *attracted* or *distracted* by any moving object, the cameraman should guard against *undesirable movement* anywhere in the scene.

GOOD CAMERA WORK BEGINS WITH COMPOSITION

Composing the scene is the cameraman's function. He must arrange the various pictorial elements into a semblance of order before he can

Calif. Div. of Highways

Even on subject matter impossible to prearrange, the cameraman can choose camera angles which provide the best viewpoint — and the best composition.

Warner Bros.

If scene should awe audience by beauty, vastness or grandeur of setting, a long shot, or extreme long shot — conveying proper mood and atmosphere — should be used.

light the players and the set; plot player and/or camera movement; break down the sequence into shots, and decide on the various camera angles required to cover the action. Until the scene is composed, the cameraman is not sure just what he is going to shoot. Even outdoors on uncontrollable subject matter, which cannot be pre-arranged, the cameraman can choose camera angles that provide him with the best viewpoint, and consequently, the best composition.

The cameraman should approach composition with the question: "What can I do with this subject matter that will aid in telling the story?" Players' actions and setting often suggest a particular compositional treatment. Script and subject should be analyzed to determine the audience impact intended. Should the viewer become moved to pity, tears or laughter? Should the audience be awed by the beauty, vastness or grandeur of the subject? Or should they be sold on a particular product, process or technique? Whatever the script's intent, the scenes should be composed to provide the proper pictorial aspects, and inspire the desired psychological response in the viewer. Pictorial thinking and appreciation of psychological compositional devices by the cameraman will produce intended mood.

COMPOSITIONAL RULES

Because composition involves artistic taste, emotional awareness, personal likes, dislikes, experience and background of the individual cameraman, strict rules cannot be applied. While composing a scene is not a mechanical process, certain mathematical and geometrical factors may help insure success. The principal difficulty in composing for motion pictures is dealing not only with *shape of people and objects,* but the *shape of motions.* A beautifully-composed *static scene* may become a senseless shambles when players, objects, vehicles, or the camera move! The motion picture cameraman must remember that rules of static composition cover still photographs, drawings, paintings, designs. Because of the static content of many shots, still compositional rules may be successfully applied to motion picture scenes with *fixed* pictorial elements.

A scene may break all compositional rules and still attract the viewer's eye to the significant player or object in the picture, merely by movement or sound dominating the frame. A poorly positioned player, for instance, may attract attention by raising his voice. Even though obscure in position, a secondary action may attract more attention than the principal action.

This does not imply that good composition

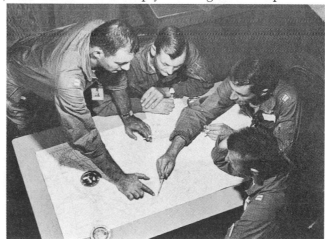

North American Aviation

The curved grouping of these airmen, planning a flight, forms a transitional line in space — extended by right arm of the officer at left — which tends to keep viewers' eyes focused on map.

199

should be disregarded, and action and dramatic dialogue substituted to capture viewer's attention. The rules of good composition should be utilized whenever possible, particularly when the scene consists of more or less static action — such as in establishing long shots, players at rest in key positions during dialogue exchanges, and any time dramatic emphasis must be attracted to dominant subject matter. Esthetic values should *not* be neglected because of eye-and-ear attractions of sheer movement and mere sound. Players and objects should be harmoniously arranged within the setting, and moved about with artistic effects, striving to capture pleasing pictures at all times; regardless of player and/or camera movement, and the need for continuous composing as the scene progresses.

COMPOSITIONAL LANGUAGE

> *LINES*
> *FORMS*
> *MASSES*
> *MOVEMENTS*

These compositional elements speak a universal language which trigger similar emotional responses in almost every viewer. Properly integrated and employed in an artistic, imaginative,

Lines should not parallel any side of the frame unless formed by a building — or columns, trees or other lines, as part of a repetitious pattern. The series of vertical lines are in keeping with the dignity of the modern Music Center.

intelligent manner, they comprise a compositional language which may convey the desired mood, character and atmosphere.

LINES

Compositional lines may be actual contours of objects or imaginary lines in space. People, props, buildings, trees, vehicles, furniture — may all be expressed in straight, curved, vertical, horizontal, diagonal or any combination of contour lines. While moving about in the scenes, or following action, the eye also creates *transitional lines* in space. Such imaginary lines, suggested by eye movement or subject movement, may be more effective than actual compositional lines.

For instance, the viewer's eye may travel in a curved pattern, formed by the grouping of several players. It may move in a diagonal line as it follows an airplane taking off. Or in a vertical line described by an ascending missile. The linear composition of a scene is dependent, therefore, not only on actual contour lines but by transitional lines created by eye movement.

For most effective composition, real lines should not divide the picture into equal parts. Neither strong vertical nor horizontal lines should be centered. A telegraph pole or the horizon,

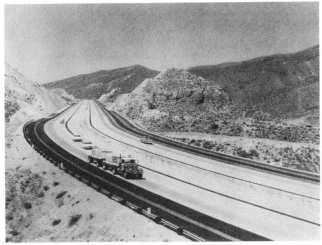

Calif. Div. of Highways

A receding curve suggests distant space, since it carries the eye into the picture. Whenever possible, scenes should be composed in depth to impart three-dimensional quality to setting.

should not be placed in the middle of the frame. The frame should not be divided into two equal parts with a diagonal line from one corner to another, as formed by the side of a mountain.

Unless formed by buildings, columns, trees or other lines, as part of a repetitious pattern, straight lines should not parallel any side of the frame. A single strong line at the side, top, or bottom of the picture should be irregular, rather than absolutely vertical or horizontal. Silhouetted lines, paralleling one or more sides of the frame — such as a doorway — should be recognized, or they may suggest image "cut-off" caused by a mis-aligned filter holder or matte box.

Viewer interpretations of various compositional lines follow:

Straight lines suggest masculinity, strength.

Softly curved lines suggest femininity, delicate qualities.

Sharply curved lines suggest action and gaiety.

Long vertical curves with tapering ends suggest dignified beauty and melancholy.

Long horizontal lines suggest quiet and restfulness. Paradoxically, they may also suggest speed, because the shortest distance between two points is a straight line.

Universal City Studios

These figures form transitional lines in space, suggesting a pyramid — conveying to viewers solidity of player relationship.

Tall, vertical lines suggest strength and dignity.

Parallel, diagonal lines indicate action, energy, violence.

Opposing diagonals suggest conflict, forcefulness.

Strong, heavy, sharp lines suggest brightness, laughter, excitement.

Soft lines suggest solemnity, tranquility.

Irregular lines are more interesting than regular lines, because of their visual quality.

Various combinations of lines may influence each other and convey different meanings. Unopposed verticals, beginning at the bottom or ending at the top of the picture, appear to extend beyond the frame. However, short secondary horizontals, such as a roof, may be used to contain a vertical composition within the frame. Short horizontal lines are useful as accents to help a series of strong verticals from becoming monotonous. Conversely, long horizontals may also be accented or broken up by short verticals, meeting at right angles or crossing. Curves require stronger straight lines for accents and contrast. A series of curves may weaken a composition unless reinforced by vertical or horizontal accents. A profusion of curves or diagonals may result in confusion, and should be used only to express shocking excitement or uncontrolled action.

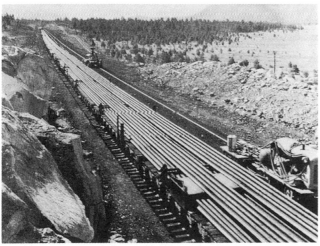

Santa Fe Railway

Parallel diagonal lines converging in distance convey action and energy—reinforced by glare of sunlight on welded rails.

Lines that lie flat on the picture surface, or recede into the distance, convey different meanings. Whenever a vertical or horizontal line becomes a diagonal, it appears to recede from, or advance toward the viewer. A tilting shot of a building indicates that it is falling backwards. An angled shot of a straight road creates the impression that it is a diagonal, receding into the distance. A geometric curve creates a pattern that lies flat on the surface of the picture. A receding or diminishing curve, however, suggests distant space, since it carries the eye *into* the picture. A diagonal line *parallel* to the picture's surface suggests a moving, falling or other action line, such as a falling tree. A diagonal *receding* into the distance, suggests a space line. Pairs of such diagonals, such as railroad tracks, seem to converge and meet at infinity.

Meanings conveyed by lines are also influenced by such forces of Nature as gravity. Diagonals are dynamic. Usually they suggest instability, because they are basically fallen verticals. A vertical tree becomes a diagonal when it falls. Lightning is a strong, sharp, jagged diagonal line. Rain drops or snow flakes form a series of softly falling lines. Rivers or meandering streams create curves as they follow the contour of the earth.

Lines also express speed qualities, which can add dramatic emphasis to the picture. Straight, angular or jagged lines, such as lightning streaks, give impressions of speed, forcefulness or vitality. Softly curved lines slow eye speed and create a leisurely or deliberate pace. Most beautiful curves attract lingering attention. Since they do not impede progress, unbroken lines make faster viewing than broken or erratic lines.

FORM

All objects, whether natural or man-made, have *form*. Physical forms are easy to recognize. Forms created by viewer's eye movement from one object to another are not always easy to recognize, unless pointed out. Thus, many abstract forms exist solely in viewer's minds in the *space* created by several physical objects.

Eye movement from one person or object to another may describe a triangle, a circle or other form. Many experienced cameramen subconsciously utilize certain compositional forms without actually analyzing them. They have learned through experience that certain groupings of people, furniture, objects, vehicles and structures present harmonious pictures. Transitional lines created by the viewer's eye moving from one object to another may result in an esthetically pleasing effect.

The following compositional forms should be considered as both physical forms and abstract

Transitional lines which describe forms in depth — such as triangle formed by this derrick loading Polaris missile into nuclear submarine — are compositionally stronger than forms which appear to lie on surface of screen.

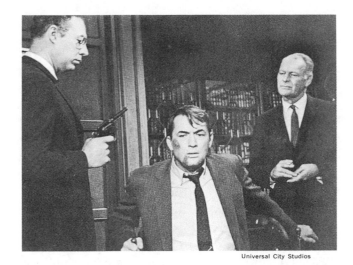

Universal City Studios

A reverse triangular composition — with apex at bottom — may also be used to compose three people. While it may be weaker in form, it is an excellent choice in this instance, because standing players dominate centered player. Composition would be weakened if player at right were absent.

forms existing in space. They should also be considered as existing in *depth*, from front to back of the picture, not solely as flat, two-dimensional forms lying on the surface of the picture.

A triangular form suggests strength, stability, solidity of the pyramid. It is a compact, closed form which causes the eye to continue from point to point without escape. A tall, thin triangle is related to the vertical, and is found in Nature in evergreen trees. A short, squat triangle is related to the horizontal and, because of its broad base, possesses greatest stability. Mountains are composed of a series of triangles. Triangle compositions are very useful for grouping people because a significant figure can dominate through added height. It is much easier to compose in *three's*, or other odd numbers; because a single compositional element may become the center of interest by rising up and creating an abstract triangular composition with the lower positioned figures on either side. A reverse triangle, with its apex at the bottom, may also be used although it lacks the stability of the pyramid, which rests on its base. In this fashion, two adults may be effectively composed with a child between them.

A circular or oval form also tends to tie in and hold the viewer's attention. A circular object, or a group of figures or objects arranged in a circular pattern, causes viewer's gaze to wander without escape from the frame. A circle of light, such as that produced by a spotlight, may be employed to encompass a player. Yet, the rest of the framed area remains dark; discouraging viewer's attention from straying from center of interest. A circle or oval lacks the broad base and stability of the pyramid or triangle. A base may be provided, however, by a shadowed area, a foreground frame, or some other lighting or compositional device.

The cross is one of the few compositional forms that may be centered, because its four arms radiate in all directions equally. The cross inspires a sense of unity and force. It is awesome and powerful because in many minds it symbolizes the Almighty. The cross may be placed off center of the picture; but it should not be placed too close to the side of the frame, or part of its radiance will be weakened.

Radiating lines are a variation of the cross, since they supply multiple arms from a centrally-located hub. There are many excellent examples in Nature — flower petals, tree branches, snow-flakes, etc. Radiating lines seem to expand and attract, especially if twirled, and their action spreads joy and laughter. While radiating lines

may be either straight or curved, to be most effective, the center of interest should be located near the hub. Unlike the cross, however, the hub need not be near the center of the frame.

Various L-shaped forms suggest informality, and are very flexible because they provide base and upright in combination. An L-shaped composition is useful for landscapes, or establishing long shots; where a broad base created by a shadow area, a walk, a wall or a road, extends horizontally to one side of the frame with a tree rising in a strong vertical. A solitary figure at one side of the frame may also form an L with the ground or floor. The L can provide repose, through its base; and dignity, through use of figure or object rising in the frame. The strongest L composition results when the upright occupies the left or right vertical line created by dividing the frame in thirds. An accent at the opposite bottom cross lines will provide the opposing compositional weight required for a balanced picture.

MASSES

The words *shape, form* and *mass* are often used interchangeably. *Shape* has to do with the *spatial aspects* of an object, its physical shape as defined by its *contour*. *Form* may be *physical* or *abstract* as explained in the preceding pages. *Mass* is the *pictorial weight* of an object, an area, a figure or a group made up of any or all of these. Masses are either single units, such as a large body of water, a mountain peak, a ship or an airplane; or a large head in close-up, or a combination of several figures or objects closely grouped or integrated so that they appear as a single compositional unit.

Lines and forms can dominate a composition by their esthetic or psychological value. They may attract the viewer's eye through sheer beauty or the viewer's senses through their emotional appeal. Pictured masses, however, capture and hold attention through the power of their *heavy* pictorial weight. They may also dominate by their isolation, unity, contrast, size, stability, cohesion, lighting or color.

Strength is added to an isolated mass, if it is separated from its background by contrast, lighting or color. Such treatment will cause a mass to stand out from a confusing, conflicting or otherwise "busy" background.

A unified mass is strengthened when several figures or objects are tied together; so that they combine into a dominant group. Wildly scattered groupings should be avoided.

A dark mass will stand out against a light background, or a light mass against a dark one — through contrast. This is the simplest way to provide emphasis, and pull a figure or object away from the background.

A mass may be a single pictorial element — such as a mountain peak — or it may consist of closely grouped figures that appear as a single compositional unit. A large mass captures viewers' attention through the power of its heavy pictorial weight.

A large mass will dominate the scene if contrasted with one or more small masses. Size of mass can be increased in relation to the frame through careful choice of camera angle, lens focal length and placement in the picture.

A finely-composed mass with a heavy base, presents an immovable appearance which will dominate through stability. The pyramid form, particularly with a dark foreground, is very effective when massed into a dominant full-frame pictorial element.

A compact mass — without projections, jagged edges or other protuberances — will dominate the scene because of its cohesiveness.

Massive lighting effects, especially if shot against a darker background, will dominate by creating unity and contrast. A burning forest, a streak of sunlight through church windows, a fireworks display, or the backlighted rays of sunlight on the water are all dominant masses created by light alone.

A predominating color, such as a large blue shadow area or red-streaked clouds illuminated by a setting sun, may create a massive color effect. Primary or highly-saturated colors are most effective when used to dominate the scene.

MOVEMENTS

Compositional movements are a particularly important aspect of motion picture photography. Complete movements may be only *suggested* in *still photography*. They may be both *suggested* and *depicted* in *motion pictures*. Movements possess esthetic and psychological properties, which may convey varied pictorial and emotional connotations to the viewer. Movement may be created by the eye going from one point to another within the scene, or by following a moving object. Such eye movement results in transitional lines which are similar to compositional lines. Movements may change during a shot, or a sequence of shots, to match the changing character, mood or tempo of the action. Meanings of various compositional movements may be described as follows:

Horizontal movements suggest travel, momentum, displacement. Left-to-right movement is easier to follow, more natural, smoother. Reading

U.S. Air Force

Ascending vertical movement suggests freedom from weight — as depicted in shot of missile rising from launching pad.

from left to right has pre-trained the audience to accept such movement; and to follow it with little or no effort. Right-to-left is stronger, because it is "against the grain." Since left to right offers less resistance, it should be used for travelogue panning shots or similar easy-going action. Right to left movements should be employed where a stronger, more dramatic *opposition* must be depicted, such as the hero moving toward the villain.

Ascending vertical movements suggest aspiration, exaltation, growth, freedom from weight and

Santa Fe Railway

Descending vertical movement suggests heaviness, danger or crushing power — as portrayed by this waterfall.

205

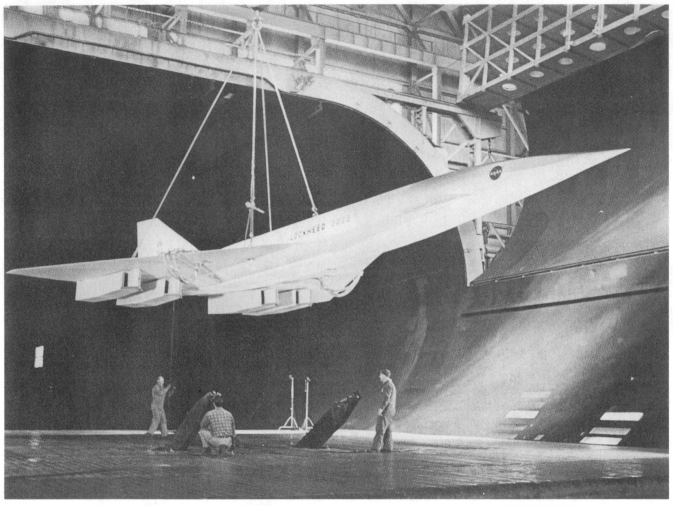

This one-fifth scale model of proposed supersonic transport plane being readied for wind tunnel test, appears as if in actual flight — because it is angled in ascending line.

matter — such as smoke ascending from a candle, or a missile rising. Since an upward movement is uplifting, it may be employed for religious subjects. Feelings of lightness, free flight, happiness, elevation may be conveyed by such movement.

A descending vertical movement suggests heaviness, danger, crushing power, such as portrayed by a pile driver, an avalanche or a waterfall. Such downward movements may portray doom, imminent death or destruction.

A diagonal movement is most dramatic because it is the strongest. Diagonal movements suggest opposing forces, stresses and strains, power, overcoming obstacles by force — such as in battle scenes. Diagonal movement may be suggested even in many static scenes by a Dutch tilt angled camera, which creates slanting dynamic lines. Thus, a statue, a building a dominant player, may be given added dramatic impact by diagonal treatment. A *lower-left-to-upper-right* diagonal motion should be used for an *ascending movement*, such as climbing a mountain. An *upper-left-to-lower-right* diagonal motion should be employed for *descending movement*, such as lowering an object. Zig-zag diagonal movements — such as lightning flashes — suggest swiftness and menace. Crossed diagonals suggest opposing forces, such as crossed swords in battle scenes.

Curved movements suggest fear; such as a curved snake, or fascination through fear. Circular or revolving movements, however, suggest cheerfulness, as found in amusement park rides. Revolving movements also suggest mechanical energy; such as wheels of industry or travel.

Pendulum motion suggests monotony, relentlessness, such as prison scenes or the back-and-forth pacing of nervous person or caged animal.

Cascading motion suggests sprightliness, lightness or elasticity such as a ball bouncing, water rapids or a child skipping or playing hop-scotch.

Spreading or radiating motions suggest centrifugal movement, such as concentric ripples on the surface of a pool resulting from a stone thrown into the water. Radiating movement may also suggest growth from the center outward. Spreading motion suggests panic, such as in a mob rioting. Radiating motion suggests radio broadcasting, or any activity emanating outward from the center of interest.

Interrupted movement, or movement that changes direction, attracts greater viewer interest than continuous movement or movement in a constant direction.

Movement toward the viewer is more interesting because it increases in size. Receding movement decreases in size and loses viewer interest.

BALANCE

Balance is a state of equilibrium. If all forces are equal, or compensate each other, they are said to be "in balance." An out-of-balance figure or object will usually topple over. Physical balance, therefore, is influenced by the law of gravity, by compensating forces and the power of attraction.

Unbalance *upsets* the viewer because it disturbs his sensibilities, and creates unrest in the brain. That is why some pictures may not "look right." A properly-balanced composition is subconsciously agreeable, because the various elements are combined in an acceptable picture. On special occasions, the cameraman may wish to *disturb* the viewer, and purposely presents an unbalanced composition. Ordinarily, the scene should be presented so that the laws of balance are observed.

Pictorial balance in motion picture composition can be either complicated or enhanced by player and/or camera movement. Moving players or vehicles and the necessity for panning, tilting or dollying the camera, require continuous composing as the scene progresses. Motion pictures compositional *balance* is a series of *pictorial compromises* based on *key positions* of players and pauses in the action when elements are at rest. Static scenes require better balance than moving scenes, where action will attract the viewer's eye,

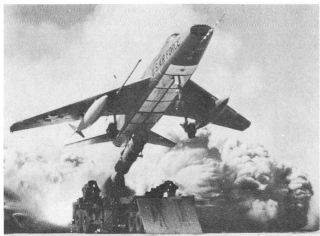

Lower-left-to-upper-right diagonal motion should be used for ascending movement. Angling this mobile-launched jet fighter, so that it moves across the screen in this manner, results in a dynamically effective shot. If this shot were filmed from the opposite side, it would depict the aircraft with an opposing transitional line which should be used for descending motion.

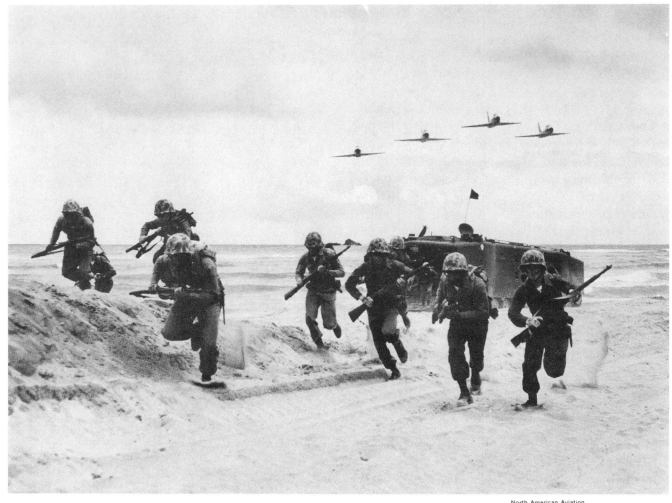

Movement toward viewer is more interesting, because it increases in size as it advances. Movement of Marines rushing forward in this amphibious landing is further reinforced by jet fighters flying toward the camera.

regardless of compositional inadequacies.

Real life balance is concerned with *physical weight. Pictorial balance* is concerned with *psychological weight*, which is influenced by relative *eye attraction* of various compositional elements in the picture. Each element attracts in accordance with its size, shape, tonal value, color, movement, direction it faces, contrast with its surroundings and placement in the frame. Balance may be considered as a pair of balances or a seesaw. A *large static* object on one side of the scene may thus be counter-balanced by a *small moving* object on the opposite side — such as a tiny car moving toward a large mountain — because they both have *equal* psychological or pictorial weight.

The *location* of a compositional element within the frame influences its weight. A figure or object placed close to the *center* of the frame possesses *less* compositional weight than one nearer the side — because it exerts little influence on the seesaw and cannot tip it either way. Therefore, a lighter weight element may be moved further away from the center; while those of heavier weight should be positioned closer toward the center — to keep them in balance. Placing a heavy weight element too far to either side of the frame will unbalance the composition and cause it to topple visually.

The following compositional weight factors

North American Aviation

This scene is pictorially interesting because fuel truck is in background, framed by airplane wing. It would lack interest if shot square-on, with aircraft and fuel truck in straight line-up across screen.

Weber Aircraft

Documentary subjects — such as this high-speed space capsule ejection seat test with instrumented dummies — may be formally composed when two objects are of equal interest.

should be considered on the basis of all other factors being equal:

A moving object possesses more weight than a stationary object. This applies regardless of size. A relatively small moving object — particularly if light in tone, brightly colored or contrasted against the background — will command greater attention than a large stationary object.

An object moving toward the camera becomes progressively larger, and therefore carries greater weight than a diminishing object moving away.

The upper part of a picture is heavier than the lower part, because a higher object appears heavier than a lower one.

Since most viewers' eyes automatically move toward the right, the right side of the frame can obviously attract and hold more attention than the left side. Thus, the left side of a picture can support greater pictorial weight than the right side.

An isolated object possesses more weight than an object crowded, merged or stacked with others. This applies whether isolation is achieved by positioning, lighting, contrast, color, or other factor.

An object will appear heavier if placed at the side of the frame, since the center of the picture is compositionally weakest.

A large object in a static scene will carry more weight, since it tends to dominate the picture regardless of position or other factors.

Regularly-shaped objects carry more weight than irregularly-shaped objects.

Peculiar, complex or intricate objects may appear heavier because of the additional interest they generate.

A compact object, with mass concentrated around its center, will carry more weight than a loosely-joined object.

A vertically-formed object will appear heavier than an oblique object.

A bright object will possess more weight than a darker one. A high-key, light-toned object appears to *advance* toward the viewer; while a darker object *recedes* into the background. A black area must, therefore, be larger than a white area to counter-balance it. A bright surface appears relatively larger than a dark one, because of irradiation effect.

Warm colors, such as red, are heavier than cold colors, such as blue. Bright colors convey more weight than dark colors.

Harann Prod.

Formal composition balance should be used to depict quiet, restful, static scenes —such as injured girl being comforted by her parents. Simplest camera and lighting treatment can best convey peaceful events.

TYPES OF BALANCE

FORMAL, or symmetrical balance
INFORMAL, or asymmetrical balance

FORMAL BALANCE

When *both* sides of a composition are *symmetrical*, or almost equal in attration, *formal* balance results. Formal balance is usually static, lifeless, lacking in force, conflict and contrast. A formally-balanced picture suggests peace, quiet, equality. A cross, a courthouse, or a pastoral scene should be formally balanced because they are generally presented to convey these qualities to the viewer. Such scenes should be filmed almost square-on, with little or no camera angling, so that pictorial elements on each side are similar in image size. Formally balanced compositions should not be garish in handling — lighting, tonal values, colors and contrast should be subtle.

Formal balance is employed in the popular profile two-shot, in which two players sit or stand on opposite sides of the frame facing each other. Dominance switches from one player to the other as each speaks in turn. Since each player is equally important pictorially, it is dialogue, facial expression or other action which attracts audience attention. It is possible to "unbalance" such formally balanced two-shots by *favoring* one player with

210

Informal balance is used on close-ups because the subject must be positioned slightly off-center to provide more space in the direction of look.

brighter lighting, slightly better angling, brighter color costume, better separation with the background or any of the other compositional tricks described elsewhere in this chapter. Thus, opposition, force and conflict may result from an otherwise peaceful composition.

INFORMAL BALANCE

When *both* sides of a composition are *asymmetrical*, or different in attraction, *informal* balance results. Informal balance is dynamic because it presents a forceful arrangement of opposing compositional elements. In an informally-balanced picture a dominant figure or object provides the center of interest. In contrast, or opposition, is a secondary figure or object of equal compositional weight on the other side. Compositional elements of different shapes, sizes, color or tonal values, or static and moving subject matter, may thus balance each other because both sides of the picture are equal in compositional weight. Asymmetrical balance is employed subtly on close-ups — where a single player fills the frame — by placing the head *slightly* off-center, so that slightly more space is provided in the direction in which the player *looks*. By association — with the off-screen player, object or action with whom the player is relating — the look carries sufficient weight to compensate

for the head's off-center position. The on-screen player is thus balanced with an "invisible" off-screen player!

The simplest method for creating asymmetrical compositions is to think of a *see-saw* or fulcrum, with *one side heavier* than the other. The heavy side is the *significant* figure or object, the center of interest in the scene. This dominant compositional element must have an opposing element on the opposite side of the frame, to balance composition of the scene.

A smaller opposing compositional element can compensate for its size by additional weight incurred through its location, shape, brightness, movement or color value. Since movement creates greatest interest in a motion picture scene, smaller moving figures or vehicles carry greater compositional weight than much larger static objects, such as buildings, trees, or mountains. Thus, the center of interest may be a *small* boat moving toward a *large* harbor. Physical size should *not* be the only consideration in choosing a dominant compositional element. Movement is important, too.

The dominant subject should *not* be placed in the same horizontal line with the lesser-weight opposing element; but should be slightly higher

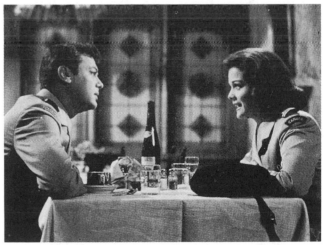

Universal Pictures

Formal balance is generally employed for two-shot of boy and girl. Audience interest will shift from one player to other as each speaks in turn — or performs significant action.

211

20th Century-Fox Film Corp.

The player who should dominate the scene should not be placed in the same horizontal line with a lesser player. Positioning the nun at the right of the frame, and higher than the seated figure, provides a compositionally stronger treatment.

or lower — preferably higher — so that it shows heavier weight in order to attract attention. Therefore, a dominating player should appear higher than the supporting players. Or, if placed lower, or seated, dominate the scene by better lighting or positioning; such as being placed on one of the four strong compositional points of the frame; or even capture attention by the "looks" of the other players directed toward him. Being positioned higher or lower will do the trick, but placing the dominant player at equal compositional height with less important player may weaken the scene. Positioning may also be accomplished in depth by positioning the selected player forward of the others to make him appear higher, or positioning him further back so that he appears lower.

INFORMAL BALANCE WITH ODD NUMBERS

A simple method for creating informal balance is to compose with an odd number of players or objects. An odd number of pictorial elements, particularly three, may be so positioned that a single element will dominate the remainder. Also odd numbers facilitate *uneven* arrangement of pictorial elements; which permits placing the dominant element at one side of frame — or at top or bottom of frame — thus creating a triangular composition. Dominance may be switched from one player to another as the scene progresses, by changing positions, or by one player standing — if all are seated — or by stepping forward. A lower than eye-level camera angle may be given the significant player by placing him toward the right side of the frame, facing inward. The right side has greater pictorial weight. The left side is more obscure.

This does not imply that *all* arrangements should consist of odd numbers of players with the leading player at the apex of a triangular right-handed composition! Variations on this theme should be used whenever practical. The dominant player need not remain compositionally strong throughout the shot, or sequence. He may achieve dominance by movement, or by the movement of other players, or the camera. He may thus capture audience interest only when it is required — such as when speaking an important line of dialogue or performing a significant action.

GRAVITY INFLUENCES BALANCE

Human senses rebel at compositions that defy the laws of gravity. Heavy compositional elements reaching skyward should possess a *low* center of gravity, or they will seem about to topple. A tall

Gravity influences balance. Large structures should have heavy bases — such as steps. Shadowy patterns of foliage aids in breaking up large foreground area.

structure should be supported by a broad base, preferably dark-toned, to aid in supporting its top-heavy visual effect. A relatively large foreground area should be dark shadowed — or illuminated with light filtered through tree branches — to counter-balance buildings or other strong compositional elements. Large areas of sunlighted pavements should be avoided in such instances, either by elimination, or by lowering the camera to foreshorten the area from front to back.

Gravity also influences movement: a balloon ascends upward, an object falls downward, water flows downhill (preferably with upper-left-to-lower-right movement), and a man climbs uphill (preferably with lower-left-to-upper-right movement).

Unbalanced composition may be created by defying the laws of gravity through employment of *baseless* pictures. A tall building jutting diagonally through the frame; or tilted Dutch-angled shots of players, objects or structures depicted in slanting diagonals, which create out-of-balance pictures; may be used when the script calls for violence, fear, panic or impressionistic effects.

UNITY

A picture possesses unity when all cinematic elements incorporated in the scene are perfectly

Talent Arts Prod.

This fight scene forms an inverted triangular composition — with subdued player at bottom apex.

integrated. The desired mood and atmosphere should be conveyed by proper usage of line, form, mass and movement; lighting, player and/or camera movement; tonal values; color combinations; over-all photographic treatment; and editing. The many technical, esthetic and psychological elements should be correlated in order to convey a unified emotional feeling. Mixture of cinematic effects results in a discordant clash, which will weaken the story-telling.

Universal City Studios

Although at left of frame, and lower; the woman dominates the above shot because she is more favorably angled toward the camera, and better illuminated.

Universal City Studios

Low camera angle and selective focusing make player in foreground stand out sharply against supporting players in background, who are lower in frame.

213

An odd number of players, preferably three, may be informally balanced with a single center of interest — such as the actress in this three-shot, who is positioned lower and better lighted than the other players.

DO's & DON'Ts

Do combine long horizontal lines, static or slow-panning camera, soft lighting, slow moving or static players, lengthy scenes, to inspire a quiet, peaceful, restful mood. *Don't* destroy the effect by tilting the camera upward, or by allowing fast player movement, or by editing with short, choppy scenes.

Girl dominates this scene because she is lower, positioned on right and angled toward camera, compositionally stronger.

The ascending motion of these jet fighters is further suggested by flying a diagonal formation. This creates a lower-left-to-upper-right transitional line in space.

Do compose a series of tall vertical columns fronting a courthouse in a dignified manner with a symmetrical, static composition. *Don't* destroy the effect by panning horizontally across the vertical columns.

Do increase the action effect of mountain climbers, racing cars, marching soldiers, by staging their movement so that the viewer's eye must travel in a diagonal pattern.

Do record the graceful effect of a skier twisting and turning downhill by following with a curving camera movement.

Do employ slanted Dutch camera angles, dynamic compositions, dramatic lighting, and rhythmic editing to create an unbalanced, tilted, unstable effect on anything weird or violent.

Don't employ unusual camera angles, distracting background movement or off-beat lighting on a simple scene with important dialogue, which requires greater audio than visual attention.

Do strive always to preserve unity of style throughout a sequence.

ONE CENTER OF INTEREST

A picture should feature *one* center of interest. *Two or more* equally dominant figures, objects or actions in a single scene *compete* with each other

for the viewer's attention, and weaken the picture's effectiveness. A two-shot may appear to be an exception to this rule — but it isn't! One player at a time dominates a two-shot as he speaks or performs a more significant action. A single player may also be favored in a two-shot in a number of ways previously discussed. The eye will thus be attracted to a single player either by his speech or actions or by more favorable compositional, lighting or camera treatment.

The viewer's attention should always be attracted to the most significant portion of the scene. This does not imply that foreground and background action may not occur simultaneously, or that several, or even hundreds of figures or objects may not appear in a single scene. Background action should complement foreground action, so that it provides the setting and atmosphere for the principal players without competing with them.

A dominant compositional element need not consist of a single figure or object. It may be several figures, or any closely-knit combination of figures or objects, which may be merged into a unified grouping. Groups of players, trees, buildings, or marching soldiers, a squadron of airplanes or several machines, may be formed into a single compositional center of interest. Prefer-

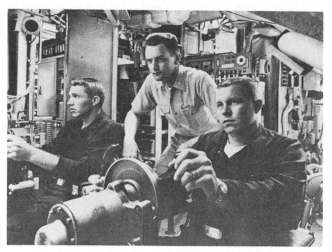

Informal balance is easiest to achieve with an odd number of players, or pictorial elements. Although the seamen are steering this nuclear sub, the officer standing between them is obviously in command, because he dominates the triangular composition. The effect is further enhanced by the officer being dressed in light-colored clothing — which adds pictorial interest.

ential compositional treatment plays up significant portions of the picture. There are occasions when *several scattered* centers of interest are justified; such as in scenes of battle, riot, panic, catastrophe and other actions involving violent,

Woman dominates this informally balanced two-shot because she is positioned on right, favorably angled toward camera and better lighted. Audience is also directed toward girl by man's look.

Viewers' eyes will be attracted to dominant player in a two-shot whenever he is given compositionally stronger positioning, better angling, more favorable lighting — or, more dramatic speech or action.

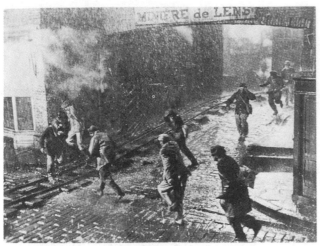

20th Century-Fox Film Corp.

Scenes of riot, panic, catastrophe or other violent happenings may employ several scattered centers of interest such as these people running in different directions.

20th Century-Fox Film Corp.

Framing of players in close-up may be varied if balanced against other objects. Higher positioned candles on right allow framing player's head lower on left.

North American Aviation

The left side of the frame can support greater compositional weight, so this radar operator is properly positioned on right in opposition to the larger mass on left.

unbalanced, disturbing happenings. Members of a unified group of players, for instance, may scatter in all directions in a mob scene; or, individual airplanes in a squadron may peel off toward various ground targets.

POSITIONING CENTER OF INTEREST

The center of interest should seldom be centered in the picture. A cross, a radio or television antenna, or any other object that radiates equally in all directions, would be the rare exceptions. The center of interest should preferably be at the right dominant side of the frame. Making this a fixed rule, however, will result in visual monotony.

A simple and effective method for positioning the center of interest in a dominant portion of the picture, is to divide the frame into three equal parts; first vertically, then horizontally. All *four points* where these lines cross are compositionally strong. As a rigid rule, this may produce a series of mechanically-positioned centers of interest — always falling into similar places in the picture. As a loose rule it will *prevent* bisecting the picture vertically, horizontally, or even diagonally — which results in visually dull compositions.

The horizon, for instance, should not be centered in the frame, because it will divide the picture into two equal parts. The sky may occupy one-third or two-thirds of the picture, but never one-half of the frame. There are situations when the horizon should be completely out of the picture, such as in a low angle shot against the sky, or a high angle shot looking down. Or, the horizon may be a thin line running along the very bottom of the frame — if the sky is featured, as in a sunset shot.

A telephone pole, a tree or similar object, should

Seated player is center of interest in this simply composed, effectively angled and well lighted scene. Position of player, composition and lighting draw viewers' attention toward dominant seated figure. Supporting player on left is subdued by being angled away from camera and less favorably illuminated.

not be vertically centered, or it will divide the picture into two equal parts in the same manner. A diagonal line, such as the slope of a mountain, should not run precisely from one corner of the frame to the other, or it will create two equal parts. Dominant subject matter should be positioned so that it faces inward toward the center of the picture. Framing with a slight lead in the facing direction, will place it slightly to one side of the picture.

The frame should be divided so that prominent lines — horizon, buildings, trees, columns, windows, doors, large lamps — are positioned to attract the eye to a strong compositional point. Odd-numbered divisions, preferably thirds, are best. Cross points should be moved about, however, so that the center of interest occurs at *irregular* positions in the frame in various scenes.

Principal pictorial elements should not be composed with monotonous regularity. Many cameramen discover what they consider a satisfactory compositional arrangement, and they stick with it. This may result in a compositional similarity from shot to shot, though subject matter changes.

Through variety in horizon placement, changing position of center of interest, and diversifying

Harann Prod.

A player may remain subdued in the dark recesses of a room — until moved into the light. Lighting in contrasting planes allows the player to move about from dark to light areas.

player and camera movement; compositions of the various scenes will not appear repetitious.

ATTRACTING OR SWITCHING CENTER OF INTEREST

Audience interest may be attracted *or* switched during a scene by:

POSITION, MOVEMENT, ACTION & SOUND
LIGHTING, TONAL VALUES & COLORS
SELECTIVE FOCUSING

POSITION, MOVEMENT, ACTION & SOUND

The significant player, object or action may capture and hold the audience attention by being positioned in the most dominant portion of the composition; or by moving into the best position as the scene progresses. Or, he may attract attention by being isolated from the other players, or moving *away* from them during the scene. A player may also move for better contrast with the background. Or, a player may stand up or move forward, thus increasing his height or relative size in the frame. A sudden move on the part of a previously inactive player may shock or surprise the audience, so that the player becomes the center of interest in the scene. Or, a player may act forcefully; such as pounding his fist on a table,

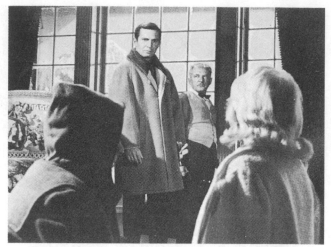

Universal City Studios

Centered player is at apex of a triangular composition, staged in depth. He dominates the scene until player at left, although hooded and unseen, steps up. The center of interest in a scene may change through forceful player movement. Thus, viewer interest can be switched from one player to another, as dramatic interest changes. Such actions are also reinforced by looks of other players.

Universal City Studios

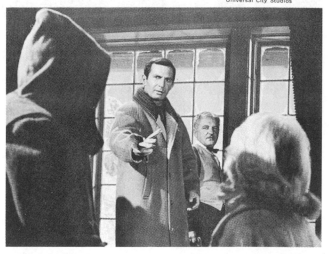

striking another player, or drawing a knife or gun. A player may reverse his direction, so that it contrasts with the movement of other players. Or, a player may assume dominance by moving in front and obscuring other players. The principal player may gain dominance through effective use of sound: by speaking louder or even shouting, by silencing others so that he alone is heard, or by speaking the most dramatic lines.

A player may assume dominance of a group by standing up, while they remain seated.

Audience interest will be centered on player telephoning, because sharp images attract most attention.

LIGHTING, TONAL VALUE & COLORS

Viewer's eyes are normally attracted to the most brightly illuminated, the lightest toned, or the most colorful area of a picture. This eye attraction may be exploited to make the leading player the center of interest by lighter or more colorful clothing, or better illumination. Large screen image is seldom necessary, since even a relatively small object, lighter toned or more brightly colored than surrounding objects, will attract attention. This is due to the contrast formed with its surroundings. A brighter object advances from a darker background *toward* the viewer. It is, therefore, important to see that a subordinate player or object does not *steal* the scene unintentionally through these advantages.

Player or camera movement may be utilized so that a principal player may move into a more brightly lighted area, to increase dramatic emphasis during a scene. Thus, the player may remain subdued, even if costumed in light or colorful clothing, until he moves into the light. Such movement should be timed, of course, to coincide with action significant to the audience. Lighting in contrasting planes allows the player to move about from dark to light areas. Outdoors this may be shadow areas created by tree branches, foliage, buildings, etc. Light and dark

areas are formed throughout interior sets by simulating low key lighting from individual lamps or windows.

SELECTIVE FOCUSING

A very effective method for attracting viewers' attention to the center of interest is selective focusing, which presents significant subject matter sharply, and the remainder of the picture slightly soft in focus. The human eye will always seek out the sharpest image, in preference to soft or out-of-focus images. A player, or object, therefore, will have the greatest eye attraction if it is the sharpest image in the scene.

Modern filming techniques require that only pictorial matter of story-telling significance need be sharp. Unlimited depth-of-field is rarely necessary in theatrical motion pictures. Medium shots and close-ups are generally sharp against a slightly out-of-focus background in dramatic films. The background becomes progressively softer as the camera moves in for closer shots. Such gradual fall-off in background sharpness will be barely perceptible if foreground action depicted is interesting enough to hold attention.

EYE SCAN

The *scanning* movement of viewers' eyes, as they search the picture for its meaning, should

219

Harann Prod.

Harann Prod.

Matched pairs of close-ups of opposing players should be similarly sized from opposing camera angles. Looks are thus on a line toward each other.

be given serious consideration by motion picture cameramen. Studies have been made — many with complex optical instruments that measure eye movement — by advertising and military agencies to learn more about this interesting phenomenon. Advertisers seek a sure-fire method to direct the reader's gaze to product being promoted. Air Force designers want to find the most practical grouping for flight instruments in a jet fighter cockpit, or a space capsule.

The cameraman is concerned not only with the eye scan *within* the frame but — more important —the movement from *one frame to another* when the picture *changes*. For instance, in a two-shot, and subsequent close-ups, the viewers' eyes are directed first to one player and then the other in a back-and-forth pattern. Positions of players in the frame; their relative heights, whether their looks at each other are level, or up or down; will result in definite eye-scanning motions by viewers.

That is the reason individual players must be given correct framing and lead in close-ups. Proper framing places the player's eyes in the proper portion of the picture, and the lead directs the look off-screen to the opposite player, who in turn will appear on the opposite side of the frame, with opposite lead. Viewers' eyes are thus kept on a level; or may look up or down if one player is higher; and be directed back and forth with each cut. If players are improperly positioned in the frame, viewers may be jarred in scanning, and be momentarily distracted.

This also works with long shots, followed by closer shots. Viewers' eyes may be led to the center of interest in a long shot. This area should then be presented in approximately the same portion of the frame in the following closer shot. Otherwise, viewers' eyes will make a decided jump to try to find the center of interest once more. This eye positioning can be easily checked on a Moviola, or other editing device which permits marking the film with a grease pencil. A mark should be made on the portion of the frame where the eye is attracted — either the center of interest, or the place where a player in the scene is looking. Then the film should be rolled a frame or two to the next shot, and a similar mark made. In a series of correctly-framed and composed scenes, the eye will scan approximately the same area; be directed toward the proper portion of the frame in the following shot; or will scan back and forth, as in a two-shot.

While eye scan should be smooth and orderly for most sequences, there are occasions when the center of attraction should jump about. A sudden burst of activity, a new story development, a surprising move on the part of a player, may cause the eye to shift abruptly to a new area of the frame. This should be done whenever the script calls for shocking the viewer into looking at a

QM Prod.—ABC-TV

QM Prod.—ABC-TV

Although government agents and gunman are depicted in separate shots, their guns are fired on similar line across screen. Viewers' eye scan will shift back and forth alternately to follow line of fire.

player, object, or action in another part of the screen. A murderer may be introduced, a vehicle may suddenly appear, or a twist in the story brought on with this jarring treatment. It is wise, therefore, to trap the viewer into scanning a certain area, lead him to believe that *this* is the place to watch — then, in a sudden cut, reveal action elsewhere!

Eye scanning is most effective on a large screen. It is less important on television and small screen 16mm projection because the eye

encompasses the entire area at all times. As 16mm non-theatrical screens become larger, and such films are shown to bigger audiences, the value of eye scanning will be increased. While this practice may appear novel and a scientific curiosity to some observers, it deserves more attention than it generally receives from cameramen.

Scenes may be scaled up or down so that they present small size images — as in a long shot; and large images — as in a close-up. The eye will adapt itself to such scaling whenever the scenes are

Printed matter should be angled to slope up-hill — from lower left to upper right. Such angling permits viewers' eyes to drop down for next line. Downhill angling forces eye to move up to read next line in unaccustomed manner.

CORRECT
EYE SCAN

INCORRECT
EYE SCAN

Columbia Pictures Corp.

A murderer should be suddenly introduced from screen left — to shock viewers who observe his intended victim on right side of picture. Abrupt eye scan from right to left contributes to startling effect. Audience will be shocked by action after preceding lull

progressive, regressive, contrasting or repetitious in image size. However, the eye rebels when images are changed *slightly* in size, or *slightly* in angle – an effect similar to a jump-cut. This occurs when close-ups are presented in a hodge-podge of image sizes, rather than in pairs of matched close-ups, filmed in series of opposing angled shots, or, series of same size reaction close-ups of several players. Close-up images, slightly smaller or larger than bracketing close-ups, create expanding and contracting effects when scanned. This lack of uniformity in image size is most disconcerting to viewers.

Erratic eye scanning, caused by scattered, oddly-sized, oddly-angled images, may be employed when unbalanced or weird effects are desired. Scenes of panic, catastrophe or violence may be enhanced by being oddly-sized or oddly-angled; or even Dutch-tilt angled. Viewers will thus be forced to scan the screen with abrupt back-and-forth, up-and-down or diagonal eye movements, involving the audience more closely with the screen action.

The *CAMERA ANGLE* chapter discussion on filming signs and printed matter should be re-read for its eye-scanning effects.

Universal City Studios

This scene is compositionally interesting because lines of tunnel diminish toward right, and frame far player in center of circular opening.

IMAGE PLACEMENT

Image placement is the positioning of subject matter in the frame, or *framing*. Many scenes involve player and/or camera movement, which require *continuous composing* as the action progresses. A moving player should be given slightly more space in the direction in which he *travels*. Statically-positioned, he should be given slightly more space in the direction in which he *looks*.

Amount of head room — distance between tops of players' heads and top frame line — varies with combinations of players, backgrounds, compositional masses — such as framing devices — at top of picture. Head room that may be excessive when players are positioned too low in the frame, with a plain background; may be just right if an overhanging tree branch stretches across top of picture. Excessive head room will make the picture look bottom-heavy. Insufficient head room will cause the picture to look crowded.

Players should *not* come into contact with the frame by standing or sitting precisely on the bottom frame line; or leaning, or in precise line-up, with the sides of the frame. The bottom frame line should *not* cut across a player's *joints;* knees, waist, elbows, shoulders, etc. Positioning of players particularly in closeups, should be arranged so that the frame line cuts *between* body joints.

223

COMPOSITION

Care should be exercised in moving shots so that a player, or players, come to a key position with framing similar to that used for static shots.

Careful framing of moving shots — where player's image size varies throughout the scene — is just as important as composing static shots. The most important player, object or action should generally be positioned on the right. If the dominant player needs to be positioned on the left, he may be given preferential compositional treatment by better lighting, more favorable body angling, stronger contrast or separation from background, or other methods. In a symmetrically composed two-shot, each player will dominate the shot in turn as he speaks. If it is desirable to surprise or shock the audience, a new player may be suddenly introduced from the left. This will cause the viewer to shift attention abruptly from right to left. The villain may pounce on the hero from screen left, an important prop or significant action may suddenly appear at the left of the screen — by moving in, or through camera movement — to gain attention. This is much more successful if it occurs during a lull in the action, so that the audience is taken unaware.

Leading lines should diminish toward the right, to attract the viewer's eye to the center of interest. Large masses positioned on the right, however, may *overbalance* the picture. As example, an important player may stand on the right and look at a large mountain peak on the left. If the picture is reversed, he may be "lost" on the left, and the mountain would overpower the composition. The cameraman should be aware of merits of various frame positions, so that he can place dramatic emphasis to best advantage.

IMAGE SIZE

A viewer interprets the size of an *unknown* object in a picture by contrasting it with an object of known size or with the background; or by its appearance in relation to the frame. The viewer's experience furnishes a mental scale by which he judges the relative size of known figures or objects at varying distances from the lens. He has no way of judging the size of unknown objects unless furnished with a clue — such as contrast with size of

Lower than eye-level camera and forward positioning causes Indian brave to dominate this shot. Selective focusing also aids in capturing audience attention.

a familiar object — or by its relationship with a background of known dimensions.

In theatrical films, it is often necessary to cheat the height of a leading player, so that he can look down at other players from a higher level. This is accomplished subtly — particularly in medium or close shots — by having the player stand on a block, or by positioning him forward of the other players and lowering the camera so that he appears taller. Sometimes motion picture art directors design *converging* sets, with built-in *forced perspective* in which normal-sized players appear in the foreground, and under-sized or even midget players are positioned in the distance! The eye is easily deceived by the *apparent* size of objects. Relative size, distance, perspective, may all be distorted or exaggerated.

In non-theatrical films, however, the opposite ordinarily applies. Falsification of any kind must usually be avoided, and the true size of the objects be shown. Tools, instruments, machines should be filmed with an operator in position to show their proportionate size. If such items are filmed in close-ups against a plain background, they should be combined with objects of known size, or a hand should be introduced. Where this is not possible, they should be positioned against a background of familiar dimensions.

Charles O. Probst

Space scientist checks out instrumentation and radio telemetry circuit before mounting equipment in missile nose cone. Through showing of hardware during progress of operations, story is not interrupted by static display.

Regardless of their actual physical size, images that *crowd* the frame are considered larger than images which are relatively small in relation to the frame. A tiny object may appear huge, if crowded so that its edges almost touch the edge of the frame. A large object may appear small, if filmed with a great deal of space around it. A mountain may appear lofty, if it is positioned high in the frame so that little sky appears above it. A relatively small number of people, objects or machines may appear greater if crowded so that they overlap the frame, suggesting there are more *outside* the picture. Seeing *less* than the whole — whether crowds, electronic circuits or machine gears — will relay the impression that the entire picture is too vast or complicated to capture in its entirety. If filmed from a high angle, so that personnel overflow the framed area, a small group of draftsmen at work may suggest a large organization. The same effect may be accomplished with small numbers of machines, computers, file cabinets, etc.

A figure or object may be made to appear taller by angling the camera upward, particularly if the image consists of vertical parallel lines tending to converge. A low angle, wide-angle lens shot of a tall building will make it appear even taller. A low angle subjective shot of a person from a

225

child's viewpoint, filmed so that he crowds the frame, will convey a similar height effect.

Psychological aspects of image size and angling, in relation to the frame, may produce greater emotional response in viewers than appearances alone. An extreme long shot, looking downward from a high angle, on a tiny group of pioneers inching their way across a vast rugged landscape instantly portrays the hardships and privations endured on a long, lonely trek. Theatrical films make extensive use of such contrasting shots; not only for visual variety, but to provoke the audience into greater involvement in the story by arousing emotions. Non-theatrical film makers may also employ extreme long shots or extreme close-ups for dramatic effects.

INTEGRATE COMPOSITION & CAMERA ANGLES

Pictures must be composed with definite viewpoints in mind. A perfect composition arranged for a particular camera angle may be very poor when viewed from an opposite angle. This is especially difficult in motion pictures where a sequence, or a series of shots, involve viewing the scene from several angles. Composition and camera angles should, therefore, be integrated so that players and pictorial elements will be properly composed as the camera is moved about to film the various shots making up the sequence.

Generally, a good long-shot composition will work well on closer shots, if the camera set-ups are not drastically altered. Moving in and around the subject matter need not change the player/background relationship, if all shots in a sequence are carefully lined up in advance during reheasal. Player and/or camera movement are most important in integrating composition and camera angles, because such movements may develop into assets or liabilities.

An excellent static composition may deteriorate into confusion as players or camera move *during* the action; or when player/background relationship is drastically changed from one set-up to another. On the other hand, players and/or camera may move in harmony as the action progresses, so that the scene is continuously com-

posed and the player/background relationship constantly revised to meet any compositional problems that may develop. Such planned movement will allow moving the players out of awkward pictorial situations, so that they are lined up properly when the camera moves in for medium shots and close-ups. Side angles and over-the-shoulder close-ups may suddenly introduce table lamps, furniture or other objects, which distract from main action, or merge with player's

Santa Fe Railway

Switching camera angle from above shot to scene below results in better composition. Faces of Indian woman and child are seen. Hands are not hiding work, and pattern of rug is clearly shown. Side angle also results in converging lines and overlapped figures positioned in depth — rather than across screen.

Santa Fe Railway

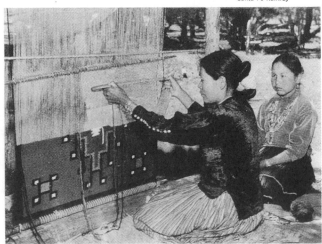

features. Consideration should be given to cheating such items, or removing them temporarily.

Continuous composition, which keeps the players properly framed as they move during the scene, is not difficult to maintain. It requires constant vigilance, however, to see that: players are given proper leads at all times; player/background relationship is pictorially pleasing; and pauses at key positions are particularly well composed. This can be best accomplished if players are first placed in *each* key position and carefully composed for the best pictorial effect; and *then* moves in between key positions are worked out.

PERSPECTIVE

Perspective is appearance of objects as determined by their relative distance and positions, or as influenced by atmospheric conditions.

There are two types of perspective:

LINEAR
AERIAL

LINEAR PERSPECTIVE

Linear perspective produces *convergence* of *parallel lines* in any plane at an angle to the viewer. Parallel horizontal lines, such as railroad tracks, appear to converge at a distant point on the horizon. Parallel vertical lines, such as the sides of a tall building, appear to converge if a

Santa Fe Railway

Parallel horizontal lines — such as railroad tracks — appear to converge on distant horizon.

viewer looks up or down. Illusion produced by geometrical linear perspective help the viewer judge distance of an object of known size. The appearance of depth and solidity in a picture depends much on linear convergence, created by diminishing sizes of figures and objects as distance increases.

AERIAL PERSPECTIVE

Aerial perspective is a *gradual lightening* and softening of distant outdoor objects, caused by

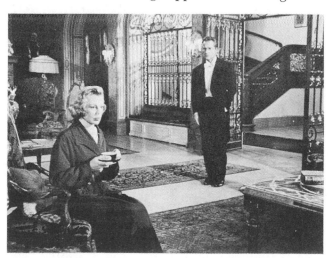

Universal City Studios

Players should first be composed in key positions. Then moves between key positions should be worked out.

Charles O. Probst

Angle shot of this Javelin rocket presents interesting composition due to depth effect produced by converging lines.

Aerial perspective supplies translucent quality to this wildlife scene. The more distant foliage is lighter and provides a soft background for the sharper, darker figure of the doe and trees.

intervening haze. While weather conditions influence aerial perspective even on a clear day, appearance of distant objects is governed by the amount of atmosphere through which the viewer, or the camera lens, must look.

HOW TO INCREASE PERSPECTIVE EFFECTS

The following staging techniques and camera treatments may be employed singly or in combination to increase perspective effects:

Choose camera angles which portray the greatest number of planes or facets of the subject. Shoot angle-plus-angle so that the front, side *and*

top *or* bottom of an object are recorded for greatest solidity.

Choose a combination of camera angle and lens focal length which produces the greatest linear convergence *without distortion*. Select the *shortest* focal length lens (not necessarily a wide-angle lens) that will record a realistic linear perspective with converging lines to lead viewers' eyes into far reaches of the scene. Extreme wide-angle lenses should be used only for special effects where greater than normal convergence is desired. The finest modeling of the players and setting, and the greatest audience involvement results when the camera is brought as close as possible, to record

Santa Fe Railway

Aerial perspective supplies depth to this outdoor scene because the distant mountain is lightened and softer in contrast to the trees closer to the camera.

the scene *without* distorting the images.

Position players, props, furniture and other objects so that they *partially* overlap. Overlapping conveys spatial relationships simply and effectively. Isolated figures and objects may be *any* distance from the camera. Clues to which are nearer are furnished by their known size. Since sizes of unfamiliar figures are difficult to judge, positioning questionable objects behind other objects — so that they overlap — leaves no doubt in viewer's mind of which is closer.

Move players and/or camera to cover and uncover other players, objects or furniture in the setting. Have players move *between*, rather than in front of, other players. Or, have players move *between* or *behind* furniture, lamp fixtures, desks or other objects; so that they are partially covered at intervals in their travel from one position to another in the setting. Move the camera, so that it shoots through or past foreground objects, as it follows the players or moves about the set. Overlapping on movement in this fashion introduces *motion parallax*, a variation in image travel of objects at different distances from the lens. This conveys position and distance of various players and objects in the setting to the viewer.

Move the players or vehicles *toward* or *away* from the camera, rather than straight *across* the

229

North American Aviation

Greatest linear convergence results when camera is centered amidst series of horizontal lines receding into distance. Depth without distortion is achieved in this view of underground missile silo —

screen. An image that *increases* or *decreases* in size as it travels, conveys a feeling of spatial depth and distance. An image that moves across the screen remains the same size throughout its travel. Even when a player or vehicle must move across the screen, try to angle the camera slightly; or stage the movement so that it is not precisely at right angles to the lens. Always strive to impart a change in image size — even if slight — so that the moving player or vehicle advances or recedes when traveling across the frame.

Avoid filming in flat light, indoors or outdoors. Over-all shadowless illumination produces a flatness of field minus projections and modeling, lacking texture, and preventing separation of figures and objects. Utilize side lighting, or any lighting which produces shadow areas that impart three-dimensional modeling to figures and setting.

Light an interior scene so that the picture presents a contrasting series of planes, with various degrees of light and shade. Such differential lighting imparts a front-to-back quality to players and setting. When filming outdoors, try to include the lighter distance background for additional aerial perspective. A similar effect may be achieved indoors by lighting the background just a trifle "hotter," in order to carry the viewer's eye into far reaches of the setting.

North American Aviation

— and this scene of a magnetic tape library. The further viewers' eyes must travel into scene, the greater the depth effect. Camera should be centered for this type of shot, so that lines converge at center of picture.

BACKGROUNDS

Theatrical motion picture producers transport casts, camera crews and equipment thousands of miles so that stories may be staged against authentic backgrounds. Dramatic feature films employ interior and exterior backgrounds to advantage as story-telling aids.

For the most part, non-theatrical cameramen, filming on location, do not take sufficient advantage of backgrounds. In many cases, they deliberately eliminate or misuse them. For instance, backgrounds are often ignored in factories because lighting or sound present technical prob-

lems. Backgrounds may be wrongly treated on outdoor locations, because the director and/or the cameraman do not understand the importance of backing up players and action.

Whenever possible, the background should be tied in so that it may contribute activity, authenticity or realism to the story. Industrial subjects may be set against machines; farm subjects against growing crops; flying films staged with airport background activity. Camera angles should be chosen and action staged so that the players move against backgrounds that spell out the particular activity whether oil field, giant steel mill,

231

20th Century-Fox Film Corp.

Angle-plus-angle filming produces interesting linear pattern in this scene. Effect is enhanced by semi-silhouette foreground object, well-lighted players and lighting in contrasting planes.

amusement park, assembly line or wheat harvest. Thus, foreground actions tied in with the background, provide greater scope, additional pictorial interest and a *you-are-there* feeling.

Documentary films shot on actual locations can be made more effective by proper regard for storytelling backgrounds. Finding suitable sites for staging the action will add realism by backing players with whatever machinery, activity or scenery is available. The background should constantly, yet subtly, remind the viewer that the story is taking place on the waterfront, in a steel mill, in a nuclear power plant.

Backgrounds are just as important indoors as outdoors, and should be carefully scouted on interiors where there is a choice of staging the action. For instance, it is not fitting to stage a factory production sync-sound sequence in a quiet area against a nondescript background. This treatment detracts from, rather than contributes to, the story. In this approach, the true meaning of location filming is lost on the viewer. It is not enough to film establishing long shots of the actual setting, and then retire to plain settings for the heart of the story — just because it is easier to handle that way. Such scenes may be filmed *anywhere!* There is no need for expensive travel to location; then shoot against walls, or trees and sky.

International Harvester Co.

Farm background makes this scene imme- diately identifiable to audience. Stage action against background which may contribute story value to activity being depicted.

Bob Jones University-Unusual Films

Figure at side of frame may provide simple L-shaped composition because it supplies a vertical in combination with a ground base. Foreground soldier and tent provide excellent frame for distant camp scene.

Warner Bros.

The camera should shoot through fore- ground objects — such as this oil well — whenever possible. Such treatment adds depth effects and suitable atmosphere.

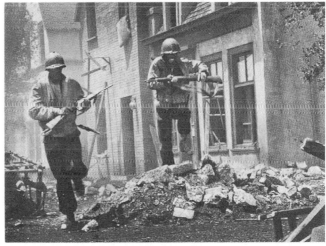

ABC-TV

Stage moving action so that it is angled in relation to camera. These running soldiers increase in image size as they advance to- ward audience.

On occasion, it may be best to isolate the play- ers against the sky or other nondescript back- ground, if action or dialogue demands concentra- tion without distracting elements. This becomes increasingly important as the camera moves in closer; and a small group of players, or even a single player, must command the audience's com- plete attention. The background should never be more interesting than the player's action or dia- logue, or it will steal the show. The background should balance with the foreground by remaining in place *behind* the action. It should not intrude on the foreground players or action, or distract the audience in any way by its make-up, move- ment or color.

Players should be positioned so that there is

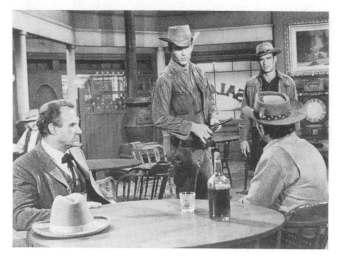

Universal City Studios

Action should be staged and camera angles chosen to allow shooting across or through foreground objects. Players should move between, or even behind other players, and pause in positions which present them overlapping one another. Composing in depth and staging action in this manner will present players, setting, objects, with solid, three-dimensional appearance.

distinct separation between foreground action and background. A figure or object, similarly toned or colored, merging with the background, will flatten the picture. Separation and isolation with lighting effects, contrasting tones or distinct color is most helpful. This is particularly important in close-ups, where the player's head should stand out from the background. Often, moving the camera a few inches, higher or lower, or to one side, will achieve a better background relationship by preventing an annoying line or shape from piercing a player's body or head; or by removing the edge of an object or a tiny portion of a light fixture, a window or some other disturbing element. Any moving or distracting object, or colorful activity which may attract unwarranted attention, should be eliminated.

FRAMES

A frame may consist of any foreground pictorial element which surrounds the picture partially or completely. Frames available or contrived for the purpose may be: arches, windows, awnings, doorways, street lamps, bell towers, sign

Warner Bros.

Spreading tree branch furnishes pictorial foreground frame for riders.

20th Century-Fox Film Corp.

Interior frame — such as this window — may be used to depict exterior scene.

posts, portholes, iron grilles, fences, porches, columns, bridges, or a portion of larger objects, such as an airplane wing, a tree branch or a cannon barrel. A frame supplies a pictorial foreground element, contains the action, and prevents viewer's eyes from wandering off screen.

The frame should not be composed evenly on all sides, unless it is round or absolutely symmetrical. Frames are much more photogenic if shot from a three-quarter angle, rather than square-on. A slight angle will show the frame's depth, add solidity and prevent a cardboard cut-out appear-

Calif. Div. of Highways

Foreground palm tree frames distant building, and also suggests warm climate.

Lockheed-California Co.

Underside of this pier forms excellent frame for docked boat.

Talent Arts Prod.

Narrowing screen width with doorway frame produces confining effect to convey feelings of younger wife about ailing husband.

ance. Back-cross or even complete back lighting will add to the effect by sending a sun-splashed pattern of light toward the camera, which repeats the frame's outline on the foreground. Long leading shadows, adding depth to the setting are also supplied. Back lighting will also edge-light the frame and separate it from the more distant view by outlining it. This will impart a luminous, ethereal quality to foliage and other translucent objects. The frame itself can often act as a gobo — to shield the lens from direct rays of the sun.

FRAME REQUIREMENTS

A frame must be appropriate, and yet not detract from the main subject. Determining a proper frame is not difficult. Usually improper frames are artificially contrived. Keeping a frame subdued can often cause trouble. Elaborate, or otherwise distracting frames, should be avoided. The *subject* is the picture; the frame is only a compositional aid.

DISTINCT FRAME SEPARATION NECESSARY

There should be distinct separation among frame, main subject and background. Merging caused by similar tonal values, similar colors or similar light effects will destroy the separation necessary for distinctive pictorial effect. A frame should not be shot in a flat front light, or it will include the same tonal values as the main scene

and merge with it. Frames should be filmed in silhouette, semi-silhouette or partial shadow. If front light is unavoidable, or desirable for color; employ a tree branch, a gobo or a "cookie" to add a shadow pattern, and thus break up and tone down the frame era. A foreground player, in profile or looking into the scene, will add the human element; and direct viewers toward main action.

Partially-illuminated foreground frames are more effective in color than in black and white.

235

Calif. Div. of Highways

Warehouse doorway frames ship loading operation.

A frame in partial silhouette will contain soft underexposed bluish hues, which offer subtle color contrast to a correctly-exposed, warmly-illuminated subject and background. Exposure should be based on principal subject — not the frame.

PARTIAL FRAMES

When a full surrounding frame is missing, a partial frame consisting of top and one side, should be used. A part of a tree branch, or other object, should *not* be included. A frame should show solid connection. It should not merely hang in space. Too little of a frame may tease the audience, if they cannot deduce what it is.

Partial frames are a great compositional aid in breaking up large expanses of empty foreground, or bald skies. A low wall or a shadow pattern cast by tree leaves, with a suggestion of a tree at the side, will enhance a dull sun-lit pavement. Other props, such as wagon wheels, parts of awnings, lattice work and grilles will be useful on occasion.

FRAME FOCUS

Frames should be sharp. An out-of-focus foreground object, occupying a major portion of the picture, can prove very disturbing. By splitting the focus, or employing the hyper-focal distance setting, both the frame and the main object can be kept equally sharp. A *slightly* soft-focus frame is permissible, if sufficient depth-of-field is not available, providing the frame is underexposed or in silhouette. Since it possesses a much greater depth-of-field than a normal objective, a wide-angle lens will prove useful. However, a telephoto lens may sometimes be necessary, in order to film a nearby foreground frame, and enlarge more distant subjects. If the subject is too small, in relation to the frame itself, it can be made to appear larger by moving the camera back; employing a longer focal length lens, and recording the full-scene frame with relatively large images of the main subject.

FRAME MOVEMENT

Wildly moving frames — such as tree branches in a high wind, flapping awnings or dancing leaves — should be avoided, because they may detract from the main subject. Camera movement *toward*, *away from*, or *across* a frame is permissible; providing the frame itself remains static. A slow pan or dolly shot ending in a well-composed frame as the camera slowly moves into position, following moving action, can be most effective. A dolly may pull back in a tracking shot, and go through a doorway or arch to frame the scene. A

North American Aviation

Tail of tanker aircraft provides frame for long shot of plane. Subjects with long, low silhouette — such as jet airplanes — are more easily composed with aid of foreground frame, which covers excess sky.

Santa Fe Railway

Metal arm and hose line — for welding steel rails — make appropriate frame for track laying operation.

moving camera, mounted on a car or train may frame a distant tunnel opening, which gradually becomes larger, revealing more and more of the view until the framed scene finally opens wide on the screen. An annoying *skipping* effect may result from panning across a frame with strong verticals close to the camera.

FRAMES CAN AID STORY-TELLING

The wing and landing gear of a giant airplane — framing boarding passengers — instantly spells fast travel to far places. A bridge — framing a distant city — may provide the means of carrying the audience across an expanse of water, into the heart of the scene. A canopied boat deck may frame a welcoming harbor, as a ship makes port. Silhouetted factory chimneys belching smoke — framing a distant swinging crane — may suggest industry. A long, low overhanging branch, together with a winding white fence — framing a farm setting — may convey restful country atmosphere. An arch, framing an old Spanish mission, pictures old-world architecture in both close-up and long shot. A series of arches, receding into the distance, creates a pleasant rhythm through repetitious diminishing lines; which provide strong converging linear perspective and third-dimensional quality.

DYNAMIC COMPOSITION

Dynamic composition, in which forceful pictorial elements evoke a *sudden* change in a static set-up, should be employed when abrupt or surprising effects are desired. In this way, quiet scenes may spring into vigorous life, or motionless elements may abruptly become dramatically active. A restful distant scene may be interrupted by a nearby figure or object popping up, falling down or running or swinging through the frame. This startling compositional effect is a familiar classic in western pictures, where many Indians suddenly appear from behind rocks!

Vehicles may be dynamically utilized in many ways: an auto may swing into a country road from the side of the frame; a truck may zoom up into the picture from the bottom of the frame; an airplane may drop jarringly down into the picture from the top of the frame, and bounce on to a quiet runway as it roars away from the camera. A distant peaceful vista framed through a bell tower may startle eyes and ears of the audience, in a close-up as the bell swings into view and clangs loudly. A long shot of oil derricks may be suddenly interrupted by a close-up of a pump arm swinging up into the frame. Dynamic compositions are most effective when the audience is encouraged to concentrate first on a quiet *distant* scene for a second or two. Then the suddenly

Santa Fe Railway

A quiet street scene may be abruptly interrupted by a trolley moving into the frame.

237

moving object or vehicle moves into the scene close to the camera. Treatment of this type requires the utmost discretion, so that it is limited to properly-motivated dramatic situations. A long calm passage may have lulled the complacent audience, who now need a forceful and surprising cinematic device to recapture their attention.

SUSPENSEFUL COMPOSITION

Suspenseful composition — in which significant action is hidden, absent, or prolonged by the manner in which it is staged — can be a valuable story-telling aid. While the villain may be moving behind a pile of boxes in order to pounce on the hero, the audience is shown only a slow pan of the boxes, with no indication of where the action is about to take place. Or, because the runway is too short, a rescue airplane must take off and *drop* into a valley to pick up flying speed. A suspenseful tail-away shot may be filmed from behind so that the aircraft takes off, and falls out of the frame. For a few agonizing seconds, the audience sees blank sky. Then the plane climbs back into view!

Variations of blank screen suspense may occur in a fight sequence between two armed men. They fall out of the frame as they fight, but the camera does not follow them down — it remains on the *empty* frame for a few seconds. Then a shot is heard. The audience is kept in suspense until the victor rises. Suspense is prolonged in the classic shot where the heroine is undecided whether or not to board a train and leave the hero. The camera is switched to the opposite side of the tracks, and the entire train goes by before the audience will know her decision, by her presence or absence on the platform.

An industrial film may keep the audience in suspense by showing raw material entering the feed end of a machine, and follows manufacturing procedure, so that the product is kept secret until it emerges. Camera angles may be employed to keep the identity of a setting a secret; such as a foreign-appearing locale in an American city — until revealed as a surprise.

Whenever suspense of a "cliff-hanging" variety is the keynote of the sequence, all possible methods of handling the subject matter should be con-sidered, so that the audience is kept in doubt as long as desired. A simple switch in camera angle, player movement or unconventional staging is generally all that is required.

CATALOG PICTURES

Catalog pictures; shots of tools, machines, packages, instruments — either singly or in groups — seemingly defy laws of good composition. Non-theatrical film makers, particularly producers of industrial, military and training films, are concerned with catalog-type layouts depicting the paraphernalia involved in assembly, repair or other work. Similar type shots consisting of groups of buildings, engineering test equipment, laboratory layouts, rows of drafting tables, lines of machines, instrument panels, and myriad other objects, may lack a *single* center of interest.

Catalog shots need not be static. They may be panned, dollied, zoomed, or otherwise given movement. They should be inserted without interrupting the film's flow. A picture on operation of a turret lathe should not suddenly stop to show a static catalog shot of accessories required for performing a particular job. Equipment needed should be shown in course of the work.

There are occasions, however, when one or more objects must be positioned and photographed to resemble the still photographs found

North American Aviation

Diagonal and circular lines may be used for composing objects for display. Pair of shots of similar objects should be filmed in opposing compositional patterns.

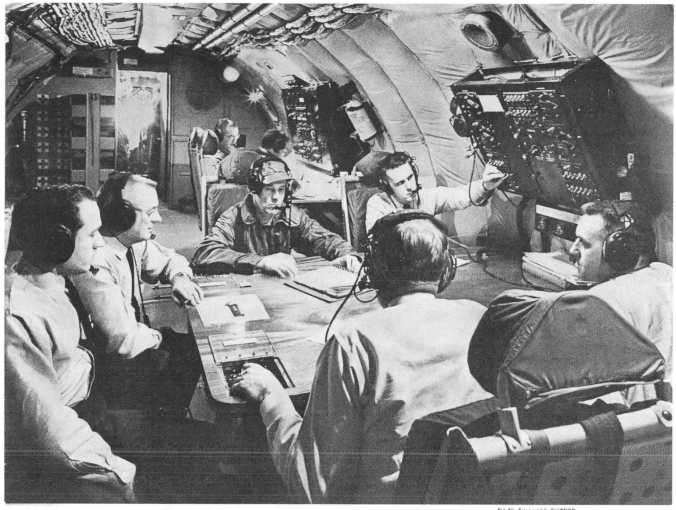

North American Aviation

Flight officers in this SAC B-52 flying command post face inward in a simple
circular composition — to reinforce their unity of purpose.

in a catalog. Rather than standard commercial catalog views, patterns of lines, shapes or forms conveying an esthetic or emotional impact on the viewer make more pleasing and effective shots. A single center of interest may often be composed by forming a pattern. For instance, a group of lathes may be shot from a high angle, so that they form a rhythmical repetition of diagonal lines suggesting action, purposefulness, urgency. The lines in this case should travel lower left to upper left, to impart an *ascending* spirit of accomplishment. Running upper left to lower right would result in an opposite pattern, with a downbeat effect.

Compositional rules should not be discarded without serious consideration of the various ways in which the items may be positioned. A package should face inward toward the center of the frame, with slightly more lead in the facing direction; and so angled that the front, side panel and top are seen. Three packages may be positioned to form a triangle. Tools, boxes, cans, gears, small parts may be grouped in compositional forms, such as triangles, circles, ovals or various L combinations. Items may be lined up in diagonals, rather than straight across the frame. Two consecutive shots may be composed, facing each other in opposing diagonals. Items may also be stacked in pyramids, or grouped in ovals around a central object. Whenever possible, shoot angle-plus-angle slightly from the side, so that groups

239

Series of similar objects should be lined up in diagonal pattern — rather than straight across — for more dynamic shot.

A dominant player may be centered in a composition on rare occasions, such as the above scene, where the girl's head acts as a hub and surrounding players' looks radiate toward her.

of objects face one side, rather than flat front. Informally-balanced pictures or formally-balanced pattern pictures which convey a feeling of unity, rather than a scattered effect, are preferred.

When filming a series of pattern pictures for a montage sequence, the cameraman's prime considerations should be arrangement of the various shots in compositional opposition for greater forcefulness, conflict or contrast. A diagonal line-up facing left may be opposed by a right; a high angle by a low angle, etc. It is wise, if both time and budget permit, to film such scenes both ways. With this precaution, the film editor has a choice on a left or right, a high or low, or a camera movement in either direction. Often a pan, tilt or dolly shot may be opposed by a similar shot in the opposite direction. The order in which the shots may be used should be left to the editor.

COMPOSITIONAL VARIETY

Variety is the spice of motion picture compositions. A film should maintain unity of style in integration of its technical, esthetic and psychological elements. At the same time, it should present a variety of compositions, camera angles and image sizes, so that players and settings are not depicted in a monotonous pattern. Similar compositional treatment of the various settings or similar staging, player movement or camera

A dominant character consoling a distressed player is best composed with a head resting on a shoulder to form a pyramid composition.

movement should all be avoided.

A cameraman may easily slip into a rut, particularly on short schedule, low-budget films. He may be tempted to stay with a compositional routine and stock photographic treatment — safe, easily-handled and — since it has long been repeated — apparently effective. Slightly different treatment, whenever possible, may add interest.

Harann Prod.

Position players in depth — rather than across the frame — so that viewers feel they are in the midst of the setting, not observing the event from afar.

Warner Bros.

This three-shot forms a triangle in depth. This is basically a two-shot — with the judge in the far background forming the apex of a triangle.

COMPOSE IN DEPTH

Create compositions in depth, rather than simply positioning players or objects *across* the screen equi-distant from the camera. Utilize every practical depth device to build a three-dimensional illusion on the motion picture's two-dimensional flat screen. Shoot angle-plus-angle. Position various players throughout the setting, so that they

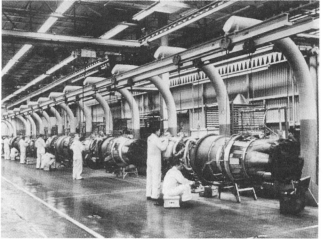

TWA

Angling the camera on this jet engine repair operation — rather than shooting square-on — creates converging lines.

overlap. Move players and camera back and forth, toward or away from the viewer. Choose camera angles and lenses which produce converging lines and interesting perspective effects — light in contrasting planes, with less light on foreground objects — so that silhouette or semi-silhouette effects result. Shoot deep settings whenever possible, so that distant background may be seen.

Employ foreground frames or set pieces, so that the camera shoots *through* or *across* objects, to record the players and their action in the middle distance. Select interesting backgrounds that tie in and back up player's action. Position the camera so that it is in the midst of the setting, players and action; rather than back out of range, and simply looking on from a distance. Avoid shooting across unobstructed empty space to record players or objects, standing as if posing for an elementary school class picture. Arrange players, objects and set pieces so that *both* front and side views are seen, not simply the *front* or the *side*. Always work for rounded, well-modeled views of players. Integrate composition and camera angles so that players, and their relationship with their surroundings and the background, are well composed in all shots comprising the sequence. Use forethought and imagination!

Strive to overcome any tendency to restrict depth, because it is easier to light, carry focus and

241

North American Aviation

Harann Prod.

Although these scenes — jet fighters, above, and train wheels, below — are dissimilar in subject matter, they have one common quality. Both are composed in depth, with repetitious circular patterns receding into the distance.

Profile two-shots are flat because subjects are filmed square-on, above, and display little modeling or roundness. Over-the-shoulder close-up, below, presents players in depth, with foreground player overlapping rear player.

Santa Fe Railway

Harann Prod.

stage action in a limited area. *Always* think in depth. Avoid flat angles, flat lighting, cross-screen movement and positioning players and staging action in a lined-up straight-across fashion. Remember that depth on the screen begins with composition; and is enhanced by camera angles, which produce three-dimensional solid effects.

SIMPLICITY

The secret of good composition can be explained in one word: *simplicity.* A complicated or cluttered composition, even though it obeys all

rules of good composition, will not be as effective as a simple one. Simplicity does not imply starkness. A simple composition is economical in use of line, form, mass and movement; includes only one center of interest; has unified style which harmoniously integrates camera angles, lighting, tonal and color values.

The test of good composition is whether anything can be *removed* from the picture without destroying its effectiveness. Any element in the frame not required for story-telling purposes, attracts

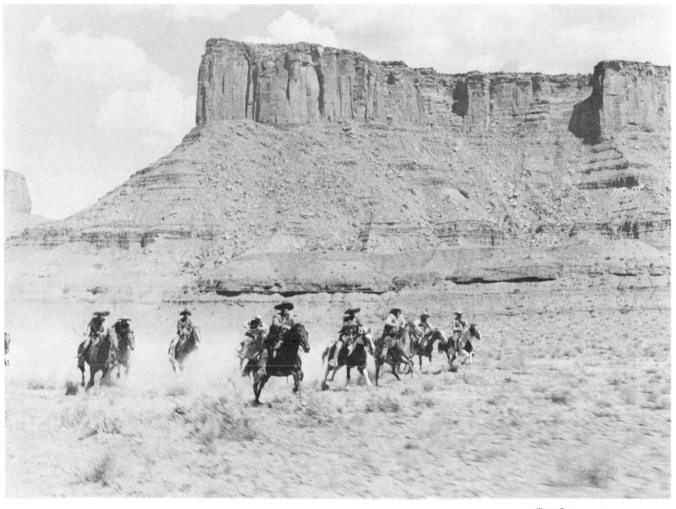

Warner Bros

Extreme long shot — depicting vastness of setting — dwarfs these riders against arid, rugged terrain and mountainous background.

unwarranted audience attention. Such distracting pictorial elements may steal the scene from principal subject matter. A simple composition is immediately recognizable and readily assimilated by the audience. The viewer should not have to search the framed area to discover the shot's meaning. This is most important in motion pictures, which are series of individual scenes. A person may study a still photograph until he is satisfied that he comprehends it. A movie scene appears for a limited time, and is then removed. Confusing or puzzling compositions irritate the viewer, and may cause him to lose interest.

Simplicity does not depend on the number of scenic elements; or the area included in the pic-ture. A table-top shot depicting half a dozen objects may present a cluttered composition; while an extreme long shot of an advancing army may convey a unity of force and power immediately recognizable, because of its simplicity. If a vast number of compositional elements must be photographed, they should be harmoniously grouped.

CONCLUSION

Think of composition as the pleasant arrangement of players and objects in the setting, or as a division of space. Don't be awed by composition. Become familiar with the various characteristics of lines, forms, masses and movements. Consider compositional weights, so that the frame may be

243

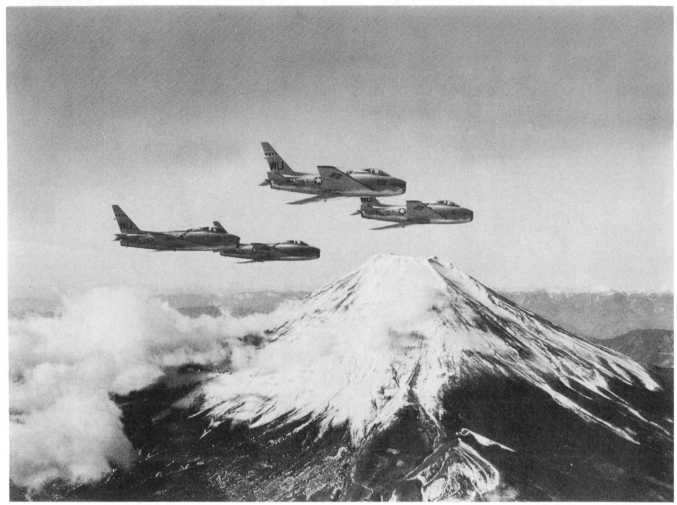

North American Aviation

Man's conquest of the skies is simply depicted in this scene of soaring aircraft over a snow-capped mountain.

properly balanced. Understand differences between formal and informal balance, and when to use each for proper audience response. Remember that the viewer must be affected both pictorially and psychologically, to convey the script's intent to arouse his emotions. Never allow more than one center of interest on the screen at one time unless a disturbed, or scattered effect is desired. Frame moving players or vehicles carefully, so that they always have the correct lead. Consider all camera angles required to film the entire sequence when composing the master scene, not just the long shot. Utilize perspective effects. Compose in depth for a three-dimensional screen appearance. Employ foreground frames to enhance the composition; and be certain they are appropriate, and do not detract from the main subject. Utilize backgrounds, by connecting them to the principal action. Consider the viewers' eye scan from shot to shot. Work for visual variety, by changing compositional effects often. Eliminate frills, gimmicks and complex arrangements.

Make *Keep It Simple* the working slogan for interesting compositions.

INDEX

With Appreciation

In my prologue, I explained that the writing of THE FIVE C's at times seemed almost impossible. To a great extent, this book has been made possible through the kind cooperation of many organizations and individuals.

For use of photographs, my sincere thanks are extended to :

John E. Allen, Inc.
American Broadcasting Company
California Division of Highways
Cine-Probst, Inc.
Columbia Broadcasting System
Columbia Pictures Corporation
Harann Productions
International Business Machines Corporation
International Harvester Company
Irvmar Productions
Industrial Film Producers Association
Bob Jones University – Unusual Films
Kramer Company
Lockheed-California Company
Matson Lines
Metro-Goldwyn-Mayer
Claude Michael, Inc.
National Aeronautics & Space Administration

North American Aviation, Inc.
QM Productions
Martin Rackin Productions
Raco Machine Products Co.
Radio Corporation of America
Santa Fe Railway
Talent Arts Productions
Tech-Camera Rentals, Inc.
TRW Systems
Trans World Airlines, Inc.
Twentieth Century-Fox Film Corporation
Universal City Studios
University Film Producers Association
University of Southern California, Department of Cinema
United States Air Force
United States Army
Warner Bros.
Weber Aircraft

For helpful technical comments and suggestions, I am particularly grateful to William Zsigmond, and the following individuals:

Irvin Berwick
Robert Bethard
Paul E. Braun
Thor Brooks
Jarvis Couillard
Louis Hochman
Robert Jessup
Everett C. Kelley
Edward Martin
Frank Meitz
Frank Messinger

George J. Mitchell
Howard Moore
R. P. Murkshe
Roy Neil
Kenneth Nelson
Charles O. Probst
W. Dale Russell
Peter Sorel
Mrs. Gilbert Stenholm
George W. Sutphin
James S. Watkins

Gerard Wilson, A.C.E.

For the efforts and professional skills graciously given in posing for explanatory photographs, to illustrate THE FIVE C's, I am indebted to:

SHARY MARSHALL

TODD LASSWELL

JOHN HARMON

TOM IRISH

RON HAGERTHY

For art direction I thank Alexander Ratony; and for assistance in graphic preparation, reproduction and binding, these capable men:

Everett Brown, *Typesetting* Dale Pettet, *Screened Negatives*
Richard Burg, *Printing Plates and Presswork*
Raymond Ahlich and Richard Herzog, *Edition Binding*

The author is especially grateful for the friendship of Mack William Radstone, whose knowledge of our language put technical procedures into clear, concise wording; and whose experiences in graphic processes and advertising arts have helped transform my life-long dream into reality.